T0261071

EWVA

European Women's Video Art in the 70s and 80s

Cover image: Lydia Schouten, *The Lone Ranger, Lost in the Jungle of Erotic Desire*, 1981, still from video. Courtesy of the artist.

EWVA European Women's Video Art

Arts & Humanities Research Council

Duncan of Jordanstone College of Art & Design University of Dundee

Research supported by:

Arts & Humanities Research Council; Duncan of Jordanstone College of Art & Design; University of Dundee

EWVA
European Women's Video Art in the 70s and 80s

Edited by
Laura Leuzzi, Elaine Shemilt and Stephen Partridge

Proofreading and copyediting by Laura Leuzzi and Alexandra Ross
Photo editing by Laura Leuzzi and Adam Lockhart

British Library Cataloguing in Publication Data

EWVA
European Women's Video Art in the 70s and 80s

A catalogue entry for this book is available from the British Library

ISBN: 9780 86196 734 6 (Hardback)

Published by
John Libbey Publishing Ltd, 205 Crescent Road, East Barnet, Herts EN4 8SB,
United Kingdom
e-mail: john.libbey@orange.fr; web site: www.johnlibbey.com

Distributed worldwide by **Indiana University Press**,
Herman B Wells Library – 350, 1320 E. 10th St., Bloomington, IN 47405, USA.
www.iupress.indiana.edu

Printed and bound in China by 1010 Printing.

Contents

'EWVA | European Women's Video Art in the 70s and 80s' is the main output of the
eponymous research project funded by the Arts and Humanities Research Council and
based at Duncan of Jordanstone College of Art and Design, University of Dundee.
The research team consisted of Professor Stephen Partridge, Dr Laura Leuzzi,
and Adam Lockhart, led by Professor Elaine Shemilt.
We wish to thank all the authors, artists, copy-editors, translators and our publisher without
whose dedication and passion, this volume could not have been achieved.
This book would have not been possible without the generous contribution of all the artists,
curators, academics, theoreticians, practitioners, technicians, galleries, museums,
video art centres and archives that have participated in the project.
To each and all of them we owe our immense gratitude.
Hopefully this publication justifies their trust in us.

Foreword

Siegfried Zielinski

The origin is a trap. Michel Foucault, archaeologist of sexuality, knowledge, and power, stressed this over and over again – following in the footsteps of Friedrich Nietzsche. In seeking the provenance of complex phenomena, there is never only a single point, a single truth from which all else derives. Interdiscursive contexts, such as video art made by women, or feminist video art, likewise develop from a set of historical conditions.

Women's revolt against patriarchal relations in Europe after the Second World War, aspirations to break the taboos regulating established gender norms, an invalidation of the legitimacy of male domination in the art market and in cultural institutions since the latter half of the 1960s – these were decisive for those conditions. But there was also another set of impulses resulting from techno-social, techno-political, and medial factors.

In the early 1970s, the writings of so-called theorists of the apparatus in the Parisian journals *Cahiers du cinéma* and *Tel Quel* (Jean-Louis Baudry, Jean-Louis Comolli, Marcelin Pleynet) radically did away with the naïve idea that the technologies of film and cinema were in any way neutral.

Basing their analyses on sources as diverse as Plato's critique of the image in his 'Allegory of the Cave', Husserl's phenomenology, Lacan and Kristeva's still incipient psychoanalysis, and above all a Marxist-inflected critique of ideology, these theorists made it unmistakably clear that the dominant power relations were inscribed in the apparatical structure of cinema technologies themselves and that film undergoes complex processes of encoding, from the recording of external reality to its projection on the screen.

Laura Mulvey concretised these perspectives on the cinema in 1975, with her critique of traditional film. *Visual Pleasure and Narrative Cinema* became the paradigmatic text of feminist media critique, with concepts such as 'phallocentrism', 'scopophilic instinct', and 'a woman's to-be-looked-at-ness' evolving into analytical *leitmotifs* in progressive thought on cinema. In the following years, Italian-American cultural theorist Teresa de Lauretis and the Korean-American artist and theorist Theresa Hak Kyung Cha, who was raped and murdered in lower Manhattan in 1982, helped to further develop the apparatus-heuristic into an important theoretical instrument for the women's movement.

Enormous critical potential also unfolded in the immediate field of media technology itself. Laura Mulvey and Peter Wollen's critical-discursive *Riddles of the Sphynx* was still, in 1977, produced on 16mm film (with music by the legendary Mike Ratledge of Soft Machine). At the same time, in France and Switzerland with their joint production company *Son+Image*, Jean-Luc Godard and Anne-Marie Miéville had been working for several years already with the amateur's gadget – electronic video – which they preferred to cinematography because of the lightness and flexibility of the medium.

Like this work, which was done in the beginning with explicit reference to the Russian avant-garde artist Dziga Vertov,[1] the whole early period of artistic engagement with the new electronic medium was very explicitly political in character. The Raindance Corporation, originating in the United States but expanding to include other groups and cooperatives from other capitalist countries, understood video as a component part of social movements and as a medium of interference: for a systematically decentralised television of many producers and for greater autonomy in possible cultural expressions. This development had a techno-economic basis: the new mobility of this video technology – its continuing reduction in size and price peaked with the Sony Portapak introduced in Japan in 1967 and in the US in 1968 – was what opened the possibility of thinking a flexible, spontaneous, and autonomous application of the medium.

There was already manifest artistic video work done in the second half of the 1960s, by the likes of Bruce Nauman, Nam June Paik, and Wolf Vostell. Female artists discovered the potential in this new aesthetic and political instrument a little later, but with greater energy and impact. The *Menstruationsfilm* that VALIE EXPORT made in 1967, now considered lost, was still filmed on 8mm cine film. The provocative, now iconic projects in Expanded Cinema that VALIE EXPORT and Peter Weibel made in the late 1960s are not at all video works. *Cutting* (1968) was a multi-part performance using paper screen, slide projectors, and a naked male actor (Weibel), whose body hair was shaved with a razor into decorative patterns by the director (EXPORT). EXPORT/Weibel's *Tap and Touch Cinema* (1969, German title: *Tapp – und Tastkino*) was an action piece that dispensed entirely with film as a medium; that was the profound meaning of the action, which understood itself to be above all a critique of the image-imaginary. The documentation that remains of another action featuring Peter Weibel reading through a megaphone from an inflammatory text on the capitalist exploitation of sexuality in cinema while, among others, the filmmaker Werner Nekes is permitted to stroke EXPORT's breasts for a few seconds was also captured on cine film. The confrontation between the illusionary and the real was also the guiding idea behind EXPORT's *Action Pants: Genital Panic*. But the originary action is less well-known. Wearing jeans with a hole cut out at the genitals, VALIE EXPORT squeezed her way through the rows of a movie theater, just prior to the start of a show, so that the seated audience was presented with the object of male desire immediately at eye level.

An early exhibition of exclusively video art, organised by Willoughby Sharp in New York, in August/September 1970, included only men. Here Vito Acconci, Bruce Nauman, Dennis Oppenheim, and others presented their first black-and-white tapes in half-inch reel format.

Shigeko Kubota began assembling her *Broken Diary* videos (1972/73) in the Experimental Television Center in Binghamton, New York, in the final days of the Fluxus movement. Marcel Duchamp, John Cage, George Maciunas, and a young Nam June Paik were her artistic collaborators. At the now famous MoMA conference *Open Circuits* in New York in 1974, from which resulted the book *The New Television: A Public/Private Art*, Kubota was the only female artist invited to speak about her work. She opened her speech like this: 'Men think: "I think, therefore I am". / I, a woman, feel: "I bleed, therefore I am". / Recently I've bled … ten thousand feet of half inch tape, every month. Man shoots me every night … I can't resist. I shoot him back in broad daylight with a vidicon or tivicon, taping in overexposure. / Video is Vengeance and Victory of Vagina'.[2] At the conference, Joan Jonas was nevertheless able to deliver a statement from the audience, which she used to present,

briefly and impressively, her 1972 work *Organic Honey's Visual Telepathy*. Ulrike Rosenbach's earliest black-and-white videos also date back to 1972. Friederike Pezold's body-anagrammatical works first began appearing in 1973, following several videographic experiments in 1971. As of 1973, VALIE EXPORT also turned to film, and more intensively to the electronic medium. In 1973 alone, EXPORT produced the video sculpture *Time and Countertime*, early video installations like *Interrupted Movement* and *Autohypnosis,* the video tape *Visual Text: Finger Poem*, and the performance videos *Asemia* and *Hyperbulia*.

By the mid-1970s at the latest, with Martha Rosler's grandiose parody of female household labour, *The Semiotics of the Kitchen* (1975), women's art had taken hold of the new electronic medium and begun to assert itself politically, symbolically, and aesthetically.

A project like EWVA | European Women's Video Art in the 70s and 80s, has supported the uncovering and de-marginalisation of these practices and the book will act as a key instrument to continue in this sense.

(Translation by Lauren K. Wolfe)

Endnotes

1. Vertov's famous film *Man with a Movie Camera* (1929) is still to this day mistranslated, both with respect to gender specificity and technological description. The original Russian title could be literally translated as 'The Human with the Cinematographic Apparatus'.

2. Shigeko Kubota, 'Women's Video in the U.S. and Japan', in Douglas Davis, Allison Simmons (eds.), *The New Television – A Public/Private Art* (New York: Electronics Art Intermix 1977; Cambridge/MA, London: MIT Press, 1978), p. 97.

Preface

Laura Mulvey

'EWA | European Women's Video Art in the 70s and 80s' brings a nearly forgotten moment in the history of women's art practice back to life, vividly evoking its special sense of excitement and promise that still resonates across time. The essays trace an almost magical coincidence between the appearance (across the 1970s and 80s) of video technology and women's urgent need, inspired by early feminism, to find a new mode of expression through a new kind of art. Repeatedly and from multiple perspectives, the book is a reminder of the way that the fragility and informality of the medium worked as a complement to a nascent feminist aesthetic, which was able to benefit from the ephemeral and the immediate. The stories told in these essays have opened my eyes to the history of a feminist art of which I have always been aware but, I now feel, I have never properly understood.

Working as a feminist with film in the 1970s was a very different experience from the feminist encounter with video. For instance, film had its own important radical traditions and, in 1979, I argued for 'an objective alliance' between a feminist aesthetic and the avant-garde, with an emphasis on materiality and on structure, with a wary approach to self-expression, especially as an emanation of the female body and spontaneous emotion.[1] But as I learnt about this extraordinary episode in feminist aesthetics, I found myself using terms such as 'bringing back to life', and 'magical coincidence' to evoke both the wonder of this art and its own particular materiality, grounded in time and space, as cognitively rich as that of cinema and dedicated to experimenting with ideas and images specific to women's experience of oppression.

Feminist film and video were both dedicated to challenging patriarchal tradition, especially its exploitation of the image of woman in art and in commodity culture. But the way the absolute novelty of the medium affected the encounter between women artists and video comes across strikingly from different accounts of movements across different European countries. In itself, novelty brought liberation: video had no place in the history of art and gave women artists an unprecedented freedom. As Elaine Shemilt puts it:

> It was the freedom that we were afforded. Every artist that used video had that, but I would argue that creating moving imagery where a film crew was not required

was particularly liberating for women.[2]

The equipment was easy to use, a woman could handle the camera on her own and, perhaps even more crucially, the form had not been contaminated by years or even centuries, of male domination. But Shemilt's remarks point beyond this practical and ideological issue. If the new camera afforded freedom, what kind of new language, images and ideas did the new freedom then afford?

It is here that the question of the 'specificity of the medium' takes a fascinating turn that leads directly to the 'specificity of women's oppression'. Over and over again, across national and cultural differences, themes recur that are closely associated with the female body and most particularly motherhood. Then, in the process, as Catherine Elwes points out, the mutually exclusive terms 'mother' and 'artist' are unsettled. While these images worked in deliberate opposition to the traditions of male art, more significantly, they provided a completely new visibility to women's own experiences of their bodies. The new cameras enabled the artist to film herself intimately and the pregnant belly came to be a crucial visual trope, giving visibility to something nearly universally experienced, but universally subject to patriarchal taboo, all too often lived in isolation. But the image of motherhood inevitably leads further into feminist politics: the difficult task of bringing this rich, complex interweaving of the physical, the emotional and the social aspects of motherhood out of the unspoken world of women into cultural discourse, in this case, through video art. In this example

alone, the video camera afforded the woman artist access to the feminist aspiration to move from the silence and isolation of the private into the public sphere.

In terms of themes, video enabled the intimate and the private to be explored by women artists, and also, as eloquently discussed by Laura Leuzzi, offered new modes for representation of the self, introspection and subjectivity. Beyond themes relevant to women, video materialised new ways of conceiving time and space. As the image appears on the monitor the instant it is recorded, the time of 'now' can be expanded, or fragmented, creating unexpected levels of simultaneity. Leuzzi points out that the formal device of instant feedback brought extra dimensions to feminist video self-portraiture, important, for instance for Elaine Shemilt's *Doppelgänger* (1979–81):

> Artists could see themselves on the video monitor whilst videotaping and the tape was available immediately after the shoot. The monitor could generate an instant double of the artist … .[3]

And, as Maeve Connolly emphasizes, video could transport site specific performance from outside into the interior of a gallery, creating a formal dislocation of time and space that could, in the Irish context, evoke the thematic dislocations of migration and post-colonial legacies.

Throughout the essays in the book, there is a further, more disturbing, temporal dimension. The completely new ways of visualising time, so essential to the work, are haunted by video's own and actual ephemerality and its uncertain future. On the

one hand, with a pre-history that related strongly to performance art, essentially a one-off form, the tentative, fragile, nature of the new language of video coincided with the tentative move women were making into art and self-expression. In a rejection of the commodification of art, the new medium's relation to the present, even its uncertain future, could keep pretentiousness, preciousness and incidentally, male artistic self-importance, at bay.

But on the other hand, throughout the book, there is an undertow of mourning, first of all, for the lack of infrastructural support (mentioned, for instance, in Irish and Polish contexts) that limited women's video art practice and, then, for all the work that failed to survive. In their conversation, Sean Cubitt draws attention to the difficulty of making copies of tapes, in the first instance, but also to their material vulnerability; while Elaine Shemilt remembers:

> I did not feel as though video was a medium that was supposed to stand the test of time. It was designed to be short term and usually part of an installation … I made a new body of work; it was all transitory, short lived. It's odd now to look back at the remaining videos with a precious attitude.[4]

Malcolm Dickson traces the importance of artists as activists and propagandists for their medium. He discusses Stansfield/Hooykaas' comparatively successful preservation of their work, but also notes: the practi-

cal and theoretical issues around medium specificity and the technological shifts that result in certain 'carriers becoming obsolete'. He also points out that in the UK, with a similar activist spirit, key artists found a place for video in the art school curriculum under the name 'time-based art'.[5]

Introducing *After Uniqueness. A History of Film and Video Art in Circulation* (2017),[6] Erika Balsom rephrases André Bazin's question 'What is cinema?' as '*Where* is cinema?' (using the term 'cinema', obviously, as a catch-all). In 'European Women's Video Art' the problem of 'Where?' resonates poignantly, from the very beginnings of women's work with video when its ephemerality and refusal of definition was almost part of its poetic instance, through the stories of loss and disintegration. The book suggests that 'where?', in this context, is a space for ideas and memories as well as the physical presence of the object (however welcome that would be). I would like to end with a quotation from VALIE EXPORT that elegantly sums up the importance of the book and the way that the political and the artistic potentials of the video medium were inextricably entwined:

> The question of what women can give to art and what art can give to women can be answered like this: transferring the specific situation of women into the artistic context establishes signs and signals that are new forms of artistic expression that serve to change the historical understanding of women as well.[7]

Endnotes

1. Laura Mulvey, 'Film, Feminism and the Avant-garde', in Id., *Visual and Other Pleasures* (London: Macmillan, 1989), pp. 111–126.

2. See p. 87 in this publication.

3. See p. 12 in this publication.

4. See p. 90 in this publication.

5. See p. 72 in this publication.

6. Erika Balsom, *After Uniqueness. A History of Film and Video Art in Circulation* (New York: Columbia University Press, 2017).

7. See p. 119 in this publication.

Introduction

Laura Leuzzi

In 2003, in her article on the New York Women's Video Festival (1972–80), Melinda Barlow commented 'there could be no better time to undertake this task, for both the legacies of video and feminism are literally at peril'.[1] Since then, studies exhibitions and research have been dedicated to specific women artists – who have now become 'mainstream' – such as, for example, Marina Abramović. But overall, the fundamental contribution of women artists to video – especially in Europe – is yet marginalised and the legacy of women artists' early video is still precarious.

In 2015, Elaine Shemilt (Principal Investigator), Stephen Partridge (Co-Investigator), Adam Lockhart (Media Archivist) and I (Post Doctoral Researcher) were awarded an Arts and Humanities Research Council standard grant to undertake the research project EWVA | European Women's Video Art in the 70s and 80s at Duncan of Jordanstone College of Art and Design at University of Dundee (Scotland).

The application to the Arts and Humanities Research Council was prompted by the knowledge acquired during the AHRC funded projects the team was previously involved with: REWIND and REWIND*Italia*. EWVA emerged from the profound agency and understanding of the necessity to investigate and uncover the contexts in which women artists' video was produced and first exhibited, in order to trace how the artworks were distributed and also to collect information about access to technology, expertise and funding. Furthermore, it was clear that the loss of many works was partially due to the ephemerality of many early video artworks, performances and installations – to which women were particularly committed, often because they refused the commodification and reification of their work.

A key aspect that emerged from preliminary studies was that some early women's video artworks 'resonated' with each other: many videos showed similar approaches to the medium, reflected upon common themes and issues and employed similar metaphors and semantic elements. Many artworks were linked to feminist theories and movements of the time, challenging patriarchal concepts and power structures that informed the art system – including art schools and colleges, and more generally, our society. With its European scope and international collaborations, EWVA offered a privileged and specialised platform to investigate these aspects.

The project was developed through a mixed methodology by collecting archival and bibliographical materials and oral testimonies from artists, curators, cultural entrepreneurs, conservators and producers. The documents, images and papers collected were made available through our website (www.ewva.ac.uk) in the spirit of sharing knowledge, but also promoting women artists' profiles, supporting their careers, and advocating for equality in the video art history canon.

From the beginning of the project, it was apparent that it was not possible to give a full recollection of women artists' video in Europe, given the geographical extent of the project. A number of case studies were chosen from different countries, diverse approaches to the medium and their relevance, in order to stimulate research and debate in the field and uncover under-researched work. These case studies have highlighted further themes, issues and how the social, political and cultural context have influenced and shaped these practices.

Another element that emerged during the interviews was the importance of feminist groups in producing and distributing video in the 70s and 80s for many women artists. In the UK, for example, the feminist group Circles, founded in 1979 by Felicity Sparrow, Lis Rhodes, Jo Davis and Annabel Nicolson, operated by distributing and supporting women artists' video and film.[2]

During EVWA, a number of research and exhibition events were organised to engage with research communities, disseminate the findings of the research, and test and experiment with practice-based research methods and platforms in relationship to the subject of the investigation. Research, feedback and data gained and collected in these events have been incorporated into the chapters of this book.

In 2015 I co-curated *Autoritratti* with the London based curators Giulia Casalini and Dr Diana Georgiu, founders of the queer feminist organisation CUNTemporary. *Autoritratti* was a performative screening at the Showroom, London, that drew from the innovative and experimental book *Autoritratto* [Self-portrait] by the feminist thinker Carla Lonzi.[3] The book *Autoritratto* created dialogue among artists that interlaced interviews independently recorded by the author, from which an extraordinarily lively portrait emerge from the personal and professional exchanges and interconnections between the artists and the critics. Engaging with multiple methodological approaches and curatorial strategies, including dialogue, autobiography, cross-genre and fragmented narratives, *Autoritratti* created an entwined cross-generational and international dialogue of voices (real or interpreted) and video artworks by women artists from the 70s to today, around concepts of identity, self-representation and definition. The event explored themes such as motherhood, the role of women within society, traditional popular culture at large, the status of women working as professional artists, intimacy, and the agency of the body. An iconic video that was included in the screening was Ketty La Rocca's *Appendice per una supplica* (Fig. 1), a work produced by the video pioneer Gerry Schum in 1972. The performative

work explored issues such as gender, communication, language and dialogue and acted as a milestone in Italian and European video art history and in our screening.

A second iteration of this format, entitled *Self/Portraits* at the Centrespace, Visual Research Centre (DCA, DJCAD, University of Dundee) and co-curated with Casalini and Georgiou, developed further on Lonzi's approach and engaged with theories from the Italian feminist philosopher Adriana Cavarero's book *Relating Narratives: Storytelling and Selfhood* (2000), where an exploration of one's own identity is framed as the desire to hear one own story narrated by another person.[4]

Another practice-based methodology consisted of the re-enactment of early video works. In October 2016, I co-curated with Lockhart, Shemilt's *Doppelgänger Redux*, a live re-enactment of the early video performance *Doppelgänger* (1979–1981).[5] The re-enactment acted as a fundamental research tool to investigate the piece: it allowed for greater understanding of how the artist took advantage of the mechanisms and technical features of early video equipment and allowed her to decompose and recompose the structure of the piece. The re-enactment embedded both the memory of the original artwork and the live engagement of the audience. The production and the backstage of the video were revealed live to viewers for the first time. It created an intimate environment and provided an enhanced emotional involvement by projecting the feed from the camera.

Other relevant exhibition and research events developed during the project include *The Time is Right for*

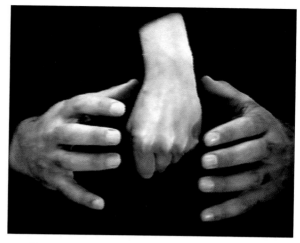

Fig. 1. Ketty La Rocca, *Appendice per una supplica*, 1972, still from video. Courtesy of The Ketty La Rocca Estate, Florence.

..., *Marikki Hakola, Ketty La Rocca, Elaine Shemilt, Giny Vos*, an exhibition curated by myself and Lockhart at Summerhall, Edinburgh (2 August – 24 September 2017, Fig. 2). The exhibition explored the approach of women video artists to a wide range of socio-political themes and issues such as peace-making, systems of power, dialogue, conflict, control and equality, in connection with contemporary contexts, debates, and historical events.

In Autumn 2017, EWVA was invited to participate in Neon Festival in Dundee as part of *The Polyphonic Essay on Memory* curated by Dr Alexandra Ross, Gayle Miekle and myself.[6] The curators investigated the EWVA and REWIND archives and each selected two video-works, exploring, from a feminist approach, the theme of memory from different perspectives and angles; including historical and personal memory, archetypes and forms of narrative. The selection was reciprocally revealed only during the event and the curators developed a discussion, responding live to the individual works, offering opinions, comments and feedback based on their own curatorial and art historical

Fig. 2. Marikki Hakola, *The Time is Right for …*, 1984, photo composite. Courtesy of the artist.

expertise, research and background. This semi-improvised dialogue stimulated an interesting response from the audience which reacted to the selection and the debate.

In March 2018, EWVA joined Horsecross Arts at Threshold artspace, Perth, to celebrate International Women's Day with an iteration of the series *3G Three Generations of Women Perform*, curated by Iliyana Nedkova and myself. The event incorporated women artists' video with live performance from the video pioneer Elaine Shemilt, and young artists, creating an inter-generational dialogue.[7]

This book constitutes the main output of the research conducted through EWVA and aims to retrace some of the stories of early women artists' video experimentation in Europe, and their achievements, and features chapters on some fundamental case studies of European women artists' early video artworks. This book aims to contribute to the

reassessment of women artists' involvement in early video art in strengthening their profiles and identities within the art historical canon.

The volume includes chapters on themes, elements, styles and trends, that emerged as particularly significant across Europe in early video artworks by women artists: self-portraiture, identity and representation in relation to art history, theory and the canon (Leuzzi, Emile Shemilt); ephemerality, traces of artworks and the apparatus (Partridge); the dichotomy between Nature and Urban environments (Lockhart); romance, agency of the body, sexuality and eroticism (Cinzia Cremona); closed-circuit video (Slavko Kacunko); and how women video artists challenged the traditional concepts and stereotypes in relation to motherhood (Catherine Elwes). Elaine Shemilt develops a complex dialogue with the media art theorist Sean Cubitt engaging with political contexts, transitions

in mediums and themes in relation to early women artists' video in Europe.

Some chapters focus on select under-researched case studies from specific European regions including the Balkans (Jon Blackwood), Northern Europe (Lorella Scacco), Poland (Marika Kuźmicz) and Ireland (Maeve Connolly). The chapter by Malcolm Dickson is dedicated to the germinal work and legacy of the Scottish/Dutch video pioneers duo Stansfield/ Hooykaas. These chapters provide exceptional specialist analysis and assessment of how women artists experimented with the medium, also providing a clear context of how the inception of the medium differed from country to country in Europe, due mainly to political and economic situations and systems.

We were honoured to open this book with a preface and a foreword, by two esteemed theorists and academics in the field, Laura Mulvey and Siegfried Zielinski.

In conclusion, the EWVA book aims to provide a tool for academics, curators and the general public, hoping to uncover and reassess the many histories of women artists, in order to inform future conservation, study and exhibition of the pieces, as well as their induction into the canon.

Endnotes

1. Melinda Barlow, 'Feminism 101: The New York Women's Video Festival, 1972–1980', *Camera Obscura*, 54, v. 18, n. 3, 2003, pp. 3–38, p. 4 for the quote.

2. Katy Deepwell, 'Felicity Sparrow: forming Circles', *n. paradoxa*, v. 34, 2014, pp. 86–95.

3. *Autoritratti* was part of the feminist program *Now You can Go*, organised at The Showroom, Raven Row and the ICA in London by the Feminist Duration Reading Group and coordinated by Helena Reckitt and Dimitra Gtizta. *Autoritratti* included videos by Anna Valeria Borsari, Cinzia Cremona, Catherine Elwes, Tina Keane, Ketty La Rocca, Federica Marangoni, Maria Teresa Sartori, Elaine Shemilt, and Elisabetta di Sopra. The event featured live performances by Catherine Elwes, Maria Teresa Sartori and Elaine Shemilt.

4. *Self/Portraits* included video artworks by Pilar Albarracin, Cinzia Cremona, Catherine Elwes, Francesca Fini, Antonie Frank Grahamsdaughter, Sigalit Landau, Tamara Krikorian, Muda Mathis & Pipilotti Rist, Lydia Schouten, Elaine Shemilt, Annegret Soltau. It featured live performances by Cinzia Cremona, Elaine Shemilt and Lydia Schouten.

5. The event was part of the festival Visions in the Nunnery, at the Nunnery Gallery, Bow Arts, London, curated by Cinzia Cremona and Tessa Garland.

6. Neon Festival is a digital arts festival based in Dundee, started in 2009. The 8th edition of the festival in 2017 was dedicated to Media Archeology and was curated by Clare Brennan, Sarah Cook, Mark Daniels, and Donna Holford-Lovell. This edition of the Festival was a collaboration between DJCAD, University of Dundee and Abertay University. *A polyphonic Essay on Memory* included works by Antonie Frank Grahamsdaughter, Rose Garrard, Tamara Krikorian, Annegret Soltau, Maria Vedder & Bettina Gruber and Marion Urch.

7. The curated screening included videos by Klára Kuchta, Federica Marangoni, Elaine Shemilt and Teresa Wennberg. The event was closed by site-specific performances by Contemporary Art Practice students from Duncan of Jordanstone College of Art and Design led by artists Richard Layzell and Pernille Spence.

Self/Portraits: The Mirror, The Self and The Other. Identity and Representation in Early Women's Video Art in Europe

Laura Leuzzi

Self-Portrait and Gender

During the Renaissance, a new sense of agency in the role and identity of the artist stimulated the self-portrait as an independent genre. Since that period, many artists have explored this genre with different results and sensibilities, employing new and old media. For a number of reasons, including unequal access to professional artistic education, the marginalisation from 'high art' genres and the expected role of women within society in the past, many women artists were not allowed to become professionals in the field of art and allowed to reach 'the grandeur'.[1] Considering this, nonetheless, several key examples of women artists' self-portraits are to be found in the Modern Age. Self-portraits at the time not only depicted the artist's appearance, but also, and more importantly, represented the status and achievements she obtained. Ultimately, self-portraits were employed for professional and promotional purposes.[2] Relevant examples include Artemisia Gentileschi's *Self-portrait as Allegory of Painting*, and Sofonisba Anguissola's and Lavinia Fontana's numerous *Autoritratti* (self-portraits).

With advancing access to the art profession and practice, the number of women artists' self-portraits increased significantly during the 20th Century. For many of them, the self-portrait became a tool to defy the conventional and stereotypical image of the woman as a mother and a saint; to defy the idea of the female nude as the embodiment of beauty and the object of the voyeuristic male desire and to renegotiate their representation, with the aim to negate the 'male gaze' (a famous definition created by Laura Mulvey in her famous piece *Visual Pleasure and Narrative Cinema* in 1975).[3] For example, as noted by Whitney Chadwick, Surrealist women artists frequently employed the self-portrait and self-representation and that, in Laura Iamurri's view, this can be explained by the

necessity to challenge 'the ambiguous mythicisation of women so typical of the Surrealist movement' and to face, particularly through photography, 'self-perception starting from their own bodies'.[4]

Marsha Meskimmon, for example, defines what she calls 'occupational portraits'. Since the beginning of the 20th Century, the representation of women artists at work, as makers, producers, in their demiurgic activity of creating art became a 'simple' but meaningful trope: it challenged the very art historical canon that has marginalised and excluded women. It represented a powerful statement: to affirm their status of professional artists and to proclaim their independence.[5]

With second wave feminism, many women artists felt the necessity and urgency to regain control of their image and representation in a patriarchal society, and incarnated in mainstream media, to present themselves with no mediation, ultimately defying the stereotypical equation woman/saint/sinner and the duality within the patriarchal art system of artist/man and woman/model.[6]

Themes previously sanitised by the hand of the male artist, including women's sexuality, desire, aging and pregnancy, were finally developed from a woman's perspective, becoming tools to question what is identity and draft their own self-portrait. Second wave feminism led to an unprecedented number of representations of the female body, including the artist's body; self-representation and self-portraiture were explored in different media and with different results, aiming to represent women from a woman's perspective and for women.

An image not meant to please, but as tool to express themselves, communicate, engage and challenge society and its stereotypes.

In this paper, I will argue how the category of the self-portrait is significant to critically interpret and contextualise some key women artists and early video artworks, which engaged in and tried to defy some tropes and topoi of this genre from various perspectives. In this respect, video became a tool to de-territorialise the genre of self-portraiture, as a means for female artists to actively position themselves in art history and to further challenge the art historical canon in general.

Early Video and Women Artists: Using their own Body

When video was made commercially available in the late 60s and early 70s in the USA and in Europe, it appealed to many visual artists as it presented several advantages.[7] Besides being relatively less expensive than film, the technology was comparably easier to operate.[8] Video did not require a large crew and artists were able to operate the equipment alone or in very small groups of two or three, creating an intimate set: a safe space for experimentation. Furthermore, video didn't need processing and printing, as in the case of film. The images could be viewed – while taping – on a feedback monitor and the artist could check the shot constantly. The video could be also replayed on the monitor after shooting. All these elements favoured the exploration of the body, identity and self-representation.

In 1976, the American video artist

Hermine Freed pointed out that artists used their own body because it enhanced a sense of control, allowing the artist to work alone.[9] This brings us to a point raised at the beginning of this chapter. In a context of re-appropriation of their own image as a way of self-representation, video was particularly attractive to many women artists in the 70s and 80s for these reasons, also because it was perceived not to be dominated by male tradition.[10] The progressive availability of the video camera coincided partially with second wave feminism and female artists and feminist collectives soon employed it in documentaries, performance documentation and artists' videos.[11] Women artists involved in video and performance in Europe and especially in England, were well aware of the risks of objectification that lay in the use of their body and nudity in their practice. They were keenly aware of the dangers of re-perpetrating the 'male gaze', especially using a medium – video – that was employed by Broadcast TV.

As noted by British artist and theorist Catherine Elwes, they 'looked for ways of problematizing the appearance of the female body whilst negotiating new forms of visibility'.[12] Elwes describes some approaches adopted by women video artists to bypass the 'pitfalls of sexual representation'. For example, Elwes discusses the case of Nan Hoover's use of 'the built in close-up lens of the video camera to disrupt the unity of the female body'.[13]

Educated at the Corcoran Gallery School in Washington from 1945 to 1954, Hoover moved to Amsterdam in 1969, and started to work with video in 1973, becoming a pioneer of the medium in Europe. In her analysis of strategies of re-mediating the image of the body, Elwes references Hoover's *Landscape* (1983, Figs. 1a-b) in which the camera peruses the artist's hand from such close proximity that its creases and surfaces look like a landscape and the female body loses its sexual connotation.[14] This illusion is reinforced by intense blue sky in the background of this unusual landscape. In this work, we can identify several key elements of Hoover's practice: the illusion, the use of light and the hand, which is a recurring element in her videos. On this issue, Dieter Daniels commented: '[...] the hand is a self-portrait reduced to its most essential elements'.[15] The hand of the artist evokes the gesture of painting and manipulating matter, the 'craftsmanship', the traditional practice (in Hoover's case, drawing was her most beloved technique), but also the status of the professional artist. The hand becomes a metaphor for what has been denied to women for many centuries, and a portrait of the artist by a visual synecdoche.

The body is central to Hoover's early video practice and we can detect several other strategies employed by the artist to re-mediate its image:[16] in *Movement in Light* (1975–76), for example, Hoover moves her body – which is only partly visible – very slowly in front of the camera. The slow motion combined once again with the 'fragmentation' – as well as the strong use of light – leads into abstract forms, and as a consequence, totally de-sexualises the body. Two other elements contributed further to a de-objectifying effect of the artist's body: colour and light. This can be observed, for example, in Hoover's

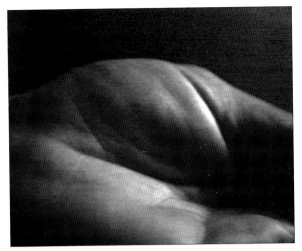

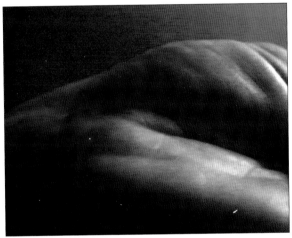

Figs. 1a-b. Nan Hoover, *Landscape*, 1983, stills from video. Courtesy of LIMA Amsterdam.

offering herself to the eye of the viewer.

Hoover always stated she was not a feminist and defined herself as an 'apolitical', 'free person' and her approach was informed by 'equality thinking' as she used to think of herself as an artist first and then as a woman. On this issue, Jansen comments that Hoover's shadows and silhouettes could as well be 'male or female'. The de-sexualisation and manipulation of Hoover's own body appear to be part of a process of neutralisation of the sexual connotation and de-personalisation of the self-portrait: the self-images are aimed to become something else, the body is a gateway to imagination. Although the body seems to become a way to tell 'other' stories, and to avoid the artist's own life story, at the very same time it is a way to express their internal world and a desire to narrate it.

The artist's hand assumes a key role in several artworks. A relevant example of this is *The Motovun Tape* (1976, Fig. 2) by the Croatian artist Živa Kraus. The video was made on the occasion of the Fourth Encounter in Motovun which was dedicated to the theme of identity – this was when Kraus used video for the first time. In *The Motovun Tape*, Kraus explored the theme of identity in relation to personal memory as well as the historic memory of the city of Motovun through the physical contact of her hand. Originally, as shown in some photographs taken during the shoot, the video was meant to open with a shot of the artist's navel. The artist reckons that Paolo Cardazzo – co-director of Galleria del Cavallino and producer of the video – cut out this

Projections (1980). The camera captures shadows of objects on the wall, creating perspectives and illusions from ephemeral effects. The viewer once again tries to identify forms and elements, deformed by lighting effects; at some point we detect a window and the artist in the darkness, as a shadow. At the end of the video, the artist slowly crosses the screen: a confirmation that we have not seen a ghost and, using Plato's allegory of the cave, the viewer is finally able to see reality as it is, unmediated. The artist finally turns her back to the camera, standing as an unintelligible presence, avoiding capture once again,

sequence later in the post-production phase in Venice.[17] The navel evokes fundamental concepts including the generative power of women's body or in some religions such as Hinduism for example, the generation of the world.

In the video, the portrait of the artist is reduced to a minimum: the hand, the hand that in Kraus' practice also draws and paints, acts as a synecdoche of the artist. The video is ultimately an investigation into the theme of identity that leads us to both a collective and personal memory represented by the walls of the city of Motovun, that are charged with history, made of Istrian stone creating a connection to the city of Venice, Kraus' new adopted home (to where she moved in the early 70s). This work opens up an investigation to the centrality of the representation of the hand in artists' self-portraits which has been the object of several studies.[18]

Portraits to an Electronic Mirror

The mirror has played a key role in history in shaping artists' self-portraits: beside the theoretical and societal reasons that accompanied the development of the self-portrait during the Renaissance, technical progress in mirror-making and the availability of mirrors greatly facilitated the practice of self-portraiture. Indeed, Italian Renaissance theorist Leon Battista Alberti conjoins the invention of painting with the myth of Narcissus (the doctrine of *imitatio/electio*).

In Western Philosophy, the mirror has been a complex, somewhat ambivalent symbol: for platonic philoso-

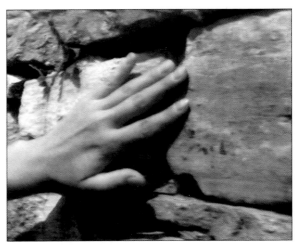

Fig. 2. Živa Kraus, *The Motovun Tape*, 1976, still from video. Courtesy of the artist.

phy it was mostly considered to be the bearer of false and deceptive knowledge, an illusion (and Saint Paul would use a similar perspective in *1 Cor*, 13.12); in contrast, it could also be read as a symbol of the divine and a tool to reflect and capture spiritual essence of things (Saint Paul, *2 Cor*). In the visual arts, the mirror may assume a positive value. It was sometimes employed as a metaphor for painting itself, a supposedly trustworthy representation of reality and in the Renaissance it also assumed the function of amending reality from its imperfections (for example as in Alberti's *imitatio/electio* doctrine once again).[19]

As noted by Meskimmon, examining the traditional modern art historical canon, the mirror was a symbol of vanity and when included in female nude artworks painted by male authors, suggested a sort of innate desire for women to be objectified and act as a passive element of male desire. On this topic, the art historian Frances Borzello remarked that the very myth of women artists' affinity with self-portraiture – which in reality has no foundation – may likely have been supported by this negative

female association with the vice of vanity with the mirror.

In Lacanian psychoanalytical theory, the 'mirror-stage' is a fundamental moment in the formation of the *I*, differentiated from the mother, and in gaining an individual identity. Feminist thinkers and authors have challenged 'the logic of the mirror' that diminishes and objectifies women. As pointed out by Meskimmon, 'to challenge the mirror and its associations for women is again perceived to be an important stage on the path of female emancipation'.[20] Simone De Beauvoir, Lucy Irigaray and Virginia Woolf all employ the metaphor of the mirror to explain how, in patriarchal society, women simply reflected, and possibly magnified the 'first sex'.[21] The 'mirror metaphor' with its 'implications' is fundamental to analyse the attempt to renegotiate forms of 'representation outside the male dominated structures of art, philosophy, history and literature'.[22]

Most significantly, in the 70s the mirror was used as a powerful metaphor in video in several early theoretical essays. In 1970, for example, the Italian art historian and critic Renato Barilli defined video as a 'clear and trustworthy mirror of the action'. In 1977, the German art historian and curator Wulf Herzogenrath described 'Video as a mirror', as one of the three artistic ways to use video in his classification. Probably this metaphor was inspired by the instant feedback provided by video. Artists could see themselves on the video monitor whilst videotaping and the video was available immediately after the shoot. The monitor could generate an instant double of the artist that could play as an interlocutor or an antagonist; and

recording more than once on the same tape was also possible in order to make multiple ephemeral 'doppelgängers'. The viewers could see their own reflection in the mirror glass of the monitor on which the work was displayed (at the time projections were rare).

The mirror-metaphor was central in Rosalind Krauss' renowned essay about video, *The Aesthetics of Narcissism* from 1976.[23] Krauss states that 'unlike the visual arts, video is capable of recording and transmitting at the same time – producing instant feedback. The body [the human body] is therefore, as it were, centred between two machines that are the opening and closing of a parenthesis. The first of these is the camera; the second is the monitor, which re-projects the performer's image with the immediacy of a mirror.' Proceeding from an analysis of Vito Acconci's *Centers*, Krauss linked this loop to a narcissistic quality of video, although at the end of her piece she took a step back from this assertion. Although her paper provided key elements to analyse video at the time and still partially provides avenues for today, we can consider its main point – the narcissistic nature of video, to be completely surpassed. In 2003, Michael Rush challenged this interpretation suggesting, very interestingly, that Acconci was instead addressing himself to the invisible – to the audience beyond the camera. Following from Krauss' essay, in *Sexy Lies in Videotapes* (2003), Anja Osswald highlighted that the metaphor of video-as-mirror is not completely accurate. Video doesn't offer a reversed image, but a double, so the 'other' breaks the narcissistic loop. Ultimately, video for Osswald, the

'electronic mirror' is 'rather the reflection of the self-reflection'.[24]

From Osswald's perspective, this would be supported by the fact that only a few videos include the term self-portrait in the title. These videos confine the artist to the depersonalised role of 'an empty container', exposing the 'rhetorical artificiality of self-images' (including the doubling, splitting that are part of our analysis) and what she defines the 'paradox of "self-less self-images"'.[25] Nonetheless, it might be worth remarking that relevant exceptions exist and that besides the title, several early videos – especially the ones by female artists – engage the issue of representing the artist's appearance, body and identity, challenging stereotypes and normative interpretations imposed by society and tradition. Interestingly enough, both Osswald and Krauss agree on the introspective function of video.[26] This element might suggest that the camera beyond its physical representation, in some way reconnects the electronic mirror to the spiritual interpretation of the traditional mirror.

Starting from all these premises, I think it is interesting to verify if and how the metaphor of video as an 'electronic mirror' – keeping the narcissistic element completely to the margins – and the creation of a double are fruitful in two lines of enquiry. First, to analyse women artists' video artworks that engage with issues of self-portraiture, self-representation, image and identity. Second, to question if these elements are still relevant to understand how women artists used video to challenge the traditional visual art genres, subvert the stereotypical version of women's representation, as a form of aestheticised beauty and object of desire and investigate, experiment and renegotiate alternative forms of visibility and exposure.

Among the examples of most renowned videos that include the word 'self-portrait' in their title, there is *A Phrenological Self-portrait* (1977, Fig. 3) by the Swedish video pioneer Marianne Heske, produced at M HKA in Antwerp. This work provides a key example of the examination of the very notion of identity through video and the use of both doubling and mirroring elements. In the work, Heske addresses herself and writes on a monitor that plays a video of herself. This monitor within the video evokes the system of video feedback that is core to the mirror-metaphor. The piece opens by showing the monitor with a video that displays Heske with her head down. The artist then raises her head facing the camera directly. Not only the camera of the video recorded on the monitor, but consequently the second camera, the one to make the video a *mise en abyme* is reinforced when the work is shown on a monitor. So Heske is addressing us, the viewer, directly, as Rush suggested for Acconci. Then another Heske enters the scene, placing herself in front of the monitor, facing herself towards the camera. There is the double, the other, the interlocutor of the artist, and a dialogue starts between the two: referring to what Osswald pointed out: the video allows for producing a doppelgänger of the artist.

Heske in the recorded video on the monitor lists with numbers and names the 'individual organs' that compose the brain and where 'functions' were localised according to the

Fig. 3. Marianne Heske, *A Phrenological Self-portrait*, 1977, still from video. Courtesy of the artist.

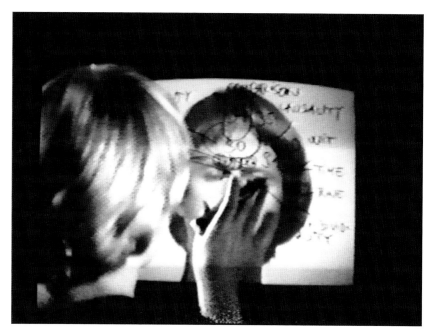

phrenological theory invented by the German physician Franz Joseph Gall in 1796. The second Heske – the one that performs in the video – repeats what the one in the monitor says and draws on the reflecting glass screen, on her own image/portrait, the phrenological chart of the brain, of which she keeps a model in her hand. This repetition creates an echo, a form of reiteration or mirroring: there is no real dialogue between the two, the actions of the second seem to derive from the first. And yet, in a couple of passages, the 'live' Heske anticipates the other, reminding us that everything has been pre-recorded, it is a past action, the double provided by the electronic-mirror is just an illusion, as video ultimately is. It reminds us that the second Heske – the one outside the small monitor is the one in control: as such, a sort of shift in the power dynamic occurs. Finally, Heske moves in front of the monitor, in front of her own portrait and facing the camera, repeats the list, preceded by

her recorded self, but this time pointing out the parts of the skull on her head: the artist and her portrait/double coincide. The writing visible on the glass creates a halo around her face, and tautologically accompany this repetition. In the end, the 'monitor Heske' says 'That's the one', the 'live' Heske replies 'ok', echoed by the other. The 'live' Heske leaves, and her doppelgänger remains alone for a brief moment. The monitor is turned off and the writing on the glass stays to reveal once more the illusion of its materiality.

Phrenological thinking became extremely popular in the 19th Century, later dismissed as a pseudoscience. With this video performance, Heske ultimately raises issues of how man has tried to grasp, describe and explain human behaviour and attitudes in a constructed and artificial way; also of how our beliefs and perception of what is science and what has changed and transformed.

Heske stated: 'I am playing by

categorising my own mind with my alter ego in *A Phrenological Self-portrait*. Video is particularly suitable to reflect and correspond to the human senses'.[27] In this statement the artist summarises a series of elements that are part of our analysis: the double, the reflection and the investigation of the possibilities of video. Heske stated she was not part of any feminist movement – 'For me feminism = humanism = human rights'.[28] From this perspective, video is employed for an investigation of identity, of self-portraiture as a traditional genre and as a concept, and resonates with video works of that time in the way it experiments with the medium.

Heske's practice is deeply rooted in ecology, and she paralleled a phrenological approach of the human skull to a geographical exploration of the Earth.[29]

Examining other early video artworks by European female video pioneers, several European women artists also employed physical mirrors in their innovative video artworks when addressing issues of identity and representation, evoking both the traditional use of this tool in painting and the metaphor of video as electronic mirror and a tool. A relevant early video artwork that employs the mirror in and outside the screen is Elaine Shemilt's *Doppelgänger*. Today, Elaine Shemilt is an internationally renowned printmaker, but little is known about her early experimentation and work with video. This is in part due to the almost complete loss of her early video pieces. Shemilt started incorporating video in her practice in 1974 as a student at Winchester School of Art, with a Sony Rover Portapak. In the following years she made

several video artworks including *Conflict*, *Emotive Progression* and *iamdead*, which were featured in *The Video Show*, a seminal independent video festival held at the Serpentine Gallery, London (1 to 25 May, 1975).[30]

Although she participated in this exhibition, Shemilt was never part of the British video 'community' (which included London Video Arts) and her exchanges with other video artists were almost non-existent.

Due possibly to this isolation and to the fact that she considered video as part of ephemeral installations, in 1984, before moving to Dundee, Scotland, Shemilt destroyed the only existing copies of her 70s videos. The traces – including photographs, drawings and prints – from those 70s videos remain as the final artworks. Two videos from Shemilt's early production, both made before 1984, are still existing: *Doppelgänger* (1979–1981, Fig. 4) and *Women Soldiers* (1981).[31]

Doppelgänger is a performance to camera that was made by Shemilt at the end of a three-year residency at South Hill Park Art Centre, where, thanks to an award from Southern Arts, video facilities were available.

In the video performance, Shemilt draws with make-up a portrait of her reflected image on a mirror, placed in front of her. As the performance proceeds, the portrait slowly shapes up and the double – the *doppelgänger* is formed. The artist continues to mimic with her face the expression as if she were applying make-up onto her own skin. In the end, the double on the mirror is left alone, replacing the artist in front of the viewer. Shemilt's *Doppelgänger Redux*, a re-enactment of the video-performance at Nunnery Gallery, Bow Arts, London in 2016 was

Fig. 4. Elaine Shemilt, *Doppelgänger*, 1979–1981, still from video. Courtesy of the artist.

as an effective practice-based research tool to understand better how the video was originally taped. In the video, the portrait is apparently built merely on the mirror, but as the re-enactment reveals, the artist used a key feature of early video: the video feedback. A monitor that streamed the feedback was placed perpendicularly to the mirror so that the image was reflected in one of its angles: if one observes *Doppelgänger* closely, the artist is looking at her left. She is looking at the reflection of the feedback on the mirror. In this way, Shemilt clearly engages directly with the point raised by Osswald: she needs to reverse the image produced by the feedback in order to portray it correctly on the mirror. The artist shows in this case a deep understanding of the medium and how it functions.

Analysing the sequences, photographs of Shemilt interrupt the flow of the performance. Multi-layered images of the artist appear, sometimes naked, creating multiple doubles. This echoes the sense of multiple personalities conveyed by the schizophrenic audio recordings that accompany the performance. This image acts as a window to her inner-self: the mirror

(the electronic, but also the real one) is a gateway to her. Elizabeth Grosz's words about Irigarays' interest towards Carroll's *Through the Looking Glass* come to mind: 'She goes through the looking-glass, through, that is, the dichotomous structures of knowledge, the binary polarisations in which only man's primacy is reflected'.[32] The artist offers her body to the audience, an un-sanitised version of it, in an attempt at de-objectification. Keeping in mind Elwes' point of view, this multi-layered representation of the artist's own body can also be interpreted as another strategy for remediating and representing the female body through a technique similar to the one that Shemilt was developing with her prints.

Furthermore, it destabilises the notion of the 'self', creating a representation that is – to use Meskimmon's terminology in the context of a feminist approach to the male-dominated genre of autobiography and its notion of a 'stable self'[33] – 'de-centred' and questions identity as a transient, constantly shifting and stratified element, uncovering its 'constructions'.

Re-enacting the traditional role of the painter with the mirror stage, Shemilt directly references the genre of artists' self-portraiture (and also specifically that of women artists) and therefore engages with the art historical canon. The piece stimulates reflections upon the perception of women as professional artists, their status in the canon and within society and more specifically within art schools and the art system. Once again the self-portrait is used to challenge the patriarchal art system and advocate for recognition.

For a powerful visual comparison for Shemilt's *Doppelgänger*, we can even go back to early Renaissance, to one of the many illuminated representations of Marcia – one of the characters of Boccaccio's *Concerning Famous Women* – in which the artist, placed obliquely in relation to the foreground in the intimacy of her studio, paints a self-portrait that look like a double, using a mirror.[34]

A direct reference to the use of the mirror with its symbolism in painting and notion of self-portrait is to be found in Tamara Krikorian's *Vanitas* (1977, Fig. 5). In the video, the camera frames the artist and an oval mirror reflecting a still life with *vanitas* and a TV monitor. The TV broadcast is interrupted by a video featuring Krikorian with an oval mirror reflecting the back of the artist's head and the monitor in which the artist speaks. In these interruptions, the artist explains how she conceived the work and her research about still life, and specifically the *vanitas* and the artist self-portrait. Krikorian's interruptions, in some sense, evoke the idea of what Stephen Partridge has defined as an artists' TV Intervention: an artist's piece that breaks the flux of normal broadcasting without the broadcaster's mediation. In her interludes, Krikorian explains that she drew inspiration from Nicolas Tournier's *An Allegory of Justice and Vanity* (1623–24, Oxford, Ashmolean Museum). Her analysis then focuses on some renowned pieces including David Bailly's *Vanitas Still-life with a Portrait of a Young Painter* (1651), where the artist is surrounded by his works and symbols of *vanitas*. In this case, as noted by Krikorian, the self-portrait becomes the subject of the *vanitas*. This notion

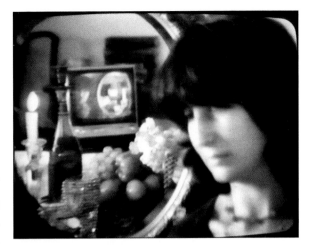

resonates with the very concept of the video itself.

Interestingly, the silent Krikorian in the foreground assumes a very reflective pose of melancholic meditation on the ephemerality of life. While in contrast, the Krikorian within the TV set is looking to the camera, addressing the audience (although her face cannot be seen clearly due to the low quality of the image), replicating the communicative strategy of the TV presenter. Her voice is mediated by the loudspeaker, creating a sound equivalent of the *mise en abyme*. Krikorian remarked that *Vanitas* is a 'self-portrait of the artist and at the same time an allegory of the ephemeral nature of television'.[35] In this quote, the artist underlines how the video explores two traditional artistic genres – the portrait and the still life with *vanitas* – of which the TV has become part, implying its transitory nature. Here, the artist employs some fundamental topoi of both genres: the portrait and self-portrait (the mirror and the *mise en abyme*) and the still life with *vanitas* (once again the mirror, the candle – usually extinguished, the fruit, the glass and wine as Eucharistic symbols). The inclusion of these elements

Fig. 5. Tamara Krikorian, *Vanitas*, 1977, still from video. Courtesy of Ivor Davies.

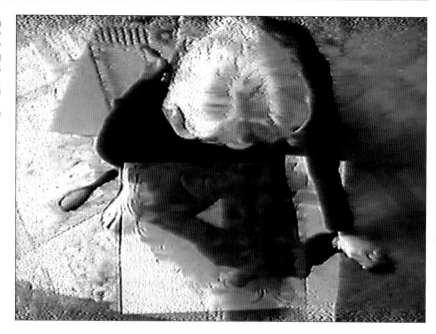

Fig. 6. Klára Kuchta, *Etre blonde c'est la perfection* [Being Blonde is Perfection], 1980, still from video. Courtesy of the artist.

and the words spoken in her interventions engage directly with art history, so that Krikorian positions herself in its canon, and indirectly – once again – encompasses the concept of the recognition of women artists.

The mirror in relation to portraiture and representation of the female body are also themes raised on many occasions by the Hungarian-Swiss artist Klára Kuchta in early video practice. In *Etre blonde c'est la perfection* [Being Blonde is Perfection] (1980, Fig. 6), for example, Kuchta combs her hair, one of her signature motifs, in front of a mirror and a female voice continues to repeat how being blonde means to be perfect ('*La beauté des cheveux c'est sa blondeur, être blonde c'est la perfection*' / the beauty of hair is its blondeness, being blonde is perfection). In this work, the mirror symbolises physical beauty and in order to break this stereotype, the artist physically breaks the mirror, destroying the integrity of the image. Also, with the friction between the image and the

voice – which becomes more and more distorted with time – the artist rebels against these stereotypes linked to women's beauty and creates a dramatic climax.

The themes of hair and stereotypical female beauty are part of Kuchta's life-long research into the capitalist socio-economic system. These themes have also been explored in her *Biondo Veneziano* [Venitian Blonde], a video artwork produced in July 1978 in Venice by Ferrara's Centro Videoarte for the exhibition *Venerezia Revenice*. In the video, Kuchta's hair is dyed in the traditional process of Venetian Blonde, a type of light red/blonde colour, which became popular in Venice during the Renaissance. For the artist, the hair acts as a 'social metaphor', to discuss the origins of the capitalist system and its degeneration in the 'accelerating global capitalist celebrity culture' of the 70s. In the exhibition, charts and graphs that describe Kuchta's research into how women

manipulated the appearance of their hair (at what age they started going to the hairdresser, how many times per month, etc.) accompanied the video. Referring to a traditional 'constructed' standard of 'angelic beauty' and symbolically captured in *Biondo Veneziano* by this particular hairstyle, the artist questions not only how these standards have always influenced women's self-perception in the past, but also how they are still influenced today.[36]

As explained by Kuchta, who had studied the traditional process of hair colouring as reported by Pietro Bembo, this particular way of bleaching the hair characterised the women in Tiziano Vecellio's paintings – from which it took its name. Once again, reference to the history of art seems to play as a tool to challenge the patriarchal, traditional portrayal of women's beauty, and how this embodies a mercantile economic and social structure as it does for capitalism even today.

In a letter to Janus, Kuchta also notes: '*Le mouvement de la camera était en spirale continuellement, symbolisant la continuité et perpetualité historique et gestuelle*' [The movement of the camera was continuously in a spiral, symbolising the historical and gestural continuity and perpetuity[37]]. As commented on by the artist, 'the shooting in the round' – from the 'theatre in the round' – aims to defy the 180-degree style of filming to show all sides in constant movement. This particular style aimed to increase a sense of 'intimacy and an immersive experience' and reflected the artist's approach to communicate more directly and in an enhanced way through video with the viewer.

Me, Myself and I: Ephemeral Doubles, Doppelgängers and Puppets in Front of the Electronic Mirror

A key element that emerges in our analysis of early video artworks dedicated to portraiture, is the double. Created with a mirror or with other media, the double appears to engage with other forms of re-mediation and re-negotiation of women's bodily visibility and provides an essential tool to explore the body. This use of the double can be observed in Anna Valeria Borsari's *Autoritratto in una stanza, documentario* [Self-Portrait in a Room, Documentary] (Fig. 7), and is a fundamental video performance produced by Galleria del Cavallino, Venice in 1977. In this piece, Borsari isolated herself in a room of the gallery, and through a photo and video camera investigated her body and her identity introspectively, in relation to the confined space. The viewer is walked through this intimate journey by the artist's own words.

In the video, the representation and exploration of the artist's body is indirect: we never see her. At first, the camera shows us the room: we see through her eyes, we are her. And then, the camera shows us a female

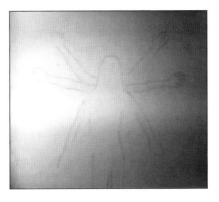

Fig. 7. Anna Valeria Borsari, *Autoritratto in una stanza, documentario* [Self-Portrait in a Room, Documentary], 1977, still from video. Courtesy of the artist.

version of Leonardo's *Vitruvian Man*: Borsari's drawing, which has been outlined from her own body, challenging the male dominated classical model which embodied perfection and becomes a tool to represent and study the artist's body. Once again, the reference to the traditional art historical canon re-emerges: the artist aims to question its assumptions based on the patriarchal system and propose alternative forms. With the drawing, the camera gently travels through the pencil line, visually caressing the artist's body. This light and conceptual representation is followed by a visually contrasting pile of soil, that materially occupies the space and replaces the artist's body, symbolising its connection to the earth, and its rhythms.

Another pioneer who employs the use of doubles in her early video practice is the Italian artist Federica Marangoni who started experimenting the medium while collaborating with Centro Videoarte of Palazzo dei Diamanti, Ferrara, the only publicly funded Italian video centre in the 70s and 80s. In 1979, Marangoni made *The Box of Life* (Fig. 8), a performance initially shot on 16 mm and later transferred to video.[38] In the first segment of the work, Marangoni melts wax body parts, cast from her own body, and red wax flowers on an electrically heated table, with a blowtorch. In the action the artist retrieves the body casts from a small cupboard – the so-called *Box of Life*. Since 1975, Marangoni used to bring a similar cupboard to the city market (*Il baule del corpo ricostruito in una piazza al mercato* [The Reconstructed Bodies Trunk in a Market Square]);[39] selling those casts of female body parts as a

form of protest against the objectification of women's bodies and their image. Marangoni literally objectifies her body in multiple doubles and materially annihilates her doppelgänger to visually exemplify how the body is a territory of exploitation in capitalist society. Ultimately she raises her voice on issues such as human trafficking and the exploitation of sex workers. In the second part of the video, the double is incarnated by transparent plastic masks, moulded on Marangoni's face, worn by the artist and the group of people who surround her. Marangoni commented on this sequence, that she is like a priestess after the ritual of 'sacrificial offering'.[40] The doppelgänger in this case plays an ambiguous role: although at first the mask looks like a layer upon the faces, still perfectly recognisable, little by little, as the figures' breath opacifies, the veneer and the camera goes out of focus, single characters start to disappear and the face of the artist multiplies. This physical 'barrier' in some way de-personalises the singular and builds up a group of equals to represent the fact that life is ephemeral and that we are all destined to the same end.

This theme is reinforced by a quote from Marcel Duchamp's epitaph at the closure of the video: *D'ailleurs, c'est toujours les autres qui meurent* [Anyway, it's always the other guy who dies].[41]

In 1980, Marangoni once again employed the use of wax body parts on an electric table in the installation *La vita è tempo e memoria del tempo* [Life is Time and Memory of Time] for the Venice Biennale. In this work, the double is also embodied by a negative silhouette on a plexiglass surface:

it stands among two videos on monitors, which represent the transient quality of time embodying once again humanity's destiny, life and death. Looking to Marangoni's video artworks and installations, analogies can be drawn to Elaine Shemilt's early video performances (as *iamdead* or *Conflict*) in which the artist employed the use of casts and wire puppets.

Interestingly enough, for both Shemilt and Marangoni, these ethereal, indexical and in some ways de-personalised self-portraits play as tools to represent humanitarian or existential issues, their bodies become that of every person in an attempt to embody these reflections. Reading these elements through Elwes' point of view, the use of these ephemeral doubles could be also seen as strategies to re-mediate and to renegotiate new forms of visibility and representation of the female body. Ultimately, they also evoke, once again, traditional artistic practice: the demiurgic labour of the artist that manipulates matter.

The reference to the art historical canon and the double is key to reading the renowned live video performance *Don't Believe I am an Amazon* (1975) by Ulrike Rosenbach, in which the face of the artist is superimposed onto the head of Stefan Lochner's *Madonna im Rosenhag* [Madonna in the Rose-bower] (Wallraf-Richartz-Museum & Fondation Corboud, Cologne, 1451). Arrows are shot by the artist and hit the reproduction of the painting and at the same time the portrait of the artist superimposed onto the video. The two faces/portraits (Robenbach's and the Madonna) were shot independently and merged together on a monitor: the audience of

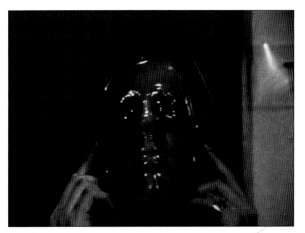

Fig. 8. Federica Marangoni, *The Box of Life*, 1979, 16 mm transferred to video, still from video. Courtesy of the artist.

the performance could see the performance live and the video which merged the two images on the monitor. *Don't Believe I am an Amazon* addresses multiple issues from a different prospective. On one level, Rosenbach is directly addressing the traditional, stereotypical and idealised representation of women in the arts. She challenges the 'pure', 'ethereal' and 'unattainable' representation of the woman in art history, which relegated the female to the role of mother, saint and virgin, constantly embodied by the figure of the Virgin Mary or Saints. The idealised portrayal of the woman – fruit of a cultural, social and political construction fixed in centuries of western art history – is evidently represented in Rosenbach's video by the presence of Lochner's painting. The rose in Lochner's work, in particular, is one of the traditional attributions of Virgin, *rosa mystica,* particularly popular in the Medieval Age: 'Rose without thorns, you have become a Mother' were words from a popular song.[42] This image of pureness of the Virgin is contrasted by the violent action of the Amazon which could symbolise the patriarchal system, with its 'structures of power' based on aggression and attack.[43]

In the 70s, the conversation on the methods of representing women in western art history was opened up and debated by different authors – including, for example John Berger in *Ways of Seeing* (1972) and an accurate analysis of motherhood was made in 1976 by Marina Warren in *Alone of All Her Sex: The Myth and the Cult of the Virgin Mary*. Rosenbach's body of video work in those years complements and comments upon this debate and defies this tradition, directly referencing art history.

On another level, the ghostly portrait of the artist floats upon the more stable image of the Madonna, and creates both the effect of a sort of double, but at the same time a new image, that of a third character in which the lines of the two faces, as the two characters, merge. The Madonna and the artist are part of the same being. The arrow hits both, and its haunting sound shakes the viewer. In this case, agreeing with Osswald and Krauss' interpretation of video, we propose its use in connection with self-portraiture and the representation of identity, used as an introspective tool: quoting Annette Jael Leehman 'the video recording is mental feedback of the artist'.[44]

From this brief analysis emerges an understanding of how the genre of portraiture connected with themes of the representation of identity and image seem to be key to reading post-1968 women's self-portraits, and consequently some fundamental works of women video pioneers. The lack of a male dominated tradition within video art allowed the liberty to explore the tropes of this genre and re-appropriate them. The powerful tool and metaphor provided by the mirror play a new, renovated role: matching the mirror-metaphor associated with the video as medium itself, it assumed the function of the introspective device. In the context of the systems of art and academia, women sought recognition and status: in this respect, video became a tool to represent the professional artist and to advocate for a new status and a new position for women within the art historical canon.

Ultimately, with the rise of second-wave feminism, video became a new weapon for women artists to defy stereotypical representations of the body, to change the perspective from model to artist and again newly back to model, but with a shift from object to active subject.

Acknowledgements: This chapter could have not been possible without the support and help of Giulia Casalini, Cinzia Cremona, Catherine Elwes, Diana Georgiou, Adam Lockhart, Dorcas Müller, Federica Marangoni, Stephen Partridge, and Elaine Shemilt.

Endnotes

1. Linda Nochlin, 'Why Have There Been No Great Women Artists?' (1971), in *Women, Art, and Power and Other Essays* (New York: Harper and Row, 1988).

2. Several examples of women artists' self-portraits are discussed, for example, in Frances Borzello, *Seeing Ourselves. Women's Self-portraits* (London: Thames & Hudson, 1998).

3. Laura Mulvey, 'Visual Pleasure and Narrative Cinema', in Leo Braudy and Marshall Cohen (eds.), *Film Theory and Criticism: Introductory Readings* (New York: Oxford UP, 1999), pp. 833–844.

4. This includes for example Claude Cahun's photographs. Laura Iamurri, 'L'impronta e il corpo – l'ombra e lo specchio', in Laura Iamurri, Marilù Eustachio (eds.), *Autobiografia/Autoritratto: Eustachio, Catania, Montessori, Ricciardi, Monaci, Stucky, Woodman*, exhibition catalogue, Rome, Museo Hendrik Christian Andersen, 26 October 2007 – 20 January 2008 (Rome: Palombi Editore, 2007), p. 32. The translation is the author's.

5. Marsha Meskimmon, *The Art of Reflection. Women Artists' Self-portraiture in the Twentieth Century* (London: Scarlet Press, 1996), pp. 27–32.

6. For a general overview of female self-portraiture in the 70s, see Frances Borzello, *Seeing Ourselves* (Thames & Hudson: New York, 1998), pp. 159–190.

7. On the benefits of video, see also Catherine Elwes, *Installation and the Moving Image* (Columbia University Press and Wallflower Press: New York and London, 2015), pp. 230–231.

8. Although it could be heavy if carried for long periods. On this specific issue see for example *ibidem*, p. 248 n. 36 and 'Interview with Catherine Elwes by Laura Leuzzi and Elaine Shemilt' available at http://www.ewva.ac.uk/catherine-elwes.html (accessed December 2017).

9. Helen Westgeest, *Video Art Theory: A Comparative Approach* (Malden, MA: Wiley Blackwell, 2016), p. 56.

10. This view has been shared by several video pioneers interviewed during EWVA research, including Catherine Elwes, Elaine Shemilt and Anna Valeria Borsari. Furthermore, this point has been raised by critics and art historians on more than one occasion. Examples include: Yvonne Jansen, 'The Body and Light. Nan Hoover in the world of video and performance', in Leen Huet, Wim Neetens (eds.), *An unexpected journey, Vrouw en kunst/Women and Art* (Antwerp: Gynauka, 1996), p. 150.

11. On the topic, see for example Anne-Marie Duguet 'La video des femmes', in *Video la mémoire au poing* (Paris: Hachette, 1981), pp. 89–111; Stéphanie Jeanjean, 'Disobedient Video in France in the 70s: Video Production by Women Collectives', *Afterall A Journal of Art, Context, Enquiry*, n. 27, Summer 2011, pp. 5–16.

12. Catherine Elwes, *Video Art: A Guided Tour* (London: I. B. Tauris, 2005), p. 48.

13. *Ibidem*, p. 49.

14. *Ibidem*.

15. Dieter Daniels, 'How to use a pencil as a video camera', in Rob Perrée (ed.), *Nan Hoover. Movement in Light* (Rotterdam: Con Rumore, 1991), p. 72.

16. For a survey of elements used by Hoover in her videos: U. Bischoff, 'Movement and Stillness – Light and Time – Line and Space', in *Ibidem*.

17. Interview to Kraus, unpublished, Venice, 31 August 2015. See for a photo of the shooting, Dino Marangon, *Videotapes del Cavallino* (Venice: Edizioni del Cavallino, 2004), p. 45.

18. Tommaso Casini, 'La mano "parlante" dell'artista', *Predella*, n. 29, http://www.predella.it/archivio/indexebb4.html?option=com_content&view=article&id=167&catid=65&Itemid=94 (accessed December 2017).

19. For an overview, see for example E. Di Stefano, 'Leon Battista Alberti e la metafora dello specchio: fonti bibliche e filosofiche per un *topos* artistico', in R. Cardini, M. Regoliosi, *Alberti e la tradizione per lo 'smontaggio dei "mosaic' albertiani*, Atti del Convegno del Comitato Nazionale VI centenario della nascita di Leon Battista Alberti, Arezzo, 23–25 September 2004.

20. Meskimmon, *The Art of Reflection*, p. 6.

21. *Ibidem*, pp. 5–7.

22. *Ibidem*, p. 7.

23. Rosalind Krauss, 'The Aesthetics of Narcissism', *October*, v. 1, Spring, 1976.

24. Westgeest, *Video Art Theory*, p. 55.

25. *Ibidem*, p. 56.

26. 'Interview with Marianne Heske by Laura Leuzzi', EWVA. Available at http://www.ewva.ac.uk/marianne-heske.html (accessed July 2017).

27. *Ibidem*.

28. 'Interview with Marianne Heske by Laura Leuzzi', available at http://www.ewva.ac.uk/marianne-heske.html (accessed July 2017).

29. See Nicolas Bourriaud, 'Marianne Heske or the Art of Relocation', http://www.marianneheske.no/?page=texts/art_of_relocation (accessed 17 July 2017).

30. *The Video Show* included a selection of some of the most relevant international video pioneers of the time as well as British artists among which Ian Breakwell, David Critchley, David Hall, Brian Hoey, Tamara Krikorian, Mike Leggett, Stephen Partridge, Lis Rhodes and Tony Sinden were included.

31. Both were finally recovered and migrated to digital in 2011 by the AHRC funded research project REWIND (2004–ongoing), led by Prof. Stephen Partridge and based at Duncan of Jordanstone College of Art and Design, University of Dundee. Media Archivist on the project is Adam Lockhart. A still from the recovered version of *Doppelgänger* was published for the first time in Sean Cubitt, Stephen Partridge (eds.), *Rewind | British Artists' Video in the 1970s & 1980s* (New Barnet: John Libbey, 2012), p. 88. *Doppelgänger* was discussed by the author of this chapter in: Laura Leuzzi, Elaine Shemilt and Stephen Partridge, 'Body, Sign and Double: A Parallel Analysis of Elaine Shemilt's *Doppelgänger*, Federica Marangoni's *The Box of Life* and Sanja Iveković's *Instructions N°1* and *Make up – Make down*', in Valentino Catricalá (ed.), *Media Art: Towards a new definition of arts* (Pistoia: Gli Ori, 2015), pp. 97–103; Laura Leuzzi, 'Embracing the ephemeral: lost and recovered video artworks by Elaine Shemilt from the 70s and 80s', *Arabeschi. Rivista internazionale di studi su letteratura e visualità*, n. 7, 2016, http://www.arabeschi.it/embracing-the-ephemeral-lost-and-recovered-video-artworks-by-elaine-shemilt-from-70s-80s/ (accessed 25 March 2019).

32. Elizabeth Grosz, *Sexual Subversions: Three French Feminists* (Sydney: Allen and Unwin, 1989), p. 130–131 quoted in Meskimmon, *The Art of Reflection*, p. 7.

33. *Ibidem*, p. 72.

34. See for example, Bibliothèque Nationale, Paris, Ms. Fr. 12420, fol. 101 v.

35. Text by Tamara Krikorian dated 1978, REWIND Archive, DJCAD, University of Dundee. Available on http://www.rewind.ac.uk/documents/Tamara%20Krikorian/TKR053.pdf (accessed December 2017).

36. 'Interview with Klara Kuchta' by Laura Leuzzi and Viola Lukács, http://www.ewva.ac.uk/ klara-kuchta.html (accessed 12 July 2018).

37. Lisa Parolo, *Biondo Veneziano. Klara Kuchta*, in Cosetta G. Saba, Lisa Parolo, Chiara Vorrasi (eds.), *Videoarte a Palazzo dei Diamanti. 1973–1979 Reenactment* (Ferrara: Fondazione Ferrara Arte, 2015), p. 110. Translation into English by the author.

38. The film was directed by Gianluigi Poli. *The Box of Life* is available on Marangoni's website, http://www.federicamarangoni.com/portfolio/1979-the-box-of-life/ (accessed 17 July 2018). See Lorenzo Magri (ed.), *Centro Video Arte: 1974–1994* (Ferrara: Gabriele Corbo, 1995), p. 27 and Gabriella Belli (ed.), *Federica Marangoni. Il filo conduttore/The Leading Thread* (Venice: Ca' Pesaro International Gallery of Modern Art, 2015).

39. Viana Conti (ed.), *Federica Marangoni. I luoghi dell'utopia: iconografia e temi fondamentali nell'opera di Federica Marangoni* (Milan: Mazzotta, 2008), pp. 68–69.

40. Vittorio Fagone (ed.), *Camere incantate, espansione dell'immagine*, exhibition catalogue Milan, Palazzo reale, 15 May – 15 June 1980 (Milan: Comune, Ripartizione cultura e spettacolo, 1980), p. 146.

41. In Italian, 'D'altronde sono sempre gli altri che muoiono'.

42. Jean Delumeau, *History of Paradise: The Garden of Eden in Myth and Tradition* (1992), (New York: Continuum 1995), p. 125.

43. Annette Jael Leehman, 'Actions and Interventions of the German Video Ant-Garde', in Randall Halle, Reinhild Steingröver (eds.), *After the Avant-garde: Contemporary German and Austrian Experimental Film* (Camden House, 2008), p. 84.

44. *Ibidem*.

Chapter 2

Natural Interruptions

Adam Lockhart

'Who breaks a butterfly upon a wheel?' An expression first coined by Alexander Pope in his *Epistle to Dr Arbuthnot* in 1734.[1] The allusion being as to why something so gentle and insignificant as a butterfly be placed on a horrendous torture device such as the wheel. This expression has been used many times since to describe excessive punishment or criticism for minor misdemeanours.

As will become clear throughout this chapter, a common theme in many women's early work was the association of nature with the urban environment and technology, and also, in a number of cases, the violence against nature.

In 1982, the Italian artist Federica Marangoni created a video performance called *Il volo impossibile* [The Impossible Flight] (Fig. 1). This involved the destruction of various butterfly effigies by cutting, nailing, smashing and burning them. After each type of destruction was performed, the resulting recording appeared on a monitor behind her. This continued until all four screens were filled, turning the destruction or 'killing' into a spectacle.

In the previous year, 1981, she made the digital piece, *Il volo impossibile – Videogame* [The Impossible Flight – Videogame] (Fig. 2) made at Centro Video Arte in Ferrara, assisted by technical engineers Carlo Ansaloni and Giovanni Grandi. It is a programmed computer animation in the style of three different early video or arcade games, from the shooter and Pac-man genres. However, in this case, the 'enemies' are butterflies rather than ghosts or aliens. As the butterflies fly around freely, various sounds are heard from popular arcade games, such as Space Invaders, 'firing' at the butterflies, but none of them are killed. It's not until the Pac-man type game that we see the butterfly becoming trapped in the maze, and it is killed by a warrior-type figure. In the final game, a butterfly looks like it is escaping from a cage and flying off into the distance to freedom. It is almost like the butterflies are trapped inside the monitor and in the end can finally escape. This is similar to Tamara Krikorian's *An Ephemeral Art* (Fig. 3) first shown at the Third Eye Centre in Glasgow, in 1979, where real butterflies were displayed inside an empty TV monitor and could be viewed through its glass.

There is something quite prophetic about *Videogame*. Although

Fig. 1 (above). Federica Marangoni, *Il volo impossibile (The Impossible Flight)*, 1982, still from video. Courtesy of the artist.

the violence in video games at the time was unrealistic and cartoon-like, it still pointed towards the direction that video games subsequently took, culminating in the more realistic violence of the *Grand Theft Auto* (GTA) series (1997– present) and its clones, which have generated much debate

Fig. 2 (right). Federica Marangoni, *Videogame*, 1982. Courtesy of the artist.

Fig. 3. Tamara Krikorian, *An Ephemeral Art*, installation, 1979, Third Eye Centre, Glasgow. Courtesy of Ivor Davies.

and controversy on their psychological impact on the user, particularly upon young people. It was one of the first videogames in the UK to receive an 18 certificate by the BBFC.[2] Interestingly, Dave Jones, one of the original creators of GTA, stated that *Pac Man* was an influence on the game, where the main character runs over pedestrians and is chased by the police, replacing the dots and the ghosts in *Pac Man*.[3]

Something to note that is unusual in this case, for video games of that time, is that the colour of the background screen is green, when normally this would have been be black. This is interesting, as usually green is associated with nature and also with peace. A common theme in many early women's video work was this association between nature with the urban environment and technology. In 2009, women played a huge part in the Iranian Green Movement, seeking change by peaceful means. Perhaps most notably, Neda Agha-Soltan, a 26-year-old music student, who became a symbol for the movement, tragically died from a gunshot wound after protesting peacefully in Tehran.[4] A butterfly on a wheel indeed.

Wildebeest [Wild Beast] (Fig. 4), a video installation, by Dutch artist Giny Vos shares some of these concepts. This was first shown at Aorta in Amsterdam in 1986. In the piece, a herd of 47 small toy gnus are arranged on the floor as if they are galloping or stampeding across a constructed 'savannah' made from sand and miniature trees. This savannah was formed into the shape of an animal hide. Behind them, in the middle of the hide, is a video monitor showing the same herd of fleeing gnus previously recorded by a video camera moving as though it was a diving and swooping aeroplane above them. This is accompanied by a montage of library recordings of real aircraft sounds and the thundering sound of hooves. Every so often, a gunshot is heard as though someone in the aircraft were firing a rifle at the gnus. The piece evokes ideas of what is real and what is fake, and succinctly deals with matters of life and death. Of course, nothing is actually real or alive in this piece, even the soundtrack has been created as a collage from various sources and edited together to give an impression of an actual sound recording of the event. The concept of fake news has come to the fore more recently, however manipulation of the media by various powers has existed for many years. In this work, the monitor shows the fake, manipulated version and in the front of this we see the

Fig. 4. Giny Vos, *Wildebeest*, 1986, installation with sand, plastic wildebeest, miniature trees, monitor, modelling clay. Courtesy of the artist.

reveal with the toy animals and trees, fixed and unmoving. All the manipulation being carried out by an unseen performer, likely the artist.

An interesting theme in both Vos and Marangoni's pieces is that the animals are both simulations and not real. Also, in each piece, none of the animals are 'killed', even though the environment in which they are set in warrants this to happen. In *Wildebeest* we can hear the gunshots, presumably directed toward the gnus. In *Videogame*, low-resolution digital firing sounds and explosions are heard and, although the warrior figure in the Pac-man-like section does eventually incapacitate the butterfly, it is resurrected at the start of the loop again. These works point toward a hack/intervention achieved by artist Brent Watanabe in *Grand Theft Auto V* called *San Andreas Deer Cam* (2015–16). In this artwork, Watanabe inserted a virtual deer into the fictitious city of San Andreas, where all the gaming action takes place, allowing it to wander around of its own accord in amongst the other computer-controlled char-

acters in the game. Intriguingly he made the deer immortal, this resulted in it being run over, shot at, beaten up and blown up by tanks. Like Marangoni's piece, the deer became incapacitated, but got up again and carried on. *San Andreas Deer Cam* is presented by use of a virtual camera that follows the deer around the city, similar to the camera in *Wildebeest* following the gnus.

The vulnerability of the animals in these pieces is also echoed in the way in which the three works are preserved. All three now only exist as documentation. Sean Cubitt mentions that in *Videogame* the fragility of the butterfly is apparent in the fragility of the tape.[5] The U-matic tape used to record the output from the computer monitor has degraded over time and the digitised version of this tape retains the drop out and video noise from the tape. This recording has now become the 'work'. *Wildebeest* is an installation, so unless the installation is recreated, the only thing that exists is the videotaped documentation. Of course, the video shown on the moni-

Fig. 5. Marie-Jo Lafontaine, *L'Enterrement De Mozart/Combat De Coqs*, 1986. Courtesy of the artist.

tor still exits separately, but this requires to be shown correctly as part of the installation. *San Andreas Deer Cam* used to be available as a live stream of the deer's current activity, but this is also only available now as documentation.

The Belgian artist Marie-Jo Lafontaine, took the virtual to reality in the piece *L'Enterrement De Mozart/Combat De Coqs* (1986, Fig. 5). This translates as 'The Funeral of Mozart/Cock Fight'. Here we are shown a recording of a real, live cock fight. Illegal now in most western countries, the practice continues in certain Asian countries and in the underground. It still continues to fascinate, yet at the same time the brutality is indisputable. As an installation, the piece features 6 monitors displayed in 2 rows of 3, with each monitor showing the same thing, serving to increase the intensity of the event. The squawking and flapping of wings creating an eerie tone. The bank of monitors is built, like much of Lafontaine's work, into a sleek dark monolithic sculpture. This is similar to the video sculptures by the artist David Hall, such as his *Situation Envis-*

aged series (1978–1990). This monolith takes on a futuristic look, almost like a bank of CCTV monitors looking into the past. The piece, of course, references someone from the past, namely the composer, Ludwig Amadeus Mozart.

In fact, there are many parallels in his life with this piece. Lafontaine's 1999 monograph states 'The Image itself bursts with arrogance, completely filling the screen. Everything about the bird is tense from the crest to the spur. The wings are spread, the body puffed up, while the majestic crop is swollen with confidence'.[6] Mozart was known for being a show off, with his extravagant dress and his self-confidence built upon his precociousness that one might regard as arrogance. The fight could also be attributed to Mozart's supposed rivalry with fellow composer, Antonio Salieri.

At the beginning of the piece, two cockerels are briefly positioned in a stand-off akin to that of gunfighters in a western movie, waiting to pounce. We also hear music similar to that by Ennio Morricone in the *Dollars Trilogy*

(1964–66), featuring Clint Eastwood. Spurs are normally attached to the ankles of the cockerels to aid their fighting, similar to the stereotypical cowboy. The fight is also shown slightly slower than normal which evokes a cinematic drama to proceedings, much like Mozart's music. Of course, only one of the fighters can win and due to the title of the piece, *L'Enterrement De Mozart*, we have to assume that it is Mozart that is the losing cockerel, who of course, died prematurely from an unknown illness. Around the time of his death, he was writing his *Requiem in D Minor*, which he did not complete before his death. The Requiem mass, is the religious ceremony held in the Catholic church for the souls of the dead. It could be said that Mozart wrote this for himself, a final act of posturing. However, it wasn't finished, almost as if he were saying that there was more to come, and there certainly was. After his death, his music became much more popular than it was during his lifetime – even to this day. As Lafontaine's piece ends with the loser incapacitated, it starts again on a loop reviving the cock to fight over and over again, much the same as Mozart's music, turning the attention to the mystique of the 'loser' rather than the 'winner'.

As in *Videogame* by Federica Marangoni, the life/death loop continues, and the action takes place in a small arena, the computer screen, in *L'Enterrement De Mozart* the action is in the confines of the fighting arena known as the cockpit and also in the video monitors exhibited in the gallery. Curiously, the word for cockpit in an aircraft is derived from the cock fighting arena.[7] Early aviation was heavily utilised for war and fighting and still it

is today. It is also used in Formula 1 racing to describe where the driver sits. This sense of primarily male dominated competition fits well with the primitive 'cock fight'. The UK artist Tina Keane, in her piece, *In Our Hands, Greenham* (1984, Fig. 6) features a childlike song, amongst others, called *Take the Toys Away from the Boys*, mocking the escalation of military hardware, particularly nuclear weapons, during the Cold War. This work is about the women-only movement who protested at the Greenham Common Peace camp outside an RAF/USAF base housing cruise missiles, located in Berkshire, England during the 1980s. In addition to the songs, the piece contains audio testimony and super 8 footage of women in the camp. Chroma-keyed on top of these images is a pair of moving women's hands along with images of spiders mating which alludes to the Rudyard Kipling poem *The Female of the Species* (1911),[8] where tradition dictates that the female spider is dominant. A subtle, yet elegant observation of the futility of male posturing. A review of the protest in 2007 stated 'The women only nature of the peace camp gave women space to express their beliefs and assert their politics in their own names and traditions without the customary dominance of men'.[9] These women could be said to have surrounded this 'cockpit' calling for the hostilities to end. The base, now obsolete, is closed and is now being used as a location for films and art projects.

In 1977 the UK artist Rose Garrard made a video work called *Smile Please* (Fig. 7), which plays on the rivalry between Winston Churchill and Adolf Hitler during WWII, and their

public personas. She takes on the idea of the clown who always smiles and never reveals their true feelings. Her own face is seen in the black and white piece manipulated with luma-key whilst taking off masks and mixing this with images of Charlie Chaplin, Hitler, Churchill and clowns, blurring the boundaries of political leaders and slap-stick comedians. At the end of the piece, she announces:

> After he had gone, some people said hero was a hero and villain was a villain. And after he was gone, some people said hero was a villain and villain was a hero. But some people stayed silent and said to themselves. There are heroes and villains in all of us. They are never conquered, we must keep watch behind the smile in the mirror[10]

As with the cock fight, we also never know which one is the hero and which is the villain, rather, both of them are victims. More recently the artist Fiona Banner took these ideas of conflict and turned them into elegance. In her piece, *Harrier and Jaguar* (2010) exhibited at Tate Britain she 'tamed' two decommissioned fighter jets – a Sea Harrier and a Sepecat Jaguar. The Harrier was held captive, hung by its feet, pointing nose down and the Jaguar was lying on its back on the floor in a submissive orientation. Thus, finally ending the life of conflict for the two animals.

The domestication and captivity of animals by humans has always been controversial. *Escena dom-éstica con gusano verde* [Domestic Scene with a Green Worm] (1983, Fig. 8), by the Spanish artist Marisa González features a caterpillar which is seen moving around in different locations in a home and being watched

Fig. 6. Tina Keane, *In Our Hands, Greenham*, 1984, still from video. Courtesy of the artist.

and talked to affectionately by a young child. Adult voices are also heard interacting with the child, the mother (the artist) engaging the boy and the caterpillar. The father is heard complaining that the child isn't eating his food. A classic domestic scene that we are privy to as strangers, just like the caterpillar is. The child is fascinated by the creature, just as many young children are, learning and exploring the world, just as the caterpillar is exploring its surroundings. Both the child and the caterpillar are at the beginning of their lives, although interestingly at this moment the child is being told off for not eating, whereas caterpillars at this stage of

Fig. 7. Rose Garrard, *Smile Please*, 1977, still from video. Courtesy of the artist.

y tienes... la boca sucia

Fig. 8. Marisa Gonzáles, *Escena doméstica con gusano verde* [*Domestic Scene with a Green Worm*], 1983, still from video. Courtesy of the artist.

their life are constantly eating. Of course, the next stage for the caterpillar is metamorphosis when it turns into a butterfly, linking again to Marangoni's *Videogame*, where it can escape from its domestic captivity. The scene is again framed by the video monitor, with only the caterpillar seen throughout.

Another of Giny Vos' pieces, dealing with issues of captivity, is the video installation *Nature Morte* [Still Life] (1988, Fig. 9). In the gallery there is a cage, the type of which could be found in a zoo with sand in the bottom. Inside the cage there is a video monitor showing the side or flank of a stationary zebra, the slight movement of its body pulsating as we hear it breathe. Every so often, in front, another zebra moves past. The camera is fixed throughout. Outside of the cage, attached to the wall, is the stuffed head of a real zebra looking longingly at the monitor inside the cage. Zebras have never really been domesticated the same way as horses and donkeys have, so apart from seeing them in the wild, one has to go to a zoo or safari park to see a live one. In Vos' work, the dead zebra is on the wall and the living ones are caged within bars and then sub-

sequently caged inside the video monitor. However, the dead zebra on the wall appears to want to be in the cage. There are many interesting aspects to this work. The black and white stripes of the zebra resonate with the bars of the cage, can also represent life and death and also right and wrong, but as is the world, things are never black and white, but grey. The confused imagery of this piece provokes the viewer to consider these things. Even the title confuses this, the literal translation of *Nature Morte* from French to English is 'Dead Nature', however the phrase used in English for the same meaning is 'Still Life', which references art history and also confuses the issue of life and death – a common thread for Vos, similar to her work *Wildebeest* mentioned earlier.

There are also a few other less obvious connections to art history. The stripes of the zebra are a form of camouflage, not used to conceal but to distract, confuse or dazzle their predators. In WWI, the marine artist Norman Wilkinson came up with the idea of dazzle camouflage for ships, which were known as 'Dazzle Ships' using the same concept as the zebra camouflage.[11] The idea was that the enemy submarines would be confused by the course of the ship caused by the optical illusion the stripes and shapes created through the lens of a periscope. Many of these designs were influenced by Cubism and Vorticism and in a way, became art works in themselves. In 2016, the Scottish based artist Ciara Phillips created a new Dazzle Ship which she called *Every Woman* as part of the Edinburgh International Festival, a repainted ship named the MV Fingal

which was temporarily located in Leith Docks. Its purpose was to commemorate the work which women undertook in the First World War and particularly the role in the dazzle designs that, the largely female team, played working under Norman Wilkinson, established in the Royal Academy in London and around the UK.[12] The close up of the zebras in the *Nature Morte* video almost look like they are being viewed through a periscope or the sights of a hunter's rifle, the abstraction assures it is not always clear what we are looking at.

Another aspect of *Nature Morte* is the moiré pattern that appears in the video when the second zebra walks past quickly. The stripes move and are manipulated by the frame rate and interlacing effect of the video camera, creating an image that looks like it has been created using some form of video synthesis, rather than by the animal itself.

The *Adjungierte Dislokationen* [Adjoined Dislocation] series by Austrian artist VALIE EXPORT which she started in 1973 and particularly in *Adjungierte Dislokationen II* (1974–78) and *III* (1978–1997) used the idea of stripes and video to create expanded cinema performance pieces. In *Adjungierte Dislokationen II* she had two video cameras attached to her, one to the front and one to the rear. Each camera's output was connected to two sets of four separate monitors, stacked in two rows, two levels high. Each set was positioned at opposite sides of the performance space. The front camera was connected to the top rows of monitors and rear to the bottom. On three walls, there were three different images of stripes representing the three different familiar

directions – horizontal, vertical and diagonal. The fourth wall was left for the audience. Due to the use of live CCTV in the piece, there is an absence of videotape, however, this absence is referenced within the long stripes, replacing the recorded medium, the stripes can also represent scan lines used in video technology at the time. In the middle of the scene was a weaving Perspex (originally a rope) path that she would follow through the space, and which also became a snaking sculptural object in itself. As she followed the path, the moving images from the walls created new optical and geometric patterns on the monitors similar to moving 'dazzle' patterns. Of course, as she moved,

Fig. 9. Giny Vos, *Nature Morte*, 1988. Courtesy of the artist.

the audience would sometimes appear on the monitors too, breaking the so-called Fourth Wall. In the end, the space is converted from a 3D environment to a 2D one on the monitors, then back to 3D again when both are combined in the performance. The cameras facing forward and back may represent the past and future following a predetermined path that is marked out, representing the 'ideal' life journey for the woman that she is not expected by society to deviate from. The next iteration of this series, *Adjungierte Dislokationen III,* did not require to involve an event, but was a live gallery installation. The two cameras were attached to the roof, again, pointing in opposite directions, but this time rotating via an electric motor. This time there were three banks of eight monitors against the three walls with horizontal, vertical and diagonal stripes. Again, the output of one camera is attached to the top row of monitors and the other to the bottom. The Fourth Wall can be truly broken on this occasion whereby the audience also becomes the performer. Through the sights of the camera, the hunter and the hunted become one and perhaps now in this version the woman has broken free from her expected path.

The use of live CCTV cameras in a gallery context was also used several times by the long-time collaboration of Scottish/Dutch artists Elsa Stansfield[13] and Madelon Hooykaas. These artists are interested in the natural world and its perception, but particularly in the unseen. Natural phenomena such as radio waves, magnetism and wind have been used throughout their work. In his chapter for the book *Revealing the Invisible*, F. David Peat states that 'Two female

artists became concerned with ways in which art can dialogue with nature, rather than portray, represent, classify, frame, select and categorise'.[14] Humans have always tried to harness nature, use it and control it for their own means. Stansfield and Hooykaas have always made nature the controlling element of their work, allowing *it* to decide how the work progresses, and through their design, providing an avenue in which we can see this.

In their installation piece *Compass* (1984, Fig. 10), which was a development of previous similar incarnations such as *Outside/Inside* (1982) and *The Force Behind its Movement* (1984), they used the concept of a wind vane, which has often historically been portrayed as a cockerel, thus making a link to the aforementioned Lafontaine piece. In *Compass*, the wind vane was mounted on the roof of the Stedelijk Museum in Amsterdam. Attached to this was a live CCTV video camera which was connected to a gallery inside the museum below. In the gallery were four monitors, each pointing inwards in the directions of the compass – north, south, east and west, with a fifth single monitor in the middle. Each of the monitors showed different, previously recorded video material, chosen spontaneously which were related to each of the four points of the compass. These images displayed elements of nature such as earth, sky and water. They were also cropped to form either horizontal or vertical single lines, echoing the directions seen on a real compass. Meanwhile, the video images coming from the roof camera were connected to a device which, depending on the direction the camera was pointing, due to the wind, would replace the image on

the corresponding monitor in the gallery, 'pushing away' the images of nature with the live urban skyline of Amsterdam. Elsa Stansfield describes this as 'a natural interruption'.[15,16] The wind, in a sense, partially curating the exhibition or perhaps a becoming a co-artist along with Stansfield and Hooykaas.

Apart from the intervention from the wind, there is also the concept of magnetism in *Compass*. The earth's naturally occurring polar magnetic field has been used for many years to operate a simple magnetic compass: the dial will always point from north to south working as a navigation aid to the user. But as unpredictable as the natural environment can be, this magnetic field is constantly moving and changing ever so slightly. The phenomenon of magnetism has more recently been controlled and used in such things as electric motors, microphones, MRI scanners and of course magnetic tape, which became the main recording medium for video and sound for many years. Magnetic tape was quickly harnessed and experimented with by artists to create new pioneering work and establishing new media art forms that were never before possible. In *Compass,* although there is no direct intervention by the earth's magnetic field, it is referenced with the magnetic tape and the magnet coils contained inside the CRT monitors. In their performance piece, *Magnetic North* (1982) Stansfield and Hooykaas used magnets to deliberately disrupt the colours on the video cameras and CRT monitors, hence creating, an 'unnatural natural interruption'.

Another of Stansfield and Hooykaas's works, the single screen

Solstice (1989, Fig. 11), relates to the electromagnetic spectrum. Contained within this spectrum is visible light, radio waves, x-rays, infrared and microwaves. In this piece, the obvious connection comes from the title, referencing the winter and summer solstices. One where light is almost absent and the other where there is light for almost a full twenty-four hours. Scrolling text appears throughout the piece describing the solstice, e.g. 'The Solstice: the day the sun appears to stand still: *Sol* (Sun); *Sticium*; *Statum* (Stand Still)'.[17] Aside from this, the other thread in this work is the reference to Guglielmo Marconi, the wireless telegraphy pioneer who

Fig. 10. Madelon Hooykaas, Elsa Stansfield, *Compass*, 1984. Courtesy of Madelon Hooykaas.

Fig. 11. Madelon Hooykaas, Elsa Stansfield, *Solstice*, 1989. Courtesy of Madelon Hooykaas.

carried out the first transatlantic radio transmission in 1901. This signal was sent between Poldhu in Cornwall, England and Signal Hill in St John's, Newfoundland.[18] The scrolling text in the piece tells us 'S... S... S... S... S... S... was the first letter transmitted by wireless telegraphy across the Atlantic by Marconi in December 1901'.[19] 'S' was chosen due its simplicity in Morse code, three dots or clicks. The 'S' was sent continuously for a period whilst the receiving station listened. There is a correlation between 'S' and Solstice being inferred in the piece, the scrolling text lists words beginning with 'S' that may have been represented in the transmission, almost as if a third party is listening and trying to make sense of it.

The whole piece takes on a dream-like state, a video collage with abstract imagery and various unrecognisable human figures appearing, all pinned together with a cropped square in the middle of the screen displaying images of the sun reflecting on water, representing the Atlantic. It is augmented by the Francis-Marie Utti soundtrack which begins with radio-like interference and

then moves into a more melancholic string ensemble that sounds like grinding and scraping metal. This fits with the abstract images of metallic transmission antennae from Marconi Beach in Cape Cod, Massachusetts, where the first transmission from the United States to the UK took place. Amongst these images is a photograph of The Ring of Brodgar, an ancient stone circle found on the Orkney Islands in the north of Scotland. Along with the more renowned Stonehenge, these sites are said to have connections to summer and winter solstices and also to other astronomical alignments, functioning, perhaps, like a receiving station from the heavens. To broaden this concept, one of the first images we see in the piece is that of an astronomical chart and later on, an image of a radio telescope. This radio telescope was from an earlier, related piece by the artists called *Radiant, A Personal Observatory* (1988), this featured a receiving dish with a monitor in the middle playing out sections of what would later become *Solstice*. Not long after radio communications had been firmly established in the years after Marconi's experiments, the direction of these receivers were pointing up into outer space, gathering signals that have allowed great advances in our knowledge of the universe. Just like the ancients, our fascination with celestial phenomena has not diminished. At the end of *Solstice*, the cropped square with the water and sun tilts towards the horizon until it disappears into a line. Thus, the sun, in an electronic sense, 'sets', bringing the piece to a close.

The video installation *Television Circle* (1987, Fig. 12) or *Electron* when shown as a single screen, by the Lon-

Fig. 12. Judith Goddard, *TV Circle/Electron*, 1987. Courtesy of the artist.

don based artist Judith Goddard also relates to these themes of mysticism and electromagnetism. This piece consisted of seven large CRT monitors, arranged in a circle with a diameter of around twenty feet, playing back the same image from a single source. The first time it was exhibited it was located outdoors in a wooded area on Bellever Tor in Dartmoor National Park on the south coast of England. This location is significant due to the large amount of Neolithic standing stones and stone circles in the Dartmoor area, creating a modern day electronic stone circle, resonating for modern day visitors now as the old ones did for the ancients; this again links to the Stansfield/Hooykaas piece. On the monitors are images of electrical substations, wires and pylons, shot in the twilight creating an otherworldly feel. Interspersed amongst these are shots of a typical family home, the houses of parliament and the old Shell-Mex building. Each of these represent domestic, government and commerce respectively, but in particular, in the latter – energy

commerce. Also seen is the ring of a cooker, glowing red and stark. Chris Meigh-Andrews describes this as a '[...] contemporary mandala of light and power'.[20] The feeling of power is enhanced through the piece by the Keir Fraser soundtrack which features a drone mixed with crackles and pulsating electronic sounds. In and out of this comes a choral version of *Jerusalem* (1916) (by Sir Hubert Parry with words by William Blake), which fights with the electrical sounds, like the old 'England's green and pleasant land' is fighting with the modern world. At the end, the soundtrack changes to a solitary female voice singing the traditional folk song *The Banks of the Lee*, perhaps making us think of the past, however at the same time the modern domestic cooking ring is seen again gradually moving away from the screen into the distance.

Another important aspect to this piece is the images of fossils encased in amber which appear throughout. The word 'electron' derives from the Ancient Greek word ἤλεκτρον (ēlektron) which was the word used by the

Fig. 13. Judith Goddard, *Celestial Light and Monstrous Races*, 1985 (2012 HD Composite version). Courtesy of the artist.

Greeks for the mineral 'amber'. This was perhaps due to the Greeks' discovery that amber was good at naturally storing static electricity. In the piece, we see various insects and lizards fossilised in the amber, almost in stasis, transcending the ancient and the modern world, with the sound of buzzing electricity surrounding them. The cracks in the amber also reflect the electrical wires and pylons seen before and after. When the installation was installed at Dartmoor, all seven of the monitors were encased in steel frames with transparent Lexan plastic (used for police riot shields) to protect the monitors from the weather and vandalism. This brought in another slant, that the monitors themselves were being encased as fossils, protected by their steel and plastic boxes for generations to come. These were CRT monitors which, in the short space of recent modern history, could now be described as 'fossils' themselves.

Many of Goddard's artworks, fit this cyclic theme of life and death, past and modernity, nature and urban. *Celestial Light and Monstrous Races* (1985, Fig. 13) is a single screen or a 2 x 4 video wall installation of eight monitors. It was simulated in 2012 in conjunction with REWIND at Duncan of Jordanstone College of Art & Design, as an HD composite image. The piece is prefaced with a quote from John Milton's *Paradise Lost* referencing the fall of man. This links with *Television Circle/Electron,* due to her fascination with the mystique of William Blake who illustrated *Paradise Lost* by John Milton and penned the words of the poem *And Did Those Feet in Ancient Time* (1808), which became the words to *Jerusalem* and was the preface to Blake's fantasy poem *Milton: A Poem in Two Books* (1804–1810). This piece mixes the surrealism of Blake with images created using chroma-key to recreate modern versions of medieval monsters such as the Cyclops and the Blemmyae highlighting people's fear of the 'other'. Before this, we see a series of images relating to the modern world; high-rise buildings, aircraft and electric lights pointing upwards to

blue skies. The sound track that accompanies this section (again by Keir Fraser, who also physically features in this) is hard and fast, the same way in which the shots are edited, whereas the surreal part has more melancholic tone. After the surreal section, we are taken into nature with images of plants at ground level, where the soundtrack takes on a more ambient quality, but still has a slight melancholic edge and the images are edited together contemplatively and slower. At various points in the soundtrack we hear church bells, which refer, culturally, to the continuous life cycle of birth, death and marriage. Furthermore, the piece is bookended with an abstract face of a man at the beginning and a woman at the end, mysteriously peering back out at us from the screen, like a mirror.

In all these video works, these women have tried to make us think about how we see the world and how the world sees us, through nature and technology, past and future. But as we look at the screen, the black mirror, it reveals much more than perhaps we want. '[…] there are heroes and villains in all of us. They are never conquered, we must keep watch behind the smile in the mirror […]'.[21]

Endnotes

1. Alexander Pope, *An Epistle from Mr. Pope, to Dr. Arbuthnot* (London: printed by J. Wright for Lawton Gilliver, 1734 [1735]) http://www.eighteenthcenturypoetry.org/works/o3674-w0010.shtml (accessed 23 February 2018).

2. British Board of Film Classification. At that time responsible for rating video games.

3. 'Dave Jones: GTA Same As Pac Man' *Now Gamer*, 15 July 2009, available at https://www.nowgamer.com/dave-jones-gta-same-as-pac-man/ (accessed 17 April 2018).

4. Robert Tait & Matthew Weaver, 'How Neda Agha-Soltan became the face of Iran's struggle', *The Guardian* online, 22 June 2009, available at: https://www.theguardian.com/world/2009/jun/22/neda-soltani-death-iran (accessed 22 June 2017).

5. Sean Cubitt, 'Glitch Aesthetics and Impossible Flights', in Laura Leuzzi, Stephen Partridge (eds.), *REWIND* Italia: *Early video art in Italy/I primi anni della videoarte in Italia* (New Barnet, Herts: John Libbey Publishing, 2015), pp. 203–221.

6. Marie-Jo Lafontaine and Bernd Barde, *Marie-Jo Lafontaine* (Berlin: Hatje Cantz, 1999).

7. 'Cockpit, n.' Oxford English Dictionary Online, Oxford University Press, available at https://en.oxforddictionaries.com/definition/cockpit (accessed 22 June 2017).

8. Kipling, Rudyard. *Rudyard Kipling's Verse: Inclusive Edition*, 1885–1918 (London: Hodder & Stoughton, 1919).

9. 'Protest at Greenham (1981 to 1983)', *The Guardian* online, 3 May 2007: https://www.theguardian.com/uk/2007/may/03/greenham.yourgreenham3 (accessed 22 June 2017).

10. *Smile Please*, dir. Rose Garrard, per. Rose Garrard, 1977, video.

11. Roy R. Behrens, *False Colors: Art, Design and Modern Camouflage* (Dysart, Iowa: Bobolink Books, 2002).

12. 'Dazzle Ship 2 June-21 January 2017' *Edinburgh Art Festival*, https://edinburghartfestival.com/dazzle (accessed 22 June 2017).

13. Elsa Stansfield died in Amsterdam in 2004.

14. F. David Peat, 'The Art of Bridging' in *Revealing the Invisible: The Art of Stansfield/Hooykaas from Different Perspectives* (Amsterdam: De Buitenkant, 2010).

15. *Compass Documentation*, directed by Madelon Hooykaas & Elsa Stansfield, performed by Madelon Hooykaas & Elsa Stansfield, 1984,video in *Revealing the Invisible*.

16. The title of this chapter is taken from this statement by Elsa Stansfield.

17. *Solstice*, directed by Madelon Hooykaas & Elsa Stansfield, 1989, video.

18. Roger Bridgman, 'Guglielmo Marconi: Radio star – Feature', *Physics World*, v. 14, n. 12, 2001, pp. 29–33.

19. See endnote 12.

20. Chris Meigh-Andrews, *A History of Video Art : The Development of Form and Function* (Oxford: Berg, 2006).

21. *Smile Please*, dir. by Rose Garrard, per. by Rose Garrard, 1977, video.

Chapter 3

Desire for More

Cinzia Cremona

This chapter cuts across the other contributions to this book by identifying and analysing works and practices that focus on desire. It is impossible to overestimate the importance of this subject in early women's moving image practices – the complex dynamics that restrict the voice of a woman when expressing her desire reveal psychological and political processes of power, sexuality, identity and relationality. After a selective survey of the history of the concept of desire in this context, I will examine artists and artworks from the 1970s to the early 1990s in this light in order to build a cartography of early practices by women who are not afraid to show what moves them. That being said, I would argue that for many women, the negotiations they have with the fear attached to making their desire known, is key to reading the works examined here.[1]

From Freud allegedly asking 'What does a woman want?' to the continued enforcement of laws that legislate on the rights of the foetus over the rights of the mother, it seems completely acceptable to tell women what they should desire.[2] It also seems completely acceptable to judge and comment upon women's actions based on what their intentions

or desire might be, without asking them. It is generally – although, as we will see not always – a very complex process for a woman to express her desire, because the consequences of acts of defiance of others' expectations can be dangerous. A woman expressing desire that is not deemed suitable by the society to which she 'belongs' risks exclusion, ostracism and, in some cases, death. A woman represented expressing her desire can be misconstrued by the dominant ideology as pornography, exhibitionism, inappropriate behaviour, manipulation, all the way to hysterical pathology. For these reasons and many more, a woman's externalisation of her desire is often complex and contradictory.

The title of this text – *Desire for More* – is also a working hypothesis: what if, under these pressures, the woman who finds it particularly hard to qualify her desire resorted to perform an unspecified desire for more? How can we decode these layers of courage and fear, self-censorship and shamelessness, confession and demand?

A question of desire

Desire is understood here in Lacanian terms as an unconscious desire to

indicate the relation to a lack that appears to be fulfilled by the other. It is worth remembering that Lacan makes a clear distinction between the other with a small *o*, on which the subject tends to project its desire, and the Other with capital *o* – the completely separate and different Other, relaying the weight of language and social norms, and which is radically alien. As it informs the unconscious, the Other precedes, informs and continues to act upon the subject through language and in the dynamics of the gaze. When the gaze is at work, the radical alterity of the Other is reduced to a function of the subject itself and it becomes the other with a small *o*.[3]

The subject uses the other to engage its own desire and interprets the response in relation to its fundamental lack of wholeness. From this perspective, the gaze originates in the subject being looked at, and not in the subject looking. This omnipresent disembodied gaze carries the power of the Other – laws, rules and prohibitions that shape the cultural and social environment in and through language, but it also shapes unconscious desire itself. Whereas looking physiologically engages images and appearances, the gaze activates the complex significance of objects and subjects, engaging desire and language.

Moving image critical discourse on representation of women and their desire has inherited Laura Mulvey's reading of the gaze as constructed in *Visual Pleasure and Narrative Cinema*.[4] In Mulvey's approach, the gaze is transitive and mono-directional: it originates in the (male) cinema spectator to end with the on-screen representation of the (female) character. She argues that because of this es-tablished power dynamic, 'there is no way in which we can produce an alternative [to the language of patriarchy] out of the blue, but we can begin to make a break by examining patriarchy with the tools it provides, of which psychoanalysis is not the only, but an important one'.[5]

Undoubtedly, the pressure of both of these dynamics of the gaze was perceived – and in many ways still is – by a large number of artists who make desire and its negotiation the focus of their practice. Under these conditions, desire is censored and distorted, adapted to fit the limits enforced by interlocutors, family, audiences, institutions and generally to sit within the frame of an internalised image of the expectations of the Other. Among the biggest dangers in expressing desire that is not acceptable to the Other are rejection and abjection.

> Abject. It is something rejected from which one does not part, from which one does not protect oneself as from an object. Imaginary uncanniness and real threat, it beckons to us and ends up engulfing us. It is thus not lack of cleanliness or health that causes abjection but what disturbs identity, system, order.[6]

Kristeva describes the complex swinging back and forth of the subject between surrender to and distancing from a desire that one has learned not to accept. This process is continually paralleled by political mechanisms that accept or reject desiring subjects and their performance of desire – as Judith Butler continuously reminds us, being excluded endangers lives that are not intelligible.

Desire to desire and desire for an undefined 'more' may be useful notions to examine how some artists materialise, in their moving image practices, appropriate responses to a culture that expects women to fit into specific parameters of desire. A gross taxonomy of practices demonstrating various degrees of surrender, self-censorship, fear or distortion of desire would be disrespectful towards the artists and their work. Nevertheless, using this approach to explore early women's moving image work offers a fascinating tool of analysis.

Practices

The German artist Ulrike Rosenbach proposes the video screen as a tool for separation and distanciation of her sexualised body from the viewer. Her strategy moves women's representation away from the role of object of desire assigned to them without renouncing visibility. In her first live videoperformance, *Isolation is Transparent* (1974, Figs. 1a-b-c), Rosenbach wraps herself in white ropes behind a pane of glass, in front of a video camera that relays the images to a monitor. She describes the work as 'psychological feedback', and the virtual space inside the video monitor as her 'inner space':

> [t]he recipient who watches the video-feedback gets to know that the video provides a demarcation between *him* and me. The monitor pane mitigates my direct impact on *him*, makes it cool and neutral, so that the view of the psychological reflection that I want to convey to *him* becomes more important and primary.[7]

The contemporary presence of her physical body performing live and of its image relayed on screen articulates the grammar of this mediated relational dynamic. Moreover, by taking control of the tools, Rosenbach can determine her own image and perform a desire for visibility that removes her from objectification as a first step towards agency in desire. She does not deny her own desiring, but attempts to deflect the male viewer from the desirability of her body in order to draw attention to her 'inner' psychological life. Working on the same premises as Laura Mulvey's that 'there is no way that we can produce an alternative out of the blue', Rosenbach sets out in the first instance to disrupt the processes of the gaze so that visibility can encompass, in this case, her psychological life.[8]

From this perspective, it becomes important to examine moving image practices that do not explicitly focus on sexual desire to uncover different possible configurations of the desire for more.

The British artist Judith Goddard produced her first videos while still a student at the Royal College of Art. These early works – particularly *Time Spent* and *Under the Rose* (1983) and *Lyrical Doubt* (1984) – perform a dialogue between desire and expectations. In *Time Spent*, Goddard herself is sitting at a domestic table, almost frozen, while out of shot looped voices (two male and one female) discuss travelling and other activities. She appears to be waiting and somehow unable to move. The suggestion of repetition, lack of agency, invisibility and incapacity to act creates an uncomfortable claustrophobic atmosphere within which she almost dissipates, even when she is doubled

abundance and scarcity. The abrupt cuts between images give the work a syncopated pace that in itself relays a refusal to conform to expectations. Goddard immerses herself in the screen and into the image – a form of belonging and agency, even if the artist herself barely moves – but the price for this immersion is that her representation is completely determined by what is around and behind her.

It is clear that each element of Goddard's work has symbolic and metaphorical significance – the flowers explicitly hint at genitals, particularly vaginas, and are shown as vulnerable or strong, open and broken, in large displays or held by a trembling hand, looked at by a female subject with full agency or visually swallowing her. *The Garden of Earthly Delights* (1991) brings this approach to a zenith and references directly a Boschean triptych. This three-monitor installation performs desire in dialogue with social pressures, fear, expectation, gender and culture at large. In each scene, the same woman takes centre stage; first as a bride who

Figs. 1a (above), 1b (below),1c (facing). Ulrike Rosenbach, *Isolation is Transparent*, 1974, photograph of the installation and details. Courtesy of the artist.

in the mirror on the other side of the room. Similarly, in *Lyrical Doubt*, Goddard's face is taken over by the images of flower shops in West and East Germany with their stark contrast of

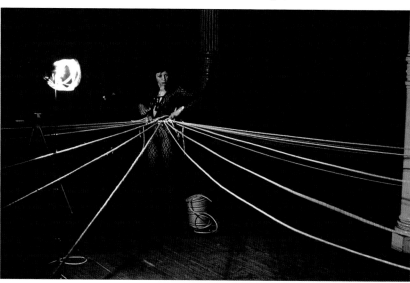

sheds her gown and blonde wig, then as a mother traversing the screen and the city, and lastly as a spinning figure in the sky in the most direct performance of desire for more. Each frame of *The Garden of Earthly Delights* overflows with colours, movements, presences and objects in a disturbing carnival that is almost a nightmare, yet the work's pace, and composition, and the body language of the woman are highly controlled.

Like Bosch, Goddard overlaps symbols in an unmanageable *toomuchness*. There is no need to establish which element is feared or wanted, as desire maintains the paradox of the co-existence of the two. The position of a woman in many societies still entails irreconcilable demands – conditioned to desire one or more of these combinations as well as their own freedom, self-determination and agency, many women find themselves in the impossible situation of living with an overwhelmingly paradoxical desire, further complicated by fear of its consequences. Goddard does not resolve these contradictions, but exposes them as desire for more. Despite the quantity of elements, her images are carefully composed into ordered spaces. To desire more does not mean being a passive victim of desire or a hysterical,[9] out of control subject. It may mean acknowledging a condition of living under pressure where occasionally anger (*You May Break*, 1983), dissociation (*Celestial Light & Monstrous Races*, 1985) or longing (*Who Knows the Secret?*, 1985) take over.

Conversely, the Dutch artist Lydia Schouten performs her desire and freedom with ease in playful, colourful and inventive fantasy worlds, in which,

for example, she rolls on chalk drawings allowing the bright pigments to cover her skin. This unbridled freedom embodies her desire to celebrate the female body and play 'with animals and men of cardboard and taking the initiative myself in my adventures'.[10] Schouten's work maintains the qualities of her live performances in that her movements are only generally planned in their quality and sequences, as she allows a crescendo of intensity to guide her decisions. *The Lone Ranger, Lost in the Jungle of Erotic Desire* (1981) offers a colourful and safe cartoon jungle for the artist to explore and enjoy: 'I didn't want to be Jane, waiting for the stories of Tarzan, but making my own adventures'. And in *Romeo is Bleeding* (1982), 'I wanted to travel the world flying through the sky, landing one moment in the city, having my affairs with different men (however they were constructed of foam or cardboard) and the next moment landing in the jungle and having erotic affairs with animals'.[11]

Schouten's freely expressed fantasy desire bypasses the problem of being cornered in the role of the object of desire. She is clearly the desiring

Fig. 2. Lydia
Schouten,
*Covered with
Cold Sweat*,
1983, still from
video.
Courtesy of the
artist.

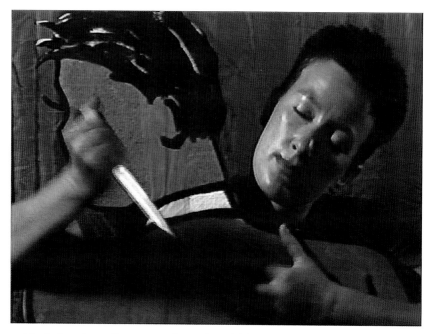

subject, free from the constraints of cultural expectations and uncensored. The colours, choreography, rhythms, characters and titles of her works leave no doubt that she feels free to desire and to live her desire, no matter how unconventional it is or how easily it can be condemned as abject. *Covered with Cold Sweat* (1983, Fig. 2) continues the theme of the cartoon world and the bi-dimensional men, once again emphasising the active role of the desiring woman. The joy that animates Schouten's videos shows her ease with her own desire and sexuality and her freedom from the pressures of a culture that would like to see woman as the object of man's desire. Schouten freely desires and from her perspective the other and object of her desire is naturally man. The cardboard and polystyrene men of her video works are literally objects to caress, kiss, stab and dance with. This can be read as a revolutionary act only if Mulvey's statement that 'there is no way in

which we can produce an alternative out of the blue' is accepted as an undisputable fact.[12] In Schouten's practice her body is desirable and desiring without separation as there is no problem in becoming the object of another's desire when one is first a desiring subject.

Similarly, the individual and collaborative body of work of the Swiss artist Pipilotti Rist (Elisabeth Charlotte Rist) demonstrates a knowingness and comfort with desiring and being desired in expanded relational and representational practices. Between 1988 and 1994, Rist was a member of Les Reines Prochaines, a multimedia performance and music band founded by the artists Muda Mathis, Teresa Alonso and Regina Florida Schmid. The group proposes a fragmented and contemporary feminist aesthetic, which includes cooking sounds, costume making, political statements, complex visuals and 'democratic music'.[13] *Japsen* (Figs. 3a-b-c), produced in Basel in 1988

with Muda Mathis and with the help of Teresa Alonso, but not attributed to Les Reines Prochaines, carries many of Rist's signature images. Fast camera movements, women moving freely in the city and in natural surroundings, animals and plants, extreme close-ups, unusual viewpoints, intense colours, explicit references to sex, the strategy of dividing up the work into distinct sections and a recognisable combination of playfulness and sinister overtones.

Rist had already started working with video in 1986 producing a work that responds directly to the ubiquitous male pop artist in the language of the pop promo. In *I'm not the Girl Who Misses Much* (1986, Figs. 4a-b), she dances in front of the camera with the top of her dress pulled (or falling?) down to expose her breasts. The artist repeatedly sings 'I'm not the girl who misses much' in response to The Beatles' lyric from *Happiness is a Warm Gun*, written by John Lennon in 1968: 'She is not the girl who misses much'. In this videoperformance Rist obliterates her face and voice with electronic effects and answers back to pop music with a strategy close to Rosler's *Semiotics of the Kitchen*, and to Adrian Piper talking back to her white other. As a woman interpellated by incorporated mass distributed music, Rist plays with the aesthetic and technical possibilities of postproduction, and allows her own eccentric voice to resonate with all its morbid complexity. In this agitated use of the first person singular redolent of hysteria, she takes control of her desire by allowing it to go overboard and by not containing it within her dress.

It could be argued that Rist performs the desire for more simply by

being more – faster, louder, more distorted, more exposed and yet disguised behind the video artefacts. Music, performance and sexuality have remained a significant intoxicating blend throughout her practice.

Figs. 3a-b-c. Pipilotti Rist and Muda Mathis, *Japsen*, 1988, stills from video. Courtesy of Muda Mathis.

Figs. 4a-b. Pipilotti Rist, *I'm Not The Girl Who Misses Much*,1986, stills from video. ©Pipilotti Rist. Courtesy of the artist, Hauser & Wirth and Luhring Augustine.

Rist proposes a version of visual pleasure that integrates narrative and characterisation, colours, floating forms and strategies that encourage viewers to engage in specific relationships with the images on screen. The artist's signature imagery of close-ups of eyes and body parts complements the narrative structure in which the knowing innocence of the female protagonist and her agency drive the plot. Her works feature mostly women,

often naked and behaving in unexpected ways. These female performers and characters offer a representation of self-determined femininity, freely expressed desire and playful sensuality. Rist's women drive the narrative by acting outside the framework determined by patriarchy.[14]

Whilst Schouten and Rist freely perform their desire, other artists thrive on the endless negotiations with the Other that result in limitless postponement. Žižek illustrates this mechanism when he writes that 'from "I can't love you unless I give you up" to "Don't give me what I ask for, because that's not *it*" – desire is defined by this *ce n'est pas ça*: that is, its most elementary and ultimate aim is to sustain itself as desire, in its state of non-satisfaction'.[15] I would argue that the British artist Catherine Elwes engages with this set of contradictions more directly than many other artists, and skilfully navigates the complexities of desire and repression connected with sexuality and motherhood. Elwes seems to create situations that act as multidirectional mirrors reflecting desire as well as the operations that shape it. Her awareness of the pressures that media representation, class, religion and more generally the Other impose on the female subject becomes a precious tool to unhinge and critically engage with this constellation of forces. She performs her desire, avoiding to offer herself as the object of desire. Her clipped received pronunciation contributes to this distanciation – Elwes demonstrates a deep understanding of the language of authority and that she can make it her own without hesitation.

Interviewed by Laura Leuzzi and Elaine Shemilt, Elwes articulates women's interest in interpersonal relationships in the context of the intimacy and immediacy of video.[16] It is understandable that under the pressure of being defined by the other as *his* other, a female subject needs to unravel love, desire and intimacy. In *With Child* (1984) in particular, Elwes tackles the persistent sexual desire that besieges her pregnant body, the imposed order and the threatening chaos that surround the body and psyche of a woman, the difficult love for her child, and more generally desire and its suppression. But first, she wonders about representation and about 'how to create an image of womanhood or femininity that reflected what you were rather than what you were expected to be'.[17] But expectations are contradictory as well, so Elwes performs these contradictions viscerally, erotically, formally, visually and aurally. The stop-frame animation of the erotic encounter between two stuffed monkeys collapses an artificial technical rhythm with the explicit jerking of sex and the flowing notes of a symphonic soundtrack, affecting and creating distanciation in equal measure. The sucking of the thumb caressing her nose, the full breasts hanging as she dresses a doll, and the hands folding white linen are all gestures that stage and restage the paradoxes of desire and its formal containment. Elwes also performs the darkest side of desire by flashing a kitchen knife, adding shooting sounds to her doll's movements and clashing toys against each other.

The popular and social definitions of family, intimacy and romantic love could be seen as ways to organise desire into acceptable and man-

ageable structures. Falling in love it-self constitutes a blinding surge of desire driven by an overwhelming sense of recognition of something in the other. Many legal systems are only beginning to acknowledge that violence within the privacy of home is socially unacceptable, but it is easy to imagine how this has been the context to let desire loose safely and in ways that apparently do not interfere with social relations. Lauren Berlant writes about the 'institutions of intimacy' and of how 'the inwardness of the intimate is met by a corresponding public-ness'.[18] In this context, intimacy is the ultimate interface of normativity and performativity – subjects perform their own versions of the institutions of monogamy, marriage and parenthood as they confront prescribed versions of their roles within them. Intimacy is an opportunity to test the incompatibilities within the subjects' 'history of identifications'.[19]

While it would be easy to stop at a sexual definition of desire, the concept harbours so much more. Aggression, power, belonging, motherhood, destruction, union, separation, care, freedom, possession, submission, recognition, validation – there are no limits to what desire desires, making it the most dangerous element of subjectivity. In this framework, the clashes of contradictory desires in the work of Elwes walk the difficult line between the desire to be seen and the desire not to be objectified. Similarly, while navigating their own desire, women also negotiate the desire of the other and of the Other in order to break oppressive patriarchal patterns of pretend reciprocity. Where reciprocity consists of male desire defining the boundaries of female desire, women

look for strategies for self-determination.

The paradox of performing and representing herself as a desiring, desirable and desired subject multiplies the diversity of approaches in women's moving image work. One recurring strategy consists in associating performance with video to disrupt and layer the dynamics of the gaze. Where Rosenbach in *Isolation is Transparent* (1974) adopts the material differences between the screen and the living body to highlight processes of looking and distanciation, other artists use video as a stage to perform personas that exaggerate or defy the constraints placed on women's desire. Even in their unbridled playfulness, Lydia Schouten's humorous exaggerated costumes, made-up faces, cardboard men and animals hint at caricatured shifting of roles and power games.

Similarly, in *Mama's Little Pleasure* (1984, Figs. 5a-b) the German artists Bettina Gruber and Maria Vedder (Fig. 6) juxtapose two female characters with different costumes, body language and the songs that accompany their presence. The first character wears a short white sailor's uniform and hat. She fixes her eyes into the camera and consequently the viewers', eating gooey red food out of a calla lily flower and licking it suggestively, eating petals and fondling a stuffed penguin. Her stylised movements border on the grotesque, but her eyes indicate that she is in control. The dissonant and simplified songs that separate the two parts of the work are reminiscent of the atmospheres of Les Reines Prochaines and Rist's individual works. The music is the opposite of seductive as it creates a

different form of distanciation – pro-
vocative words are set to dissonant
and strident music. The character
plays with the penguin, throws the
flowers to the floor and poses with a
cardboard dog. Another similarity
specifically with *Japsen* (1988) con-
sists of Pipilotti Rist and Muda Mathis
delegating some aspects of desire to
a dog, an important presence in the
second part of the work.

As the first song fades out, the
image fades to black and cuts to pink.
Gruber reappears on all fours wearing
a red tulle dress that allows her to
build visual references to the opening
of a red flower, often used as a meta-
phor for a vagina welcoming inter-
course. As a living dog shakes its tail
and weaves its way in and out of
Gruber's skirt, she gingerly moves her
hips and remains fairly passive. The
combination of sounds and Gruber's
laconic movements in her red dress
form an ironic ensemble that could be
interpreted as a parody of sexual
availability. The words of the song
also evoke several sexualised read-
ings: 'So do me wrong, so do me right,
but who cares what the prince looks
like tonight'. It is tempting to interpret
this as a call to debunk the myth of
prince charming as the man who will
fulfil a woman and an appeal for free-
dom in sexual desire. In fact, I would
argue that *Mama's Little Pleasure* per-
forms a desire to be outside estab-
lished roles and conventions. The use
of the flower by the first character sug-
gests the sexual pleasure that a
woman can derive from another
woman's vagina, while the second
character could be seen to profess
sexual desire outside romantic love.
Yet, it is more accurate to state that
Gruber and Vedder expose the com-

plexity that surrounds a woman's de-
sire. Desire is inextricably linked with
a formal game with established roles
and structures of power. Playfulness
remains tainted by dark emotional un-
dertones.

A similarly dark undercurrent tr-
averses the videos of the Austra-
lian/British artist Deej Fabyc, whose
work in moving image moved from
Super 8 to video at the end of the
1980s. Fabyc examines her own de-
siring body complementing slow
paced, barely moving images with ob-
jects and relevant texts. After some
projects that focused on surveillance
and the awareness of being watched,
she produced *80 Days* (1992, Figs.

Figs. 5a-b.
Bettina Gruber
and Maria
Vedder, *Mama's
Little Pleasure*,
1984, stills from
video.
Courtesy of Maria
Vedder.

Fig. 6. Maria Vedder and Bettina Gruber in the studio, 1982. Courtesy of Maria Vedder.

7a-b) while living in Paris. The recurring image of a room so narrow that the bed touches the walls shows the artist motionless or stirring, completely covered by a white duvet under the reproduction of a suggestive painting of a naked woman. At its first appearance, this scene turns to black and white as words from Fabyc's diary seamlessly merge with sections of Gertrude Stein's *Melanctha*.[20] Images of flowers, of the artist bathing, crocheting and eating accompanied by upbeat music are tainted by the perceivable darkness of seeing her coming out of bed fully dressed and the realisation that this is probably a symptom of depression.

Fabyc negates desire and desire turns against her – the lack of sexual desire is as frustrating as the unfulfilled longing that finds no response or satisfaction. Desire and the impossibility of desire, blocked or denied desire can turn aggressively against the subject and become a form of self-harm. The subject of *80 Days* is waiting and passing the time in a way that could be seen as damaging. Even when she takes a phone call and arranges a visit, the sigh that immediately follows performs a fatigue towards the outside world and an un-

willingness to make the effort it takes to interact when there is no desire that moves the subject to act. Repressed desire leaves a mutilated subject fighting against itself. The atmosphere, pace and undercurrent of this work are reminiscent of Chantal Ackerman's *Jeanne Dielman, 23 Commerce Quay, 1080 Brussels* (1975) – Fabyc goes about her chores, but her thoughts move in different directions. Moreover, a simmering threat of violence is perceivable in the way her voice hurries during the phone call. The work offers fragments of only three out of the 80 days mentioned on the green Etch A Sketch at the end of the first 'day' and this leaves open the possibility that this turning of desire against the desiring subject might lead to irreversible consequences.

Although Fabyc's first significant works in video *Look not for Meaning* (1990) and *Putting the Heart in It* (1991) are from the very beginning of the 1990s, it is important to include them in this discussion in order to remain aware of the difficulties women artists continue to face in openly desiring and performing their desire. Fabyc operates under the notion that all sex is a transaction and the underlying anger perceivable in her work

Figs. 7a-b. Deej Fabyc, *80 Days*, 1992, stills from video.
Courtesy of the artist.

derives from this awareness. She found support with feminist lesbian groups, but suffered from the absence of dialogue with other practitioners using videos. For this reason, she moved between Europe and Australia, finding a fertile environment in the UK in the early 1990s. This embedded internationalism, practiced by a number of artists, precedes email and social media – it is not based on the ease fostered by emerging technologies, but ideologically based, a context fostering practices and dialogues not rooted in a specific locality. This nomadism is sometimes the cause of the loss of early works and lack of local support as artists end up not belonging anywhere.

The combination of difficult practical conditions and the general hostility towards desire in women artists' work and life fill women's videos with particular intensity and urgency. Desire ripples through video images like a pressure bubbling up from under the surface. Rereading early moving image practices from this perspective

offers the opportunity to recognise the importance of these early works as performances of feminine voices that found little space in a male dominated environment. I have only scratched the surface of the works mentioned here and there are many more that would be important to examine in this context. Nevertheless, this brief survey shows how many early women artists engaged with desire as desire for more in an understanding that desire cannot be contained, rationalised and qualified even at the moment of living, performing and representing it.

Endnotes

1. This text relies on reflections and information derived directly from my participation in the event *Self/Portraits* (Visual Research Centre, Duncan of Jordanstone College of Art and Design, DCA, Dundee, 5 December 2017) curated and presented by Giulia Casalini, Laura Leuzzi and Diana Georgiou, and part of the AHRC funded research project EWVA. Moreover, Judith Goddard, Lydia Schouten and Deej Fabyc have generously shared their time and thoughts with me on their work and ideas.

2. Although this quote is attributed to Freud, it can only be sourced in Ernest Jones, *Sigmund Freud, Life and Work. Volume 2, Years of Maturity 1901–1919* (London: Hogarth Press, 1955).

3. Jacques Lacan, *Écrits*, Bruce Fink (trans.) (New York: Norton, 2006).

4. Laura Mulvey, 'Visual Pleasure and Narrative Cinema' (1975), in Leo Braudy and Marshall Cohen (eds.), *Film Theory and Criticism: Introductory Readings* (New York: Oxford University Press, 1999), pp. 833–844.

5. *Ibidem*, p. 834.

6. Julia Kristeva, *Powers of Horror: An Essay on Abjection* (New York: Columbia University Press, 1982), p. 4.

7. Liza Béar and Willoughby Sharp, 'Video Performance', *Avalanche*, no. 9, May/June (New York: Center for New Art Activities, 1974), pp. 10–11, emphasis added.

8. Mulvey, 'Visual Pleasure and Narrative Cinema', p. 834.

9. I use this term to recall the long history of hostility towards women who take active roles and more generally towards women's bodies. The accusation of hysteria and 'wandering uterus' directed at women who dared express frustration or vitality is today sublimated into less explicit, but similarly damaging comments. These remain a tool of power designed to discourage women from voicing their dissatisfaction or acting on it to improve their status. Hysteria marks the continuity in the history of the prohibition of women to assert their own rights.

10. For the research project EWVA, Laura Leuzzi interviewed Lydia Schouten as well as other key protagonists of the period analysed in this volume. All interviews are available from http://ewva.ac.uk

11. For the quote see 'Interview with Lydia Schouten by Laura Leuzzi', 2015, available at http://www.ewva.ac.uk/assets/lschouten_interview.pdf (accessed 18 May 2017).

12. Mulvey, 'Visual Pleasure and Narrative Cinema'.

13. Les Reines Prochaines, http://www.reinesprochaines.ch (accessed 30 May 2017).

14. *Pipilotti Rist* (London: Phaidon, 2001).

15. Slavoj Žižek , *The Ticklish Subject: The Absent Centre of Political Ontology* (London: Verso, 2000).

16. Catherine Elwes (2015) Interviewed by Laura Leuzzi. Online. Available from http://ewva.ac.uk/catherine-elwes.html (accessed 30 April 2017).

17. *Ibidem*.

18. Lauren Berlant, *Intimacy* (Chicago: University of Chicago Press, 2000), p. 1.

19. Judith Butler, *Gender Trouble: Feminism and the Subversion of Identity* (London: Routledge, 1990), p. 331.

20. Gertrude Stein,'Melanctha', in *Three Lives: Stories of the Good Anna, Melanctha, and the Gentle Lena* (New York: The Grafton Press, 1909).

Chapter 4

On Women's Video Art in the context of Yugoslavia, 1969–91

Jon Blackwood

Introduction

The potential of video as a technology and vehicle for communication was recognised, and its socializing role determined. The producers – the artists – in former Yugoslavia did not control the fate of these utopian desires, which were dictated rather by ideological and economic demands […] video artists were essentially isolated in a ghetto from which they were unable to have a wider impact on society.[1]

Written from our vantage point, the categories of 'Yugoslavia' and 'video art' are historical. Having grown up in the 1980s with video art as the most contemporary of the new art practices, and with Yugoslavia seemingly a permanent fixture on the map of Europe, it is a strange essay to have to write. But the awful dissolution of Yugoslavia in the 1990s, and the swamping of video by the emergence of digital cultures and their attendant technologies, makes this perhaps a timely moment from which to consider the key role played by women artists and cultural workers in the emergence of video technology from the late 1960s, right through to the post-Yugoslav present.

The scope of our discussion, however, falls mainly in the late Yugoslav period (1968–91) and I would like to consider four principal case studies in the uses of video made by women in this period. After a structural consideration of the place of women artists in late Yugoslav society, and the place of video art and video technologies with this specific cultural ecosystem, we will consider the examples of Nuša and Srečo Dragan, Marina Abramović, Sanja Iveković, Dunja Blažević, and Zemira Alajbegović; in our conclusion we will consider the legacy and reflections made by contemporary artists on these pioneering careers, in the late Yugoslav period, and hint at possible future research developments in uncovering histories of video art made by women in former Yugoslav republics not covered as much in the current historiography: Bosnia-Herzegovina and Macedonia. We should begin with a succinct over-

view of the development of modern and contemporary art in Yugoslavia, and the position of women as it evolved in successive generations of artists and cultural workers.

Founded during the German occupation on November 29, 1943, to begin with, the future Socialist Federal Republic of Yugoslavia was modelled on the Soviet constitution, and in the first years after the end of the Second World War, seemed set to copy the Soviet template as faithfully as countries in the Warsaw Pact. But the position of Yugoslavia in the post-war geopolitical order was determined by the 1948 *Informbiro* crisis, in which the Yugoslav leader, Josip Broz Tito, broke decisively with Stalin and Soviet Russia, and determined a 'third way' course for the country he ruled absolutely; neither part of the Soviet bloc, nor the emerging Western Powers affiliated to NATO, but as a 'non-aligned' country seeking friendly relations with both sides of the Cold War divide, and using this pivotal position as a means of jockeying for a leading role amongst the countries of the developing world, emerging from the colonial era.

In cultural terms, Tito's political handbrake-turn in June 1948, brought to an end a very brief period of socialist realism in the Yugoslav context. It is also important to understand that there was never really such a thing as 'Yugoslav' art. Modern and contemporary art in the period of Yugoslavia was dominated by the three most powerful republics in the federation – Serbia, Croatia and Slovenia – with art schools in the capitals of each of these republics determining the shape of certain practices; Belgrade for painting, Zagreb for sculpture, and

Ljubljana for graphic art. And it was these three cities that were to play a prominent role in the development of video art in Yugoslavia from the late 1960s onwards.

'Yugoslav' art, therefore, was a portmanteau term for the specific progress of cultural development within each of the six republics, and two associate republics, of the federation, which had their own specific cultural histories and developmental priorities. In the context of the socialist world, and Yugoslavia's very specific position as a pivot between the two antagonists in the Cold War, the context for visual culture was markedly liberal compared with that experienced in Warsaw Pact countries. Belgrade hosted travelling exhibitions of contemporary Dutch and French art in the early 1950s, and welcomed a comprehensive show of American abstract expressionism in 1956.

In the context of the partisan struggle for the liberation of Yugoslavia from fascist occupation, women enjoyed not only equal status as full combatants on the front line, but also the promise of full equality and an end to deep-rooted, traditional patriarchy in peacetime. The research of the feminist collective CRVENA, in particular Adela Jušić and Andreja Dugandžić, into the anti-fascist women's archives in the Historical Museum of Bosnia-Herzegovina in Sarajevo, has revealed a richly layered history of the development of women's ideas and political aspirations ahead of the future peacetime development of Tito's Yugoslavia.[2]

Unfortunately, these aspirations remained largely unrealised in peacetime. Whilst it is true that women had much more opportunity for education

and professional advancement in so-
cialist Yugoslavia than in previous
state formations, as the 1950s devel-
oped, so too did a re-formulation of
patriarchy. A propaganda film of
1958, *Grad od Deset Ljeta* [A City at
Ten Years Old], of Novi Travnik, dis-
cussing the development of the 'new
socialist city', presents a familiar nar-
rative where men are engaged in con-
struction and industrial jobs, with
women returning to traditional roles in
childcare and domestic labour; the
film even jokes about the supposed
haplessness of men in the domestic
context.[3] Such propaganda narratives
present Yugoslavia as a young, devel-
oping country aspiring to grow as
quickly as possible, yet is notably si-
lent on gender equality and the roles
that women and men have to play in
such a project of modernisation.

But this short, informative, light
hearted film, typical of the kind pro-
duced to reinforce the political narra-
tives that the Yugoslav leadership
wanted people to internalise, was very
much part of the pre-1968 generation,
of a phase of re-construction and cor-
rection of war damage that lasted well
into the following decade. The first
experiments in video art were to come
at the end of the 1960s, in part grow-
ing from a rich cross-fertilisation be-
tween political and artistic
subcultures, and the heady mix of
New Left ideas which informed and
sustained some aspects of the youth
rebellion that swept across the Euro-
pean continent in the summer of 1968.

This was a moment of political
turbulence and subsequent sober
self-examination that gripped Yugo-
slavia. By this stage, Tito was seventy-
six; as in other countries, a younger
generation had tired of hearing war-

time stories and of the sacrifices
made by their parents, and looked for
change. Whilst, politically, this was ex-
pressed through the Croatian spring
(1968–71), a loose grouping of intel-
lectuals who wanted to look again at
Croatia's status within federal Yugo-
slavia, and the 'Slovenian roads affair'
(1969), the idealist side of the de-
mands for political change were ar-
ticulated in the 'June events' of 1968
in Belgrade, Sarajevo and Zagreb,
which took the form of student upris-
ings against police brutality, control of
intellectual discussion, and perceived
failings in the system of Yugoslav self-
managed socialism.[4]

Whilst it is difficult to draw a direct
link between this intellectual and po-
litical atmosphere and the emergence
of video art, certainly it formed an im-
portant loam from which the early en-
gagement with the new medium grew;
not to mention a renewed focus on the
role of women within Yugoslav socie-
ties. An important outcome from the
years of protests was the estab-
lishment of student and youth cultural
centres in the major cities of the Fed-
eration, notably in Sarajevo (1969)
and in Belgrade (1971), as a place for
younger people to meet and develop
culturally. The SKC in Belgrade was to
become synonymous with the devel-
opment of the 'New Art practices' in
the 1970s in Yugoslavia, particularly in
performance art, in video and in inter-
national manifestations such as the
Belgrade October salon, and the Bel-
grade international theatre festival
(BITEF).

Structurally, the development of
video art in Yugoslavia proceeded
slowly in its first decade. The reason
for this was the prohibitive cost of
camera equipment and the availability

Fig. 1. Nuša and
Srečo Dragan,
*Belo Mleko Belih
Prsih* [White Milk
White Breasts],
1969, still from
video.
Courtesy of
Srečo Dragan.

of video-tape. Video art, by reason of necessity, had to be made in partnership with institutions, in particular the various television stations of Yugoslavia; the relationship between video artists and national broadcasters was a close one, throughout the period. As Barbara Borčić has shown convincingly, this period came to an end – and many of the pioneers ceased making video for a period – because of a shortage of video tape and equipment, and also in frustration at being stuck on the very margins of the differing Yugoslav art worlds, working in a medium still seen as very new, and lacking comprehensive understanding or following.

Beginnings and Development of Video Art by Women in Yugoslavia

The first piece of video art made in Yugoslavia was made in Ljubljana. In the atmosphere of social and creative experiment described above, the creative partnership of Nuša and Srečo Dragan, which lasted from 1967–88, produced the first experiment with the new medium. Nuša Dragan (1943–2011) had graduated in sociology and psychology in the same year that this video was produced, whilst Sreco (b. 1944) emerged from Ljubljana's faculty of fine arts. Srečo Dragan also moved in the same social and creative circles as the radical avant-garde grouping OHO, who were amongst the first to experiment with performance, process and post-object art in the Yugoslav context.[5]

In the early years of video production in Yugoslavia, the mood was very much one of tentative experimentation, gradually growing in confidence. The Dragans' first video work, *Belo mleko Belih prsi* [White Milk of White Breasts] (Fig. 1), appeared in 1969. In actual fact, this work is a still image of a woman's breast, with a bead of milk

visible; playing across this image is a sequence of changing, edited graphic signs.

This video piece stands at a turning point, between the traditional still image, and the coming new techniques of editing, cutting and mixing. These techniques assumed an increasing maturity and subtlety in later works produced by the partnership, such as 1974's *Šakti is Coming* that speaks directly to emerging postmodern concerns of the image-within-the-image, and of endless repetition. The Dragans' involvement in the earliest developments of video art quickly allowed them to grow an international profile; Nuša worked at the British Film Institute in London for a period in 1972 where her knowledge of video and television techniques grew exponentially; together with Sreco, she was included in Richard Demarco's canonical exhibitions of Yugoslav art in Edinburgh, in 1973 and again in 1975 (Fig. 2).[6]

Alongside technical experimentation, the other key early function of video art was documentation. These documentary works became artworks in their own right as the event it recorded faded in the memories of those who had seen it live. In the early 1970s, performance and video were intimately linked together in Yugoslavia. A good example of the documentary link is Abramović's *Art Must be Beautiful, the Artist Must be Beautiful* (Fig. 3) first performed in 1975, at the Charlottenburg Art Festival in Copenhagen.[7]

Abramović's performance is now canonical, but at the time, this video allowed viewers an insight that would have been difficult for the live audience. The piece lasts for fifty minutes,

in which the artist aggressively combs her hair using two large combs, clearly in pain at times from the scraping of the comb's bristles on her scalp, whilst repeating the mantra 'art must be beautiful, the artist must be beautiful'.

On one level, this is an unalloyed feminist critique of patriarchy and its potential to reduce the role of the art audience and the female artist to one of passivity and consent to being observed. The performance, therefore, in its strange mixture of vigorous, self-harming physical activity and lapsing into trance-like periods of active silence, fundamentally rejects not only the gendering of art practice, but also of its reception.

Yet on another level, the video document of the performance gives it

Fig. 2. *ASPECT '75*, cover of the exhibition catalogue, Edinburgh, Fruitmarket Gallery, 1975. Courtesy of the Demarco European Art Foundation and Demarco Digital Archive, University of Dundee.

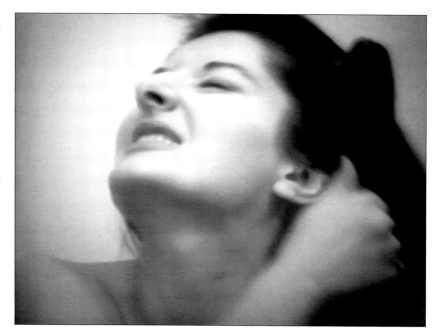

Fig. 3. Marina Abramović, *Art Must be Beautiful, the Artist Must be Beautiful*, 1975, Charlottenburg Art Festival, Copenhagen, Denmark. © Marina Abramović. Courtesy of the Marina Abramović Archives.

a life that it otherwise would not have had. Moreover, the focus of the camera on the artist's head and hands allows the viewer of the video to have a psychological insight into the development of the performance and the physical struggle experienced by the performer; a close up insight that simply would not have been possible for the spectators of the live event. It is this psychological drama, and the subsequent critical interpretation and artistic re-appropriation that have given this particular work a lively timeline in its reception, and helped to grow the artist's profile substantially after her departure from Yugoslavia for the Netherlands in 1975.

However, it is perhaps the work of Sanja Iveković in video that addresses most directly the position of women in 'actually existing socialism' in 1970s Yugoslavia. This artist graduated from Zagreb's academy of Fine Arts in 1971, and quickly found herself associated with the 'New Art practices' in the Yugoslav context. In her focus on

the structural position of women in Yugoslavia, the patriarchal organisation of the internal socialist 'marketplace', and her wry observations on the outworking of male political power in this decade, in retrospect, Iveković's work offers the most sustained analysis of these issues; central to her practice, rather than just a part of them. Iveković stressed in an interview in 2012 that:

> […] I have repeatedly asked myself, what is my position in the social system, my relationship with the system of power, domination and exploitation, and how I can respond and act meaningfully as an artist […] I want to be deliberately active rather than a passive 'object' of the ideological system.[8]

Moreover, as Laura Leuzzi's developing research has shown, Iveković benefitted strongly from participation in the Motovun 'encounters' between Yugoslav and Italian video artists in the 1970s, and through these connections was able to have

some of her work produced in the Italian context, bypassing the limitations of Yugoslav conditions for production.

A good example of Iveković's 1970s work is *Make Up – Make Down* (Figs. 4a-b), a five and a half minute video made first in black and white in 1976, with the involvement of the Galleria del Cavallino in Italy, with a new version in colour made in 1978. The subject of the work is the private, intimate moment of applying make up. The artist is not visible in the film, but the focus is rather on the make up products, and how Iveković interacts with them during the process. The work speaks to a broader narrative of the commodification of identity and desire, and through a pitiless examination of those processes, inviting broader analysis of the rituals that women engage in before presenting a public persona.

Parallel analyses of the male domination in the role of *defining* beauty and then acting on it socially, can be found in *Instructions no. 1* of 1976, in which the artist draws a series of mock-plastic surgery lines and marks on her face before obscuring them, or the performative action *Trokut* [Triangle] of 1979, where simulated masturbation on a balcony during a parade by Tito in Zagreb caused a hurried reaction from state forces, show a clear and focused development of a practice that has institutional critique of political power, and the exercising of that power on a gendered basis, at its core.

If the artists that we have focused on so far are widely acknowledged as pioneering profiles in Yugoslav women's video art, then we must also acknowledge the key role played by

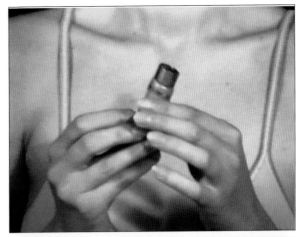

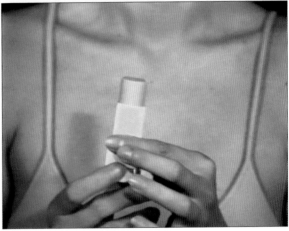

women in the dissemination and production of video. Perhaps the most important figure to acknowledge here is the curator, writer and producer, Dunja Blažević. Trained as an art historian, Blažević was a key figure at the Student Cultural Centre Art Gallery in Belgrade, where she served as director from 1971–76 and then head of programming, until 1980. In 1978, Blažević was one of the joint organisers of an international conference on feminism, entitled *Comradess Woman – Women's Questions: A New Approach* at SKC, which featured a rare meeting between western feminists and those active in the context of socialism.[9]

Figs. 4a-b. Sanja Iveković, *Make Up – Make Down*, 1976–78, stills from video. Courtesy of the artist.

In this early period, she also curated exhibitions that openly queried the status of traditional art forms in the Yugoslav context and included radical calls for a change in the production and function of art in socialist society. In her text on an exhibition at SKC called *Okotobar 75 – An Example of Counter-Exhibition: Statements on Artistic Autonomy, Self-Management and Self-Critique*, she stated:

> Art should be changed! As long as we leave art alone and keep on transferring works of art from studios to depots and basements by means of social regulations and mechanisms, storing them, like stillborn children, for the benefit of our cultural offspring, or while we keep on creating, through the private market [...] art will remain a social appendage, something serving no useful purpose, but something it is not decent or cultured to be without.[10]

If this was true of painting and sculpture, then it was truer of video art. With only a small number of practitioners, difficulty in acquiring equipment and material, and a tiny audience, what video art needed more than anything was an informed public. The logical step was to try to move examples of video art onto mainstream television, and this Blažević was able to achieve after a change of role in the 1980s.

As Barbara Borčić has shown,[11] video art began to move away from the realm of aesthetics and art criticism in Yugoslavia at the end of the 1970s, and towards the realm of the mass audiences that television could bring. Blažević's move from the world of curatorship to television production began in 1981 when she began to

work for TV Belgrade; she introduced video art on her programme, *Other Art*, in that year, and from 1984 to 1991, her series, *TV Gallery*, was to produce over sixty programmes on contemporary art practices, including programmes on video. We can locate Blažević's practice as a television producer as perhaps, in the 1980s, surpassing her undoubted experience and ability as a curator and arts administrator, in influencing the taste for contemporary art amongst a popular audience, reaching those who were not immediately involved, at a social or practical level, in the differing art scenes around Yugoslavia.

Whilst Blažević's pioneering television began to shape new audiences for video art, in the last decade of Yugoslavia – the 1980s – the practice and aesthetics of video began to diverge. The 1974 re-draft of the Yugoslav constitution – the final version – granted full cultural autonomy to each of the six republics, allowing local cultures to be funded at the level of the local party's cultural apparatus. While in less developed republics, such as Bosnia and Macedonia, this finally allowed for the exponential growth of local scenes; for republics such as Slovenia, this was the germ of an independent set of cultural priorities, that in effect, were foundation blocks for independence and statehood some sixteen years later.

In the 1980s, it was Ljubljana that was to emerge, perhaps, as the venue for the most radical experimental and counter-cultural currents in late Yugoslavia. Institutions such as ŠKUC and the appearance of *Neue Slowenische Kunst* [New Slovenian Art] from the city's underground have been extensively researched and written about in

the last twenty years; particularly in the international profile now enjoyed by the artistic collaboration, IRWIN. However perhaps, less work has been done on the nature of video production in Ljubljana during this period.

The work of Zemira Alajbegović is instructive in this regard. Part of the video artists' group FV, which was associated with the Disko FV nightclub in the city, Alajbegović's 1983 work *Tereza* (Figs. 5a-b) reveals, at once, the confidence of an artist developing closely in collaboration with a layered and multi-perspectival video art scene, but also, confident enough to make a work openly sceptical of the Slovenian political gerontocracy, and the increasing emptiness of their rituals and messages.[12] Over just four minutes, *Tereza* cuts between excerpts from performances of Slovenian pop songs, interspersed with footage of Communist politicians receiving applause and parading in public on ceremonial days. On one level, it speaks of a genuine generational conflict; between an older generation socialised under Tito's socialism and content to repeat its structures and rituals, and a younger generation for whom the slogans and practices derived from the partisan struggle had little meaning beyond empty repetition and perfunctory observation. *Tereza*, therefore, is a piece which shows the emergence of a contemporary televisual culture which bore little relation to the founding narratives of the Yugoslav state, and the coming emergence, a few years later, of a global youth culture driven by American brands such as MTV.

Alajbegović's practice, of course, did not develop in isolation. Together with Neven Korda, she produced

video under the duo's pseudonym ZANK, and the duo were also involved later in the multi-media events of the Borghesia artists' group. She was able to benefit from improvements in the conditions for the production of video work, through the Galerija ŠKUC video production programme, and the encouragement and interest of producers and managers at Ljubljana television; and in particular, of international exhibitions and discussions on video art in the city, in 1982 and again in 1985.

Cultural decisions, taken at republic level since 1974, ironically had an unintended consequence; they encouraged local cultural scenes to think critically and independently, and

Figs. 5a-b. Zemira Alajbegović, *Tereza*, 1983, stills from video. Courtesy of the artist.

without doubt played a small part in the eventual coming apart at the seams of the Yugoslav federation in the period 1989–91.

The growing acceptance of video art in the 1980s and the emergence of a television-savvy generation, saw video art begin to appear consistently beyond the Belgrade-Zagreb-Ljubljana axis in Yugoslavia. The first dedicated showing of video art in Bosnia-Herzegovina was at the Olympic gallery in Sarajevo in March 1985, curated by Nermina Žildžo; this exhibition featured a range of the most prominent video practitioners from Yugoslavia alongside colleagues from the UK, USA and West Germany. Video art also featured in the canonical *Jugoslovenska Dokumenta* exhibitions in Sarajevo's Skenderija in 1987 and 1989, the biggest showings of contemporary art from Yugoslavia mounted in the federation during its history.

In Macedonia, social and creative friendships between TV producers and visual artists, according to the pattern established elsewhere in the federation, began to produce concrete results, with Dragan Abjanić, Katica Trajkovska and Iskra Dimitrova, producing their first works at the very end of Yugoslav times. The mature outworking of these early experiments did not happen until after the dissolution of the Yugoslav federation in 1991, and Macedonian independence.

Conclusion

The Bosnian artist Maja Bajević's video piece *Art Must Be National* of 2012, is a painful re-working of Marina Abramović's, *Art Must Be Beautiful*

discussed above. In the performance, Maja re-works the original piece, copying the physical movements of Abramović in the original and merely replacing the word 'beautiful' with 'national'. The piece is painful as, in a very pungent way, it illustrates the fate of the Yugoslav idea and the consequences of its dissolution. Any chimerical notions of 'beauty' have been overwritten by a political monomania on national and ethnic identities, and the often-absurd demarcations of common language, and ideological re-writing of history that has taken place since the end of the Yugoslav Wars of succession that lasted from 1991–99. Whilst the performance has been re-enacted elsewhere in terms of re-engaging with half forgotten material, or re-interpreting it in a different cultural context, Maja Bajević's video piece is an acute summary of futility, loss and regret.

In this essay, we have discussed some of the contours of the development of contemporary visual culture in the former Yugoslavia, and the key roles that women played in its development. After an early phase of learning and technical experimentation, video art, confined to the margins of artistic avant-gardes in the 1970s, developed by means of documentation, and by focused engagement with societal and gender issues of that time. In the work of Sanja Iveković, video is used as a very sharp tool of institutional and ideological critique.

Video from the beginning in Yugoslavia had relations with unlikely bedfellows; the milieu of experimental performance, music and theatre on the one hand and the mass audience of television on the other. Yet it was this very relationship, thanks to the

foresight and determination of Dunja Blažević in Belgrade and others at republican level, that brought video to a television audience in the 1980s and grew and shaped a taste for a type of art that previously had struggled to gain a profile beyond the milieu of student cultural centres and a small minority of active artists.

Although we began the essay by noting the historical nature of the medium of video, the legacy of this timeline that we have traced in this essay is still felt strongly in the work of young women artists from ex-Yugoslav countries in our time; for example Adela Jušić's work on the Bosnian war and its consequences politically and personally (*The Sniper*, 2007), Milijana Babić's video essay on the humiliations and disappointments of young women seeking employment in chronically precarious post-socialist economies (*Looking for Work*, 2013), or Jasmina Cibic's video, *For Our Economy and Culture* that represented Slovenia in the 2013 Venice Biennale.

Moreover, the artists mentioned earlier in the essay are mostly still working in video as their primary activity. Nuša Dragan, continued as an independent practitioner, until her death in Ljubljana in 2011, leaving behind over forty years of video work; Dunja Blažević inspired a whole new generation of young women artists in her works as director of the Soros Center/SCCA in Sarajevo from 1996–2016; Sanja Iveković has enjoyed an unprecedented profile in the last decade, with a major retrospective at MoMA and acquisitions by national galleries and institutions that had long been ignorant of her work.

It is in the persistence of these practices, in the face of the challenges mentioned, and a still-present patriarchal scepticism as to the ability of women to handle video equipment and its attendant technologies, that forms the bedrock of much contemporary video practice in the territories of ex-Yugoslavia. It is the richness of the work of the younger generation of video artists who have followed, the continued commitment to documentation, experimentation, institutional and social critique, and cross-disciplinary collaboration, that is the richest legacy of the early years of women's' video art discussed in this essay, and one that will endure.

Endnotes

1. Barbara Borčić, 'Video Art from Conceptualism to Postmodernism' in Miško Šuvaković and Dubravka Djurić (eds.), *Impossible Histories: Historic Avant-Gardes, Neo-Avant-Gardes, and Post Avant Gardes in Yugoslavia 1918–91* (Cambridge Mass.: MIT Press, 2003), pp. 495–496.

2. The archive, in the Bosnian language, can be accessed at: http://www.afzarhiv.org/ (accessed 24 July 2017).

3. *Grad od Deset Ljeta*, Loveèn Film, 1958, can be seen online at: https://www.youtube.com/watch?v=oIHxgPMxaro (accessed 24 July 2017). For a further discussion of the film in context, see Sarajevo Culture Bureau, 'On Socialist Utopia and Stojadins', 27 June 2012. https://sarajlijacult.wordpress.com/2012/06/27/on-socialist-utopia-and-stojadins/ (accessed 24 July 2017).

4. For a full account of the motivation and development of these demonstrations, see Madigan Fichter, 'Yugoslav Protest: Student Rebellions in Belgrade, Zagreb and Sarajevo, 1968', *Slavic Review*, vol. 75, no. 1, March 2016, pp. 99–121. See also Geoffrey Swain, *Tito: A Biography* (London: IB Tauris, 2010), chap. 6, pp. 139–165.

5. OHO (a neologism combining the Slovene words for eye and ear) existed between 1966–71. For a full history and development, see Miško Šuvaković, *The Clandestine Histories of the OHO Group* (Ljubljana: Zavod P.A.R.A.S.I.T.E, 2010); and also http://www.artmargins.com/index.php/oho-homepage

6. These exhibitions were *Eight Yugoslav Artists* in Edinburgh in August 1973, and *ASPECT '75*, which began in Edinburgh and toured in Northern Ireland and England during 1975/76. For more information, see my essay 'Richard Demarco and the Yugoslav art world' in Euan McArthur & Arthur Watson (eds.), *Ten Dialogues: Richard Demarco and the European Avant-Garde* (Edinburgh: RSA, 2010).

7. A thirteen-minute excerpt from this film can be found at: https://www.youtube.com/watch?v=ZUgBAT4nvdM (accessed 22 May 2017).

8. Roxana Marcoci, 'Sanja Iveković', *Flash Art*, March/April 2012, accessible online at: http://www.flashartonline.com/sanja-ivekovic/

9. For further details on this conference, see Hedvig Turai, 'Bojana Pejić on Gender and Feminism in Eastern European Art', in Katrin Kivimaa (ed.), *Working with Feminism: Curating and Exhibitions in Eastern Europe* (Tallinn: Tallinn University Press, 2012), pp. 198–201.

10. For further information on this exhibition visit: http://tranzit.org/exhibitionarchive/tag/dunja-blazevic/

11. See Borčić, 'Video Art from Conceptualism to Postmodernism', p. 506.

12. The work can be seen at: http://www.e-arhiv.org/diva/index.php?opt=work&id=384 (accessed August 2017).

Chapter 5

Slender Margins and Delicate Tensions: Projects by European Video Pioneers Stansfield/Hooykaas

Malcolm Dickson

The work of Stansfield/ Hooykaas surfaces from the cross currents of a fertile and formative period of artistic and cultural activity stemming from the 1960s, when cultural, technological and social energies intersected and transformed one another in new and previously unseen ways. They might be called the younger breed of the first generation of video artists to start exhibiting their work in the 1970s and whose practice has had an influential effect in Britain and in Europe helping to define the expanded area of video installation (Fig. 1). After forty-six years, their work remains at the forefront of such developments in European video practice.

Their 'oeuvre' is inextricably linked to the *ecologies of practice* which determine how art is mediated – modes of spectatorship (the various forms through which work travels, from galleries, to online); distribution and production (access to facilities, workshops, funding, educational institutions, distributors, collectives, galleries, festivals, television and the internet); as well as the networks which strengthen and extend international links. They have moved between, sometimes uneasily, the nuances of moving image culture, the art world and television broadcasting. Furthermore, the process of archiving serves to illuminate the practical and theoretical issues around medium specificity and the technological shifts that result in certain 'carriers' becoming obsolete, thereby raising further questions about the veracity of particular works being 'restaged' or re-purposed, and throwing up options for renewed reading and fresh perspectives.

This is highlighted in the video environment *Labyrinth of Lines*, recently seen at the M HKA in Antwerp. This followed the components of the original work from 1978, produced for the ICC in Antwerp as a site-specific work for the 'horse stables' of the Palace on the Meir. Writing about the work in October 2017, the Museum states 'Historically, this work is of

Fig. 1. Elsa
Stansfield and
Madelon
Hooykaas, at the
World Wide
Video Festival,
The Hague, 1985.
Courtesy of
Madelon
Hooykaas.

Fig. 1. Elsa Stansfield and Madelon Hooykaas, at the World Wide Video Festival, The Hague, 1985. Courtesy of Madelon Hooykaas.

great importance. Firstly, of course, as part of the Stansfield/Hooykaas oeuvre, but above all because of the use of many different sizes and types of monitors. When the work was first installed, this variety of technology was unique. Now, thirty-nine years later, the reinstalment of the work poses a challenge, since the old video technology will be re-used'. It uses twelve monitors and a closed-circuit video installation, two video tapes, fourteen black-and-white photos printed on linen, water barrel, mirror, leaves and lead wire – the sound was based on earlier recordings by 'sculptress of sound' Delia Derbyshire. It is a work that is emblematic of the genre and their audio-video-photo installational approach.[1]

Catherine Elwes has written that their work anticipated

> the internationalism of today's art world, whereas in the 1980s, video practice was often framed around a localism tied to the politics of identity, and social inequalities affecting communities in the immedi-

ate vicinity of where the artists lived.[2]

The nomadic nature of their practice however has also created obstacles in that curators and collectors struggled to define their practice as International, European, or British, an otherwise perfunctory issue except when it comes to curatorial legitimisation. They didn't quite fit within the feminist discourse prevalent in the 70s and 80s, which premised themes of sexuality, identify, the body, and social hierarchy and in fact they rejected invitations to participate in exhibitions that may have forced that reading on their more pluralistic practice. Collaboration was also a rarer mode of working in the early 70s, especially those by women. As Hooykaas notes, 'we were never a part of a feminist group and there weren't any specifically feminist groups then in the Netherlands working with artists'.[3]

Their first and last 'video installations' were made in Scotland in 1975 and 2004 respectively, the latter being the latest iteration of a collaborative

Fig. 2. Elsa
Stansfield and
Madelon
Hooykaas, *Day
for Night IV*,
video installation,
VRC, DJCAD,
Dundee, 2004.
Photo: Courtesy
of REWIND
Archive, DJCAD,
Dundee.

work made when Stansfield was still alive, *Day for Night IV* (Fig. 2) which concluded a residency at the Visual Research Centre, DJCAD, within Dundee Contemporary Arts, Scotland in 2004.[4] Though, it is neither appropriate nor indeed accurate to call it 'final', as Hooykaas has continued to produce artworks in their name and with all the hallmarks of their approach.

What's It to You? (Fig. 3) was shown at Glasgow's Third Eye Centre in 1975,[5] quite possibly the first video experiment in a public gallery space in the city, if not in Scotland, and embodied elements that have maintained some continuity through their practice. It makes reference to the site it is located in, combines live and pre-recorded video, includes photography, and involves a questioning of the role of the viewer. It linked two monitors playing tapes from The Barras flea market in the East End of the city with the arts centre, situated on one of the busiest shopping streets of the city, Sauchiehall Street. A third monitor teased passers-by to stop; a camera

was offered to record viewers thoughts, and materials for them to write their comments, which were in turn displayed alongside the photographic panels. The title refers to the Glaswegian dialect and mannerism of rebutting a question with a possible hostile response: – 'How are you today?', answer – 'What's it to you?'. It is this interactivity and site-specificity that gives their work, like that of others experimenting with video at the time, a contemporaneous link to new media.

The tapes were shown again a year later in Glasgow during the conference *The Future of Video in Scotland* organised by Tamara Krikorian to coincide with the second exhibition of video in the city *Video: Towards Defining an Aesthetic* (again held at the Third Eye Centre). Included in that show were a group of artists associated with London Video Arts – David Hall, Tony Sinden and Stephen Partridge – who were also exploring the characteristics of the medium, namely instant playback, its looping capacity,

Figs. 3a-b. Elsa Stansfield and Madelon Hooykaas, *What's It to You?*, 1975, video installation, Third Eye Centre, Glasgow. Courtesy of Madelon Hooykaas.

and closed circuit capabilities. Writing in *Studio International* at the time, in a special issue edited by David Hall, Tamara Krikorian remarked:

> There has been a commitment in Scotland which at times has been lacking elsewhere: [the conference topics] successfully brought the discussion back to the level of what video is all about: a tool, which, if skilfully handled, offers an alternative to the broadcast mode. It allows the users insight into the

situation in which they are involved, and an insight into the medium itself. A possibility of analysing, reassessing and eventually re-directing TV itself.[6]

Their next work in Britain was at the Whitechapel Art Gallery, close to where they had recently moved studio to in Wapping, where they made a site-specific three-tape work in 1976 entitled *Journeys* (Figs. 4a-b). It related the development of technology from agrarian beginnings to urban de-

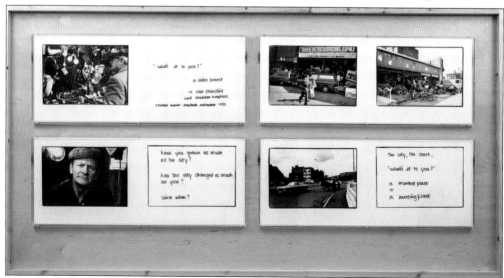

Figs. 4a-b. Elsa Stansfield and Madelon Hooykaas, *Journeys,* 1976, Whitechapel Art Gallery. Collection Tate Britain, London. Courtesy of Madelon Hooykaas.

ployment through the movement of peoples, and being placed in an area rich with the different cultures that settled in East London; it was a strongly site-specific work combining a series of photographs and video. One year later *Just Like That* was exhibited at Air Gallery in Shaftsbury Avenue, a work whose recurring concern was how time influences (or distorts) memory explored in an installation introducing elements of man-made and organic

materials – the menu reads: 1 pre-recorded tape (15 min), 1 playback deck, 2 b/w video-monitors, 14 mixed media works: 50 x 60 cm, 1 round mirror, 1 oval mirror, and 2 plants.[7] One wonders if this data capture was in anticipation of future archiving to avoid any historical inaccuracies in recollecting the work, or indeed, forgetting it completely.

Hooykaas has remarked that as a result of showing at Whitechapel they

were invited to exhibit at De Appel,[8] a new contemporary art space in Amsterdam, with the piece *Memory Window*, in 1977, this time with two environments focused on video, and with a series of fourteen photographic images printed onto linen, and again including plants. The artists' fascination with the scan lines of the 'video' raster was a theme of *Horizontal Flow*, shown at Teesside College of Art in Middlesbrough and at the L.Y.C. Museum in Cumbria, also in 1977, which had five monitors showing images from two tapes of a pan of a horizon.

A flurry of video environments driven by the conceptual interest in lines followed in the next year as the reputation of the artists spread along with the increasing interest in the art world in video and installation. Exhibitions such as *See Through Lines* at Agora Studio, Maastricht, *Moving Lines* in Studio Amazone, Amsterdam; *Continuing Lines* at Gamm(a), Utrecht; *Video-Pond*, Museum Fodor, Amsterdam; *VideoChanges*, Het Langhuis, Zwolle; and also, in the same year of 1978, a return to the shores of Britain with a work at Chapter Arts Centre in Cardiff, *Sea of Light* which concerned the cycle of the sea. In this work, three monitors were sourced from one tape, but with each monitor tuned differently and each situated in three of the four gallery spaces used – this work suggests a widening of their concerns with the video image and to link it to the body and the landscape, as Hooykaas recounts, using 'the luminance of the video image as if it were breathing'.[9]

The concept is determined by the 4 units of the gallery and its proximity to the sea. The piece encapsulates a time cycle of 24 hours divided into 4 units of space from darkness to light. As you move through the piece from one space to another you carry with you a memory, an image or a sound, this is central to the experiment of the environment. This is a play on different perceptions of reality from the photographs of stones, the real stones and the video recording of the stones original setting.[10]

This period represented an expansion of the British/European aspects of their exhibition practice, in tune with the Scottish/Dutch synthesis of their collaboration. In mid-1970s Britain, the context for the production, cultivation, promotion and critical appreciation of time-based art was dramatically shifting with a series of interconnected individuals, organisations and initiatives cropping up – in the UK for example with 2B Butlers Wharf (London, 1975), LVA (London, 1976), and the Ayton Basement (Newcastle, 1976). Many of these venues or projects played important roles as being international ports of call and points of contact in the developing European and international video art scenes.

Stansfield/Hooykaas used the first accessible facility for video, Fantasy Factory, which was set up in 1974,[11] and through that, were introduced to artists and facilities at London Video Arts, which had formed itself on the crest of the critical wave of the exhibition *The Video Show* at the Serpentine in 1975. While London Video Arts had a core nucleus of artists involved,[12] who were active in building a culture for video art, there were a great many others whose association with London Video Arts

helped fortify the wider climate for the reception of video art, Stansfield/Hooykaas amongst them. This was significant in asserting video as a distinct time-based art form, with its own aesthetic features which set it apart from the discourse and theory around experimental and structuralist film. This was reinforced in broadcast television and in the specialist art press, with the BBC's arts magazine series *Arena* producing a *Video Art Special* introduced by David Hall, and the pioneering art magazine *Studio International* publishing a special issue on video art, again guest-edited by Hall. This wasn't all confined to the London orbit of course, and parallel to the work which the Ayton Basement were doing in Newcastle, *Artists Video: An Alternative Use of the Medium* was organised by video artist Brian Hoey and Wendy Brown in Tyne and Wear. The second outing of it in 1977, which took place at Biddick Farm Arts Centre, Tyne and Wear, included work by Stansfield/Hooykaas, as well as by other artists such as Mick Hartney, David Critchley and Stuart Marshall.

In the Netherlands, things were changing too. The In-Out Center, founded in 1972 as the first independent artist space in Amsterdam, offering a platform for new art at the time. As Rob Perrée has pointed out:

> They may have only reached a limited audience, but what is more important is that they represented a growing group of foreign artists who felt drawn to Amsterdam for its tolerant, artistic and grant-friendly climate, and whose innovative and refreshing presence had a stimulat-

ing effect on developments, particularly Dutch video art'.[13]

The origins of some of the early incentives were galvanised by social ideals, such as that of Videoheads, formed by Henry Jack Moore in 1971, a facility used sporadically by Nan Hoover and Raul Marroquin and also by Stansfield/Hooykaas.[14] Agora Studios had a more experimental and art-based approach, as did Open Studio, which was used by Stansfield/Hooykaas, and other artists such as Ulay/Abramović. Some of these organisations were short-lived and were eclipsed, according to Perrée, by De Appel in 1975: 'Soon after its launching in 1975, De Appel became one of the most important art institutions in the Netherlands, this [....] was the international centre for those forms of art that knocked on the doors of the museums in vain: performances, environments and situation art',[15] with notable artists such as Jenny Holzer, Nan Hoover, Laurie Anderson and Charlemagne Palestine all having performed or staged work there.

Het Kijkhuis opened in The Hague in 1975, and from 1982 onwards was to be the regular venue for the Worldwide Video Festival, one of the more established events in the annual video art calendar across Europe and further afield. In 1978, Montevideo arose with a specific focus on video art, and in 1982, The Association of Video Artists was formed (of which Madelon Hooykaas was President for four years), and through it, Time Based Arts was established in 1983. In 1993 Montevideo and Time Based Arts merged into the Netherlands Media Art Institute (NIMk).

The origins of the term 'time-based art' is largely assigned to co-instigator of the Artist Placement Group, John Latham, with whom David Hall was associated, with the latter setting up a department within the Fine Art School at Maidstone called Time Based Media, with a focus on video, in 1972. In 1979, Elsa Stansfield was the first recipient of a video bursary from the department, funded by the Arts Council of Great Britain, and this was the first of a number to take place with different artists over the course of several years. Elsa Stansfield moved to Maastricht to set up and head a postgraduate video department at the Jan van Eyck Academie, a research institute in 1980, taking the term with her, which subsequently became an appropriate 'catch all' for a variety of practices.

A 'landmark' exhibition took place at the Stedelijk Museum in Amsterdam in 1984 called *The Luminous Image* which profiled the diversity and energy around the areas of video installation, with each work created for or premiered at the event. It included a number of European and international artists, in what was probably the most gender balanced manifestation in a contemporary art exhibition, including women practitioners Dara Birnbaum, Max Almy, Nan Hoover, Marie-Jo Lafontaine, Lydia Schouten, Shigeko Kubota, and Marina Abramović [and Ulay].[16] Stansfield/Hooykaas responded to the invitation by installing a camera mounted on a wind vane on the roof of the museum, which, when moved by the course of the wind, would change the images transmitted to the four monitors which were arranged on the four cardinal points of the compass. The images on monitors in the gallery were directly affected by the direction of the wind, providing an experience of the relationship between past and present, with natural forces as an active participant in the creation of the work.[17]

Elsa Stansfield proposed that David Hall write in the exhibition catalogue, to which he contributed the essay, *Video Art Education: 20 Years On*.[18] Elsa Stansfield also organised a two-day symposium on the themes of the exhibition at the Jan van Eyck Academy, with most of the artists in that Stedelijk show travelling to Maastricht to participate in the symposium.

Stone TV – Broken TV (Figs. 5–6), a two-part site-specific sculpture, marked a return to Scotland as part of a group show *Holland at the Festival* in 1989 organised by the Richard Demarco Gallery, in association with the Contemporary Art Foundation, Amsterdam. The work combined a stone TV on Calton Hill, which overlooks Edinburgh, and another in a medieval Abbey at Inchcolm Island in the Firth of Forth.[19] Hooykaas explains:

> The stone TV had an antenna and phosphorescent paint on it. It was like when you switch off a monitor and you see the phosphorescent material. We have used that a lot in our work also because phosphor is part of a monitor. So, in the Abbey we had another stone TV with an antenna and a phosphorus screen. They were five miles apart but they related to each other. We also had a speaker cone as a kind of sculpture with silver leaf on it. In the room, we opened the window and you heard the sea and the seagulls and many people thought that the sound came from the speaker. But there was no electricity used in *Stone TV – Broken TV*.[20]

The theme of navigation re-emerges in their work *Intermittent Signals*, shown for the first time in Liverpool as part of *Video Positive 91*. Inspired by visits to Scotland and its 'powerful' landscape, the work is part of a series of installation works entitled *From the Personal Observatory* – it references the ancient stone circles found in Callanish in Lewis and the Ring of Brodgar in Orkney, as solar or lunar observatories, 'like giant fossilised antenna'[21] which are seen as metaphors to excavate the past. The work also responds to the copper plaque that was sent up with the Voyager spacecraft as a symbol of our civilization should any extra-terrestrials encounter it. The work took up a large space at the Tate Gallery in Liverpool and comprised a number of projections of images deemed by the artists to have similar significance, contrasting with small liquid crystal display screens as points of the constellation. In the middle of the space was a platform, an observatory, from where to view the work.

Works after 2004 were invariably dedicated to Stansfield – *Daydreaming* (Fig. 7), an audio/video installation consists of a hammock hanging in the middle of the room from where the viewer could view a projected image on the sloping ceiling and look out to sea. *After Image/After Language* from 2006, a site-specific audio/video installation by Stansfield/Hooykaas and Chantal duPont shown in a park in Montreal in 2006 consists of an erected hexagonal shape erected within the lake in the park onto which were projected further images of water, with the disk reflected in the lake. Images included a seagull in slow motion, Elsa Stansfield walking

on a beach, sounds of water and the lapping of waves. A second sculptural version of this took place in Galerie La Centrale in the same city, and combined other elements like metal, salt and water. *Winter Solstice* – another site-specific video installation in 2006 shows a projected image of a Buddha head, one half in black the other in white. The images are lyrical: a silhouette of Hooykaas stroking a feather, a figure walking in a snowdrift, or next to a stormy sea lashing its spray around the walking figure – the elements of light, time, and wind are again recurring.

Stansfield/Hooykaas' work displays the emblematic characteristics of video installations as spatial, tem-

Fig. 5. Elsa Stansfield and Madelon Hooykaas, *Stone TV – Broken TV*, 1989, site-specific two-part sculpture, Calton Hill, Edinburgh. Courtesy of Madelon Hooykaas.

Fig. 6. Elsa Stansfield and Madelon Hooykaas, *Stone TV – Broken TV*, 1989, site-specific two-part sculpture, Incholm Island, Scotland. Courtesy of Madelon Hooykaas.

Fig. 7. Elsa Stansfield, Madelon Hooykaas, *Daydreaming*, 2006, KeterlFactory, Schiedam, The Netherlands, 2010. Courtesy of Madelon Hooykaas.

poral and hybrid forms – intuitively-felt explorations which included such media and materials as video, photography, audio, and natural materials such as earth, stones, copper, steel and electronic detritus. Because of the themes embraced, they invite multiple readings that are more significant than those confined to art world discourse. Given these factors, in addition to the issue of site-specificity, how then might these types of installations be preserved, collected and re-presented in the future? It is clear that electronic media must migrate as new carriers become available and older ones obsolete – a time consuming and costly exercise to justify resources to. It is also self-evident that the issue of display equipment is subject to similar preservation approaches if recon- structions of the work are to be true to form.

Between 2007 and 2009, the indexing and cataloguing of the Stansfield/Hooykaas archive took place at Hooykaas' studio, supervised by the Netherlands Media Art Institute/Montevideo (NIMk). This served to provide some critical elements and evidence for *Revealing the Invisible: The Art of Stansfield/Hooykaas from Different - Perspectives* in 2010 (Fig. 8), which

Fig. 8. View of *Revealing the Invisible* exhibition at Street Level Photoworks, Glasgow, 2010. Courtesy of Street Level Photoworks.

was both a landmark exhibition as well as a punctuation in four decades of their work, augmented by a well-researched, comprehensive and luxuriously produced tome published by De Buitenkant and edited by Madelon Hooykaas and Claire van Putten.[22] As the title suggests, the exhibition embraced a selection of works providing multiple readings rather than a single vision and it was seen at Street Level Photoworks and the CCA in Glasgow,[23] and at De Ketelfactory project space in Schiedam and Museum Gouda, both in the Netherlands. Their work is described as 'a well-knit organic whole' because the artists 'continually refer back to previous ideas and motifs and rework passages of old tapes into new ones'.[24] In this process, the role of the artist in verifying details is critical, given the hybrid nature and site-specific approach of some of their work and materials, and this serves to illustrate the urgency required to preserve the work of the first generation of media artists who can, through the first person narrative, ensure conditions (and recollections)

are accurate, and that social and cultural memory continues in relation to the practice. With the Stansfield/Hooykaas archive, this extends to such details as the original location, the technology used, the form of its presentation, the driving concerns of the artists at the time, and of course any amendments within the course of that investigation.

In 2012, NIMk ceased its activities with some of its personnel, collections and apparatus transferring in 2013 to LIMA, also located in Amsterdam, as a new platform for media art, thereby providing some continuity in the knowledge, collection, conservation, as well as the access and distribution for media art practice.[25] An informative case study written by Gaby Wijers details the twin challenges LIMA faced in the digitisation of the Stansfield/Hooykaas work:

i. How to make sustainable digital reproductions of the artists' videos while maintaining their significant properties in the digital form?

ii. How to make the digital reproductions accessible online in order to create an experience that can be considered the digital equivalent of the analogue experience?[26]

Ambitious projects such as RE-WIND instigated a process within the UK of ensuring periods of practice and many specific artworks are not lost from the received narrative on British art, as well as providing a resource for researchers. EWVA takes two critical steps further into a European context and the contribution made by women in 'broadening the potential of the medium beyond its early techno-prestidigitation and its deconstructive and declamatory functions'[27] which has largely been eclipsed, neglected, if not at times ignored, despite the writings of Elwes and others. Hooykaas also established the Foundation Stansfield/Hooykaas in 2012 for the presentation and preservation of the duo's works which includes finding appropriate archives in which to place work where it remains active – online, digitised, and certainly not dormant.[28]

This is the challenge that makes collecting work difficult, as most institutions are not permeable to this extent and some of the traditional establishments view acquired works as monetised assets. Nevertheless, Hooykaas has orchestrated with considerable patience, energy and conviction, a determined trajectory which, in recent years, has seen some of their ambitious works finding appropriate domiciles – at times specific to the original works, geographically as well as in the cultural context.

In 2014, the video work *Running Time* (1979) was gifted by the Foundation Stansfield/Hooykaas to the Scottish National Gallery of Modern Art, the venue where, in 2009, the eponymous survey show *Running Time: Artists Films in Scotland from 1960 to Now* took place. That exhibition aimed to foreground Scotland's long and important history in the development in film and video as distinct practices but also as a medium of choice for many current artists, even though there are scant records of this in the official chronology.[29] It covered the avant garde experiments of Margaret Tait, to more contemporary manifestations of work exploring the various experimental influences on artists' video through the work of Rosalind Nashashibi and Katy Dove in the 1990s.[30]

In 2016, Glasgow Museums acquired the surviving photo panels and related documents from their first video installation work *What's It to You?*, first seen in the city in 1975, as discussed earlier in this chapter. This was presented at the Gallery of Modern Art in Glasgow in 2016 in the exhibition *Please Turn Us On*, an exhibition which also included Arthur Ginsberg with Video Free America, Videofreex, alongside a new commission by Heather Phillipson. Although it did not acknowledge previous research and writing on this work, the exhibition consciously supported what this writer would propose is now more of a maxim than a hypothesis that Scotland was on a par with countercultural developments across the globe.[31]

In 2015, the photographic part of *Labyrinth of Lines* (Figs. 9a-b)was donated to the Museum of Contemporary Art in Antwerp (M HKA) where it was restaged in October/November of 2017, as discussed earlier in this

Figs. 9a-b. Elsa Stansfield and Madelon Hooykaas, *Labyrinth of Lines*, 1978, Museum of Contemporary Art, Antwerp, 2017.
Courtesy of Madelon Hooykaas.

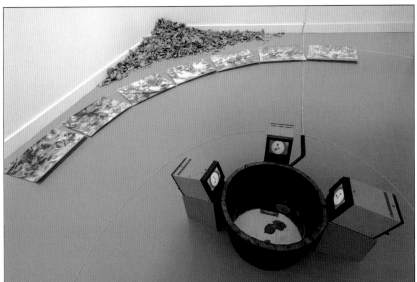

chapter. Alongside this reconstruction, a work titled *Grid* – combining projected video and drawing – was executed on the wall of the cafe, having previously been seen in *Reports from the Year of the Monkey* in Amsterdam in 2016. This recaptures and extends the continuities of Stansfield/ Hooykaas' practice to that of the individual work currently embraced by Hooykaas.[32] The direction of travel of Hooykaas' work is further illustrated in *Virtual Walls*, presented in Venice (September 2017), Amsterdam (December 2017, Fig. 10), and in Perth, Scotland (May 2018) which combined

Fig. 10. Madelon Hooykaas, *Virtual Walls II*, performance at Oude Kerk, Amsterdam, 21 December 2017. Courtesy of the artist.

video projection, performance and drawing and investigated a theme exploring the balance between the number of tourists in relation to the number of inhabitants in these cities.[33]

In 2017, the Tate in London approved the acquisition of the work *Journeys* (1976), first made for the Whitechapel Art Gallery (and edited at Fantasy Factory),[34] London. Its theme of the movement of peoples gives this work a current relevance with London being one of the most culturally diverse conurbations in the world, in the dramatic regeneration of the East End as well as the geopolitical implications of Brexit which sees a crisis of global-

isation and a signal of resurgent nationalism in global affairs. The saying 'to sow the wind and reap the whirlwind' has never had such momentous and catastrophic associations.

The pertinent slogan of second generation feminists that 'the personal is political' is relevant here with Stansfield/Hooykaas' work being premised on personal growth and individual creativity, which when combined with environmental themes, returns us cyclically to its original essence with an increased currency and resonance, contrasting deeply from the conceit of a material and morally vacuous culture.

Endnotes

1. *INBOX: Madelon Hooykaas – Labyrinth of Lines* (20 October – 12 November 2017). See https://www.muhka.be/programme/detail/1075-inbox-madelon-hooykaas (accessed 13 November 2017).

2. Catherine Elwes, review of 'Revealing the Invisible: The Art of Stansfield/Hooykaas from Different Perspectives, Madelon Hooykaas and Claire van Putten (eds), (2010)', *The Moving Image Review & Art Journal (MIRAJ)*, Volume 2, Number 1, 1 April 2013, pp. 124–130. That piece of writing inspired the title of this chapter.

3. Interview with Madelon Hooykaas by Laura Leuzzi for EWVA, edited by Adam Lockhart. https://vimeo.com/142362044 (accessed 13 November 2017).

4. *Day for Night* first manifested itself in 2000 for a video wall at the University of Twente in the Netherlands; then in 2001 as a site-specific audio/video installation during the Le Mois de la Photo Festival in Montreal. Its third realisation was in 2003 at the 20th World Wide Video Festival in Vondelpark Filmmuseum in Amsterdam.

5. Stansfield/Hooykaas were invited by its then Director, Tom McGrath, who in turn had been invited to run the Third Eye Centre due to knowledge of his work with the counter-cultural newspaper 'International Times'. Involved in the 'International Times' was a small interconnected group of individuals, one of whom Jim Haynes, founder of the legendary Paperback Bookshop, The Traverse and The Howff, all in Edinburgh, established the Arts Lab, the prototype for what would become arts centres throughout the UK and abroad, the Melkweg (Milky Way) being one venue in Amsterdam that Haynes acknowledges drew inspiration from it. Elsa Stansfield, as a young Scot new to London, as well as working as an assistant to John Latham around the period of his Bookworks 'sculptures', was one of the projectionists at the Arts Lab cinema. The Third Eye Centre closed in 1991 and reopened as the Centre for Contemporary Art in 1992.

6. 'Video Events in Glasgow: Report by Tamara Krikorian', *Studio International*, May/June 1976, p. 286.

7. *Else Madelon Hooykaas, Elsa Stansfield: 'Labyrinth' video-environment*, exhibition catalogue, editors and curators of the exhibition, Florent Bex, Jean-Pierre Daems, Glenn Van Looy, 14 October – 12 November, 1978 (Antwerp: ICC, 1978).

8. Noted in Hooykaas' interview for REWIND. See www.rewind.ac.uk (accessed 13 November 2017).

9. *Ibidem*.

10. *Ibidem*.

11. Fantasy Factory also distributed the Stansfield/Hooykaas' publications. It was set up by John Hopkins and Sue Hall as an affordable community access facility which was the first in the UK at a time when getting equipment was difficult and editing controlled by broadcasting. A talk by Hopkins and Hall was organised by Street Level at the CCA in Glasgow on 24 October 2009 as part of the *7th Document: Human Rights Film Festival*: Hoppy and Sue Hall used video, mostly black and white, in a variety of situations – on the street, as art and as television, at a time when non-broadcast video was a new, undeveloped creative medium. This informative talk showed excerpts of their early work demonstrating the social uses of video for community action and development.

12. David Critchley, Stuart Marshall, Stephen Partridge, David Hall, Roger Barnard and Tamara Krikorian amongst them.

13. Rob Perrée, 'From Agora to Montevideo: of Video Institutes the Things that Pass', in Jeroen Boomgaard and Bart Rutten (eds.), *The Magnetic Era: Video Art in the Netherlands 1970 – 1985* (Rotterdam: NAi Publishers, 2003).

14. Moore had previously been involved in the nucleus around the British counter-cultural newspaper 'International Times', with John Hopkins and others. Videoheads were originally based in the Melkweg (Milky Way).

15. *Ibidem*.

16. The male artists in the show included Vito Acconci, Michel Cardena, Brian Eno, Kees de Groot, Michael Klier, Thierry Kuntzel, Marcel Odenbach, Tony Oursler, Nam June Paik, Al Robbins, Francesc Torres, Bill Viola, and Robert Wilson.

17. Chris Meigh-Andrews, *A History of Video Art: the Development of Form and Function* (Oxford: Berg Publishers, 2006). Video documentation of this exhibition is held at the Video Data Bank in Chicago. This listing in their online library includes an excerpt with Elsa Stansfield talking about their work in the exhibition: http://www.vdb.org/titles/luminous-image (accessed 13 November 2017).

18. A version of the article also appeared in *Video Positive '89*, exhibition catalogue (Liverpool: Tate Gallery, Merseyside Moviola, 1989).

19. An inscription is set in the Abbey which reads: '*Stet domus haec donec fluctus formica marinos ebibat, et totum testudo permabulet orbem*' [May this house stand until an ant drains the flowing sea, and a tortoise walks around the whole world].

20. Interview to Madelon Hooykaas by Stephen Partridge and Emile Shemilt, 10 May 2007, transcript, p. 13 http://www.rewind.ac.uk/documents/Stansfield%20Hooykaas/ESMH510.pdf (accessed 13 November 2017).

21. *Video Positive 91*, exhibition catalogue (Liverpool: Moviola, 1991), pp. 19–20.

22. Madelon Hooykaas, Claire van Putten (eds.), *Revealing the Invisible – The Art of Stansfield/Hooykaas from Different Perspectives* (Amsterdam: de Buitenkant Publishers, 2010). The book contains international contributions by David F. Peat, Malcolm Dickson, Dorothea Franck, Nicole Gingras, Heiner Holtappels, Janneke Wesseling, Kitty Zijlmans and others. The publication also has an accompanying DVD.

23. See review at the time: 'Visual art review: 'Revealing the Invisible: The Art of Stansfield/Hooykaas from Different Perspectives', *The Scotsman*, 10 December 2010, online version http://www.scotsman.com/lifestyle/visual-art-review-revealing-the-invisible-the-art-of-stansfield-hooykaas-from-different-perspectives-1-1521380 (accessed 13 November 2017).

24. As discussed in Panayota K. Kampoli, *Remembering the Future: The Inventory of the Hooykaas/Stansfield Archive*, Thesis (MA), Presentation and Preservation of the Moving Image, University of Amsterdam, 2010.

25. Gaby Wijers, formerly head of conservation and collection at the NIMk, is the director of this new initiative, http://www.li-ma.nl/site/about (accessed 13 November 2017).

26. The digitisation of media artworks by Elsa Stansfield and Madelon Hooykaas which appears in the online platform https://www.scart.be/ under the section Case Studies and also the website of Documenting Contemporary Art, a digitisation project for art made after 1945 with a focus on cultural heritage. See 'Documentation' section in http://www.dca-project.eu/ (accessed 13 November 2017).

27. Elwes, review of 'Revealing the Invisible'.

28. A chronology of projects and link to the Foundation is available at www.stansfield-hooykaas.net

29. *Running Time – Artist Films in Scotland: 1960 to Now*, The Dean Gallery, Edinburgh, 17 October – 22 November 2009.

30. Also included was *Split Seconds* and both these works were included in the *Revealing the Invisible* exhibition at Street Level Photoworks in Glasgow in 2010.

31. *Please Turn Us On*, 28 July 2016 – 22 January 2017.

32. *Reports from the Year of the Monkey* – Emily Bates, Madelon Hooykaas & Saskia Janssen in the project space PuntWG Amsterdam, 30 April – 8 May 2016, curated by Emily Bates.

33. *Virtual Walls I* on 28 September 2017 at Archivio Emily Harvey, Venice; *Virtual Walls II* on 21 December 2017 at Oude Kerk (Old Church), Amsterdam; *Virtual Walls/Real Walls*, 14 May – 26 July 2018 at Threshold Arts Space at Perth Concert Hall, curated by Laura Leuzzi and Iliyana Nedkova. See *Read More*, issue 14 with articles by the curators on the work: https://www.horsecross.co.uk/media/2044/read-more-laura-leuzzi-and-iliyana-nedkova-on-madelon-hooykaas-issue-14-low-res.pdf

34. See endnote 11.

Chapter 6

Elaine Shemilt in-conversation with Sean Cubitt

This is a conversation which took place over a few cups of coffee, between Elaine Shemilt and Sean Cubitt, one sunny afternoon in London, on 21 March 2017.

Elaine Shemilt: I have an impression that a lot of women artists in the seventies had had a sort of 'run-in' before they used video, working with installation and performance prior – indeed some women incorporated the video into the performance itself, which is more or less how I used it. However, something occurred to me – it may just have been because it was the way that video was at that time – it was very low resolution – sort of grey-on-grey. At the time I started using video, I was also printmaking and was very particular about achieving a high-resolution photographic image. If I was working with photo-etching or photo litho in the printmaking studio, I was at pains to retain as much detail as possible to achieve a really crisp image, and yet when I used the video to perform in front of, it suited me to have this rather low-resolution quality. When we look at other women artists who were using video for their work at the same time, I wonder if that low quality was useful? I would be interested to hear what you think about that?

Sean Cubitt: I frequently refer to a William Wegman piece – the one where he's got the talking torso (sometimes referred to as *Untitled* or *Stomach Song,* 1970/1971) – to teach students that they don't need the top of the range camera; that they can make stuff with whatever they've got in their pockets. It's a bit of a con, because it's also about trying to persuade students that they don't need to use a RED Digital camera, but it's also the case that that piece is not do-able if you've got high resolution, because the gag doesn't work. His nipples don't look like eyes and the stomach doesn't look like a mouth, so it only works if it's – as the French say – *flou*: it's sort of soft and mushy. I was thinking when I was reading those notes of yours about Tamara Krikorian's *Vanitas* piece – because she's less recognisable in the low resolution and although there is quite a lot of detail in the *mise-en-scène,* it's also kind of murky, not to be too sententious about it, in a slightly 'old mastery'

kind of way – that allows the allegorical figure to function in a way that, if it had been in a more high-res, I don't think would have been possible, certainly not in the same way. When we first showed work from the Rewind Archive in public exhibitions, we got lots of students trying to emulate the reel-to-reel aesthetic because it has a charm, but it's partly for them and even for us – or maybe even more for us – a kind of period charm.

ES: With respect to that grey-on-grey low resolution, I'm interested now to look back at the political situation as it was then. When we were living and working during that period, it was simply a matter of getting by – doing our best to get the work shown and hoping for an equal position on a platform with our male counterparts, despite knowing that equality probably wasn't going to happen. Nevertheless, we did our best. There remained a situation where if you produced images that were too shocking, you could lose your job, or not get a job, or not get the exhibition, or not be included in this group or not get the funding. I suppose that worked both ways, but it seemed particularly so for women. I'm wondering – and I realise that this might sound far-fetched – but if you were going to stand up and film a naked image of yourself, it could be helpful for it not to be too clear. There was modesty involved, even though the reason I felt I needed to do that was to show vulnerability and to show that I would not deny that I was a woman – a 'take me as you see me' attitude. Does that make any sense?

SC: Yes, it does make sense. I remember being quite shocked a few years later in the mid-80s, seeing Jane Parker's early pieces and it was partly

because they were film and they were much sharper resolution. I guess she used 16mm and there was something much more shocking.

ES: I recall that I had access to 16mm and I used 16mm for my Undergraduate Degree show, but reverted back to video later.

SC: There are a number of things that I found really wonderful about video. One was the tactility – even when looking at DVD transfers from early TV. I've just been looking at the 1954 version of *1984* adapted by Nigel Kneale and produced by Rudolph Cartier – it's a classic dramatisation of the Orwell work, but one of the things that's really startling about it is how furry it is – I mean it has that kind of tactile quality. The other work that is relatively easy to get a hold of is *Quatermass* from about 1954. Some of it was in 16mm and some was recorded live to tape in the studio and it would have been 2-inch Ampex – higher resolution – but the version that we've got is telecine'd down for export, so it's lost a lot of the relatively high-res. and then it's gained a whole load of artefacts from being transferred to DVD – but it still has that sense that the blacks aren't terribly black, the highlights are often really highly lit because they pumped in enormous amounts of lighting to get sufficient contrast to transmit. The poor actors were sweltering doing these dramas live to camera. However, when you shot with available light which was typical of most video art – or at the very least, a couple of redheads or something, the quality of the image is far more grey-on-grey. The contrasts are much finer or rather, they are more fluid – they really are grey-on-grey. It has a couple of effects – one that Tony Sinden talked about –

you recall when he did the reconstruction of the diagonal piece[1] – he was sure that the blacks had been blacker (Fig. 1).

ES: I have that impression as well. I suspect we will never know.

SC: I think there are two possibilities. One is that he was using the original monitors so possibly the monitors had begun to lose some of their quality, and another possibility is that the tape signals don't read in quite the same way over their kind of their archival life. But the third is that we read grey as black.

ES: I suspect the latter is true.

SC: We knew it was meant to be black and therefore it was black in perceptual terms – so we made it be black.

ES: Even stranger – I didn't see *Doppelgänger* for many years and for some reason I remembered it in colour. Perhaps because in the intervening years, I became so used to seeing colour television.

SC: I think what shocked me about *Doppelgänger Redux* (Fig. 2) – the

remake in December 2016, was the colour.[2]

ES: It was shocking and also horrible to do because of the contemporary clarity of image. Looking at a 62 year-old face, as opposed to the face I had in my early twenties, that was tough. But of course, that was not what it was about. Remaking *Doppelgänger* created a bookend to the original. This version was really more of a performance. The quality of the original video could not be a part of that. What do you think about the current discussion about the (Sony) Video Portapak? The way we used video and the linking of it to the feminist movement? Is that something that is also far-fetched or do you think there is any validity in that argument?

SC: There were so many forms – there were things like Tina Keane's *In Our Hands, Greenham* (1984, Fig. 3), which were obviously campaigning – poetic, but campaigning pieces. Things like Catherine Elwes' *Kensington Gore* (1982) and the piece with the mon-

Fig. 1. Tony Sinden, *Behold Vertical Devices*, 1974, DCA, 2006. Courtesy of Danny Hill.

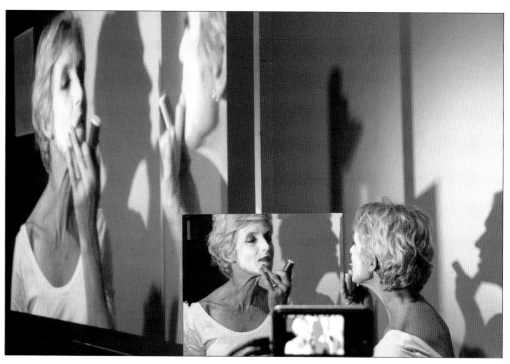

Fig. 2. Elaine Shemilt, *Doppelgänger Redux*, 2016, Nunnery Gallery, Bow Arts, London. Photo Courtesy of Orlando Myyxx.

keys, the pregnancy piece (*With Child*, 1984) – which are undoubtedly about feminist issues and they make clear addresses to that. It's almost incidental that Elwes appears in that video – there is autobiography only in the sense that it gives it authenticity, but it's not an autobiographical piece – it is far more about reproductive politics, but I think it's equally unfair to reduce it to autobiography as Rosalind Krauss did in her 'narcissism essay'.[3] As far as I remember, Krauss is mainly talking about male video auteurs, but if you were to apply that to women around the early to mid-seventies, I think it would be a serious blind spot on her part that the reaffirmation of a male ego is very different to the attempt to establish a female ego in a world where it basically wasn't a concept or a social practice. Also the production – in the ways that you were writing about with Laura Leuzzi[4] – is as much about deconstructing as it is about constructing, and I think that element is missing from Krauss' otherwise pioneering essay.

But also, the fact that the videoed woman's body is a body that is actually uncertain was one of the beauties of video; whilst it captured actuality, and you had the instant replay and performance potential of that, it also made clear the constructed-ness that you talk about. In that construction of 'beauty' and 'sexuality' and 'sexualisation' of the body, there are terms that are instantly applicable specifically to the female body in the way that Vito Acconci's body, for example, isn't sexualised – it's gendered, but not sexualised. So, there is something rather different that occurs in women's work that is really quite distinct, and relates to the tactility of the image.

ES: I think there is another element as well: the artists that we are talking about were all very young women. At

the age of about twenty or perhaps twenty-one it required quite a lot of determination to demand an equal platform. Most of my contemporaries at art college, in sculpture and print-making, were men. What the video camera offered – because it was new – was to be able to start on an equal footing with this technology. It also allowed for a certain degree of privacy and to produce images quickly; I could be much braver than if I were doing a series of photographs with a tripod. The initial videos led towards making installations that included a performative element, that took the form of photographs and video. I think it was the same for other women. I think it empowered us. I'm not sure if you would agree with that?

SC: Yes, I think you can see that in Cate's (Elwes) work, Tamara's (Krik-orian) work, and Tina's (Keane) early work.

ES: Yes, and in Sanja Iveković's work. It was also the case that you just had this little tape, which was convenient. I don't know how far to take that, but I do think that the medium empowered women. Of course, it wasn't just cre-ating an image, we were using sound as well and not least – movement. It was freedom that we were afforded. Every artist that used video had that, but I would argue that the ownership of creating moving imagery where a film crew was not required was par-ticularly liberating for women.

SC: One possible analogy might be with all the archaeological work that feminist critics have done on Nine-teenth Century women's oil painting. The vast majority of art being made by women in that period was water-col-our. Is it because it was a women's medium that water-colour was always

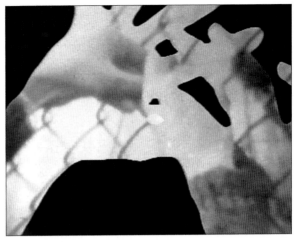

Fig. 3. Tina Keane, *In Our Hands,* *Greenham*, 1984, still from video. Courtesy of the artist.

an under-privileged, marginalised medium and still remains so to this day? Whereas, the more 'hairy-arsed' machismo of oils was the thing to aspire to. Artists like Cassatt and Morisot were rightly lauded of course for getting into that world, but I wonder if there isn't an analogy there to be made with film? It still is to a large degree, but certainly it was then, a pretty hairy-arsed, male-dominated, craft-based artisan medium where people knew how to use heavy indus-trialised equipment and stuff of that sort, whereas video was almost like the water-colour.

ES: I would agree with that for several reasons. Even the advertisement for the Sony Rover Portapak shows a woman wearing a mini-skirt and white boots carrying this camera like a sort of handbag (Fig. 4), which is a pretty off-putting image now, but the idea was that it was lightweight.[5] It was relatively easy to use and added to that there was the element of privacy. You didn't need a film crew. You didn't need men to help you with this thing. I had personally fought against that issue of 'you will do this type of work because you are a woman and less able'. I learned to weld etc., but it was

PORTABLE
VIDEOCORDER KIT

DVK-2400

Fig. 4. Sony Corporation, PR Material for USA and Europe market circa 1969.

always a case of having to prove myself, whereas working with video was different. I could concentrate on making the image, the artwork. The craft issue was a big issue.

SC: It's partly also that there was more gate-keeping available for oil painting in the 19th century and film in the 20th century – or even industrially produced television. There is a huge amount of gate-keeping that you can only get past if you have got a particular degree of experience and you are not going to get that institutional experience if the institution is entirely loaded against women; getting that 'handicapped' foot in the door – if they are going to get in, they are only going to get into certain grades, for example you can be a producer, but you can't direct. You can edit, but you can't operate a camera – that kind of thing. I was re-looking through some very early 80's stuff on community video and my memory of it was that community video had some kind of funding base. It was through library services, local government, educational outreach departments and things like that, but actually the account that I

was reading[6] was that this had been hotly fought for – even by about 1977/78 certainly into the eighties under Thatcher, in particular the BFI weren't interested and a number of other key agencies like the Arts Council in particular, were not interested in Community Video. The Arts Council struggled with some attempts to fund video art, but it was a long struggle and nobody wanted to archive it – as we know from the REWIND project.

ES: And do you think that was a good thing in the long run?

SC: I think we benefited from it in the sense that (the argument I made way back when we were putting in the application for REWIND) it had allowed video to be genuinely avant-garde, because it wasn't institu- tionalised.

ES: I agree with that. In the early seventies I was working in Winchester, not London. It was not where all the supportive groups and movements were taking place and yet my work was accepted for *The Video Show* in 1975 and the Acme Gallery in 1976 (Fig. 5). There did not seem to be a particular stigma attached to my being a woman working with video. I think because video was not mainstream, it was not institutionalised. It was disposable and had an avant-garde feel about it …

SC: One of interesting things about the Serpentine Show was the inclusion of Darcy Lange, which I hadn't realised until we got the floor plans, because although he was an auteur, there was also the sense that he was making Community Video. It would be quite recognisable to West London Media or Blackfriars Photography or any of those other groups in that world, as it did in the Fine Art world and of course it was the era of the

Artists Placement Group, so that video was able to move across a whole bundle of let's say, Post-Fluxus practices; and in many senses, practices that went the other side of art and became community activism, could quite happily be in dialogue with art. It was very unusual – it's hard to imagine anything, except possibly printmaking, having that kind of generic flexibility.

ES: Yes, it's true, but printmaking also tended to be considered as the poor relation to painting and sculpture. Looking back however, I think that the Printmaking department was quite a healthy environment in which to work – in those workshops we worked alongside other printmakers. I personally found it a natural progression to go between printmaking and video. That ability to work in black and white translated well. Are we coming full circle? I still think that if you are crossing these imagined borders, you are in the less favoured area – the 'no-man's' world.

SC: The 'no woman's' world.

ES: Yes, the 'no woman's' world – if you are working with a new medium, it's a new way of working. It may not necessarily be recognised by the Royal Academy or The Royal Scottish Academy, but that innovation also provides a certain sort of liberation.

SC: And I also think it's interesting, that by the late 60s/early 70s, there was that last wave of new painters coming up from the Royal College – Hockney and Kitaj. And then, frankly, I would think painting gradually slips into a sort of moribund state.

ES: I think so – although it still held on to its status.

SC: Absolutely, but, painting, as a place where you would go to find the

Fig. 5. Elaine Shemilt, *Constraint*, detail of installation, Acme Gallery, Covent Garden, London, 1976. Courtesy of the artist.

'new' in art, I think maybe that generation – Pop, post-Pop – are almost the last, and after that, there are no doubt individually great and fascinating painters, but as a form, it begins to lose its pre-eminence and that mantle passes more to sculpture. But sculpture at the same time, after the moment of minimalism, as it begins to move more towards conceptual, installation-based, performance-oriented forms, also opens itself up to the kind of performative work that you were doing. And that is also where part of the interest lies – this shifting of balance between the different art forms. In a sense video was able to operate as a sort of hinterland.

ES: I agree. I was aware of the Fluxus movement, the Happenings, also of Arte Povera and the desire to get away

from the sort of heavy monolithic-type sculptures that can be imposed. I wanted to be fleet-of-foot and to create things that could be dismantled and used again; which of course you could do with video. You could record over your last video artwork and use it again – which unfortunately, a lot of us women did, so now we don't have many of our early works. There was that kind of spirit. The value was in the idea and the passion that went into the artwork. It would be on show for a few weeks and then you collapsed everything down and used what you could recycle to create another artwork. It wasn't theatre, but it had aspects of theatre to it and there was a distinct lack of preciousness – it was all part of this new way of working. I certainly did not feel as though video was a medium that was supposed to stand the test of time. It was designed to be short-term and usually part of an installation. It would be in a gallery for a few weeks and then that it was it. I made a new body of work it was all transitory, short-lived. It's odd now to look back at the remaining videos with a precious attitude.

SC: Yes, but I think there were a number of other things going on. Thinking about Printmaking – one of the exciting things about Print was Tim Mara. His work so clearly comes out of Pop and the Underground, and that sort of poster imagery, album covers – so there was a sort of pop culture and then there was the Design world, and then there's this 'art practice'. They were actually surprisingly close to each other.

ES: They began to collide perhaps because of that ability to use photo reproduction. It was always a bit clunky and difficult, and then sud-

denly there was the possibility of putting light sensitive material onto the screens and printing fine detail. With that came the ability to get a better and better resolution and registration. It happened quite fast in the early 70s and then the detail improved rapidly as we adopted the polymers. We moved away from the difficulty of matching the photographic stencils and the problems of the *moiré* effect. Of course, once we were able to digitise things, all those registration problems were a thing of the past, but in the 70s it was a challenge and we had to find ways around it. I would agree with you that the barrier between Fine Art and Design once were immense, but Printmaking developments helped to break that barrier down.

ES: ...You couldn't edit (early video) – well, not very easily.

SC: Or if you did you couldn't guarantee a clean edit. You would just end up with travelling glitches and so on.

ES: Yes, and making copies was pretty difficult as well.

SC: So then there was this lovely thing about the ephemerality. On the one hand the difficulty of making multiples hampered distribution; the screenings tended to be event based rather than distribution based, but that also bounces back to that issue of the ephemeral nature of the tape. Very early on, I think 1982 or so, the London Video Arts office were talking about how the tapes were degenerating even at that point. They were really worried about where their ring mains were because they knew that their big U-matic boxes were going to get scarred and that the oxides were beginning to fall off. There was not only an archival issue (by the time that LVA had something like distribution), but

there was also the liberating sense that this is for now.

ES: Yes, but was that typical of the time anyway? I mean in the sense that we were breaking away and wanting to smash down constraints and the preciousness of art?

SC: Yes – or at least its claim that it was to be universal and forever. That Romantic or certainly Modernist idea that this was a permanent object was at its height with the minimalists, for example with LeWitt, who I think is probably the finest of the group and the least egotistical and yet the instructions said (implicitly) that the real work – the concept – remains as permanent and universal because, even more than Judd's physical boxes, the concept is always there and has this absolute, classical permanence, whereas everything else will eventually rot and yet we fight to preserve the 'two gross of broken statues'.[7]

ES: Well of course, in the late sixties Lucy Lippard had written the 'Deconstruction of the Art object'. What we haven't talked about yet is the similarity of showing these works on a monitor to television. You could imitate a kind of television situation rather than seeing film on a big screen. This TV effect was new and could be used as a device. We were used to watching newsreels about war, so artist created works influenced by newsreel documentations and then put them into galleries. People would walk towards the monitor, thinking they would have a typical television experience, but in fact what they would see was art. That possibility has changed now, because television is very different from what it was in the late seventies and early eighties.

SC: I can remember something that's really intriguing, again at South Hill Park, that first year when we got Barco (video) projectors and it was odd – some things worked very well, not necessarily because they were cinematic, because somehow the content carried the work, but sometimes you felt the actual loss of that bit of domestic furniture. It was partly the television. I should mention that video was an alternative to broadcasting. It was very much the way community video worked for example – having 'our' voice instead of 'their' voice – so there was also a lot of explicit critique of television, for example, with David Hall's work and interestingly with Mike Stubbs' or Dave Critchley's solo pieces the framing is very like television.

ES: Also, Kevin Atherton's work.

SC: Often the framing is very close, with the head and shoulders the crop is right at the top of the frame, where now you would put the face in the centre of a 3x3 grid, so the frame has shifted, but then it was using a televisual vocabulary. The other thing was that television was very much a domestic medium, so, by and large, in the seventies and into the early eighties the TV became commonplace and ubiquitous. It would be in the living room and it was a communal family object. It created a gathering together and they were ritual objects. There were fewer channels, therefore television tended to produce family events. Little, small, regular ones like 'Grandstand' or 'Steptoe and Son', and also more significant ones, like the Queen's Christmas broadcast or the Cup Final. It had a domestic family scale and was in itself interesting, because then the interventions were intriguing at the level of 'politics in the

living room', where for example, if you were watching 'Top of the Pops', you would be careful about what you said about the performers, because it was going to tell your parents about your sexuality. So, there was a caring and carefulness about it. The other thing was that television was the one place where men could wear make-up and the whole genre, partly because of very little lighting in the studios and stuff and I presume, male vanity just required a lot more make-up and it was entirely forgivable and condonable, and even in certain cases, came the great drag acts of the time such a Dick Emery and Danny la Rue.

ES: And with the medium of television, there was a kind of opening up, wasn't there? – a sort of gradual education that was going on.

SC: Well certainly about gay male sexuality and the drag scene opening up.

ES: So that was running alongside the increased platform for women do you agree?

SC: I think so, but it is also that 'the domestic' was also feminised: especially then, it was a strongly feminised domain. The public space was 'male' and the domestic space was 'maternal'. So, there was also a kind of struggle with that, so some of the anti-TV video as a critique of TV was about de-domesticating and making public...

ES: I agree. I think that's why putting a TV screen (basically a monitor) into an installation, into a gallery that was generally used for another type of work was quite avant-garde.

SC: I was thinking of Susan Hiller's explosion – the one in which she has the domestic furniture, the armchairs

and sofas.[8] There's a direct appeal to that domestic element and in her case something of an explosion in the reception of her work, but also a feminist explosion in the living room, which I think is really intriguing.

ES: Certainly. I think that's why I used the monitor in *Women Soldiers* in that way. I could easily have used a film that was projected, but it needed to have that particular feel to it – that this might have been something that would have come up on your television screen in your sitting room and 'how do you feel about that? Well – not very comfortable for various reasons'.

SC: There were a number of interventions of that sort. *'Twentieth Century Vixen'* had their film about Bomber Harris banned. It was one of several films and programmes about Bomber Harris which were banned. The subject matter was clearly too sensitive – the fire-bombing of Dresden was just too terrible. They were a feminist group making that piece, which was, in itself, intriguing. That is also part of what made television, television. It was in 1976 that John McGrath was delivering the keynote address at the Edinburgh TV festival during which he began to decry the lack of, or the loss of, the television 'event'.[9] So already by then it was diminishing – with the development of four channels I suppose.

ES: The television 'event' was very important – but it didn't last very long, did it? You mention work being banned. Images showing pubic hair/nudity and the use of war imagery in the same context was not acceptable in many galleries in the UK. Putting these images onto a television was doubly shocking in some respects, but occasionally possible if

the video was within an installation in a gallery.

SC: It was an era of defence or censorship. It was an era when you either defended free speech or supported censorship, with no complexity'.

ES: It seems extraordinary to think about now.

SC: Yes, the past is another country. So, there was one other thing that I wanted to talk about. You were mentioning that shared iconography between women was appearing in very discreet areas around Europe and for that matter, in the United States. Interestingly, although avant-garde film had its own difficulties in getting distributed, there were avenues, so people like Malcolm le Grice for example, were able to travel with films from the London Co-op to places like Colorado, to show the work and then bring rolls back to show in Camden Town. And there was also the link with the Viennese filmmaker Kurt Kren and with German artists, and so forth. Yet oddly, film started as a display medium rather than a distribution medium, and video in a certain sense begins as a distribution medium – particularly when Bing Crosby began investing in Ampex. So, Bing puts his money into it because he doesn't want to have to travel to every one-horse town in the States in order to do a live show on their TV's, he wants a recording that he can send them to be broadcast and invests in Ampex as a result. It's kind of tied into transmission, broadcast and distribution and yet oddly, it was far more difficult to move video around than it was to move film.[10]

ES: Was that because of the equipment?

SC: Partly because of equipment, but partly just because of technical constraints; because the French had SECAM, we had PAL, the Americans had NTSC colour standards (often made fun of as 'never twice the same colour').

ES: So, the technology was not generic in that sense?

SC: But even so, it was always possible to get them transferred. It was always possible to make things available; to get players into galleries that would play multi-formats, but what was odd – for whatever the reason – was that there was so little (international) distribution of video. Yet against that background, it's intriguing that some of the iconography that you used, would then reappear in Federica Marangoni's films and videos in Italy and, as you were previously saying in the work of artists in Croatia and so on. I wonder why?

ES: I don't know, but I think – and I'm just speculating here – we were all dealing with similar issues. We were of that generation where our parents – our mothers – expected that we would raise a family and be supported by a man and yet that model had kind of broken down. Women were receiving an education and they wanted to have their status recognised. I was determined to function as a woman and as an artist. I had children and I never stopped working as an artist. I think there were many women of my age who were determined if necessary to go it alone i.e. without a man to provide the finances. If you think about it, we were very concerned with maternity and our role as artists within society. How could you combine the natural function of being a mother and at the same time, work as an artist? You start by being brave enough to

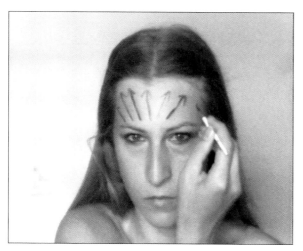

Figs. 6a-b. Sanja Iveković, Instrukcije br. 1 [Instructions No.1], 1976, stills from video. Courtesy of the artist.

agery. It's not surprising that if we were abstracting, we were abstracting to images that said the same sort of thing – like for example, two hands together, or say a distortion of the face, for example Annegret Soltau's work, or Sanja Iveković's, *Instrukcije br. 1* [Instructions No.1] (1976, Figs. 6a-b) and *Make Up – Make Down* (1976–78).

SC: On that thought – who were you imagining was your audience?

ES: Of course, I wanted my work to be seen, but I also recognised that what I was making was not a saleable commodity. It was a lonely road and I think that was the same for many, many women artists of my generation. Unfortunately, some artists fell by the wayside – they just couldn't keep going for whatever reason. It is very hard to raise children, make artwork and struggle to hold down your job in a hostile environment; but, that's the same of any group of people that are attempting to break through prejudice. So many marginalised groups of people really need to be treated with dignity and respect in order to flourish. It's tough.

SC: I guess I was thinking historically whether there was any kind of feminist or women's solidarity that was part of the exploration for the work?

ES: Well, I was inspired by Cal Arts and what was going on with the Woman's Movement in California: Judy Chicago and Helen Shapiro. I wasn't part of the London scene. I mean I exhibited in the ACME Gallery and I went into London to exhibit, but I sort of ducked in and out and didn't join those collectives or groups. Perhaps that was just a personal choice?

SC: A number of the artists were very clearly part of a group.

use these images that may not go down very well, but we were determined. For example, I am going to paint the linea nigra on my pregnant belly and I am going to photograph it. I'm going to talk about what it feels like to be pregnant. These are subjects and topics that were not discussed at that time, but were and are universal. It was still a new thing for a man to come into the maternity ward and to see a child being born in the 1970s. To talk about these things required a level of bravery, but women were emerging all over the place in Europe as individuals and so it's not surprising that we were using similar im-

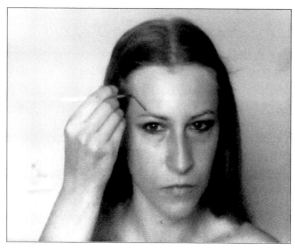

ES: Yes, artists such as Catherine Elwes and Tina Keane, they were part of a thriving group. When I talked to them, they describe a different experience. I think they felt empowered by that support. I didn't.

SC: I think that would be true of many women across Europe; there would be quite different experiences. Some would feel that they are with a group of artists regardless of gender, and some that there are collectives of women that give them support who are not all by any means working with video or indeed are even artists. Those different constellations are really intriguing. That root of taking maternity, domesticity as not only life, but also material for art, is another route and as you say, a particularly difficult one – and one that many young women artists were never able to continue. What might also be worth considering are questions about a certain kind of loneliness? That is also part of the construction of femininity as *sexualised other, the marginalised, professionally marginalised, and so forth; in the 70s and into the 80s, and its relation to real or imagined solidarities.* When I look closely at a work I always find it networks outwards into things that we have talked about, like technologies and social movements and psychology and personal stories.

ES: Perhaps that's why it's so very difficult to write and talk about work from this era. I thought I knew what a piece of work was about at the time, but with the passage of time I look back and see that it was also dealing with this, this, this and this. Some of it is no longer relevant today, but some of it is still very pertinent.

SC: I had a really interesting conversation the other day with some stu-dents. I was showing them *Au Hasard Balthazar*, the 1966 film directed by Robert Bresson, which is, as you know, about a donkey – a lovely film, but terribly sad. The students were asking about whether the film-maker's intention is really central, and how much respect they have to pay to that in their writing. So, I said that *Au Hasard* almost certainly wasn't thinking that in order to shoot his film, he had to use gelatin and that gelatin is made from boiled donkey. But, nonetheless, that's a tool for interpretation and you need to think that through. The other film we were looking at that day, just at random, was the animation called *Rango*, in which there is a story about water and the equivalent element to *Au Hasard*'s film is that it takes twenty thousand litres of water to make a batch of chips to make a render farm in order to make a film like *Rango,* a film which is itself about the loss of water in the landscape. There are ways in which films – well almost certainly Gore Verbinski who directed it was not thinking abou*t* – that and yet, it is a possible interpretation.

ES: Do you think that's why people now have an interest in video from the 70s and the 80s? I mean to say, it really was of its time. It would be completely inappropriate to make such a video now, wouldn't it?

SC: Yes, certainly, it isn't the same – because you make a video now and the next thing you do is press upload to Vimeo. So now video is – even more than it ever was – a product for a distribution medium and it's not actually a production medium as such. That's even more the case now than it was in the seventies and or early eighties, because now we have, as it were, conquered distribution; except that so

has everyone else and there are a bazillion hours of uploading done every five minutes, or whatever the statistic is. Now the problem is how to curate it and how to find the stuff; so it operates very, very differently. Contemporary art's use of video is a very different beast to video art from the seventies.

ES: We are very used to moving image now. We take photographs and film on our mobile phones. In those days, we couldn't.

SC: I think the equivalent would be to reconsider the domestic TV. A significant proportion of, certainly younger people's viewing, is done on hand-held devices and therefore, the relationship is more individual, because the distance is much closer. Physically, there is more intervention; I mean the touch-screens. So the possibilities for making work like that are very different. It's hand-held – it's that personal relationship to the screen.

ES: Also the ability to go back and check something if you missed it – now you can just flick back. And to scrutinise something – you can hone in and enlarge a part of the image.

SC: Well, actually that is something that could possibly be explored a bit. So, you were moving in from photography and printmaking into video and were using both static shots and photographs. There is something interesting there, on a formal level, between motion and fixed image, because a fixed image is different in a moving image environment, where it has a fixed duration; whereas if there is a photo on the wall, you can look at it for as long as you like, but you are told how long you are able to look at a still in a video.

ES: When I made the *Women Soldiers*

video in 1984, I was experimenting with the sound element. I hoped that the sound would give the feeling of movement to a series of still images, and I think that the reason I did that was because I was a printmaker.

SC: I think it's a natural thing for someone who is a printmaker using video, but there is something in there which is nagging at me. I haven't got anything to say about it, but it's not so much about *why,* it's more to do with the result.

ES: I don't know – I had all that video footage of the soldiers, so why did I not use it; why did I keep it as a series of still images? It was part of an installation, so I built a huge gun, like a first World War gun, half stuck in the mud and there was a life-sized photograph of myself in black, with my eyes blindfolded and my hands and ankles tied, leaning against a stained wall; in a similar the way that people were interrogated in the H Block in Belfast. That was very reminiscent of growing up in N. Ireland and the Civil War, euphemistically called The Troubles. This video was haunted by that experience and a real antipathy and genuine fear and hatred of civil war. The sound in the background running through the whole video was a recording from the gunfire and bombs in Beirut. A friend of mine had got caught up in the conflict. She escaped with her life by hiding in a cellar for several days before being evacuated out. She recorded this sound in Beirut. It sounded so like my memories of Northern Ireland. It didn't really matter that is was not recorded in Northern Ireland, because the sound was generic. It was for real, it was horrible – it was the sound of war. At first you wonder and then you

get it: that was the sound of bullets; that it was an explosion. Over these sounds there was a recording of an advertisement for women to join the army. I filmed much of the footage in a women's army training camp. It was quite light touch. It amused me that even in the circumstances of joining the army, a woman was expected to conform to the expectation of the male gaze and the male idea of how a woman should function; even if when required, the women had to put on a Nuke Suit or go into situations where she might be blown to bits. Hair must be tied back, skirts were encouraged, smart trousers, never jeans, this was training for war, what nonsense! The early eighties was a time when women were being allowed to be soldiers on the battlefield, but although they were being accepted into conflict zones to fight, women were still expected to be feminine. The *Women Soldiers* video was designed to be a pacifist statement; but as with any feminist statement it should also be seen in the broadest of contexts as a cry for fairness – for equality – decency.

SC: And of course, 1981 was the time of Greenham Common Peace Camp; and the Women's Peace Movement; then the Northern Ireland Peace Women coming forward around then; and the miner's wives and so on.

ES: Absolutely – there was a lot of fear around. We were frightened. We were nervous of Nuclear War. But there was also a feeling amongst women, which grew stronger and stronger – give us a chance and we could throw a protective blanket over things. 'Take the Toys from the Boys'.

SC: At that point, the Second Wave of feminism of the 70s had begun to attach itself to a whole bunch of social movements on a variety of accounts – peace movements and Trade Unionism etc.

ES: Yes, and I think women were getting together in a much more productive way. The early women's movements had, to a certain extent, a rather strong anti-male agenda, which I didn't identify with at all. By 1984 I had two children and I felt that there was a deeper issue. I think the movement transformed itself through a collective approach. What can we do collectively as women? Perhaps we can do something such as fight for peace? Perhaps we can fight for equality and decency where there is a particular need?

SC: That is really interesting, because what you are describing is a shift from a resistance and critique, towards a positive project, whatever the intellectual trajectories of the arguments, which were often richer and more complex, and were not just anti-patriarchal, but they were significantly *anti* as opposed *pro*. It does suggest that it is essentially about women's video rather than about necessarily feminism. In certain respects, it would relate as feminist, but it's something else as well. There are parts of *Doppelgänger* where I feel that I am watching aspects of the video as feminist – for example that painting of the mouth is so alien to men. The painted pout/bud is so much a part of the construction that it almost automatically reads now as an expression of the feminist refusal. There is a very potent, very moving scene in *Amy* – the film by Laura Mulvey and Peter Wollen – where she's making herself up in the mirror and it's a very similar shot, but differently placed inside the narrative. I find the film heart-break-

ing, which is rather different to your take in *Doppelgänger* where it's a more meticulous, more structural work.

ES: *Doppelgänger* started out as a series of prints. I put a mirror behind a large sheet of paper with a hole cut out so that I could photograph myself at such an angle that the reflection did not reveal the camera. The idea for the video grew around the theme – a woman feels the need to put on make-up to give herself courage to make herself more attractive, but of course if the woman has low self-esteem or has a mental illness she might paint herself into a much poorer version of herself. You can really distort your face – you can really mess yourself up with makeup. When I made the film, it became about people who are struggling. It became about those people who are bottom of the heap and their need to be recognised, and to be treated with dignity and respect. Throughout the film there is a recording of a psychiatrist who is disturbingly dogmatic and intolerant about the behaviour of a disturbed teenager who will not conform. Of course, it was also about my own feelings of inadequacy and vulnerability. About my fear of standing out there as an artist and not conforming, trying to make a statement; an honest interpretation of my inner world, which is why you occasionally get the images of the naked body. Just raw imagery, naked and exposed.

SC: Two thoughts – one is about the necessity of a performance, but in particular of being a woman, that it is required and is common to both of the tapes that we have been discussing to 'put your face on'.

ES: Yes, putting on a mask.

SC: Exactly, but it does make the rest of the 'repressions, oppressions, etc.' manageable, because there is a mask behind which there is or isn't something else and then the multiplications which – well they're kind of suggestions – are schizophrenic, both in the clinical sense, but also in a post-modernist sense.

ES: The double image.

SC: Yes, but the other thought that I was having is that on the one hand, this is a public statement and on the other hand, it is a personal and intimate statement. There is a wonderful thought in Adorno's[11] aesthetic theory which I go back to quite a lot where he says that philosophers, like scientists, have a kind of repertoire of tools that they can use in order to be objective about things, and we don't expect that from artists. So, one of the things that the philosophers, sociologists, etc. can tell you is that individuality is a social construct – it's fabricated in particular ways by history and culture and whatever. Nonetheless, it is a reality. It may be completely constructed, but it's a reality, and what we want from an artist is that they don't do what a philosopher does, which is to just eradicate their individuality and then use their objective tools of the trade, what you want the artist to do is to work precisely with their individuality as a kind of lens through which to bring everything else into focus.

ES: But of course, that means digging deep into our inner worlds.

End of conversation.

Endnotes

1. Tony Sinden, *Behold Vertical Devices*, 1974, 9-monitor installation with chair and step ladder.

2. Elaine Shemilt, *Doppelgänger Redux,* performed at *Visions in the Nunnery*, Nunnery Gallery, Bow Arts, London, October 2016. Curated by Laura Leuzzi and Adam Lockhart.

3. Rosalind Krauss, 'Video: The Aesthetics of Narcissism', *October*, v. 1, Spring, 1976, pp. 50–64.

4. Laura Leuzzi, Elaine Shemilt and Stephen Partridge, 'Body, Sign and Double: A Parallel Analysis of Elaine Shemilt's *Doppelgänger*, Federica Marangoni's *The Box of Life* and Sanja Iveković's *Instructions N°1* and *Make up – Make down*', in Valentino Catricalá (ed.), *Media Art: Towards a new definition of arts* (Pistoia: Gli Ori, 2015), pp. 97–103.

5. Sony AV-3400 Video Rover, 1969 (USA version), 1970 UK version.

6. Heinz Nigg and Graham Wade, *Community Media – Community Communication in the UK: Video, Local TV, Film and Photography* (Zurich: Regenbogen Verlag, 1980).

7. Ezra Pound, *Hugh Selwyn Mauberley*, Section V, 1920.

8. Susan Hiller, *Belshazzar's Feast, the Writing on Your Wall*, 1983–84, installed in the Tate Gallery, 1985.

9. Edinburgh International Television Festival 1976, *James MacTaggart Memorial Lecture*, John McGrath, Dramatist and director, founder of the 7:84 Theatre Company.

10. The Ampex Corporation (USA), developed the first commercial Video Tape Recorder for broadcast quality with its VR-100 -0 a 2-inch Quadruplex videotape recorder in 1956. In March 1957, Ampex won an Emmy award for the invention of the Video Tape Recorder (VTR).

11. Theodor W. Adorno, *Aesthetic Theory*, edited by Gretel Adorno and Rolf Tiedemann, Trans. Robert Hullot-Kentor (London: Athlone Press, 1997).

Chapter 7

Concretising the illogical: Immaterial Identities in Early Women's Video Art

Emile Josef Shemilt

I think a lot of what we call logic and rationality is a male-focused, male-invented code. So-called logic is often insanely illogical, but it's still called logic because it works within its own system. Like Formalist or Minimalist art is popularly supposed to be logical because it looks like it should be, while work with a more obvious psychological basis is called illogical.[1]
Lucy Lippard

Writing for Studio International in 1974, the American critic, Lucy Lippard, called for a re-appropriation of the way artworks were exhibited and contextualised. Like many foundational arguments in 1970s' second-wave feminist visual theory, Lippard's writing echoed a concern that women's artworks and their insights were often inadequately defined. Having already begun to express her theories with her curated exhibition *Eccentric Abstraction* in 1966, (which included the work of women artists Eva Hesse and Louise Bourgeois), Lippard's writing in the early 1970s spoke against a perceived gender bias in art criticism where women's artwork would often be dismissed as 'illogical' and/or 'psychological'. Pointing to the exclusion of women's more overtly personal works within the critical discussions of the time, Lippard attempted to expose this as a latent form of misogyny; stating that 'before the [women's] movement, women were denying their identity, trying to be neutral, and intentionally making art that couldn't be called "feminine"'.[2]

Writing later in 1980 for *Art Journal*, Lippard adopted a more unsubdued position. In describing modernist tendencies as becoming 'increasingly mechanical' in their pursuit of 'art about art', Lippard proposed that the resulting greater visibility of more emotionally-based work at the turn of the 1980s, was evidence of the significant impact that feminism had been making on art over the previous decade. Although acknowledging that many male artists would also claim to have created personal work during that period, Lippard

defended her position by stating that the feminist intervention was far 'too complex, subversive and fundamentally *political*' to be described as simply adding more emotional or autobiographical content to otherwise material-focused artworks.[3] When citing the use of domestic imagery in art in the 1950s and 1960s, Lippard had argued that women 'work[ed] from such imagery because it [was] there, because it is what they [knew] best, because they [couldn't] escape it' and that 'probably more than most artists, women make art to escape, to overwhelm, to transform daily realities'.[4] When male artists later adopted household imagery and developed Pop Art, Lippard described it as men 'moving into woman's domain and pillag[ing] without impunity'.[5] The resulting critical celebration of Pop Art (and its mostly male artists) as being revolutionary, was, for Lippard, simply another example of the underlying misogyny within art criticism, which continued to neglect the complexity of what women artists had been dealing with in their work, especially when exploring their own domestic environs.

For many second-wave feminists, the argument that 'the personal is political' had become fundamental in articulating the complex ideas with which women artists were dealing. Often attributed to Carol Hanisch after her 1969 essay by the same name, the phrase was used as a reactionary argument for exposing oppressive social structures that women regularly face in their everyday lives. Taking the term 'political' in terms of power relationships, the argument is (still) used to highlight how women's personal issues such as sex, appearance, housework and childcare, for exam-

ple, are equally significant when addressing women's societal suppressions, as are the more prominent arguments relating to unequal pay and abortion. When Lippard refers to the complexity of domestic imagery in women's art, she describes it in terms of their attempts to claim ownership and 'concretise the fantasies and suppressions' that they would regularly experience day to day.[6] Conducting a separate conversation with the art historian Linda Nochlin (first published in 1975), Lippard posed the question, '*what is female imagery?*' to which Nochlin expressed her frustration at what she felt was a constrictive term:

> I'm human, undefined by preconceptions, an androgynous being that isn't slated to give birth to any particular imagery. But my second reaction is to try and think it through. I do live in a society, and who I am is determined by the structure of experience a woman is supposed to have. My experience is filtered through a complex interaction between me and the expectations that the world has of me.[7]

The female, more autobiographical work that Lippard describes as being 'illogical' or 'psychological', in this sense can be understood to reflect the creative tension that exists in the artist's attempt to 'escape/overwhelm/transform her daily realities'.[8] This attempt is set in tension because there is also a disheartening sensation that (as yet) women have never fully managed to escape these realities. The artistic process of *attempting* to concretise (and deal with) one's suppression, on an emotional and intellectual level, reflects a poignancy that this process may be a constant, lifelong struggle.

When revisiting the emergence of video technology in the 1960s and its fruition as a critical art form in the 1970s and 1980s, it is possible to perceive similar patterns in how Video Art was originally discussed, particularly in terms of it being a 'logical' art-from. Likewise, there is capacity to argue that women's Video Art – especially when displaying the levels of complexity that Lippard was describing – was also generally overlooked (or at least misunderstood) at the time. For example, from a European perspective, especially amid the early British canon, a modernist ideology of medium specificity had been prominent in the pursuits of electronic media throughout the early years. David Hall – a leading proponent of video art in Britain during the 1970s – sought to define it as an autonomous practice, by distinguishing what he felt could be determined as 'Video Art' from what he believed were 'artists using video'. Hall stated that: 'Video Art is video *as* the art work', meaning that the specific characteristics of video technology should form the criterion for the basis of the work. This would be distinct, as Hall argued, from artwork using video for 'an already defined content' – something that could otherwise be realised through a different medium. For Hall, video's technological characteristics formed an extensive list, 'including those peculiar to the functions (and malfunctions) of the constituent hardware-camera, recorder and monitor' as well as:

> [...] the manipulation of record and playback 'loop' configurations; immediate visual and audio regeneration; the relative lack of image resolution; signal distortion; frame-instability – often purposefully in-

duced by mis- aligning vertical and horizontal frame locks; random visual noise; camera 'beam', 'target' focus; vidicon tube; and so on.[9]

To this end, Lippard's observation that modernist art was becoming 'increasingly mechanical' seems almost literally justified in its criticism. For Hall, however, refining the concept of Video Art was the culmination of a steady progression in a branch of modernism that had already engaged with an 'essential dematerialisation' of the object and had also developed significantly beyond the concerns of Greenbergian art and theory. Although Hall often promoted women's video art, (particularly the work of Tamara Krikorian, for example), such artworks, nevertheless, fell predominantly within his specified area of focus. Netherlands-based artists Madelon Hooykaas and Elsa Stansfield, for example, could be said to have adopted similar theories to Hall when creating artworks like *Horizontal Flow* (1977).

Using the specific character of the horizontal scan lines, which formed the video image on the cathode ray tube monitors of the time, *Horizontal Flow* is an artwork that makes reference to both how the image is technologically created and also how it is visually experienced. Inspired in part by minimalism, conceptualism and the optical line paintings of artists such as Bridget Riley, the artwork uses these scan-lines to play with illusions of movement. Exhibited as an installation for five identical monitors, the work is presented with the monitors aligned side-by-side in a semi-circle. On each screen is a different view of the same horizon line

(taken from a 360-degree pan of South Gare breakwater, Teeside, in the North-East of England). When the screens are viewed collectively within the installation, the horizon line appears continuous, and connected across all five screens. Having originally shot the 360-degree pan on two videotapes, Hooykaas and Stansfield reworked the tapes, duplicating them and slowing down the image until they created five pans, each lasting fifteen minutes. Each time the image was slowed down and re-recorded, the horizontal scan lines that structure the video image became more and more visibly discernible. At which point, these technological specificities began to mirror the original, recorded horizon line. Displayed on the five monitors, the panning horizon gradually flows through each screen at an extremely slow rate. Meanwhile, the visible scan lines remind the viewer of the mechanisms behind the image, as the electron beam rapidly moves from left to right across the sensor, generating fifty horizontal lines, twenty-five times per second.

Building upon the fundamental concerns of minimalism, where an artwork occupies the same space as its viewer, *Horizontal Flow* adds to this space a sense of movement. The artifice of cinema (in this case video technology) and the illusion of connected movement in the spaces between each monitor, are set in tension with the physical reality of the aligned monitors and the body of the viewer. For Hooykaas and Stansfield, this meant that their work chimed closely with the concerns in defining Video Art as a new art-form, as expressed in the writings of David Hall. Despite, being among the few acknowledged pio-

neers of early European video art to be women, Hooykaas and Stansfield did not consider their work (at that time), to be feminist. As Hooykaas explained, being part of a feminist argument was a separate concern:

> We weren't part of any specific feminist group, and there weren't specific feminist groups in the Netherlands that were working with artists. There were, of course, feminist groups working against political attempts to stop abortion and things like that […] but we didn't have any contact with Feminist groups at all in those days. We weren't aware of that and we weren't part of that… [Our work] was far more to do with the medium, which we wanted to get accepted, than what were in those days, feminists issues. The advantage of video was that there hadn't been a history yet. So we were starting to work with a new medium. Unlike the heavy things like painting or sculpture, in that way it was very new. I wasn't comparing if it was a male person or a female person making the work. It was more the content of the work and how it was shown, so [feminism] wasn't particularly the issue.[10]

While second-wave feminism and the concerns of early video art were concurrent issues, there was arguably some justification for maintaining a distinction. Whether it was a deliberate resistance or whether it was – as Lippard implied – another form unconscious misogyny, one may still argue the necessity for early video artists to define the art-form's aesthetic and conceptual basis out-with political and societal concerns. Nevertheless, a shift away from these me-

dium specific pursuits did occur, and it became more apparent in the 1980s. From a British point of view, David Hall retrospectively put this down to the rise of Thatcherite policies in the UK. 'Independent Commercial Enterprise' opportunities, for example, were established by British commercial television companies as a means of supporting creative practice. According to Hall, commissioners required their applicants to 'justify political and institutional viability', which encouraged a shift in creative focus.[11] Recognising that there was a concurrent and significant evolution in 'semiotic, psychoanalytic and gender theory',[12] Hall wrote of how such theories were adopted with great enthusiasm by artists seeking funding from commissioning bodies, which in his opinion paved a path for the postmodern period in moving image art.

The generally accepted rationale for the rejection of the medium specific practice was that for the next wave of artists, the practice had become too narrowly focused. As had happened with the emergence of Pop Art in the 1960s, artists had turned to popular culture. By the 1980s, the technology had significantly developed, and colour video cameras were commercially available, as had early motion graphics systems such as Quantel's *Paintbox*. Coupled with the emergence of cheap electronic music synthesisers, artists had a near-revolutionary sense of access to previously, exclusive production facilities. In a post-punk era, artists' references were no longer towards a modernist idealism, and their inspiration came in the forms of independent television productions, music videos and computer games. The problem for David

Hall however, occurred when the first histories of video art also began to appear during that period, and he argued that 'many showed signs of devising alternative readings of that past' and/or attempted to 'set original intentions against later theoretical debate, probably in an effort to accommodate current concerns'.[13] David Hall expressed his frustration at how theorists would also 'oversimplify, distort and ultimately misrepresent'[14] the concerns of early video art practice:

> Primarily then, my contention is with the use of Video Art as a generalised label for a great deal of artwork involving video technology to whatever ends […] Too often, enthusiastic writers have mistakenly constructed notions of a related endeavour on the presumption that simply the use of the technology presents a common factor of some ideological, conceptual or aesthetic significance.[15]

However, despite Hall's concern for an accurate analysis of medium specific Video Art, it is nonetheless worth questioning his point of view that the very use of the technology was, by comparison, ideologically insignificant. In sympathy with Lippard's reasoning that women's artworks featuring household objects were overshadowed by the impact of Pop Art, Hall's assertion appears to demonstrate a similar oversight in recognising women's use of video in a climate of otherwise male-dominated art forms. While arguing that the personal is political, second-wave feminism had focused debate around women's experience in the face of established, suppressive social structures. The fact that video was a new medium, without a designated (male-domi-

nated) history, meant that video could be an art-form that was, at least, gender-neutral. As to emotional or auto-biographical works emerging despite the modernisms of medium specificity, a more subtle point can be drawn out from the differentiation between Lippard's description of 'logical' and 'illogical' artworks. Where Lippard argues in her text, that 'a lot of what we call logic and rationality is a male focused, male invented code', she makes the point that the term 'illogical' is prejudicial, and as a result, she observes that it is often necessary to justify its use:

> When I write that something is illogical in art, and I like it, I have to add "marvellously illogical" or it will be seen as a put-down. Not so with logic, which I often think is "merely logical".[16]

If one finds oneself in agreement with Lippard's perception that 'Formalist or Minimalist art is popularly supposed to be logical because it looks like it should be', then perhaps the same can be said of medium specific Video Art as defined by David Hall. Whether or not Hall's theories, which appeared to reject more personal themes, were born from a general culture of latent misogyny is unclear. Certainly from Hall's personal perspective however, this would be a misreading of his intentions. Nevertheless, the circumstances were concurrent with a feminist reaction in a manner that sought to shed light on the notion of 'illogical, psychological' artworks.

As is conventional in academic discourse, by relating psychoanalytic stages of identification to feminist visual theory, it is plausible to perceive patterns in how ideas of woman and womanhood have been (mis)represented. Amid the general canon of feminist visual theory, John Berger's *Ways of Seeing* (1972), articulates conventional ideas that have caused tensions in a woman's social condition as both the surveyed (by men) and also the surveyor of her own physical state. Writing that 'Men look at women. Women watch themselves being looked at', Berger points to the conventional, determining relations between a woman and herself: 'The surveyor of woman in herself is male: the surveyed female. Thus she turns herself into an object – and most particularly an object of vision: a sight'.[17] Describing how this idea became exploited, Laura Mulvey's *Visual Pleasure and Narrative Cinema* (1975) exposed the systematic misogyny in the conventions of narrative (Hollywood) cinema. Observing how women are often depicted as to satisfy man's fantasies, Mulvey states that, 'unchallenged, mainstream film coded the erotic into the language of the dominant patriarchal order'.[18] Stating her intent to attack 'the satisfaction and reinforcement of the [male] ego that represent the high point of film history', Mulvey aimed to challenge these conventional cinematic languages by exposing the subliminal, misogynist prejudice, which are among the many external influences that shape a person's psychological conditioning. The more complex aspect of Mulvey's text, which discusses Freud's theory of castration anxiety, (the subconscious fear that men supposedly develop during infancy when visually confronted with anatomical sexual difference, leading them to a lifelong state of anxiety, which is typically elevated

by suppressing women), argues how typical-Hollywood narrative cinema had become a manifestation of this anxiety, (i.e. depicting women to be conquered by the male ego). Therefore, the visual pleasure a man takes from cinema, is when he observes these acts of suppression being reinforced.

As a way of discussing how these canonical ideas have been explored by women artists, some insight may be expounded from Slavoj Žižek's *The Reality of the Virtual* (2004).[19] Reversing the phrasing of 'virtual reality' – something that is more commonly associated with a computer-generated, artificial experience – Žižek describes, philosophically, how people regularly create and experience 'real virtualities' as a method of structuring their daily lives. Rooting his framework within the Lacanian psychoanalytic theories of the *'imaginary'*, the *'symbolic'* and the *'real'*, Žižek describes these 'real virtualities' through example scenarios of day-to-day existence.

With the 'imaginary', for example, Žižek describes how people regularly create 'virtual images' of each other when choosing to selectively exclude particular details, such as bodily functions, from an imaginary, 'virtual' image of another person. As Žižek explains, one knows that another person defecates and sweats, but in choosing to ignore those aspects, the mental image that a person constructs of another person is not real. It is instead a 'virtual' image. Similarly, with the 'symbolic', Žižek points to authority figures and symbols, and sets out a context whereby systems function because of a perception of power that is not enacted upon, but remains virtual. One of his examples

is democracy, with which Žižek argues that individuals collectively adhere to democratic rules, even though individually perhaps, one may not always believe it to be a successful system. Nevertheless, individual people follow democratic rules because they buy into a belief that society as a whole has collective faith in its success. For Žižek, this symbolic reality also has to remain virtual, otherwise an actuality of no-one behaving by the rules, would destroy the structures that we depend upon. With the third topic, 'the real', Žižek turns these systems of virtuality onto the self. We all carry our own forms of prejudice and insecurity which pervert or regulate our personal perceptions of reality. Understanding 'the real' is about recognising these unconscious influences. For Žižek, these 'virtualities' are an essential part of our existence, and so are a part of our reality. If one loses the virtualities that structure our experience, we would essentially lose our comprehension of reality.

Relating these ideas to artistic practice can go some way to exploring the idea of what Lippard was debating with regard to a female image. For second-wave feminists, challenging the stifling conventions, (such as those articulated by Berger and Mulvey among others), was fundamental. For some women artists these challenges were fought head-on, by reclaiming the conventional image of women as traditionally portrayed in the visual arts. In canonical art criticism, artists such as Judy Chicago, and her work *The Dinner Party* (1979, Fig. 1), are among the more typically referenced when discussing the reimagining of female depiction. In these cases, the works embellish vaginal

imagery and make decorative reference to menstruation as aspects of womanhood, which they argue should no longer be something hidden and excluded from the 'surveyed' female. In this regard, artworks like these are subversive of the established male gaze, and are representative of how Žižek's 'imaginary virtual' is revealed. Yet because of this, they also represent a 'psychological' form of tension. Attempting to claim ownership over the way a woman is viewed is, of course, impossible – much in the same way that a politicised attempt to control another person's perspective, can only ever be limited to an endeavour to influence.

Connecting these notions to women's video art, some insight can be revealed by comparing two works that are similar in appearance. The first is David Hall's *This is a Video Monitor* (1973) and the second is Pipilotti Rist's *I'm Not the Girl who Misses Much* (1986). With Hall's *This is a Video Monitor*, the work is presented as a monitor displaying a video image of a woman's face looking directly into camera, so as to appear to be addressing the viewer directly. The woman delivers a monologue, which appears to describe the conditions of video image's presentation:

> This is a video monitor, which is a box. The shell is of wood, metal or plastic. On one side, most likely the one you are looking at, there is a large rectangular opening. This opening is filled with a curved glass surface, which is emitting light. The light, passing through the glass surface, fades in intensity over that surface from dark to light and in a variety of shades of grey. These

form shapes, which often appear as images. In this case, the image of a woman. But it is not a woman.[20]

The video image then cuts to black, before the image of the woman reappears and repeats the same monologue. This time however, both the video image and the emitting sound have notably deteriorated. The cycle repeats several times and each time, the image and sound appear significantly less stable, until finally only a monotone cloud and warped sound are produced. In Pipilotti Rist's *I'm Not the Girl who Misses Much*, the work is similarly composed of a (colour) video image of a woman, although she only sparingly addresses the camera. Shot in a mid-frame, the woman, appearing in a dark dress with her breasts exposed, performs a kind of frenetic dance while repeatedly chanting/singing the opening line to The Beatles song, *Happiness is a Warm Gun* (1968). The line, 'She's Not the Girl Who Misses Much', is changed to '*I'm* not the girl Who Misses Much'. As with Hall's *This is not a Video Monitor*, the image in Rist's work cuts, and then repeats, each time deteriorating. Yet in Rist's work, the image is also sped up and slowed down, alternating the rhythm of her singing, and adding to the frenetic nature of the performance.

The creative tension in both artworks deals with the way in which we experience reality. However, they address this tension from different perspectives. It is by contrasting these approaches, that one may explain the difference between Lippard's 'logical' versus 'illogical' observation. Hall's approach is to tackle the tension be-

Fig. 1. Judy Chicago, *The Dinner Party*, 1979, mixed media, 36 in. x 576 in. x 576 in., © Judy Chicago. ARS, NY and DACS/Artimage, London 2018. Photo: © Donald Woodman.

tween reality and the virtual, by specifically addressing the way video technology, electronically artifices a virtual image. On face value, this impersonal, pared-down, minimalist artwork seems 'logical' – which Lippard may critique as 'merely logical' – because it tells us something that we already know: that the image 'is not a woman'. However, from a deeper perspective, we understand that the work is much more complex than this. Its essential basis is to express the ongoing tensions between our material existence and our imaginary existence, which regulate our every day lives. We know it is not a woman, but we nonetheless continue to, and indeed find it hard not to, identify the image as a woman. It is a pattern of human behaviour that we are constantly dealing with, between our intellectual ambitions and our often uncontrollable emotional, reactions.

With regard to Pipilotti Rist's *I'm Not the Girl Who Misses Much*, the same message is at play, except from a more personal point of view. In this work, the woman's face is obscured, and it is unclear as to whether Rist perceives the performer as herself or as a proxy. Yet, we are viewing her and the work suggests that she is aware of being viewed. Rist's exposed breasts imply her sexualisation through the male-gaze, yet perhaps her post-production obscuring and deterioration of the image, embody her personal

tension in being perceived this way. The attempt to materially interfere with and deteriorate the virtual dancing image of the self represents the attempt to concretise and deal with this external, virtual social structure that women deal with in their everyday lives. This is extended further when considering the title of, and repeated chant within, the work. 'I'm not the girl who misses much' can be interpreted as a person's internal attempt to convince themself that they are in control of their own existence. Yet, controlling our psychological selves and controlling our material selves are unrealistic ambitions. So, the limitations in Rist's desire to 'escape', 'transform' or 'overwhelm' her daily realities are exposed. In this sense, the aspiration of the artwork, and its title, can be judged in Lippardian terms as 'marvelously illogical'.

Endnotes

1. Lucy Lippard, 'Six' (1974), in *From the Centre: Feminists Essays on Women's Art* (New York: E.P. Dutton Publications, 1976), p. 93.

2. *Ibidem*, p. 89.

3. Lucy Lippard, 'Sweeping Exchanges: The Contribution of Feminism to the Art of the 1970s' in *Art Journal*, Fall/Winter 1980, pp. 362–365, p. 362 for the quote, the italics is the original.

4. Lucy Lippard, 'Household Images in Art' (1973), in Id., *From the Centre*, p. 56.

5. *Ibidem*.

6. Lippard, 'Household Images in Art', p. 57.

7. Linda Nochlin in Lucy Lippard, 'What is Female Imagery?' (1975), in *From the Centre: Feminists Essays on Women's Art* (New York: E.P. Dutton Publications, 1976), p.80.

8. Lucy Lippard, 'Household Images in Art' (1973), in Id., *From the Centre*, p. 56.

9. David Hall, 'Using Video and Video Art: Some Notes', *Aspects Magazine*, Winter 1978, http://www.rewind.ac.uk/documents/David%20Hall/DH103.pdf

10. 'Interview with Madelon Hooykaas by Laura Leuzzi' 2016, EWVA European Women's Video Art.

11. David Hall, 'Early Video Art: A Look at a Controversial History' (1991) in J. Knight (ed.), *Diverse Practices: A Critical Reader on British Video Art* (New Barnet: Arts Council of England and John Libbey, 1996), pp. 71–80, p. 73 for the quote.

12. *Ibidem*, p. 73.

13. *Ibidem*.

14. *Ibidem*.

15. Hall, 'Using Video and Video Art: Some Notes'.

16. Lucy Lippard, 'Six' (1974), in Id., *From the Centre*, p. 93.

17. John Berger 'Ways of Seeing' (1972) extract in Amelia Jones (ed.), *The Feminism and Cultural Reader* (London: Routledge, 2010), pp. 49–52, p. 38.

18. Laura Mulvey, 'Visual Pleasure and Narrative Cinema' (1975) extract in Jones, *The Feminism and Cultural Reader*, p. 63.

19. Slavoj Žižek 'The Reality of the Virtual', DVD directed by Ben Wright (Olive Films, 2004).

20. David Hall, *This is a Video Monitor* (1973).

Chapter 8

Without a trace … ?

Stephen Partridge

In our research for three consecutive projects – REWIND, REWIND *Italia*, and EWVA – the work produced by women artists has offered the greatest challenge in terms of both discovery and recovery. In the first REWIND book I wrote:

> Because of the performative approach taken by the artists with much of the early work it means that many have been 'lost'. The works were ephemeral, un-recordable as discrete material artworks, and often not intended to even be repeated. The REWIND collection can only represent these early approaches by proxy (and then only within the collected ephemera on the database). This has also led to an unintended consequence within the project as a whole, with men disproportionately represented in the collection. This can be explained by the possibility that although both men and women artists of the period shared an antipathy towards the art market and the commoditisation of art objects, the men were much more cautious at discarding elements or fragments of their works. Even if the videotape was lost, some other piece of ephemera remains to support their position in the 'canon'. Many of the women artists stayed rigidly true to their principles and

the works are lost – 'without a trace'.[1]

A prime motivation for undertaking the EWVA research was recognition of this issue, and a gradual understanding that traces often did in fact exist. The challenge then became, how to best represent these works in any meaningful way through documentation, recovery or re-enactment.[2]

In one of Marina Abramović's first performances at the Edinburgh Festival in 1973,[3] Abramović performed kneeling on white paper on the floor of the space (Fig. 1), with 20 assorted knives, jabbing between the fingers of her outstretched palm. Her stabbing rhythm was recorded on a tape recorder and used as a cue for a second repeat action:

> *Rhythm 10*, in which the sound of the initial performance with knife blades stabbing sequentially in the spaces between fingers and thumb is recorded, and serves as a template of a repeat performance, which seeks to replicate the first performance endemically, including the mistakes and woundings, and all of my early performance pieces were called rhythms and the existence of sound or the presence of silence was extremely important.[4]

Figs. 1a-b. Marina Abramović, first performance of *Rhythm 10, Eight Yugoslav Artists*, Edinburgh Festival, Stewart's Melville College, Edinburgh, 19 August 1973. Courtesy of the Demarco European Art Foundation and Demarco Digital Archive, University of Dundee.

The video documentation is now lost, but photographs taken at the time by the gallerist Richard Demarco allow us a reasonable sense of the work.[5] A video fragment of a later work *Hot/Cold* (1975, Figs. 2a-b), also performed in Edinburgh[6] was recovered by the REWIND Lab in 2015.[7] In this work, Abramović sits at a trestle table upon which is a large block of ice (approx. 1m x 2m x 0.2m). Suspended above her is a large electric heater. Abramović presses her hand onto the ice as long as she can, before the cold forces her to withdraw with an exclamation of pain. She repeats this action during this durational performance.

As an artist duo, Marina Abramović and Ulay (active together until 1988) also deserve mention despite the gender mix they represent. Although best known as performance artists, they produced a large number of video works, sometimes more as registrations or documentation of their performances, but often specifically

made for the camera, many of them serving to develop their interest in endurance and duration such as *Light/Dark* (1977), *Breathing In, Breathing Out* (1977), *Relation in Time* (1977), *AAA-AAA* (1978) and one of their most iconic works, *Rest/Energy* (1980), where they balanced each other, inclining backwards on opposite sides of a drawn bow and arrow, with the arrow pointed at Abramović's heart. Some of these works still exists as fragments in video form and photographic form.[8]

> I was not in charge. In *Rest Energy* we actually held an arrow on the weight of our bodies, and the arrow is pointed right into my heart. We had two small microphones near our hearts, so we could hear our heartbeats. As our performance was progressing, heartbeats were becoming more and more intense, and though it lasted just four minutes and ten seconds, I'm telling you, for me it was forever. It was a performance about the complete and total trust.[9]

Ephemeral

The use of video, either as 'live' (closed circuit TV or video) or a recorded videotape playback within a performance or multimedia event, was an approach that was very prevalent in the early years of video art, particularly for women, many of whom did not consider these works to be video art *per se*. It should be understood that the term 'installation' was not in use until the early 1970s – artists used terms such as *mixed media*, *multimedia*, *performance* or simply *event*, (although rarely the Allan Kaprow inspired '*Happening*'[10]).

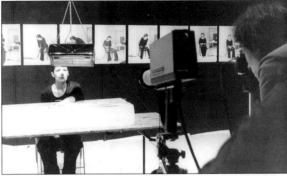

These variously termed works derived not from the theatre, but from sculpture and painting and therefore frequently referenced traditional art forms and media. Many artists saw video as a useful extension of their existing practice and media. By the mid 1970s, artists, critics and audiences alike, often confused performance art with video art. Whatever label was employed by the artist, they often involved a number of elements, some

Figs. 2a-b. Marina Abramović, *Hot/Cold*, Aspects '75, The Fruitmarket Gallery, Edinburgh, 1975. Courtesy of the Demarco European Art Foundation and Demarco Digital Archive, University of Dundee.

of which were ephemeral and temporary, and not likely to be retained. If the video element was a closed circuit video system, this means that it was unlikely that a videotape recording was made of the live feed and therefore only drawings/sketches for the work or photographs and registrations (video recordings) of the presented work would be left – as traces. Sometimes there are no traces left at all: an early performance which involved video was Susan Hiller's *Pray (Prayer)*, a three-hour long work for ten participants exhibited at the Serpentine in 1969. Hiller's exhibition/retrospective, *An Entertainment* at Tate in 2011 contained only a passing reference to the work in the catalogue; no documentation or image is in the public domain.

The ambivalence towards defining the art form as one thing or another is described succinctly by Rose Garrard:

> [...] having originally been seen myself or regarded myself as a painter, and then being made to do sculpture at college, and then going into what I saw as four dimensions by using time-based media – my work then moved through each of the what I would call core disciplines of each of those things very deliberately, and then out beyond into performance. So you might get one work that was three dimensional or a sculpture, definable as that, that led to a video or a painting or an object that was hardly definable as sculpture, and then eventually that would lead me into some sort of linkage where they would become an installation, and then I would perform within the installation.[11]

Many women artists were attracted to the instant playback property of this new medium, allowing experimentation in real-time as opposed to film, which had to be exposed, sent off for processing and then projected within any work envisaged. As a medium, film was also technically more challenging and often required at least a basic crew and separate sound recording and subsequent re-synching. The intrinsic property of video of instant playback or live relay, was referred to again and again as process rather than material, and was exploited by many women artists. For example, VALIE EXPORT produced a number of works including *Seeing Space and Hearing Space* (1973/74)[12] and *Inversion-circle-line* (1975); the latter, interestingly described as a both a video mobile and a sculpture, used a live camera feed of a black ball which was rotated by a machine a horizontal orbit. This image went to each of the four monitors successively, producing in effect, a linear movement across the screens. This work played with both the sculptural concerns of space and the intrinsic properties of the (new) medium.[13] A later work by Giny Vos, *Giovanni Arnolfini and his Young Wife* (1984) employed a reproduction of the famous painting by Jan Van Eyck: instead of the image of the painter in the mirror in the back of the painting, the audience saw themselves through a CCTV monitor cut into the mirror.[14]

Recurring Motifs

Recurring motifs occurred repeatedly with personal and original variation across Europe and North America stemming, naturally, from the

woman's perspective: such as using a glass mirror contrasted with the video monitor as a mirror; a *mise-en-scène* of the artist applying make-up to her face; the use of the artists' body, and mother and child vignettes. Tina Keane's work in the 1970s exemplifies both the ephemeral approach to media – combining slide, audio, performance and (later) film and video – and the themes and motifs explored by women artists. Her *Clapping Songs* (1979) was a projection of slides with sound.[15] Keane later developed this sound-work into a video/performance, *Clapping Songs* (1981). The work was part of a series of works (*The Swing*, 1978; and *Playpen*, 1979) which used children's songs and games, and was described by Guy Brett as:

> A struggle from the start to make visible and surpass restrictive classifications, beginning with those imposed on women. Her work is really a long series of metaphors for the existence of constraints and the possibilities of freedom.[16]

The work shows the actions of two girls made while singing traditional playground clapping songs. The songs are amusing, but can be perceived as an ironic observation of a woman's life from the cradle to the grave as they reflect the morbidity and black humour of the nursery rhyme.

Tamara Krikorian's *Vanitas* (1977) is a fine example of the use of video and the mirror. She said:

> *Vanitas* came after seeing a French painting attributed to Nicolas Tournier at the Ashmolean Museum, Oxford, An Allegory of Justice and Vanity. *Vanitas* is a self-portrait of the artist and at the same time an allegory of the ephemeral nature of television.[17]

In this work Krikorian combines the image of a well-known BBC news reader reflected in a mirror with that of her head and shoulders. A *memento mori* tableau of personal objects completes the scene perhaps referring to the transience of earthy goods and the ephemeral nature of the medium. Elaine Shemilt combined the use of the mirror with the application of make-up in *Doppelgänger* (1979–81), made in the same year as Marion Urch's *The Fascinating Art of the Ritual Feast* (1979, Fig. 3). Both feature the image of a young woman applying make-up with a voice over. In *Doppelgänger* a male voice is double tracked speaking about psychoanalysis, and in Urch's work the voice-over describes a series of facts about cosmetics and cooking recipes. Shemilt applies the make-up to her alter-image in the mirror – eventually producing the doppelgänger on the mirror's surface, while Urch makes up her own face as the screen is overlaid with magazine images of idealised feminine beauty as jig-saw fragments. Both works offer reflection and commentary (beyond the obvious soundtracks), on the female condition and the gaze of the camera-as-mirror.

Many British video artists were influenced by avant-garde film theory, particularly Laura Mulvey's writing and films. By taking up the video camera they found themselves in a double struggle. Another UK artist, Catherine Elwes in conversation with Chris Meigh-Andrews said:

> […] having abandoned the history of art, you took on the history of film. You were suddenly doing battle

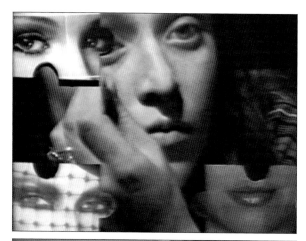

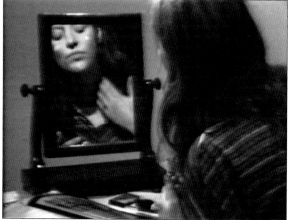

Figs. 3a-b.
Marion Urch, *The Fascinating Art of the Ritual Feast*, 1979, still from video.
Courtesy of the artist.

treated slow, rhythmic breathing. Her catalogue notes state, 'I tie us together with transparent gauze bandages. We are in any case inseparably joined'.[20] Rosenbach started making performances in the late 1960s and soon adopted video as a recording and documentation device (*Five Point Star*, 1974) and works specifically made for the medium (*Begegnungen mit Ewa und Adam* [Encounters with Eve and Adam], 1984). She proclaimed her work as a feminist perspective and experimented with using her body as a medium of expression. *Tanz um einen Baum* [Dance Around a Tree] (1979) performed outside at the Sydney Biennial falls into the registration mode of video (termed *dokumentation einer videoaktion* in the tiles) and documents a ritualistic set of movements, influenced by her stay in Australia and the Aboriginal culture.

The Body

Perhaps understated in art theory and art history literature, is the extraordinary bravery of women artists using their own bodies in their artworks. The female body, so often the subject of the male gaze, was now used expressively by the artist – and on her own terms. This often provoked hostility and derision when nakedness or erotic reference were deployed, as the imagery did not accord with the conventions of the female form, naked, clad or semi-clad. Yoko Ono stunned audiences with her *Cut Piece* in 1964 (performed and videotaped on July 20, 1964 at Yamaichi Concert Hall, Kyoto), where she sat on a stage and allowed people to cut clothing from her. In an interview with the BBC in

with the history of film and television. It's a different set of problems, but just as difficult a set of problems. The things that Laura Mulvey talked about – and the gaze of the camera,[18] whether it was possible to appropriate the gaze, and what you needed to do. How you convinced your audience that it was a female sensibility that was being expressed.[19]

A further recurring motif was the artist and child. Ulrike Rosenbach's *Einwicklung mit Julia* [Introducing Julia] (1973, Fig. 4) shows a naked child seated on the artist's lap, who is slowly wrapping a long bandage around both her and the child's upper torso. The soundtrack is of heavily

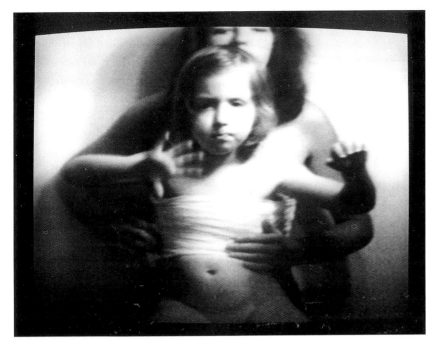

Fig. 4. Ulrike
Rosenbach,
*Einwicklung mit
Julia* [Introducing
Julia], 1973, still
from video.
Courtesy of the
artist.

2012 when she showed the original work opposite a 2003 re-enactment on the other-side of the Serpentine Gallery walls she said, 'I was expressing about how women are treated, as well as how we can survive it by allowing people to do what they want to do, there was [sic] many levels of message in that […]'.[21]

In *Art & Feminism* (2001), Helena Reckitt wrote:

> Ono presented a situation in which the viewer was implicated in the potentially aggressive act of unveiling the female body, which served historically as one such 'neutral' and anonymous subject for art. Emphasising the reciprocal way in which viewers and subjects become objects of each other, *Cut Piece* also demonstrates how viewing without responsibility has the potential to harm or even destroy the object of perception.[22]

Annegret Soltau's work, *Schwanger-sein* [Being Pregnant] (1979/81) is even more disturbing in its depiction of a cleaver on the stomach of a naked and pregnant woman, (that of the artist), with the soundtrack featuring a baby's rapid heartbeat. Soltau stated that: 'In this video, I show the psychic condition of a woman during pregnancy. My own body is seen as conditioned by time, i.e. vivid and variable, but also vulnerable and volatile.[23] There was a degree of hostility aimed at the artist at the time it was broadcast by TV (Hessischer Rundfunk) in February 1980:

> The viewers responded with letters or phone calls, some reactions were approving, mostly, however, I was blamed for the 'negative' presentation […] The pregnant body in arts was considered too intimate and embarrassing, especially if it was used by a woman artist as an embodiment of herself. Critics of well-known periodicals refused to write reviews or rather they wrote scathing reports.[24]

Fig. 5. Annegret Soltau, *Selbst* [Self], 1975–76. Courtesy of the artist.

A more general statement from her underlines the mood of many women at the time and points out the hostility towards this approach:

> [...] in 1975 I decided to work with performance (actions), photo and video. Since then I worked by myself and with my changing body, so I became more vulnerable; I exposed myself, and this resulted in fierce criticism of my work and thus I became marginalised. That happened to women artists opposing the norm, women who no longer wanted to work traditionally and looked for other forms of expression and techniques. The slogan 'The personal is political' became an important concern of women in arts and literature.[25]

Shemilt and Soltau illustrate well the common motifs and ways of using their bodies within their works, which was prevalent during the period. They both used extensions and bindings to their faces and bodies in mixed-media works that have striking similarities, although neither knew each other's work at the time of making. Shemilt produced a series of works where her body was bound by various materials within a performance featuring mixed media installation and performance at the Acme Gallery, Covent Garden, London (*Constraint*, 1976). Soltau made a series of performative works which now exist only as photomontages entitled *Selbst* [Self] (1975–76, Fig. 5), in which she overstitched grey silk thread over an image of her face which had been previously bound by the thread. Similarly, Rebecca Horn produced a whole series of body extensions/modifications to her head, fingers and arms in her series *Exercises in Nine Parts* (1974–75) which were recorded on film, and her most beautiful work *Einhorn* [Unicorn] (1972, Fig. 6),[26] which involved her walking through a wheat field wearing a body-suit with a very large horn projecting vertically from the headpiece, bound to her head and torso with straps, reminiscent of Frida Kahlo's painting, *The Broken Column* (1944).

A leading European exponent of an uncompromising use of her own body was Waltraud Lehner, who changed her name to VALIE EXPORT after a brand of well-known Austrian cigarettes. In a 1972 manifesto she wrote:

> So far art has been largely produced by men, and it has usually been men who dealt with the subjects of life, the problems of emotional life, and contributed only their statements, their answers, their so-

lutions. Now we must articulate our statements and create new concepts that correspond to our sensitivity and our wishes [...] The question of what women can give to art and what art can give to women can be answered like this: transferring the specific situation of woman into the artistic context establishes signs and signals that are new artistic forms of expression that serve to change the historical understanding of women as well.[27]

An early video work was *Sehtext: Fingergedicht* [*Visual text: Fingered*] (1968–71), which is described in the titles as *Körperaktionen* [Body Action], where she performs to the camera in a mid-shot of head and shoulders gesturing a series of finger actions. Her most successful and provocative works were performance-based, including *Action Pants: Genital Panic* (1969) where she walked through a cinema with the material cut out from around her crotch and from this she produced a series of photographs and prints/posters featuring her seated in the eponymous pants/jeans. *Touch Cinema* (1968), is a documentation of VALIE EXPORT's famous street performance, in which the public was invited to touch her breasts housed inside a curtained box attached to the artist's upper torso.[28] The work is a witty and confrontational comment on the objectification of women's bodies. In 1970 she produced a video-work *Split Reality,* where her image appeared on a monitor on a stand above a gramophone record player. The spectator is invited to play the record on the turntable, but the sound is disabled and instead the sound heard is that of EXPORT singing *a cappella* and therefore interven-

ing in the expected reality of the situation. Also in 1970, her work *Touching, Body Poem* involved four video monitors arranged two on top of two to create a 2 x 2 grid. Images of the bottoms of feet walking appear on the screens, 'touching' the virtual surface of the glass.

Later in the 1980s, the Dutch artist Lydia Schouten also used herself as the subject, actor and provocateur in a series of video performance works where she playfully and visually commented on women's expected roles and the portrayal of women as sex objects. In *Romeo is Bleeding* (1982, Fig. 7), she combines short performed vignettes with highly colourful graphic background sets, reminiscent of comic books. Schouten takes on the mantle of the man's role, wrapped in fur skin she has a spear fight with a

Fig. 6. Rebecca Horn, *Einhorn* [Unicorn], 1970–72 © Rebecca Horn / DACS. Courtesy of the artist and Sean Kelly, New York.

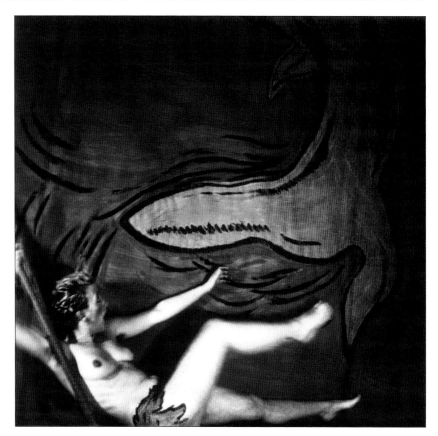

Fig. 7. Lydia Schouten, *Romeo is Bleeding*, 1982, still from video. Courtesy of the artist.

similarly dressed man, and dressed as a Hollywood gangster she pulls the trigger of her gun. In the unusual *tour-de-force* video work, there is a repeating image of a map of the world appearing between scenes, setting up the sequences, and indicating international travel. According to a text written at the time, the artist/performer [...]

> fulfills a variety of roles in a setting reflecting both comic-strip decors and primitive surroundings. Links are made with cultures of Africa, South America and Australia and the production makes clear, using both parody and seriousness that adventure and power are not male privileges.[29]

The majority of early women's video works involving the body tended to be performative and single-channel works. An exception was Friederike Pezold's four-monitor video skulptur[30] *Die neue leibhaftige Zeichensprache nach den Gesetzen von Anatomie, Geometrie und Kinetik*, [The New Bodily Sign Language Following the Laws of Anatomy, Geometry and Kinetics] (1973–1976). The four monitors are arranged in a tower and from the top show successive images of eyes then mouth then breasts, and at the bottom, the crotch of a woman (the artist herself). Each of the female zones are presented as dark graphic shapes against her white-painted skin and creates what she termed as '[....] a kind of Japanese aesthetic. The female body language becomes a sign language'.[31] The images are not still, there is slow

movement in each, and there is no sound, encouraging the viewer to concentrate on the slight changes of posture. 'Even the tiniest movement of my navel is more exciting than any crime story'.[32]

Pezold confirms her approach to video – that was also voiced by many others – was an attraction to the degree of control she could exercise:

> I was pleased to realise [...] that I could stand in front of AND behind the camera at the same time (something I could never do with film). That freed me once and for all of the old dilemma: she = nude model, and he = painter, or she as the merchandise of the production [...] Through the simultaneous re-

cording and playing back, I could also be in the present, past, and future at the same time. I gained a new sense of time. Instead of looking through the lens of a camera, now I looked at the large surface of the TV monitor's screen. All at once, I saw everything as if through a magnifying glass [...] That was how I rediscovered the body and all its regions – and invented a new body language.[33]

Researching the work of these early pioneers has revealed a rich resource of remarkable insights and expression. This chapter has only discussed a small sample.

Endnotes

1. Stephen Partridge, 'Artists' Television: Interruptions-Interventions', in Stephen Partridge and Sean Cubitt (eds.), *REWIND | British Artists' Video in the 1970s & 1980s* (New Barnet: John Libbey Publishing, 2012), p. 87.

2. A number of the artists interviewed for the REWIND and EWVA research projects confirmed that their early work was lost or not migrated to current formats: Anna Valeria Borsari, Marisa González, Antonie Frank Grahamsdaughter, Marikki Hakola, Madelon Hooykaas, Susan Hiller, Lis Rhodes and Elaine Shemilt.

3. *Eight Yugoslav Artists,* Richard Demarco Gallery, Edinburgh, 1973.

4. Marina Abramović, Kevin Henderson and Alan Woods, 'Marina Abramović, Objects Performance Video Sound', *Transcript*, v. 1, n. 3 (Dundee: DJCAD/University of Dundee, 1994).

5. Demarco Digital Archive – http://www.demarco-archive.ac.uk/collections/356-rhythm_10 (accessed 18 November 2017).

6. *Aspects '75,* Fruitmarket Gallery, Edinburgh, 29 September – 25 October 1975. Organised by the Richard Demarco Gallery, in association with the City Art Galleries, Zagreb. See http://www.demarco-archive.ac.uk/collections/397-hotcold (accessed 18 November 2017).

7. Later acquired by the Scottish Museum of Modern Art, Edinburgh, as part of the Demarco Archive.

8. *Relation in Time,* video published 26 November 2010. https://www.youtube.com/watch?v=1sRSoGAc3H0 (accessed 18 November 2017); *Marina Abramović & Ulay – The Other: Rest Energy, 11 January 2014, available at* https://www.youtube.com/watch?v=QcaaVZrUC44 (accessed 13 October 2017).

9. Catalogue for the Abramović Retrospective, *Marina Abramović: The Artist is Present*, at Garage Centre for Contemporary Culture, Moscow (Moscow: Garage Centre for Contemporary Culture, 2011).

10. A notable exception being Marta Minujín, the Argentinian artist who created a number of *Happenings* throughout the 1960s, including a television event *Cabalgata* [Cavalcade] which was transmitted live from the television studios of Channel 7 in Buenos Aires: several horses 'painted' mattresses with buckets of paint tied to their tails, while a group of athletes popped balloons and two rock musicians were wrapped up in adhesive tape.

11. 'Interview with Rose Garrard by Maggie Warwick, 29 April 2008', *Rewind | Artists' Video in the 70s & 80s* Archive. http://uodwebservices.co.uk/documents/Rose%20Garrard/RG510.pdf p.1.

12. Also exhibited as a videotape with a slightly different title *Space Hearing and Space Seeing* in *The Video Show*, Serpentine Gallery, London, 1975.

13. Re-enacted in the exhibition *VALIE EXPORT: Time and Countertime* (17 October 2010 – 30 January 2011), LENTOS Kunstmuseum Linz, Austria.

14. Re-installed in the exhibition *The Time is Right for …*, Summerhall, Edinburgh, 3 August – 24 September 2017, curated by Laura Leuzzi and Adam Lockhart.

15. Presented at Audio Arts, Riverside Studios, London, 1979.

16. Guy Brett, *Carnival of Perception: Selected Writings on Art* (London: Institute of International Visual Arts, 2004), p. 221.

17. https://lux.org.uk/work/vanitas (accessed 1 August 2017).

18. Laura Mulvey, 'Visual Pleasure and Narrative Cinema', *Screen*, 16:3, 1 October 1975, pp. 6–18, available online at https://doi.org/10.1093/screen/16.3.6 (accessed 18 November 2017).

19. Chris Meigh-Andrews, *A History of Video Art, The Development of Form and Function* (Oxford/New York: Berg, 2006), pp. 85–86.

20. http://www.medienkunstnetz.de/works/einwicklung-mit-julia/ (accessed 13 October 2017).

21. BBC Media Show, 3 August 2012. http://www.bbc.co.uk/news/world-radio-and-tv-18959341 (accessed 22 April 2017).

22. Helena Reckitt (ed.), *Art and Feminism* (London: Phaidon Press, 2001), p. 60.

23. The video is available at https://vimeo.com/44659203 (accessed 5 October 2017).

24. 'Interview with Annegret Soltau by Laura Leuzzi', available at http://www.ewva.ac.uk/assets/asoltau_interview_eng.pdf (accessed 18 November 2017).

25. *Ibidem*.

26. First exhibited at *documenta 5*, Kassel, Germany, 1972.

27. VALIE EXPORT, 'Women, Art: A Manifesto',1972, reproduced in Kristine Stiles and Peter Selz (eds.), *Theories and Documents of Contemporary Art* (California: University of California Press, 1996), 2nd revised and expanded edition (7 September 2012).

28. Re-enacted (without acknowledgment) by Swiss performance artist Milo Moiré as *Mirror Box* – with performances in Dusseldorf, London, and Amsterdam – the London manifestation resulted in her arrest in 2016.

29. The video is available at http://www.lydiaschouten.com/txt/vi82_E_romeo_intro.html (accessed 5 October 2017).

30. A term coined by the German scholar and curator Wulf Herzogenrath, for his book, *Video Skulptur in Deutschalnd Seit 1963* (Bonn: IFA, Institut für Auslandsbeziehungen, 1994), and employed for his major exhibition in Köln in 1989, Video – Skulptur retrospektiv und aktuell: 1963–1989.

31. Friederike Pezold, 'Amokläufen mit dem wadelbeisser', in *Videokunst in Deutschland 1963–1982*, in Wulf Herzogenrath (ed.), *Video Skulptur in Deutschalnd Seit 1963*.

32. *Ibidem*.

33. 'Pezold, F., and Stoscheck, J. 1973–77 | Die Neu Leibhaftige Zeichensprache', in Rudolph Freiling, Wulf Herzogenrath (eds.), *40YEARSOFVIDEOART.DE, Digital Heritage: Video Art in Germany from 1963 to the Present* (Berlin: Hatje Cantz Verlag, 2006), p. 138.

With Child: Motherhood and women's video in the 1980s

Catherine Elwes

The endless, unrecognised work of motherhood.[1]

I n his book, *Enemies of Promise* (1948), the literary critic Cyril Connolly enumerated all the impediments in life that threaten to prevent the aspiring writer from realising his full potential. While the lures of journalism, hedonism and politics were to be avoided all costs, no life choice was so destructive to a man's ambitions as parenthood. As Connolly famously declared, 'there is no more sombre enemy of good art than the pram in the hall'.[2] If becoming a father put the brakes on a man's career, how much more devastating to a woman artist's productivity was motherhood given that she was likely to take on the lion's share of the childcare? Unsurprisingly, Connolly did not address this issue, but today his sentiments are echoed in the words of Fulvia Carnevale of the artist collective Claire Fontaine who denounces the sexual division of labour in parenting and describes the maternal woman as 'an enamoured slave'.[3] Marina Abramović concurs, recently confiding to the German newspaper *Tagesspiegel* that children would have been 'a disaster for my work'.[4]

In spite of the dire predictions of Connolly and the more recent disaffirmation of motherhood voiced by Abramović and Carnevale, women artists have always borne, and continue to bear children and, quite frequently explore their relationships with their children in their work. This began in the nineteenth and early twentieth centuries when artists such as Mary Cassatt, Henrietta Ward and Berthe Morisot, and the pioneering photographer Julia Margaret Cameron, turned to their children as models and muses for creative inspiration. While these women were breaking into a predominantly male world of art, they, nonetheless, conformed to what was considered appropriate subject matter for 'lady painters' – domestic scenes populated by children, flowers, animals and servants, and as Linda Nochlin pointed out, women were frequently encouraged to dabble in 'the "minor" and less highly regarded fields of portraiture, genre, landscape, or still life'.[5] Once the first manifestations of modern feminism had taken hold in the 1960s, the undiscovered territory of female experi-

ence was liberated from its muted, marginal position and instated as a politically and aesthetically legitimate theme of art. The film theorist and filmmaker Laura Mulvey remembers the early days of the women's movement when 'there was an urgent need to focus on the question of the mother because of the impossibility of extricating the social, economic and the everyday from the mythic [...] and representational conceptualisations of the maternal'.[6] A woman's role in procreation, both the negative and the positive, came under scrutiny. The essentialist configuration of a woman's biological function that under Patriarchy destined mothers for segregation in the private sphere was systematically analysed and exposed. At the same time, the profound physical and emotional experience of motherhood, its richness and complexity was explored, celebrated and endowed with new cultural value. In the United Kingdom, the early work in film, performance and photography of artists such as Susan Hiller, Shirley Cameron and Mary Kelly made the first strides in this radical redefinition of femininity, unsettling the mutually exclusive terms of 'mother' and 'artist'. As Mulvey observed, Kelly, famous for exhibiting her son's soiled nappies, brought 'motherhood, with all the deeply traumatic emotion and unrecognised elements involved, into the kind of examination it desperately need[ed]'.[17] By the 1970s the (pro)creative process of bringing a child into the world had become enmeshed with the business of making art.

In this short essay, I will discuss the impact of motherhood on my own life and work in the early 1980s and explore how other videomakers of my generation addressed the profound changes that were unleashed as they created new life and, in the context of an emergent feminist art movement, how the work they produced fundamentally challenged the category of the maternal and the dominant modes of femininity it embodied. 'Women', asserted the painter Jacqueline Morreau, instigated a 'revolutionary change in thinking about who could speak and who could be heard'.[8]

Post-card (1986) by Catherine Elwes; the social reality

I will begin by sketching in some biographical details. By 1983, when I shot the footage for what became *Post-card* (Fig.1), I had retreated from London where my life had been dominated by my involvement in the women artists' movement. In the capital, I had belonged to two separate artists' collectives and for about three years I was immersed in the development of *Women's Images of Men* and *About Time*, two shows of women's art that I co-curated at the Institute of Contemporary Art (ICA) in London.[9] Between 1978 and 1980, this involved a campaign to flush out those women whose work remained unseen and undervalued, and to convince a major gallery to stage the exhibitions that would showcase the hidden talent we had discovered. The shows had enormous impact with the public, *Women's Images of Men* breaking all attendance records at ICA. I then rode the waves of our success in London taking a selection of the work from both exhibitions on tour. When it came to the live work and the installations

that we presented in *About Time*, we realised that if we failed to write these events into history they would disappear from view. So, I launched a new career as an art writer and critic. Into the 1980s I relocated to Oxford and continued to write, but when my son, Bruno was born, my world was turned upside down. Instead of compiling funding applications, calling meetings and making art, I found my energies and emotions were almost entirely focused on a small human creature whose continued survival was entirely my responsibility (or so I believed). While I was swept away in a wave of unrestrained, irrational love for a squalling infant who seemed to have been conjured out of the air, my husband went out to work and supported us financially, for a while at least. I know that not all women collapse under the weight of motherhood, and indeed I was lucky to have childcare in place in the first three years and that allowed me to continue with my work – up to a point. However, for me, the sleeplessness, the incessant demands on my attention and the physical work that was involved in looking after a small baby meant that I found it increasingly difficult to maintain many of the commitments that marked out my previous life in London. I resigned from a seven-year membership of the steering group at London Video Arts, an artist-run organisation that distributed my work and I also relinquished my position on the film and video panel at the Arts Council, after a four-year term. Instead, I began to teach, no more than one or two days a week, teaching posts being hard to find then, as now.

The rest of the time, I attempted to trace a viable path between the

Fig. 1. Catherine Elwes, *Post-card*, 1986, still from video. Courtesy of the artist.

needs of my son, writing, and my own practice, which continued to evolve thanks in part to the support of Bruno's father, John and a grant from the Arts Council that enabled me to purchase the Holy Grail: a series 5 U-matic edit suite and camera. I also secured a substantial (that is, substantial in those days) Channel 4 commission that kept my work afloat for about four years. Paradoxically, this period of domestic constraint proved surprisingly productive in terms of my video output and it was during this time that I developed a working method that cohered the many formal, political and conceptual problems with which I had been battling during my years in London.

All this biographical detail is designed to sketch in the background to *Post-card*, which was commissioned by London Video Arts and exhibited at the AIR gallery as part of a show on the theme of video post-cards. My own video rehearsed an aspect of motherhood around which I experienced feelings of failure and shame. Rosemary Betterton has confided the embarrassment that overcame her

when admitting to a colleague that she was writing a book about maternity and the maternal body. Her discomfiture, she said, related to 'the un-representable in our attachments to the maternal body'.[10] In my case, shame arose from my inability to cope with the part of me that had split off post-partum into the pre-lingual infant, screaming its nameless distress. The image of the crying child in *Postcard* represented an impassioned plea to my mother, who lived too far away to help, and who would not have helped in any case, her own interest in her grandchildren beginning only when they reached the age of civilised conversation. Having little hope of a response, my post-card was a confession of my ineptness as a mother; it was a gesture of despair. I isolated one particularly baffling phenomenon to illustrate the whole catalogue of mysteries that bewilder the novice carer of a newborn. I could not understand what drove an apparently loved and well-nurtured infant to cry incessantly. There is a myth that says, by some natural wisdom ingested with their own mother's milk, new mothers can distinguish between an infant's cries for food, for comfort and for the relief of pain. To me, all Bruno's crying sounded the same and my failure to decipher the code of his anguished vocalisations left me utterly distraught. It happened every day when I changed his clothes, and so could be predicted to occur with bleak regularity. I decided to make his piteous weeping the focus of the work. I positioned the camera at infant level, foreshortened his body in sharp perspective like Mantegna's *Dead Christ* (c. 1490) so that Bruno's face would not be in shot, only the top of

his head and his flailing limbs. This was not to spare the audience, but to counter an accusation that was once levelled at me at a screening of my work at the Royal College of Art, namely that I had shifted from exploiting my own body to exploiting that of my son. I wanted to emphasise that the tape was about me, not about the boy, who clearly could not speak for himself. By means of this anonymised framing, and a concentration on my hands and arms engaged in the activity of trying to dress the baby, I hoped to create not only a self-portrait of the artist as a new mother, but also a generic image of motherhood at a particular moment of crisis when the reality, as opposed to the fantasy of motherhood strikes home. This was the moment of realisation expressed by the character Clare Wald in Patrick Flanery's novel *Absolution* when she comes to the conclusion that 'investing oneself in the institution of family is always about the partial annihilation of the self …'.[11] It is the moment when the scales fall from a new mother's eyes and 'maternal ambiguity' sets in. This tangled emotion is characterised by Rozsika Parker as 'a dynamic experience of conflict between love and hate'.[12]

Intimations of that ambivalence were threaded through *With Child* (1983, Figs. 2a-b-c), an earlier video based on the anxieties that I had about impending motherhood during my pregnancy. Andy Lipman wrote that the work explored 'the boredom and murderousness, which occupy [the expectant mother's] mind […] framed by the rhythm and *longueur* of anticipation'.[13] Once all the waiting was over and my romanticised preconceptions of what it might be like to

have a child were drowned in sore nipples, butchered genitals and the mental collapse that comes from sleep deprivation, my measured postcard to my mother was something of an understatement. Looking back on it now, I might be tempted to explain my distress with a retrospective diagnosis of post-natal depression (PND) – I certainly experienced many of its symptoms. However, I would argue that those symptoms, as they are currently enumerated on the NHS website, constitute entirely rational responses to the birth of a child and should not be attributed to individual pathology.[14] For example, the NHS lists tiredness and the inability to sleep as sure signs of PND, but in my view, being kept awake all night for months on end is more or less guaranteed to result in what they euphemistically describe as 'fatigue'.

Guilt is another symptom, they say, which is hardly surprising given the way the media in general and advertising in particular portray motherhood. Young mothers are painted as miraculous beings who effortlessly raise perfect children while still managing to be goddesses in the bedroom and Mary Berry in the kitchen. Not surprisingly, most ordinary mortals aspiring to these idealised images of motherhood are condemned to abject failure and guilt. As Annabel Crabb wrote in *The Wife Drought* (2014), 'the obligation that evolves for working mothers, in particular, is a very precise one; the feeling that one ought to work as if one did not have children, while raising one's children as if one did not have a job. To do any less feels like failing at both'.[15] Low self esteem is another sure sign of PND, we are told, but surely this would

be almost inevitable given the traditional divisions of parental labour and the low (unpaid) status of motherhood in western society. Anxiety and difficulties with concentration and making decisions should alert the young mother to her PND, the NHS website helpfully continues, but how can you concentrate when exhausted from lack of sleep and your thoughts scrambled by constant interruptions, and how can you confidently make decisions when you have no previous experience of caring for an infant – and when the child manuals (in my day) tell you that a mother will always know when her baby is hungry or in pain or in need of comfort? The final symptom that is flagged up on the NHS website is what they call 'obsessional ruminations', that is, the thoughts women might harbour of harming their baby. In his article, 'Moms Who Kill', Mark Levy points to the lack of social support for a new mother and the impact of her loss of independence 'along with her role as an attention-drawing pregnant woman or as a career woman'.[16] The Royal College of Psychiatrists estimates that between fifteen and thirty per cent of new mothers suffer from PND, which is generally treated with anti-depressants or where a post-partum drop in hormones is diagnosed, with hormone replacement. Four per cent of women who experience severe post-partum psychosis go on to kill their children. I am surprised that the figures are not higher.

These were the material and social conditions that any woman contemplating motherhood had to contend with in the 1980s. There were also cultural and psychological factors that meant a descent into the

Figs. 2a-b-c. Catherine Elwes, *With Child*, 1983, stills from video. Courtesy of the artist.

morass of parental servitude also involved what Mary Kelly called 'the complex psychology of the mother-child relationship', some of which I will now explore through the work of four women video-makers.[17]

Schwanger sein II [Being Pregnant II] (1979–80) by Annegret Soltau; the 'monstrous feminine'

In *Post-Partum Document*, her 1976 magnum opus referenced above, Mary Kelly rejected the saccharine image of the Madonna and child dyad symbiotically entwined in a celestial harmony. She was determined to 'avoid the literal figuration of mother and child', that is, 'any means of representation which risked recuperation as "a slice of life"'.[18] Instead, she exhibited a series of crypto-visual displays that included soiled nappies, a child's vests, infant hand imprints and early drawings. Kelly anchored these images and artefacts in textual analyses of motherhood informed by psychoanalytic theory.[19] However, in an earlier work, the black-and-white film (transferred to video) *Antepartum* (1973), the problematic body of the expectant mother was admitted to view. Kelly turned the camera on to her own belly, swollen to full term, offering 'the body as a site' in extreme close-up.[20] There, the movements of the child confined in the smooth mound of her abdomen (itself contained in the 'box' of the monitor) created fluttering undulations as the artist attempted to make 'pre-linguistic' contact with her baby through gentle stroking motions.

The pregnant body-as-landscape analogy was also present in Susan Hiller's photographic series *10 Months* (1980) in which her belly was distilled to an arc of flesh progressively rising through a grid of frames, presenting a kind of story-boarded pregnancy, both a miracle of parturition and a topographical study of a

primordial moon rising over the horizon.[21] These works evoke Kristeva's notion of the abject maternal body, interpreted by Joanna Frueh as the spectacle of the expectant mother who 'enlarges, looks swollen, produces afterbirth, lactates and shrinks'. She embodies, says Frueh, 'breakdown, dissolution and magnificent grossness'.[22] While these images might mobilise the transgressive power of a female grotesque, artists have to navigate the danger identified by Imogen Tyler of such works 'reproducing histories of violent disgust towards maternal bodies'.[23] In order to avoid reiterating the 'cultural production of women as abject',[24] both Hiller and Kelly used tactics of abstraction and distanciation – the reduction of flesh tones to a muted grey, the avoidance of visceral images of blood and afterbirth and the imposition of a geometric framing: the tight embrasure of the monitor in Kelly's case and the formal restraint of a grid in Hiller's. In her video *Schwanger sein II* [Being Pregnant II] (Fig. 3), Annegret Soltau also displays what Betterton describes as the 'classifying tendencies'[25] of feminist art, abstracting the ripening body of the mother into a monochrome body-scape. In the third phase of the video, she adopts a foreshortened view comparable to the one I used for the crying baby in *Postcard*, although, of course, the child in Soltau's case is in utero. The artist creates an atmosphere of menace as a large scythe approaches the mother's body from the left and hangs ominously over her bump while a rapid heartbeat testifies to the precarious life gestating within. As in *With Child*, we are confronted with an image of murderousness, what

Katharine Meynell calls the 'monstrous feminine' in relation to her own work.[26] However, the scythe, an archetypal symbol of death remains an ambiguous image in *Schwanger sein*. Perhaps it implies that the threat to the child comes from the mother herself as a Freudian agent of castration or it may evoke mythological figures such as Medea who is portrayed as having the power both to give and to take life. It may also represent more tangible external threats, beginning with the obstetric interferences of modern medicine into the natural processes of childbirth. Beyond that, Soltau may be expressing fears that, in future, her child might be swept up in the horrors of war, and the artist might find herself, like Käthe Kollwitz in 1916, railing against 'this frightful insanity – the youth of Europe hurling themselves at one another'.[27] Whatever source of danger we apply as the explanation for the presence of the malignantly glinting scythe, *Schwanger sein* evokes the physical vulnerability of the pregnant woman and the helplessness of the child she carries. Further, it hints at the raft of difficulties that await the new mother as she is entrusted with the life of a newborn who will remain utterly dependent on her for several years to come.

Fig. 3.
Annegret Soltau,
*Schwanger sein
II* [Being
Pregnant II]
(1979–80), still
from video.
Courtesy of the
artist.

Escena doméstica con gusano verde [Domestic Scene With Green Worm] (1983) by Marisa González; rebellion, an 'act of hatred'

The level of personal sacrifice demanded for the proper care of one let alone several children is well nigh impossible for an average individual to make. Within women's representations of motherhood in early video, there are often instances in which mothers withdraw their 'endless and unrecognised' labour and enact what Fulvia Carnevale refers to as 'human strike'. Carnevale (and her art collective, Claire Fontaine) draw on the writings of the feminist Carla Lonzi who, in the 1960s, advocated the abdication of any designated social role that circumscribes and hierarchises human activity. This moment of rebellion from societal expectations surrounding the maternal role, says Carnevale, will always be interpreted as 'an act of hatred', a betrayal of the maternal instinct.[28]

One such withdrawal of maternal labour was recorded in Marisa González's *Escena doméstica con gusano verde* [Domestic Scene with Green Worm] (Fig. 4), a video that also provides an example of how women artists make art in and around the demands of their domestic environment with whatever materials come to hand. González trains her video camera on a small green caterpillar, recently plucked from one of her potted plants. The tiny creature makes its way across a table in dogged looping steps, while a child's voice-over speculates as to the nature of the beast, 'it is a worm not a thing', he chirps and then wonders aloud where it might be heading. The 'Third Term' in the form of 'Papa' arrives home and the mother responds absently to his greetings. She is busy recording the caterpillar. The 'worm' meanwhile is negotiating a dried leaf, looking for some means of quitting the barren tabletop, trying perhaps to find its way back to the plant from which it was so rudely torn. The child draws his father in to admire the worm. The father asks where the other two children are and the artist-mother, preoccupied with her recording, replies, 'no idea'. The off-screen domestic space, beyond the close-up of the table, is created entirely in the mind's eye by sound as the audio track fills in the details of kitchen and hallway with the percussion of childish footsteps and voices ricocheting from wall to wall. The discussions and clatter of a meal being prepared firmly excludes the mother, who occasionally grunts from behind her camera while she focuses on the worm, now clinging precariously to the edge of a man's shoe. An explosion of excited voices heralds the arrival of more children on the scene and the artist brings the tape to a close with a relieved '*bueno*!' She has got the shots she wanted and family life survived without her for a couple of hours.[29]

Fig. 4. Marisa Gonzalez, *Escena doméstica con gusano verde* [Domestic Scene with Green Worm], 1983, still from video. Courtesy of the artist.

González has offered an image of Carnevale's 'act of hatred' in her temporary withdrawal of maternal labour. The artist, firmly embedded behind the camera, denies the authority of the father by ignoring his return to hearth and home. However, there is gentle humour in the work that helps it escape any simple rehearsal of the monstrous feminine. González shifts the emphasis from the recalcitrant mother to the image of the diminutive caterpillar, lost in the desert of the tabletop. We may read the creature's plight as analogous to the feelings of betrayal and abandonment that the infant feels when its mother is temporarily out of sight or its needs are not immediately met. For me, the work evokes the loss of the mother herself, not in the Kristevian sense of a violent psychic rejection of the maternal in the process of individuation, but in the passing of a mother in death when the one person in the world for whom our own daily survival was of paramount importance is no longer there to witness the unfolding narratives of our lives.

Clapping Songs (1981), Tina Keane; creative enrichment

There are artist-mothers who deliberately preserve a separate time and space in which to create their work, and like Kollwitz and González, temporarily 'slacken' their family ties in order to do so. There are those women who choose not to have any children, and they may well agree with Kollwitz that only work is 'always stimulating, rejuvenating, exciting and satisfying'.[30] However, in the case of González, Kelly, Soltau and indeed Kollwitz herself, many others find

ways to productively combine their work and their mothering and resist the societal dictate that a woman must choose between art and children – between the masculine (enterprising, uncompromising) and feminine (reliable, nurturing) positions. There are also artists who consider the privileged access to young minds a great source of both emotional and creative enrichment. According to the filmmaker Biban Kidron, 'perspective, literalism, surrealism, unfettered imagination [and] the incredible creative abandon of a child's mind are all there to borrow and steal from'.[31] The artist Tina Keane was quick to recognise the value of her own child's creative play. In Clapping Songs (Fig. 5), the artist recorded her daughter, Emily as she and her best friend ran through their repertoire of playground songs, performed face-to-face while clapping each other's hands to provide the rhythm. One such clapping song featured the memorable ditty:

When Suzie was a teenager,
A teenager, Suzie was; she went
Ooh, Aah, I lost my bra
In my boyfriend's car
And I don't know where my knickers
 are. (Anon)

The licentiousness of the lyrics might not have been fully apparent to the girls, but Laura Leuzzi has argued that the rhymes and songs of childhood help to induct children into the ways of the world marking out their designated places in society organised along the lines of race, class and gender. However, Leuzzi also suggests that songs such as those performed by Emily, nevertheless contain within them a subtle critique of female socialisation. In the example above, the song rebels against the Puritanism

of western society that condemns 'Suzie' for her unfettered sexuality.[32] This combustible thread of rebellion is embodied in the social fabric of the voice, and was passed down through the generations, linking mothers and daughters in a chain of subversion that would lead to suffragism in the nineteenth century and the women's movement in the twentieth.

Hannah's Song (1987), Katharine Meynell; the divided self

Where Keane tuned into the transgressive undertones of matrilinear oral traditions embedded in her daughter's games, Katharine Meynell found equivalent riches in watching her own daughter progress through the developmental stages of her social and psychic formation. *Hannah's Song* (Fig. 6) was made when Meynell's daughter Hannah was still pre-lingual, but beginning to find her voice in song. The artist asked the musician Jocelyn Pook to transcribe Hannah's vocalisations and used musical notation to frame informal footage of the child singing and 'the objects and colours that fascinated

Fig. 5. Tina Keane, *Clapping Songs*, 1981, still from video. Courtesy of the artist.

her'.[33] We witness the artist's prolonged watching of her daughter, encapsulating the extended temporality of motherhood, a time that never ends but only shifts its focus as the child grows to maturity. Julia Kristeva has identified 'women's time' as synonymous with 'repetition and eternity', with 'cycles, gestation, [and] the eternal recurrence of a biological rhythm'.[34] In this respect, the *longue durée* of motherhood, found in video technology an appropriate travelling companion. Where Super 8 film only allowed three minutes of recording time, analogue U-matic videotapes came in durations of twenty, thirty and sixty minutes. The hours of a mother's watchfulness thus could be rendered virtually in real time.

In the course of one recording session, Meynell captures a critical developmental event when the infant Hannah first discovers her image in a mirror. It is not clear whether she recognises herself in her reflection, but the sequence gestures towards a milestone that would mark her transition into what the psychoanalyst Jacques Lacan designated the 'mirror phase'.[35] Here the child conceives a self that is image, she becomes a performer of femininity who must aspire to fulfil the expectations of the society into which she is born, and, according to Lacan, she undergoes a splitting off of her internal, subjective experiences and desires from the social entity that is rendered in-representation. According to Peggy Phelan, as a girl undergoes the processes of gendered individuation, her identity is performed through her behaviours, her styled appearance and her rehearsed utterances.[36] The relevance of Lacan's theory to what is

implied in *Hannah's Song* lies in the feminist mother's ambivalence towards her child's first steps to independence. She wants the child to succeed in her social integration, but is afraid of passing on, along with her love, the repressive formations that a patriarchal society bequeathed to her through her own mother's tutelage. There is, within these chains of mothering, these entangled attachments, what Meynell calls 'a slippage of roles',[37] a fusing of identities, and a concatenation of past, present and future femininities. If the mirror phase produces a psychic split, then motherhood leads to further dispersal of the self, projecting forwards in time as the fruit of the mother's womb is split off from her and moves away, at first from the breast in weaning and then from her whole body as the child takes its first faltering steps towards autonomy. The new mother may also find her sense of self dissolving into the past as a remembered symbiosis with her own mother returns to haunt her. (There is nothing more disconcerting than opening one's mouth to call a child and hearing one's mother's voice rise up from the dead.) These memories may stir up the introjected aspirations and desires that an insecure parent may have harboured for the child who is now herself a mother. The new mother may once again become aware of what the paediatrician Donald Winnicott described as the 'false self', the persona she adopted in childhood in order to fulfil the expectations of her parents and thus guarantee their love and protection.[38]

In recent years, the dispersal of self, or the decentralisation of the unified subject has become a fashionable concept in art and queer theorists have challenged the identity politics of the 1980s that were founded on the objective of securing cultural visibility for 'minority' groups. Laura Guy has argued for the subject's 'right to opacity' and she advocates the promotion of a 'fugitive identity', one that can be found in art through images that represent 'the point at which identity collapses'.[39] Guy cites the work of Boudry and Lorenz who layer and fracture the identities of those whom they portray in their work. However, I would suggest that while society decrees that a woman has fulfilled her destiny when her body is replete with meaning in pregnancy and parturition, these are also the life events that will render her identity fluid, that will most profoundly disrupt her sense of self. As a strategy for challenging proscribed roles for women in society, dispersal of the subject in-representation may simply replicate and intensify the lived condition of motherhood, which brings with it extreme physical changes and a blurring of boundaries between self and other, between past and present. This violation of the integrity of the post-partum subject is compounded by the frequent disapprobation of

Fig. 6. Katharine Meynell, *Hannah's Song*, 1987, still from video. Courtesy of the artist.

society that, asserts Tyler, means 'living as a body that is identified as maternal and abject'.[40] The objective now should be to develop creative strategies that help to reunite the divided selves of the maternal subject, rethread and strengthen the intergenerational connections that bind us to our mothers and daughters and counter the negative impact of a psychic Othering of mothering at a personal familial level, as well as at a cultural, legislative and social level. The feminist aim, then, is to improve the status and living conditions of mothers and children across the whole of society.

By way of a conclusion; the social conditions, updated

Motherhood can be experienced as a catastrophic infringement of hard-won personal liberty and autonomy or it can be revealed as a wondrous moment of creative efflorescence. Most women find it is a little of both; however, a positive experience of motherhood is substantially contingent on the financial circumstances of an individual and whether or not the support of family and friends is in place during and after pregnancy. It also depends on the expectations a woman entertained before the birth, her physical and mental strength, her previous experience and natural abilities. Motherhood – the trials and the joys – is further modified by the prevailing social conditions into which a woman gives birth. The majority of the practitioners I have discussed in this article had their children in the 1980s when they were still fighting discrimination in the art world. One might wonder

whether society and the institutions of art have changed substantially since the 1980s and whether women are still struggling to reconcile the costs and benefits of motherhood, weighing their desire for a child against their ambitions as artists.

Taking a sounding from a recent online article by Marina Cashdan, we can listen in to the conversations of a number of successful contemporary artists including Tara Donovan and Kara Walker, women who see no reason to sacrifice their hopes for motherhood to the demands of their careers.[41] Walker denies that 'one takes energy from the other' and many of the artists point to women from earlier generations who act as positive role models. Women such as Susan Hiller, Mary Kelly and Tina Keane all had a child and continued to thrive as artists. They have given younger women the confidence to embrace motherhood themselves without any sense that, in consequence, they would be diminished as practitioners. There are those, like the earlier feminists I have cited here, who find ingenious ways to combine motherhood and art: Laura Godfrey-Isaacs knitted her art when her children were small and later opened her home as a gallery, a strategy also adopted by Fran Cottell whose *House Projects* (since 2001) involve installing raised walkways that run through her house along which visitors can progress while her family members continue to pursue their everyday activities on either side of the ramp.[42]

Not all artists appear to cope so well with the conflicting demands of children's needs and their own practice. In the same article, Cashdan quotes the artist Lenka Clayton who,

like many mothers, is confronted with the problems of isolation and 'being exhausted, having no time, no space …', and many point to the discrimination women with children still experience among art dealers and museums. Diana Al-Hadid registers the patriarchal imbalance whereby, unlike women, few male artists consider foregoing parenthood for the sake of their art, and they are unlikely to be asked by interviewers whether fathering a child has changed their practice.

From reading between the lines of the Cashdan interviews and bearing in mind what I know of how certain women have dealt with motherhood, it is clear that having one child is less disruptive than begetting two or more – as Alice Walker wrote 'with one you can move […], with more than one you are a sitting duck'.[43] Clearly, financial stability and the support of a partner and extended family make all the difference. However, I would like to end by suggesting that, in general, circumstances are more critical for young mothers today than they were for me and my colleagues in the 1980s. Property prices are now astronomical, out of reach of most first time buyers on average wages; social housing has been decimated and since 2012 the laws on squatting have been considerably tightened in the UK. Putting a roof over the heads of inner-city children is a major problem for anyone who does not expect to inherit the property or savings of their own parents, that is, those properties and savings that are not eaten up by parental care in old age. Making a living out of art is still a pipedream for most graduates and employment opportunities in teaching are few and far

between. Meanwhile in austerity Britain, family services have been cut, children's centres have closed, benefits are now capped and the costs of childcare have risen exponentially, year on year.

There is another, cultural difference that I believe negatively impacts the young mothers of today. In spite of having lived through the social revolution of 1960s, and experienced the radical break from the values of my Edwardian-raised parents, I was successfully conditioned to accept that my role as a woman would involve self-sacrifice and include a substantial element of nurturing. I could expect to care for siblings, students and colleagues (should I secure a job) and finally fulfil my destiny as a woman by attending to the needs of a husband and a child. That was the message of my middle-class, Catholic upbringing, one that no amount of feminist re-education could dislodge from my well-schooled 'feminine' soul. It is possible that today, with a looser sense of social responsibility, and in a culture of consumption and unfettered individualism, young people are led to believe that they have a divine right to pursue exclusively the satisfaction of their every desire. Motherhood deprives young women of this right, at a stroke, when their bodies are taken over by a rapacious alien being, when, postpartum, their personal space is invaded, their freedom of movement curtailed, when their right to sleep and shit and make love in peace is withheld. First-time mothers may lose contact with their peers and they may find themselves cut off from their extended families, facing partner violence alone. The cost of providing for a child means that their buying power

may be reduced to the basics and a deep disillusionment can quickly set in. Post-natal depression is a sign that the besieged organism is in distress. It is a form of protest, but then as now, there is no socially sanctioned outlet for its expression, and, as so often happens, women turn their pain in on themselves. Hiding their shame, they take the drugs their overworked GPs hand out instead of the practical help they really need. Until the functional problems of childcare, housing, employment and status are resolved, motherhood will continue to be the fifty per cent bliss and fifty per cent purgatory that I struggled to project in the videos I made with just one child in the early 1980s.

Endnotes

1. Fulvia Carnevale speaking at the seminar 'Feminist Duration in Art and Curation', Goldsmiths College London, 16 March 2015.

2. Cyril Connolly, *Enemies of Promise* (Chicago: University of Chicago Press, [1938] 2008), p. 116.

3. Fulvia Carnevale speaking at the seminar 'Feminist Duration in Art and Curation', Goldsmiths College London, 16 March 2015.

4. Quoted in Nicole Puglise, 'Marina Abramović says having children would have been "a disaster for my work"', *The Guardian* online, 26 July 2016, available at: https://www.theguardian.com/artanddesign/2016/jul/26/marina-abramovic-abortions-children-disaster-work (accessed 13 October 2016).

5. Linda Nochlin, 'Why have there been no great women artists?' in Thomas B. Hess and Elizabeth C. Baker (eds.), *Art and Sexual Politics*, ([1973] 1975), pp. 1–44; p. 25.

6. Laura Mulvey, a comment made in an early draft of 'Afterword: some reflections on the engagement of feminism with film from the 1970s to the present day', *MIRAJ*, v. 7, n. 1, 2018, pp. 82–90.

7. Laura Mulvey,' "Post Partum Document" by Mary Kelly', *Spare Rib*, n. 53, 1976, p. 40.

8. Jacqueline Morreau, 'The Divided Self' in Penny Sumner (ed.), *The Fruits of Labour; Creativity, Self-Expression and Motherhood* (London: The Women's Press, 2001), p. 157.

9. For a discussion of the ICA women's shows, see Amy Tobin,'Moving Pictures: Intersections between art, film and feminism in the 1970s', *MIRAJ*, v.4, n. 1/2, 2016, pp. 118–134; and in the same issue, Amy Tobin and Catherine Elwes '"Women's Images of Men" Seminar ICA: 14 October 1980', pp. 294–311. See also Catherine Elwes,'A Parallel Universe: The UK/Canadian Film & Video Exchange 1998–2004 and the ICA shows of Women's Art in 1980', in Judith Rugg (ed.), *Issues in Curating, Contemporary Art and Performance* (Bristol: Intellect Books, 2007), pp. 101–111.

10. Rosemary Betterton,'Maternal Embarrassment: Feminist Art and Maternal Affects', *Studies in the Maternal*, v.2, n.1, 2010, p. 1.

11. Patrick Flanery, *Absolution* (London: Atlantic Books, 2013), p. 281.

12. Rozsika Parker, *Torn in Two: The Experience of Maternal Ambivalence* (London: Virago Press, 2005), p. 7.

13. Andy Lipman, 'Video – State of the Art' (Channel 4 publication, 1985), n.p.

14. See the NHS post on Postnatal Depression – Symptoms: http://www.nhs.uk/Conditions/Postnataldepression/Pages/Symptoms.aspx. (accessed 13 December 2015).

15. Annabel Crabb, *The Wife Drought* (Sydney: Ebury Press, 2014). Kindle Edition.

16. Mark Levy, 'Moms Who Kill', *Psychology Today*, 1 November 2002. Available online: https://www.psychologytoday.com/articles/200212/moms-who-kill (accessed 13 November 2015). The ambivalence that a mother feels towards her unborn child or infant was encapsulated in the image of a woman simultaneously stabbing at and rescuing a doll in my video *With Child* (1983).

17. Mary Kelly speaking to Lilian Simonsson on TateShots, 2015. Online: https://www.youtube.com/watch?v=OaKXUVDSZdQ (accessed 28 August 2016).

18. Mary Kelly quoted in Rosemary Betterton, 'Maternal Embarrassment: Feminist Art and Maternal Affects', *Studies in the Maternal*, v. 2, n. 1, 2010, p. 11.

19. Kelly's use of dense Lacanian theory drew criticism from some feminists who found it obscure and elitist. See Margot Waddell and Michelene Wandor, 'Mystifying Theory', *Spare Rib*, no. 55, 1977, p. 4.

20. Mary Kelly speaking about *Antepartum* to the Whitney Museum, undated. Online: http://whitney.org/WatchAndListen/AudioGuides?play_id=1471 (accessed 13 October 2016).

21. In her display of these photographs, Hiller included extracts from her diaries kept during her pregnancy, many of which referenced the bifurcation of her role into a 'neutral (neuter) observer', that is, an artist, and mother who is licensed to speak 'only about women's things'. Quoted in the catalogue *About Time* (London: ICA, 1980), n.p.

22. Joanna Frueh, *Monster/Beauty: Building the Body of Love* (Los Angeles: University of California Press, 2001), p. 133.

23. Imogen Tyler, 'Against Abjection', *Feminist Theory*, v. 10, n. 1, 2009, pp. 77–98; p. 77.

24. Ibidem, p. 84.

25. Rosemary Betterton, 'Maternal Embarrassment: Feminist Art and Maternal Affects', *Studies in the Maternal*, v. 2, n. 1, 2010, p. 10.

26. Katharine Meynell quoted by Chris Darke, 'Katharine Meynell' in David Curtis (ed.), *A Directory of British Film and Video Artists* (Luton: Arts Council/Luton Press, 1996), p. 126.

27. Käthe Kollwitz, 'From The Dairy and Letters of Käthe Kollwitz' in Penny Sumner (ed.), *The Fruits of Labour; Creativity, Self-Expression and Motherhood* (London: The Women's Press, 1916 [2001]), p. 111.

28. Fulvia Carnevale speaking at 'Now You Can Go: On Feminist Generations, Affective Withdrawal, and Social Reproduction', Showroom Gallery, 11 December 2015. For an account of the life and work of Carla Lonzi, see Lea Melandri 'Autonomy and the Need for Love: Carla Lonzi, *Vai pure*' in Lea Melandri (ed.), *Una visceralità indicibile* (Milan: Franco Angeli, 2000), pp. 43–50.

29. González was using one of the first Sony portable video recorders to become available to artists in Spain in 1983.

30. Kollwitz, 'From The Diary and Letters of Käthe Kollwitz', p. 105.

31. Beeban Kidron, 'What About Me?' in Penny Sumner (ed.), *The Fruits of Labour; Creativity, Self-Expression and Motherhood* (London: The Women's Press, 2001), p. 103.

32. Laura Leuzzi in conversation at *Autoritratti*, part of the 'Now You Can Go' programme, Showroom Gallery, London, 11 December 2015. Accurate to my notes.

33. See Katharine Meynell's website: http://www.katharinemeynell.co.uk/videography/index.html (accessed 13 October 2016).

34. Julia Kristeva, 'Women's Time', Alice Jardine and Harry Blake (trans.), *Signs*, v.7, n.1, Autumn 1981, pp. 13–35; p. 16.

35. See Jacques Lacan, 'The Mirror Stage as formative of the function of the I' in *Ecrits: A Selection*, Alan Sheridan (trans.), (London: Tavistock, [1936] 1977), pp. 1–7.

36. This notion was developed by Peggy Phelan in her theories of performativity. See Peggy Phelan, *Unmarked: The Politics of Performance* (London: Routledge, 1993).

37. Katherine Meynell quoted in Catherine Elwes, *Video Art, a guided tour* (London: I.B. Tauris, 2005), p. 45.

38. The 'false self' is discussed by Alice Miller in *The Drama of Being a Child* (London: Virago, [1979] 1987). See pp. 27–29.

39. See Laura Guy, 'Hiding in plain sight: Recognition and resistance in recent queer artists' moving image', *MIRAJ*, v. 5, n. 1/2, 2016, pp. 158–169.

40. Imogen Tyler, 'Against Abjection', *Feminist Theory*, v.10, n.1, 2009, pp. 77–98; p. 77.

41. Marina Cashdan, 'You Can Be a Mother and Still Be a Successful Artist', 24 August 2016, Artsy, online: https://www.artsy.net/article/artsy-editorial-why-motherhood-won-t-hinder-your-career-as-an-artist (accessed 20 July 2018).

42. See Fran Cottell's website: http://www.francottell.com/ (accessed 13 October 2016).

43. Alice Walker, 'One Child of One's Own; A Meaningful Digression with the Work(s)' in Penny Sumner (ed.), *The Fruits of Labour; Creativity, Self-Expression and Motherhood* (London: The Women's Press, 2001), p. 165.

Chapter 10

Feminism, Ireland and Women's Video Art in the 1980s

Maeve Connolly

Introduction

The history of Irish women's video art is both complicated and enriched by the fact that, during the 1970s and 1980s, many women artists engaged with Ireland and Irish society from a distance, either out of choice or necessity. Based in (or sometimes moving between) a variety of locations in Ireland, Scotland, England and the US, these women developed feminist critiques of power that directly addressed both the social construction of gender and the specific values attributed to femininity and motherhood within nationalist and colonial discourses. Some of the artists, activists and filmmakers discussed below had strong connections with international feminist networks for the production and distribution of film and video, but they were also interested in more local feminist initiatives, particularly in relation to campaigns for reproductive rights. All were actively working toward political and social change, through their practices as artists and their parallel roles as educators.

In a catalogue essay accompanying the 1990 exhibition *A New Tradition: Irish Art of the Eighties*, an exhibition curated by Medb Ruane at the Douglas Hyde Gallery, Dublin, Joan Fowler highlights the growing significance of gender and sexuality for both male and female Irish artists in the 1980s.[1] While male artists tended to engage with these issues through expressionist and figurative painting, their female counterparts – including Pauline Cummins, Mary Duffy and Alanna O'Kelly – were drawn toward new media such as video, performance or slide/tape. Fowler emphasises that these women were working in a context shaped both by the expansion of marriage and workplace rights, in the 1970s, and by a 'co-ordinated reaction'[2] to these changes. This reaction was made manifest in two particularly divisive referenda campaigns concerning abortion and divorce, which severely undermined women's rights in the mid-1980s. In a more recent account of Irish feminist performance art, Kate Antonik-Parsons also highlights the reactionary social climate of the

1980s, suggesting that it helps to explain why women in Ireland were particularly drawn to the body as a 'lens through which the intersection of personal, political, theoretical and practical concerns could be focused'.[3] The female body certainly figures very prominently in many of the new media works discussed by Fowler. But it is important to remember that this mobilisation of body as 'lens' *also* frequently involved the use of new media, including film, photography and, eventually, video. Antonik-Parsons' text appears in an edited collection of writings on performance art in Ireland, which also includes some discussion of artists working with video. As of yet, however, there are no scholarly monographs or archives[4] dedicated specifically to Irish video art or experimental film, despite the fact that moving image installation has occupied a prominent place within Irish contemporary art for several decades,[5] with the result that the history of Irish video art remains somewhat scattered.[6] In addition, a small number of works discussed in this chapter (specified in the notes) are difficult to view in full, generally due to partial degradation of the original master tapes.

In this chapter, I have chosen to focus primarily on the practices of Frances Hegarty, Alanna O'Kelly and Anne Tallentire, specifically because all three artists realised works on video for gallery exhibition (as distinct from broadcast) during the 1980s, while the other Irish women artists mentioned in this text only began exhibiting video work after 1990. Hegarty, O'Kelly and Tallentire tended to use video alongside other non-traditional media, including Super 8 or 16mm film, 35mm slide, audio tape or photography. In many of the works discussed, video allowed these artists to present recordings of site-specific gestures or trajectories within the gallery. These recordings could be displayed alongside objects, images or live actions, playing an integral role in the articulation and exploration of spatio-temporal dislocations resulting from migration, legacies of colonisation, and ongoing cultural and legal restrictions to women's rights. But it is important to acknowledge that only a relatively small number of video works by Irish women artists were actually made during the 1980s, mainly because infrastructural supports for the production and distribution (or archiving) of experimental film and video production simply did not exist in Ireland during the 1970s and 1980s.[7]

Artists who completed their undergraduate studies in Belfast or Dublin in the 1970s often gravitated toward masters programmes in London,[8] in search of video and film production facilities. But Belfast-based artists did have at least some access to new media production resources, following the establishment of the Art & Research Exchange (A.R.E.), an artist-run space with a darkroom and studios in 1978.[9] Although it did not include video production or distribution facilities, A.R.E. became an important resource for artists working with performance, eventually hosting live art events. The A.R.E. building also housed the Artists Collective of Northern Ireland, which began publishing the bi-monthly art magazine *Circa* in 1981, with a stated focus on the socio-political context on art production. The magazine's early editorial staff included the artist Anne

Carlisle,[10] known for her work with time-based media, and many of its regular contributors (including Jean Fisher, Joan Fowler and Belinda Loftus) were particularly attentive to feminism and women's art practice.

Feminist Art, Film and Activism North and South of the Border

Like their international counterparts during the 1970s and 1980s, many Irish women artists wanted to secure greater professional recognition, at home and abroad, often forming or joining advocacy associations and women-only networks to achieve this goal. Although not restricted to artists working with new media, many such initiatives involving Irish women artists led to exhibitions, seminars and conferences involving time-based or photographic media.[11] In 1987, for example, a group of Irish-based artists that included Pauline Cummins set up the Women Artists' Action Group (WAAG), organising an exhibition at Project Arts Centre, Dublin, which consisted of a slide show of works by women. Based on this exhibition, WAAG subsequently established a slide library, which was maintained by the group. Cummins' own work from this period included the slide/tape installation *Inis T'Oirr/Aran Dance* (1985), first shown at the Irish Exhibition of Living Art, Dublin, in 1985.[12] Irish women artists who were living or studying in London (or elsewhere in England) during this period also established representative groups, organising a number of conferences and exhibitions discussed below. Hegarty,

O'Kelly and Tallentire all contributed to these campaigns, but their work was also focused on issues of representation that affected women outside of the art field, both north and south of the border.

Many of the same issues were also being addressed by Irish women through the production of film, activist video or broadcast media, as evidenced by the work of Vivienne Dick and Pat Murphy and also Anne Crilly and Margo Harkin of Derry Film and Video, a feminist film and video production group established in the mid-1980s. Studying first at Hornsey College of Art and then at the Royal College of Art, the Dublin-born, Belfast-educated filmmaker Pat Murphy directed two critically acclaimed feminist feature films in the early 1980s. Her films – *Maeve* (1981, co-directed with John Davies), a semi-autobiographical portrait of a young Belfast woman struggling to reconcile nationalism with feminism, and *Anne Devlin* (1984), a feminist retelling of a key event in Irish republican history – were widely shown in festivals, film clubs and arthouse cinemas outside Ireland. Murphy's work also figures prominently in theorisations of feminist and post-colonial film by Claire Johnston and Paul Willemen.[13] *Maeve* had been funded partly by the Experimental Film Fund of the British Film Institute and *Anne Devlin* was supported by the newly-established Irish Film Board but, by 1988, these funding avenues had closed and Murphy was unable to complete her next feature film (a biography of Nora Barnacle, the wife of James Joyce) until 2000.

Like Pat Murphy, Vivienne Dick first began working with film while

based outside Ireland, receiving critical attention for her early Super 8 works featuring prominent women performers from the New York underground scene (including Adele Bertei, Lydia Lunch and Pat Place). Dick's early works were shot on Super 8, but she was drawn to the immediacy of video and her film *She Had Her Gun All Ready* (1978), features a sequence in which a performer (Lydia Lunch) studies her own image on a video monitor. In the early 1980s, Dick made several return visits to Ireland and one of her most ambitious works from this period, *Visibility Moderate* (1981) explored the vantage point of the Irish-American. Much of the film follows the journey of a glamorous young female protagonist, who visits scenic Irish landmarks and poses for the camera at heritage sites. But she also tours around decrepit inner city Dublin and attends a protest in support of Republican hunger strikers in the north with the film culminating in a statement to camera by a former political prisoner, condemning the mistreatment of women.

Although Dick wanted to establish herself as a filmmaker in Ireland, she ultimately chose to live in London, primarily so that she could access financial and social support for her practice as a filmmaker. In London, Dick became an active member of the London Filmmaker's Co-op and secured funding from the British Arts Council to make the 16mm film *Rothach* (1985), a poetic exploration of place and temporality, filmed in Ireland. Living in London also allowed Dick to expand her connections within the Irish art community. In 1987, her films *Rothach* and *Trailer* were shown as part of a screening programme that accompanied *Off the Map*, an important group exhibition at the Chisenhale Gallery, featuring works by Hegarty, O'Kelly and Tallentire, (discussed below in more detail). Dick also chronicled many aspects of the London art scene at a key moment for Irish women artists. Her 16mm film *London Suite* (1989, Fig. 1), funded and broadcast through Channel 4's 'Experimenta' season, captures both the appeal and the difficulty of London city life for women through semiscripted interactions between a large cast of predominantly female performers.

Dick was not the only Irish feminist filmmaker to be supported by Channel 4 during the 1980s. As part of its public service mandate, the new channel (launched in 1982) recognised a regional network of non-profit making, often community-based, production groups or 'workshops'.[14] This initiative was intended to demonstrate the broadcaster's commitment to under-represented constituencies, and programming was either commissioned or purchased from the franchised production groups, typically for broadcast in the channel's *Eleventh Hour* or *People to People* slots. The workshop groups included Derry Film and Video (DFV), established by Anne Crilly and Margo Harkin in 1984. During this period, Crilly and Harkin produced several documentaries, including *Strip-searching – Security or Subjugation* (1984), on the conditions endured by political prisoners, and *Planning* (1985), on urban redevelopment in nationalist areas of Derry, and *Mother Ireland* (1988), exploring the representation of motherhood within nationalist discourse.[15] Despite their inclusion in the workshop pro-

gramme, very few of DFV's productions were actually broadcast, partly because Crilly and Harkin would not make the adjustments required by broadcasting legislation (introduced in 1988) to censor the voices of those associated with proscribed organisations such as the Irish Republican Army.

Although DFV documentaries circulated among feminist networks, via independent distributors such as The Other Cinema and Cinema of Women,[16] their best known work is undoubtedly *Hush-A-Bye-Baby* (1989). The narrative of this feature-length drama is structured around the pregnancy of a young unmarried Catholic girl in Derry, with a cast that includes Sinead O'Connor. Significantly, the central characters cross the border, staying with a host family in an Irish-speaking part of Donegal to improve their language skills, allowing the filmmakers to explore how women are positioned in relation to Irish as well as British nationalism. In a particularly astute analysis of DFV's work, Jessica Scarlata emphasises that *Hush-A-Bye-Baby* is set in 1984, 'roughly a year after the abortion referendum (restricting women's reproductive rights) passed by a narrow margin in the Irish Republic'.[17] Although Britain's 1967 Abortion Act had decriminalised abortion under specific circumstances, Scarlata points out that it did not apply within the north of Ireland.[18] Crilly and Harkin's film seems to have been consciously set within the context of the mid-1980s conservative backlash since, as Scarlata notes, the lead character is shown watching the end credits of *Mother Ireland* on television, in a deliberately anachronistic gesture, since this documentary was not made until 1988.

Fig. 1. Vivienne Dick, *London Suite*, 16mm film, 1989. Courtesy of the artist.

Site, Voice and Early Video Works: Alanna O'Kelly

As these examples suggest, Irish women were actively using film and documentary video to effect political and social change in the early 1980s. While the north of Ireland functioned as a particularly important focus (and site) of feminist critiques, Irish women artists were also animated by other political causes, including the campaign for nuclear disarmament. Alanna O'Kelly is a key figure in the early history of Irish women's video art and was actively involved in women's networks, both in Ireland and elsewhere during the 1980s. Born in 1955, O'Kelly completed a BA in Fine Art at the National College of Art and Design (NCAD), Dublin in the late 1970s, studying with tutors such as Nigel Rolfe, a Dublin-based British artist working with performance, photography and time-based media. While NCAD lacked video production facilities at that time, O'Kelly knew that its graduates included Joe Comerford, one of several Irish filmmakers supported by the BFI's Experimental Film Fund.[19] Towards the end of her studies, in 1978, O'Kelly produced sculptural works near her home in Wexford

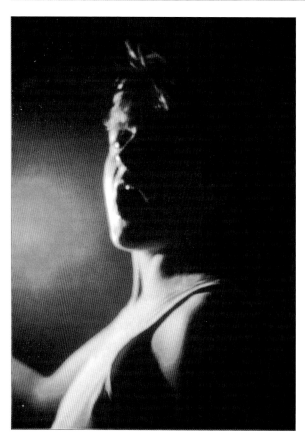

Fig. 2. Alanna O'Kelly, *Chant Down Greenham*, performance at Franklin Furnace 1987. Photograph: Raissa Page. Courtesy of the artist.

engage with the politics of site and in 1982, she devised a site-specific work, titled *City Images*, consisting of photographs projected onto the river Liffey over two nights. This project was a response to the cultural and social setting of O'Connell Bridge, an iconic and heavily-trafficked intersection in the centre of Dublin. By the mid-1980s, however, she was developing a more explicitly political engagement with the body and site, through performance and installation. O'Kelly's next work, *Chant Down Greenham* (1984–1988, Fig. 2), first presented at the SFX Theatre in Dublin, marked her first use of keening, a type of wordless lament traditionally performed by women at Irish funerals. Her keening accompanied projected images of a human chain of protesters attempting to prevent the expansion of the cruise missile base at Greenham Common in Berkshire, England.[21]

O'Kelly continued to work with keening and her audiotape *Caoineadh Na Mairbh* [Lamenting the Dead] (1985), was included in *Divisions, Crossroads, Turns of Mind – Some New Irish Art* (1985–1987), an exhibition curated by Lucy Lippard that toured to several US cities.[22] Around this time, she completed her MFA at the Slade School of Art, working with tutors such as Stuart Brisley and Susan Hiller, and also produced her first video. *Still Beyond the Pale*, was devised in 1986 for an exhibition at the Royal Hospital Kilmainham in Dublin (now the location of the Irish Museum of Modern Art), and it included a video component, consisting solely of a close-up image of O'Kelly's eyes staring at the camera, accompanied by a voiceover.[23] O'Kelly's next work, *Lament*, 1987 was

and these were documented on video by Nigel Rolfe for assessment, marking her first close contact with this medium.

O'Kelly continued to develop sculptural responses to site and context and in 1980 her work was shown in *Without the Walls*, curated by prominent Irish art critic Dorothy Walker at the Institute of Contemporary Arts in London as part of a festival of Irish art and culture staged at over forty London venues. O'Kelly was the only woman artist in this exhibition, which also included works by James Coleman, Nigel Rolfe and Noel Sheridan, and she recalls being questioned by other women artists about this gender imbalance at the opening.[20] Over the next few years, O'Kelly began to use photography, voice and sound to

made for exhibition at the Chisenhale Gallery in London as part of the exhibition *Off The Map*. It featured a video, subsequently exhibited and titled separately as *Dancing With My Shadow* (Fig. 3), shot in the west coast of Ireland after the death of O'Kelly's mother. Struggling to cope with this loss, O'Kelly wrote a letter to her late mother on several sheets of almost translucent airmail paper and, in a spontaneous ritual action, submerged the paper in a rock pool. Finding that the saltwater fixed rather than dissolved the ink, she then recorded the floating paper with a VHS camera, accompanying the image with her own voice.

Reviewing *Lament* as part of the exhibition *Off the Map*, Sarah Kent describes how the abstract sounds of voice on the audio track transform into a recognisable song, with the words 'dancing with my shadow feeling kind of blue' gradually becoming audible. Kent observes that while this piece might 'sound sentimental', it is characterised by a 'spare economy' that is 'extremely powerful'.[24] *Dancing With My Shadow* was subsequently included, with a reworked audio track, in the 1988 exhibition *Selected Images* at the ICA in London. Developed by artist James Coleman in collaboration with curator Declan McGonagle, this was the only visual arts component of the second (and much smaller) iteration of the festival *A Sense of Ireland*, which focused on the intersection between image and narrative in Irish culture and also included film works by Vivienne Dick. *Dancing With My Shadow* also featured in the influential 1990 exhibition *A New Tradition - Irish Art of the Eighties*, cited at the outset of this chapter. O'Kelly continued to work with video in *No Colouring Can Deepen the Darkness of Truth* (1990, Fig. 4). This three-monitor piece again incorporated sounds of keening, along with images of milk flowing from a breast, informed by O'Kelly's research on The Great Famine (1845–48). It was subsequently reconfigured within a larger project, entitled *The Country Blooms, a Garden and a Grave* (1992–25), which revisits the history of the famine and articulates a critique of present day inequalities.[25]

Fig. 3. Alanna O'Kelly, *Dancing With My Shadow*, 1987. Courtesy of the artist.

Fig. 4. Alanna O'Kelly, *No Colouring Can Deepen the Darkness of Truth*, 1990. Courtesy of Alanna O'Kelly.

Expanded Film and Video: Frances Hegarty

Like Alanna O'Kelly and Anne Tallentire, Frances Hegarty (b. 1946), grew up partly in the Irish countryside. But while Hegarty was still in her teens, she and her family left their home Teelin, County Donegal – a northern, rural and (then) Gaelic-speaking area of the Republic – for Glasgow, where she completed her secondary school education. Following a BA in Fine Art at Leeds Polytechnic (1969) and an MFA at Manchester Polytechnic (1970), Hegarty began teaching and over the next decade, she gravitated toward performance, experimenting with film as a means of augmenting her live presence. In November 1983, her expanded film performance *Ablative, Genitive, Dative* was presented in Belfast as part of *Three Days Of Performance Art*, at the Art & Research Exchange (17–19 November 1983). My discussion of it is based on a detailed account of the performance provided by Joan Fowler in a review for *Circa* magazine,[26] and documentation provided by Hegarty, including a telecined video of the film, which includes recorded sound of the artist's mother speaking and singing.

In her review of the live perform-

ance at A.R.E., Fowler describes a small room filled with a 'maze' of paper screens, onto which three words – 'innocence', 'morality' and 'disillusion' – had been written in clear adhesive. Moving through this space, Hegarty revealed these words by covering the screens with powdered colour pigment, before she cut through them in an action that 'represented her journey back to the land of her childhood'.[27] Following these actions, the film was projected, depicting Hegarty in various locations, costumed to suggest two different modes of contemporary, fashionable femininity. She appears in jeans, holding a 16mm film camera, moving first through fields and then the interior of an ecclesiastical ruin, turning to face a man who seems to pursue her, holding a smaller film camera in front of his face. Hegarty's stance, as she confronts this approaching figure, is wide-legged and notably assertive. These scenes are intercut with other sequences in which Hegarty, her long hair hanging loose, wears a skirt and moves through a field laying a trail of soil and red pigment, in which seed-like objects are ritualistically planted.

Many of these actions were reiterated in the live performance, which included a male photographer who followed and recorded Hegarty, until (at the close of the live event) she took his camera and turned it on him. Hegarty's own notes on the performance also describe a final gesture in which a satchel of feathers are disgorged and this echoes a particularly striking film sequence – a close up of a woman's hands tearing the crotch of her jeans apart, before pulling out a mass of tiny feathers. Hegarty's performance is, according to Fowler,

clearly 'sited within post-Lacanian theory; it suggested that our individual consciousness as formed by our culture intervenes in the return to nature which ritual celebrates'.[28] Reflecting on *Ablative, Genitive, Dative* in an interview conducted for this article, Hegarty noted her interest in masquerade, a hugely important concept for many women artists and filmmakers seeking to reclaim narrative from a feminist perspective,[29] while also alluding to the history of video technology and its associations with surveillance and military-industrial research.

A concern with technology is even more pronounced in Hegarty's 1987 video installation *Groundswell* (Fig. 5). Informed by feminist critiques of power, colonisation and militarisation (in relation to Greenham and other contested sites), this work explored parallels between the human body in crisis, as a consequence of disease and invasive medical treatment, and the contaminated or irradiated earth.[30] Devised for the exhibition *Off the Map* at the Chisenhale Gallery, this work consisted of a large, earth-covered mound, marked with powdered pigment, with a red glow emanating from a shallow central pit. The mound was surrounded by twenty domestic colour televisions, entirely wrapped in transparent plastic, displaying a 45 minute video. The video featured unedited action, primarily close-ups of a woman's hands, recorded using live studio effects.[31] The palms are pressed forcefully against glass, or formed into fists that knock or push on this surface, initially clean but then covered in soil, wrung together as though in anxiety or despair. At times, it appears as though

the hands might be reaching up from the soil, or even from within a grave. The only audio is an occasional jolt of abstract noise (possibly electronically generated or altered) synchronised with flashes of colour that appear on screen, blocking or disrupting the images of the hands.

Hegarty continued to use video alongside other media and her 1989 installation *Marital Orders* was exhibited as part of *The Wedding*, a group show at Mappin Art Gallery, Sheffield. The installation consisted of ten black and white photographs on aluminium and a 9 minute video work with audio.[32] Sounds of birdsong and a woman's voice, first humming and then singing the words of the song *She Moved through the Fair*, accompany images of a light-filled room, in which a wedding dress and veil are laid out upon a chair. In subsequent shots, a woman (Hegarty) appears wearing these garments, sitting on the chair and scattering fragments from a dark mass of soil gathered in her lap. This action is interspersed with eye line-matched close-up shots of Hegarty in two guises – as a bride wearing a white veil and a soldier wearing a dark combat helmet. Her mouth is not visible in these images and they were reproduced from the screen in ten photographs displayed either side of the video monitor in the installation at Mappin Gallery. These photographs deliberately emphasise the grid-like texture of the screen from which the images were made, suggesting an analogy between material technologies of video screen and fabric veil.

Marital Orders (Fig. 6) was, according to Hegarty, directly informed by Laura Mulvey's analysis of scopo-

philia, exhibitionism, voyeurism in her widely-cited essay on 'Visual Pleasure and Narrative Cinema'.[33] It is possible to identify continuities in the use of clothing and ritualised action, with her earlier explorations of masquerade and (less directly) her exploration of militarism. But rather than engaging with military technologies of surveillance, or the environmental destruction wrought by the military-industrial complex, *Marital Orders* deals primarily with myths of heroism, strength and sacrifice. Hegarty was prompted to make this work following her own experience (as media consumer) of a specific incident of sectarian violence, in which 'two young British soldiers who got caught up in a republican funeral at Milltown cemetery in Belfast were pulled from the car and murdered'.[34] In an insightful interview, conducted by Shirley MacWilliam, Hegarty frames *Marital Orders* both as an exploration of romantic idealism (in relation to war and love) and as a response to the representation of violence in the news media, citing her shock of 'actually seeing, on the news, the soldiers being dragged from the car'.[35] The production proc-

ess used in the realisation of the photographic images, derived from close-up images of Hegarty in costume, as bride and as soldier, was an attempt to create a distance between action and image, retaining if not attenuating the evidence of mediation.

In 1990, Hegarty completed the 7 minute single channel video *Turas* [Journey] which revisited some of the thematics, of migration and language loss, explored in *Ablative, Genitive, Dative*. If the title of this earlier work suggests an academic relationship to language, then *Turas* (Fig. 7) directly addresses Hegarty's distance from her mother tongue. *Turas* is composed from Super 8 footage shot in 1987 and includes sequences in which Hegarty traces the route of the River Foyle from its estuary to its source in Lough Finn, Co. Donegal, gathering water from the mouth and transporting it to the source. Shots of the river are interspersed with interior scenes in which Hegarty and her mother sit facing each other and perform a series of actions and interactions, including an exchange in Gaelic (which is not translated). The camera dwells on details of bodies and ges-

tures and at one moment, the younger woman's fingers lightly touch her mother's throat as though trying to learn speech through touch. In a rapidly edited sequence, images of ears, hands, throats, are intercut and overlaid with close-ups of the Foyle river.

By comparison with Hegarty's previous works, *Turas* makes its subject matter notably explicit, even for those without access to the Irish (Gaelic) language. These concerns are particularly evident in a series of textual inserts, (including phrases such as 're learn language / re gain mothertongue / re possess speech / re cover culture / re claim history'), which appear on screen at various intervals. In terms of both layout and content, these textual inserts are suggestive of grammar exercises and this clinical and detached display of text clearly differs from the ritualised revelation of words in *Ablative, Genitive, Dative,* suggesting a more self-consciously analytical approach to language. *Turas* was edited at Sheffield

Independent Film, an important production resource for Hegarty and many other women artists and filmmakers based in the north of England during this period.[36] As with several of Hegarty's early works, *Turas* was exhibited in several iterations, including a screening in LUX cinema in the early 1990s and two different installation versions, one of which combined video projection with transparencies in light-boxes arrayed on the floor. Some of these installation versions included only the language learning and exchange scenes, omitting the actions performed along the route of the river Foyle.

Actions, Words and Video Images: Anne Tallentire

A focus on language, particularly in its written form, is also apparent in the work of Anne Tallentire, which encompasses performance, photography, video and sculptural installation. Born (in 1949) and raised in Co. Armagh, in

Fig. 6. Frances Hegarty, *Marital Orders,* 1988, composite installation view. Photos and photomontage: Andrew Stones; copyright © Frances Hegarty 1988, 2018.

Fig. 7. Frances Hegarty, *Turas,* 1990, still images from single-screen video film and installation projection. Photo: copyright © Frances Hegarty 1990.

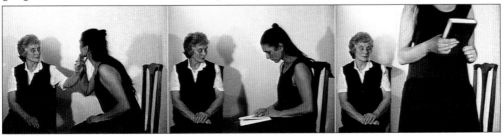

the north of Ireland (as distinct from the Republic of Ireland), Tallentire moved to London in the mid 1980s, completing her postgraduate studies at the Slade in 1988.[37] During her time at the Slade, Tallentire became very actively involved with the extended community of Irish women artists in England and Ireland. In 1987, she collaborated with Alanna O'Kelly (also studying at the Slade) on the video performance *Forbidden Heroines*, which was devised for *Live London Film Makers Co-op (Channel 6)*, an event curated by the artist Tina Keane. Shortly after the Co-op event, the performance was restaged to camera and *Forbidden Heroines* now exists as a stand-alone videotape by Tallentire (17 mins, silent, BW, 1987). The tape opens with a close-up of Tallentire's hands mixing a white substance in a bowl, manipulating it with her hands and then, as the camera pulls back, spreading it over her face and neck. The substance, which might be flour or plaster, gradually hardens and cracks as Tallentire contorts her face with eyes closed, grimacing in discomfort.

During 1986, Tallentire and O'Kelly were also instrumental in the formation of the Irish Women Artists' Group, which hosted a conference on Irish women's art at the Women Artists' Slide Library in London. The conference included papers and presentations from women artists working in range of media, such as Anne Carlisle, Liadin Cooke, Pauline Cummins and Aileen MacKeogh, and it was accompanied by an open submission exhibition of work by women artists, entitled *Eye to Eye*.[38] Tallentire and several members of the Irish Women Artists' Group also partici-

pated in *Off The Map*, an exhibition at the Chisenhale Gallery (5 August – 22 August 1987) featuring mixed media work by six artists. The press release describes the concerns of the group as 'an examination of the contradictory experience of being located between cultures and of not only being Irish but female in Britain in 1987' noting a 'desire to lay tracks and establish territories [...] as metaphor of choosing and reconstructing identity within an adopted culture'.[39] *Off The Map* included works by Frances Hegarty, Carole Key, Rose Ann McGreevy, Rosemarie McGoldrick, Alanna O'Kelly and Anne Tallentire and it was accompanied by a screening of experimental films (Super 8 and 16mm) by Vivienne Dick, Annie Fahnan, Oonagh Hyland and Moira Sweeney, most of whom were then living and working in London.

Altered Tracks (1987, Fig. 8), Tallentire's contribution to *Off The Map*, was an installation and performance work, including recorded audio. Photographs of stones on a map of Tallentire's Armagh homeland were installed on the walls of the gallery and these functioned as the backdrop to a live performance in the gallery. In this performance, Tallentire walked through the space barefoot, drawing lines in charcoal on the concrete floor, using the palm of her own hand as a guide. She then placed stones at various points on the floor markings. These actions were performed in conjunction with an audio recording of 'palmistry interpretations', read by 'one voice in an English intonation and one Irish accented'.[40] The material leftovers of the performance remained in the gallery for the duration of the exhibition – a practice that Tallentire

generally continues in her perform-
ance work. *Altered Tracks* was inter-
preted very directly by Sarah Kent, in
her review of *Off The Map*, as a com-
ment on the future of the north of
Ireland, and the possibility of redraw-
ing or rethinking the border.[41]

Tallentire's Slade Postgraduate
Fine Art Media final show in 1988 in-
cluded a work with a video compo-
nent, called *Bound Words, Stolen
Honey* (Fig. 9), which consists of an
installation of hand-made wallpaper,
depicting a pattern based upon an
image of the spines of books in Sen-
ate House Library, London; a wooden
box and a sheet of glass placed over
a sanded and scrubbed floor; and a
hand-bound book containing photo-
copied transcripts of 'bee-judge-
ments', written in Ancient Irish,
Modern Irish and English. These
'judgements' concern the keeping
and management of bees and they
form part of the *Brehon Laws*, statutes
that governed everyday life in early
Medieval Ireland. A 7 minute video,
displayed on a monitor as part of the
installation, shows a hand turning the
pages of a sun-dappled book, repeat-
edly encountering the same text, with
the distant sounds of what might be
passing traffic. This text, excerpted
from *The Life of the Bee* (1901) by the
Belgian writer Maurice Maeterlinck,
refers to an 'observational' beehive
made of glass, which allows the
author to study the behaviour of city-
dwelling bees.

Altered Tracks and *Bound Words,
Stolen Honey* both employ simple ac-
tions and gestures to explore prac-
tices and systems used to organise
and transmit knowledge concerning
habitats. During this period, Tallentire
was becoming particularly interested

in Michel de Certeau's *The Practice of
Everyday Life* (1984) and his ideas
continued to shape aspects of her
approach to action and site. *The Gap
of Two Birds* (1988, Fig. 10), which
was first presented in an exhibition
curated by David Thorp at The Show-
room in London, also communicates
an ongoing concern with the perfor-
mativity and inadequacy of written
language. The gallery installation in-
cluded a single channel 7 minute BW
video, consisting of footage shot on
Super 8, in a rural part of Ireland. As
with many of Tallentire's moving im-
age works, it depicts relatively simple
actions, incorporating details of
hands, but is much more overtly cine-

Fig. 8. Anne
Tallentire, *Altered
Tracks*, 1987,
performance (20
minutes) and
installation;
photographs
100x100m,
sound, charcoal.
Off The Map,
Chisenhale
Gallery, London.
Courtesy of the
artist.

Fig. 9. Anne Tallentire, *Bound Words, Stolen Honey*, installation; wallpaper, glass, video 7 minutes, book, box, beeswax. 1988 Fine Art Media postgraduate exhibition, The Slade School of Fine Art, London. Courtesy of the artist.

matic in its structure than (for example) the earlier performance video *Forbidden Heroines*. In *The Gap of Two Birds*, the camera is often directed downwards at Tallentire's feet as she traces a route through barren, rocky terrain. According to Jean Fisher, Tallentire consciously did not look through the viewfinder of her hand-held camera as she walked and filmed her route,[42] treating the camera rather as an extension of her entire body. Yet even if not conventionally composed by eye, the filmic image is highly legible and the camera often seems to dwell upon signs of habitation and infrastructure in this bleak landscape, such as pathways, roads and water pipes, undercutting the initial impression of wilderness.

Transferred to video, Tallentire's

film was displayed as a loop on a monitor in the gallery along with several glass panels, which were inscribed with the words 'NORTH and 'SOUTH'. During a five hour performance, she made rubbings in charcoal from the glass panels onto sheets of white paper. The rubbings were then offered by Tallentire to audience members, who were then invited to explain their choice of either 'NORTH' or 'SOUTH', a process that seems intended to complicate (through abstraction as well as interaction) any easy opposition suggested by these designations. Although she has rarely engaged in such direct interaction with her audiences, Tallentire has continued to investigate the relationship between performed action, site and communication, sometimes combining video with newer technologies. Her 1994 work *Inscribe I*, for example, used ISDN to establish a connection between two urban spaces that were usually closed to the public, by transmitting documentation of actions performed to camera in a British Telecom building (in London) to a viewing audience located in a telecommunications exchange in Dublin.

Conclusion: Collaboration and Continuity

As already noted, only a relatively small number of Irish women artists actually worked directly with video in the 1980s. Nonetheless, it was a vitally important medium for women artists and activists seeking to analyse and challenge structures of representation from both feminist and post-colonial perspectives. Sharing a common interest in language, migration, and place, Hegarty, O'Kelly and Tallentire

all integrated video with other non-traditional media, including (for example) live performance, audio, installation, text and photography. They repeatedly used video, or film transferred to video for exhibition, as a way to document their own bodies engaged in semi-choreographed movements or tasks, ranging from quasi-ritualistic gestures to more mundane actions. These actions, gestures, and rituals were performed to camera in relatively neutral studio-like or white cube environments, as in the case of Tallentire's *Forbidden Heroines*, or they were devised in relation to specific sites or situations, at some remove from the gallery. In some of the works discussed, such as *Dancing with My Shadow* by O'Kelly or *The Gap of Two Birds* by Tallentire, video seems to have functioned partly as a pragmatic mechanism for integrating recorded site-responsive performance into the space of the gallery, for presentation alongside objects or live actions. But other works, particularly by Hegarty, exploit the aesthetic properties of video or its cultural associations with television and news media. *Marital Orders* for example, was conceived as a response to the experience of viewing TV news, drawing attention to the screen as boundary. Hegarty also embraced the technical capacities of live video image processing in *Groundswell,* and subsequently used video to integrate text with choreographed action in *Turas*.

All three artists were (and still are) highly attentive to the ways in which written or spoken language can shape and sometimes constrain the articulation of personal and historical experiences, with O'Kelly and Hegarty both drawing on Irish folk traditions in their

use of song, speech, and other forms of sound. O'Kelly, for example, used the traditional Irish lament form of keening to suggest continuities between cultural and personal loss, while also recasting this folk practice as a contemporary tool of political protest, which could be deployed in many contexts (against militarism, or cultural amnesia). As Katy Deepwell has noted, many Irish women artists were interested in language and motherhood,[43] and these concerns are especially evident in video works by both O'Kelly and Hegarty. O'Kelly often favoured wordless verbal communication, but her video *Dancing with My Shadow* was specifically prompted by the writing of a letter, to her deceased mother. Hegarty's videos tend, on the whole, to place equal emphasis on verbal and written communication, as evidenced by expanded the film performance *Ablative, Genitive, Dative*, which involved the performative revelation of hidden words on pigmented paper screens, accompanied by sounds of her mother speaking and singing. In *Turas*, the Irish language is described quite literally as a 'mother tongue',

Fig. 10. Anne Tallentire, *The Gap of Two Birds*, 1988, performance (5 hours) and installation; video, wooden screen 244 x 244cm, glass, text on acetate, paper, charcoal, photographs. The Showroom, London. Courtesy of the artist.

and the video seems to suggest parallels between Hegarty's mother's body and the river Foyle, as sources. But even through she refers to the recovery of lost history and identity, Hegarty does not entirely naturalise the acquisition of the Irish language. Instead, she stages an almost clinical scenario of choreographed 'learning'; she itemises her own aspirations (to 're cover' language) on screen and engages in a quasi-scientific transposition of water from the river's mouth to its source.

If Hegarty's work often hints at gaps in meaning, whether through choreography and typography, then Tallentire is even more attuned to cultural and social processes that complicate or disrupt communication and knowledge production. Tallentire is particularly sensitive to acts of naming and to the institutional structures that intersect with everyday behaviours, habits and practices. These concerns are apparent both in *Bound Words, Stolen Honey*, with its evocations of hives and libraries, and in *The Gap of Two Birds*, which performatively explores divisions of space, and place, through the interplay of live and recorded actions. The filmic component of *The Gap of Two Birds* potentially invites comparison with both *Turas* and *Dancing with My Shadow*, since all three works incorporate performative responses to places that are predominantly rural and also watery. Yet whereas Hegarty and O'Kelly are attracted toward ostensibly natural flows of water, such as rivers and the sea, Tallentire is more attentive to the human made structures that determine these flows.

Perhaps coincidentally, Hegarty, O'Kelly and Tallentire have all been drawn toward collaborative modes of production in recent decades, establishing shared practices with male peers. In 1993, for example, Anne Tallentire formed 'work-seth/tallentire', a collaborative practice with the British artist John Seth, while also continuing to produce and exhibit work under her own name. Since 1997, Fran Hegarty has produced much of her work with Andrew Stones, co-authoring numerous video, installation and public art works under the name Hegarty and Stones, in addition to solo projects.[44] Alanna O'Kelly has also collaborated with the artists Brian Hand and Orla Ryan, realising a public art commission in 2016 as the group Stormy Petrel/Guairdeall. These collaborations are worthy of attention in their own right, and it would be interesting to know if similar trajectories might be traced in the practices of women artists based elsewhere in Europe. Equally, the interconnections during the 1970s and 1980s between women's video art and other forms of critical media practice (ranging from experimental film to activist documentary and feature drama) may merit further consideration, both within and beyond the Irish context. These are just some of the many questions that might be explored, and answered, through shared histories of European women's video art.

Acknowledgements: Sincere thanks are due to Valerie Connor, Anne Crilly, Vivienne Dick, Sara Greavu, Margo Harkin, Frances Hegarty, Emma-Lucy O'Brien, Sunniva O'Flynn, Alanna O'Kelly, Orla Ryan, Andrew Stones and Anne Tallentire for their invaluable assistance during the research process.

Endnotes

1. Joan Fowler, 'Speaking of Gender ... Expressionism, Feminism and Sexuality', in *A New Tradition: Irish Art of the Eighties* (Dublin: Douglas Hyde Gallery, 1990), p. 56.

2. *Ibidem*.

3. Kate Antonik-Parsons, 'The Development of Performance Art in the 1980s and the Early 1990s' in Áine Phillips (ed.), *Performance Art in Ireland: A History* (London and Bristol: Live Art Development Agency and Intellect, 2015), p.177.

4. While there are no archives or study collections focused on Irish artists' moving image, MExIndex, a modestly resourced, but nonetheless important database of Irish artists' moving image was established in 2015. It provides information on the work of several women artists active in the 1980s, including Anne Tallentire and Vivienne Dick. See http://www.mexindex.ie/artists/ (accessed 4 April 2017). I discuss the absence of archives and study resources dedicated to Irish artists' moving image in 'Archiving Irish and British Artists' Video: A Conversation between Maeve Connolly and REWIND researchers Stephen Partridge and Adam Lockhart', *MIRAJ*, v. 5, n. 1&2, 2016, pp. 204–215.

5. Irish artists working with the moving image have represented Ireland at many major international exhibitions, including the São Paulo Biennial (Alanna O'Kelly in 1996, Clare Langan in 2002, and Desperate Otimists in 2004) and the Venice Biennale (Jaki Irvine in 1997, Anne Tallentire in 1999, Grace Weir and Siobhan Hapaska in 2001, Gerard Byrne in 2007, Kennedy Browne in 2009, Richard Mosse in 2013, Sean Lynch in 2015 and Jesse Jones in 2017).

6. I have cited many of the key sources on Irish women's video art in this chapter, including catalogue essays, published interviews and exhibition reviews. Other sources include Shirley MacWilliam, 'Screen and Screen Again', *Circa*, n. 100, Summer 2002, pp. 42–49, and various contributions to the multi-volume anthology *Art and Architecture of Ireland* (New Haven: Royal Irish Academy and Yale University Press, 2014). My research also draws upon email correspondence and personal interviews with Frances Hegarty, Alanna O'Kelly and Anne Tallentire, conducted in late 2016 and early 2017.

7. There was a short-lived attempt to establish a cooperative-type initiative at Project Arts Centre in Dublin around 1976. See Maeve Connolly, 'Sighting an Irish Avant-garde in the Intersection of Local and International Film Cultures', *Boundary 2: International Journal of Literature and Culture*, v. 31, n. 1, Spring 2004, pp. 244–265.

8. For a discussion of this context see Peter Murray, 'Introduction', in Peter Murray (ed.), *0044 – Irish Artists in Britain* (Cork: Crawford Municipal Gallery, 1999), pp. 9–14.

9. For a history of this organisation, see Chris Coppock, 'A.R.E. – Acronyms, Community Arts and Stiff Little Fingers', *The Vacuum*, n. 11, 2003. http://www.thevacuum.org.uk/issues/issues0120/issue11/is11artartres.html (accessed 4 April 2017])

10. Born in County Antrim, Northern Ireland, in 1956, Carlisle was editor of *Circa* from 1983 to 1989. See Jane Spender's profile, 'Anne Carlisle', in the exhibition catalogue (edited by Peter Murray) *0044 – Irish Artists in Britain*, pp. 24–31. See also my discussion of Carlisle's media artwork *Another Standard* (1988) in 'Artangel and the Changing Mediascape of Public Art', *Journal of Curatorial Studies*, v. 2, n. 2, 2013, pp. 204–205.

11. For discussion of some key exhibitions and initiatives see Katy Deepwell, *Dialogues: Women Artists from Ireland* (London and New York: I.B.Tauris, 2005), p. 4.

12. This work involved images of traditional knitted textile patterns projected onto male bodies. It was subsequently transferred to video and included in the exhibition *A New Tradition: Irish Art of the '80s*, at the Douglas Hyde Gallery, Dublin. In 1992, Cummins and Louise Walsh realised *Sounding the Depths: A Collaborative Installation at IMMA*, consisting of a back-projected video, and a series of images on light boxes, accompanied by a soundtrack, exploring attitudes toward the representation of the female body.

13. Claire Johnston, 'Maeve', *Screen*, v. 22, n. 4, Winter 1982, pp. 54–71; and Paul Willemen, 'An Avant Garde for the Eighties', *Framework*, 24,1984, pp. 53–73.

14. For analysis and documentation relating to the 'workshop' programme, see Margaret Dickinson, *Rogue Reels: Oppositional Film in Britain, 1945–90* (London: BFI Publishing, 1999).

15. Belinda Loftus, 'Review of *Mother Ireland*', *Circa*, n. 44 (March/April 1989), pp. 33–34 and p. 99.

16. See Johnny Gogan, 'Derry Film and Video Collective', *Film Base News*, n. 3 (September/October 1987), pp. 10–11.

17. Jessica Scarlata, *Rethinking Occupied Ireland: Gender and Incarceration in Contemporary Irish Film*, (Syracuse: Syracuse University Press, 2014), p. 67.

18. *Ibidem*, p. 67.

19. See Connolly, 'Sighting an Irish Avant-garde in the Intersection of Local and International Film Cultures', pp. 253–254.

20. Alanna O'Kelly provided details of this and other early works in a personal interview, 16 January 2017.

21. O'Kelly was one of many artists inspired by, or engaged in, the protests at Greenham Common in the early 1980s. Jean Fisher discusses both *Chant Down Greenham* and a video by Tina Keane (a British artist of Irish descent), entitled *In Our Hands, Greenham* (1984), in 'Reflections on Echo: Notes Towards a Dialogue on Sound by Women Artists', in *Vampire in the Text: Narratives of Contemporary Art* (London: Iniva, 2003), pp. 165–166.

22. This exhibition also included work by Anne Carlisle.

23. The video component of *Still Beyond the Pale* is not available to view, as it seems to have been lost (the circumstances are unclear). The work was described to me by Alanna O'Kelly (interviewed by phone on 16 January 2017).

24. Sarah Kent, 'Preview', *Time Out*, 13 August 1987. Kent's text is one of several documents included in the Chisenhale Gallery's online archive of materials relating to *Off the Map*. http://chisenhale.org.uk/archive/exhibitions/index.php?id=158 (accessed 4 April 2017).

25. This work won a major prize when first exhibited and continues to be recognised as one of the most important responses to the legacy of famine by an Irish artist. See Catherine Marshall, 'Modern Ireland in 100 Artworks: 1994 – The Country Blooms, A Garden and a Grave by Alanna O'Kelly', *The Irish Times*, 21 May 2016. http://www.irishtimes.com/culture/modern-ireland-in-100-artworks-1994-the-country-blooms-a-garden-and-a-grave-by-alanna-o-kelly-1.2655006 (accessed 4 April 2017).

26. Joan Fowler, 'Three Days of Live Art, 22 Lombard Street, Belfast. 17–19 November, 1983', *Circa*, No. 14, January–February, 1984, pp. 38–40. Hegarty is credited as Frances Saunders in this review.

27. *Ibidem*, p. 39.

28. *Ibidem*.

29. As a lecturer at Psalter Lane Art School (subsequently absorbed into Sheffield Hallam University) in the 1970s and 1980s, Hegarty led the establishment of a department of performance art and hosted talks by numerous visiting women artists including Alanna O'Kelly as well as Helen Chadwick, Mona Hatoum, Suzanne Lacey and Carolee Schneeman.

30. In documentation accompanying this work, Hegarty specifically cites the actions and statements of the Greenham Common women activists, in addition to the writings of theorists such as Julia Kristeva, Lucy Irigaray, Elaine Showalter and Susan Sontag.

31. Only some of the original *Groundswell* master tape is currently playable – these sections were digitised and restored by Frances Hegarty and Andrew Stones and made available for me to view (online) as part of the research process for this chapter.

32. Elements of this work have also been exhibited separately, and the videotape was broadcast on Yorkshire TV. The original *Marital Orders* master tape is currently only partially playable and the clearest sections were digitised and restored by Frances Hegarty and Andrew Stones and made available for me to view (online) as part of this research process.

33. Laura Mulvey, 'Visual Pleasure and Narrative Cinema', *Screen*, v. 16, n. 3, Autumn 1975, pp. 6–18.

34. Hegarty, 'Frances Hegarty: Multiple and Transparent Images – interview by Shirley MacWilliam', in Peter Murray (ed.), *0044 – Irish Artists in Britain* (Cork: Crawford Municipal Gallery, 1999), p. 81.

35. *Ibidem*.

36. Sheffield Independent Film was founded in 1976–77 by some of the same women filmmakers responsible for establishing Sheffield Film Co-op (in 1973). See the 'Sheffield Film Co-op' interview and chronology in Dickinson, *Rogue Reels*, pp. 289–303.

37. Tallentire noted her interest in working with Lis Rhodes, Stuart Brisley, Susan Hiller, all of whom were then teaching at the Slade. Personal interview with Anne Tallentire, Dublin, 12 December 2016.

38. This exhibition is cited by Deepwell, *Dialogues,* and Fowler, 'Speaking of Gender ... Expressionism, Feminism and Sexuality'.

39. The press release is included in Chisenhale Gallery's online archive of materials relating to *Off the Map*. http://chisenhale.org.uk/archive/exhibitions/index.php?id=158 (accessed 4 April 2017).

40. A description of this work, provided by Tallentire can be found in the biographies section of Áine Phillips (ed.), *Performance Art in Ireland: A History* (London and Bristol: Live Art Development Agency and Intellect, 2015), p. 300.

41. Sarah Kent, 'Preview', *Time Out*, 13 August 1987.

42. Jean Fisher, 'Dancing on a Tightrope (For Anne Tallentire)', in Valerie Connor (ed.), *Anne Tallentire* (Dublin: Project Press, 1999). This publication also included essays on Tallentire's work by John Seth and Sabina Sharkey.

43. Deepwell, *Dialogues*, p. 5.

44. *Hegarty* had a solo retrospective titled *Self-Portrait* at The Model and Niland Gallery in Sligo, Ireland in 2003.

Highly Limited Access: Women and Early Video Art in Poland

Marika Kuźmicz

Beginnings. A Man's World

The analysis of women's video art created in the Polish People's Republic in the 1970s opens up the possibility of a broader discussion of the situation of Polish women artists. This arises because the medium in question highlighted the problems that concerned the women artists in that period. The goal of my essay is therefore not only to discuss the individual art works, but also to review the social and sociological situation of their makers. I believe it is the only way to search for real answers to important questions: why did women artists create so few works in the pioneering period of video art? And, were there really as few of them as it can be concluded, for instance, on the basis of public contemporary art collections in Poland?

For that matter, the genesis of Polish video art is already significant and symptomatic – a phenomenon that began in 1973. As John Hanhard,[1] among other authors, wrote with reference to the international situation of video art, it came into being as a medium that stood in opposition to the institution of television. Its creators originated from the field of art and adopted a critical stance towards the dominant role of the media in the society. They usually had no direct affiliation with the television industry or cinematography. The emergence of portable cameras offered them a chance to break the hegemony of television, since it provided creators with new tools, hitherto elitist and available only to representatives of the television industry. In Poland, portable video cameras were unavailable during that period, akin to many other goods and services (often including even telephones in private apartments). In Poland under Communism, the early days of the new medium are related to the milieu of professional producers acquainted with the principles of television production. Video art originated from the circle of the group Workshop of the Film Form (WFF), which was established in 1970 by students and graduates of the Film School in Łódź. Manifesting their interest in new media, the WFF artists

initially worked mainly with photography and film. They most often hailed from the Direction of Photography Department and possessed specialised skills in the field of film and television production. To a certain degree, the WFF members operated independently of the Film School. They emphasised their affiliation with the art field, they questioned official commercial cinematography, opposing that system by means of their subversive actions, but at the same time they tapped into the Film School's infrastructure as well as knowledge and experience acquired there. In the initial period of their activity, that situation resulted mainly in the production of films on 35mm film stock by means of professional film cameras. In the course of time, the WFF members began to tap into a new tool that became available to them as students of the Film School – video. In the winter of 1973, they used the school's broadcasting truck in order to create the first video work in Poland: *Transmisja telewizyjna* [Television Transmission]. That project was pursued within the group's collaboration with the Muzeum Sztuki [Museum of Art] in Łódź. For nearly three weeks, the WFF members carried out various interventions in the Museum space, including the above mentioned work, which consisted of transmitting images from a private apartment in Łódź, a cobbler's workshop and a street corner near the Museum building into the Museum interior.

In 1973 and during the years following, the WFF created artworks with video using the broadcasting truck, the television studio and later CCTV cameras to which the Film School students had access. The WFF members largely monopolised the field of video art in Poland for an obvious reason: they enjoyed the possibility of using the equipment that was indispensable for such productions and unavailable to anyone else. I am making a brief mention of the history of the WFF and its influence on video art in Poland, not only because the group's activity in the field had a pioneering character and marked a breakthrough moment, but also because throughout the entire period of the WFF's work (1970–77/78) its activity engaged forty male artists, and not a single woman artist. When asked about that situation, the WFF members replied that few women studied at the Film School in the 1960s and 1970s[2] (apart from in the acting department), and therefore, the lack of female participants of the group came as a natural consequence. If we accept this explanation, without making detailed enquiries into the Film School's policy with regard to potential female candidates to cinematographic studies, we still need to remark that, as a consequence, women artists in Poland were denied even the same limited technological potential that was available to the narrow circle of male artists. They were deprived of it for reasons that can be described as an institutionally sanctioned exclusion. Often repeated in the source literature, the statement that video art was a democratic medium, developed in opposition to the elitist medium of film and, above all, to the phenomenon of television (which is watched by masses but shaped by a handful of people) does not find confirmation in the Polish context – in the 1970s, video was an elitist medium in Poland, and the above described circumstances indicate that it

was particularly unavailable to women artists. That new field of art did emerge in Poland, but it automatically became a domain of a narrow circle of male artists.

Summarising her research for the exhibition *The First Generation. Women and Video 1970–75*, JoAnn Hanley wrote:

> However, compared to the small number of women artists traditionally included in exhibitions of sculpture or painting, video programs and exhibition catalogues of the 1970s (including special exhibitions such as the 1973 and 1975 Whitney Biennials, the 1976 Paris Biennial, and documenta 6 in 1977) list of (a) surprising number of women. [...] It offers an early history of the development of video as a medium as well as evidence of the significant role women played in the creation and definition of a new way of making art. It was, perhaps, the first time that men and women artists worked in a new medium on equal footing. Mary Jane Jacobs has suggested that women were especially drawn to video because 'access to video (as to performance, photography and installation art also emerging in the 1970s) allowed women and others – until then marginalized by the mainstream – to have an equal voice. Through these new genres they could proclaim a place for themselves in the art world that could not be achieved by the Western, male dominated field of painting. Without the burdens of tradition linked with other media, women video artists were free to concentrate on process, often using video to explore the body and the self through the genres of his-

tory, autobiography [...]. Women also used the new medium to create social and political analyses of the myths and facts of patriarchal culture, revealing the socioeconomic realities and political ideologies that dominated everyday life.[3]

As we already know, the situation of women artists in Poland looked entirely different and reflected the difficult situation of women in the Polish People's Republic, where the Communist Party authorities – against their initial official declarations and postulations concerning the equality of the sexes – limited women's access to some professions since the end of the 1940s, did away with women's organisations in order to eventually practically withdraw from the postulations of the 'equality of the sexes'.[4] The social system was founded on the vision, sanctioned top-down and unreal, of alleged equal rights of the sexes, whose consequences can be felt to the present day.

Polish women artists began to claim their place in art history only in the 1970s owing to, among other reasons, the influence of the international Feminist movement. Yet – as we shall see – it is difficult to say that they adopted Feminist strategies. It seems that adopting such strategies would inevitably bring about their marginalisation in the realm of the Polish art world as well as repression beyond that field by male artists. That is why women artists made use of the widespread Post-Conceptual artistic language and usually avoided direct references to the questions of gender identity and the social situation of women – if such content did appear, it was usually hidden under the veil of 'cold' analytical works. An exception

Figs. 1a-b
(facing pages).
Ewa Partum,
TV-Drawings,
1976.
Courtesy of the
artist.

in the field of new media is repre-
sented by the oeuvre of two women
artists of key importance for Polish art:
Natalia LL and Ewa Partum. Still, we
need to note also that their approach
in the 1970s is usually defined by re-
searchers as 'Feminist intervention'[5]
or 'intuition',[6] rather than strategy.

To return to the question of video
– the emergence of the new medium
in Poland did not bring about a
change in the situation of women art-
ists: the kind of liberation or freedom
of formulating an artistic statement as
described by Hanley. On the contrary,
they suffered yet another exclusion. It
is perhaps not far-fetched to say that
they resorted to what I call a 'formal
mimicry', which they had also used in
the fields of film and photography.
Later, such an approach also ap-
peared in the field of video, which they
additionally found so difficult to enter.
For all of these reasons, few women's
works in this medium were created in
Poland in the 1970s; what is more, the
majority of them have not been pre-
served. The works in question were
made above all by Jolanta Marcolla

(b. 1950) and Jadwiga Singer
(1955–2012).

Apart from the two above-men-
tioned artists, Izabella Gustowska
also began to use video towards the
end of the 1970s. The artist had
worked with film, among other media,
since the beginning of that decade. In
the case of Marcolla and Singer, all we
have at our disposal is the photo-
graphic documentation of works (in-
stallations) and preparatory drawings.
Symptomatically, these two artists,
whose oeuvre is an important contri-
bution to this aspect of Polish video
art in its early days, disappeared with
time, not only from the video circuit,
but also essentially from Polish art
history. The practice of Marcolla and
Singer has been almost entirely for-
gotten about and never explored in a
more profound way, probably also be-
cause video art in Poland, created by
both men and women, took a long
time to attract a broader interest of
researchers, few of whom noticed the
separate nature of the medium and
the necessity of developing an ade-
quate language to discuss it (a mono-

graphic study of the history of Polish video art still remains to be written).

There are specific reasons why I have decided to include several film works within the scope of this text. These are two projects by Natalia LL and Ewa Partum's work, *TV-Drawings* (1976, Figs. 1a-b). However, what I do not discuss here are the remaining works by these artists, which are important for the art of the 1970s in general and for Feminist art in particular (Partum's *Poem by Ewa*, *Self-Identification* and *My Problem Is a Problem of a Woman*; and Natalia LL's *Consumer Art, Post-Consumer Art*), because in these works the artists made use of a film, and not a video camera, a fact without particular relevance in these cases. For the same reasons, I do not discuss some other projects: works by Anna Kutera and Teresa Murak from the 1970s, as well as Teresa Tyszkiewicz's films from the 1980s with a heavy Feminist underpinning, because in these instances the choice of medium does not influence the form – the camera is reduced exclusively to the role of a recording device. In turn, I do focus on Izabella Gus-

towska's work, because her 16mm film *Względne cechy podobieństwa* [Relative Similarities] (1979) clearly indicates the direction of her further explorations in the sphere of video.

Ewa Partum

Ewa Partum (b. 1945) initially studied at the State Higher School of Visual Arts (PWSSP) in Łódź and later at the Academy of Fine Arts (ASP) in Warsaw. Partum became an artist of key importance for Polish art. She initially carried out performances in the public space, which originated from her interest in concrete poetry (scattering cut-out paper letters in various locations), and in the mid-1970s went on to focus above all and nearly exclusively on Feminist art and avant-garde film.

The aforementioned work, *TV-Drawings*, sits within a broader global current of projects pursued by artists with the use of television transmission. The artist operated on a TV screen which displayed a news broadcast filled with propaganda delivered by the country's Communist Party lead-

ers. Using a felt-tip pen, Partum drew geometric figures on the screen. Her simple gesture betrayed a strong political edge, which was not a frequent phenomenon in the Polish art of the 1970s, and something almost absent from women's art. Tapping into the limited possibilities existing under the totalitarian reality, Partum used the private space of her apartment and laid bare the propaganda message of the media and their ideologisation.

Natalia LL

Two works created by Natalia LL in the 1970s manifest a common characteristic, which is important for our reflection – the use of a film camera in a way in which a video camera could have been used instead. Natalia LL (b. 1937) graduated from the State Higher School of Visual Arts (PWSSP) in Wrocław in 1963. In 1970, alongside Andrzej Lachowicz and others, she established the PERMAFO group. Under the same banner, the artists also ran a magazine and a gallery, which soon became a landmark on the map of avant-garde art in Poland. The members of PERMAFO wrote in the group's manifesto: 'The photographic or film camera lens and photosensitive materials may witness phenomena that escape us from one second to the next. [...] we are interested in reality only'.[7] In line with that declaration, in the early period of her practice, Natalia LL concentrated primarily on recording the everyday.

The first of the discussed works by Natalia LL is *Rejestracja permanentna co 1km autostrady E22* [Permanent Record of Every 1 km of the E22 Motorway] (1970), which records the image of a road as seen from a car

window. The manner of using the camera (let us remember that a New York City street seen from a car also provides the motif of Nam June Paik's work recognised by many as the first video art project) clearly suggests an interest in the process of recording, which is parallel to action and could easily become a transmission. What mattered for Natalia LL was a record that was simultaneous to action as well as everything that the recorded reality could reveal, owing to such a manner of recording. This way of thinking is close to experiments pursued by many artists who worked with video and provides a reason to assume that Natalia LL would have used a video camera in *Permanent Record* if only, to put it plainly, it had been available to her – such a tool would have been more adequate in that situation than the film camera.

Insofar as *Permanent Record* is a project that sits comfortably in the main current of Post-Conceptual art in Poland during that period, in the course of time, the artist began to transpose her experiences onto the Feminist territory. Natalia LL's presence in the field of Feminist art betrayed a non-linear character. After her return from a scholarship in the USA, she attempted to spread Feminist ideas in Poland by organising the first exhibition devoted to such issues in the country,[8] among her other initiatives. Yet, given the lack of understanding for her activities, she distanced herself from the problematic of Feminism in the later period.[9] Nevertheless, her works, which undermined the language of Conceptual analysis that dominated in Poland, were and still are read as manifestos of Feminist views. I evoke here the

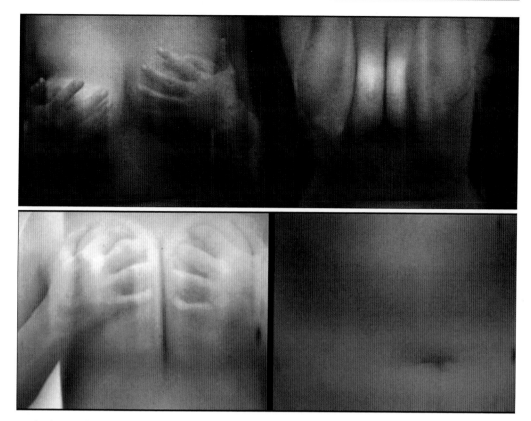

work *Impresje* [Impressions] (Figs. 2a-b) from 1973, which, although recorded on 16mm film stock, represents the broad tendency of 'autobiographic' video. Using portable video cameras, women artists portrayed themselves, often in the interiors of their own homes, and made use of their own image to convey meaning. *Impressions* is Natalia LL's self-portrait created probably in her own apartment. Her face is invisible, but we can see her young, vital body, which becomes a source of joy, fun, and pleasure – the body can be touched and squeezed. *Impressions* provides an image of conscious corporeality – an image that was rare in the art of Poland under Communism. The work is a joyful, spontaneous story about female subjectivity, a film self-portrait, which, despite its differ-

ent appeal, can nevertheless be compared with other video self-portraits, such as, for instance, the canonical work by the Canadian artist Lisa Steele, *Birthday Suit with Scars and Defects* (1974).

Jolanta Marcolla

The first woman in Poland to create four video artworks in 1975 was the aforementioned artist Jolanta Marcolla, who began her studies at the State Higher School of Visual Arts (PWSSP) in Wrocław in 1970. Alongside Zdzisław Sosnowski, she established the artistic group Gallery of Current Art (Galeria Sztuki Aktualnej). At the Studio of Visual Activities and Structures, run at the Wrocław school by Professor Leszek Kaćma, Marcolla

Figs. 2a-b.
Natalia LL,
Impresje
[Impressions],
1973, 16mm film.
Courtesy of
Natalia LL and
lokal_30 gallery
Warsaw.

wrote her dissertation *Badania akty-wności struktury wizualnej przekazu telew izyjnego dla potrzeb reklamy i propagandy* [Study of the Activity of the Visual Structure of Television Transmission for the Needs of Advertising and Propaganda] which is particularly valuable for our present reflection. The text was penned on the basis of the artist's earlier internship at a television studio, which allowed her to discover the principles of the organisation of work and general methods of television production. In the first part of her text, Marcolla addressed the situation at the television centre in a critical way. Broadcasts were created according to a scheme established many years before, directors and scriptwriters did not introduce any new ideas, and set design was characterised by naive literality – '[...] film editing: consists exclusively in cleaning the material [...] the editing table offers an immense potential of manipulating reality. Completely untapped apart from removing "dirt" and "hiss" [...]; the television camera is essentially treated as a static tool of passive reproduction [...] camera operators are paid for keeping the image in focus'.[10]

In the second section of her dissertation, where she analysed television as a mechanical reproduction device, Marcolla addressed the questions that interested her and used that experience to draw conclusions, which were later reflected in her artistic practice. The artist analysed the trust placed by the viewers in television transmission and the consequences of that situation. She related it to the broadly described question of the credibility of mechanically generated images for human perception, from photography, to film, to television:

> [...] The invention of film made it possible to further broaden the field of possibilities of reproduction, since it was able to represent reality in time. That fact further enhanced the belief in the real presence of the basis and material of reproduction, which is reality. In turn, television introduced another important characteristic, namely the temporal simultaneity of representation and reality. [...] What is more, television achieved something hitherto impossible: it transmits images of reality to any place at the same time, as if it defeated space.[11]

Since the beginning of her studies, Marcolla was searching for her individual manner of formulating artistic statements; she abandoned painting and turned to photography and film:

> I was exploring the arcane details of the painting workshop, study drawing, principles of composition and selection of colours, and it slowly began to occur to me that I was stuck in a closed and ossified world of values, because when you stand in front of a canvas with a paintbrush in your hand, you can only copy someone else's achievements and make use of someone else's experiences.[12]

These words bring to mind the statement of another woman artist, who also abandoned painting for film, and later for video. Catherine Elwes (b. 1952) reminisced in one of her interviews about the breakthrough moment of her practice:

> I think initially it was an impatience with painting. I needed a more direct and immediate way of communicating the stories that were in my

Fig. 3. Jolanta Marcolla, *Dimensions*, 1975, photo of the backstage. Courtesy of the artist.

head and that I was trying to get out. For me the difference between film and video was like the difference between painting and drawing. I also didn't like the waiting. Video was a bit like having a pencil with a rubber. I could put something down, and if I didn't like it I could just rub it out. I started working with performance first, and then incorporated video into the performance, then abandoned performance and worked exclusively on tape. The only difficulty was how you convinced your audience that it was a female sensibility that was being expressed.[13]

Marcolla's reflection bore the fruit of four video works created in the studio of Polish Television in 1975: *Dimension 1, 2, 3* and *4* (Fig. 3; Figs. 4a-b). The videos lasted between 5 and 15 minutes, but, unfortunately, they are known today only from photographic documentation. Invited to participate in the IV International Open Encounter on Video at the Centro de Arte y Communication in Buenos Aires, the artist sent the only existing copy of the material, which she never received back. What remained is a set of photographs, which has not only a purely documentary value, but also demonstrates something more than the works themselves – it is a record of an activity of a woman artist working in the 1970s in Poland. The preserved photographs show her focussed, looking into the camera lens to check if everything works or taking part in her own projects as a participant-performer. The works were created in a television studio, but they never aired – it wasn't her intention. In her situation it was impossible – a person not affiliated with television society and environment, had no opportunity to broadcast her own tv-show. Marcolla's *Dimensions* are video-installations on the basis of which we can analyse the phenomenon of transmission; their function was rather that of 'mock-ups' that illustrated the operating principle of television transmission.

Dimension 1 (Fig. 5) featured two people: the artist and a studio employee, sitting on two sides of a wall.

Figs. 4a-b.
Jolanta Marcolla,
Dimensions,
1975, photo of
the backstage.
Courtesy of the
artist.

On each side there was a camera and a monitor; the camera transmitted the image from behind the wall onto the monitor. The participants could talk to each other, but only in a mediated way. As Marcolla wrote in the script of the work:

The video camera transmits that secondary situation to the monitor. Three elements: video monitor which transmits the situation, TV set which shows a specific pro-gramme, and a general view of the studio are recorded on video. A situation is created in which two people contact one another only by means of cameras and monitors.

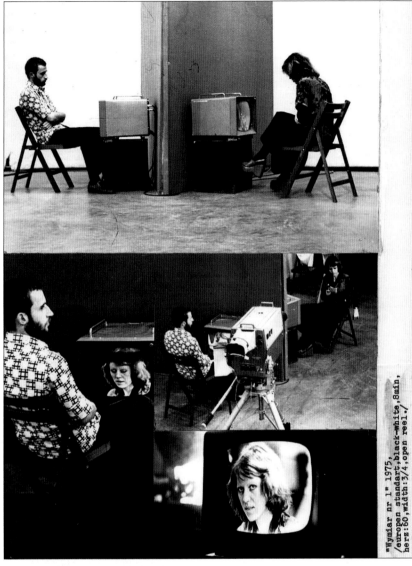

Fig. 5. Jolanta Marcolla, *Dimension 1*, 1975. Courtesy of the artist.

Camera A, which records the face of one person, transmits it to monitor A1 – available only to the other person. In an analogous manner, camera B transmits the image of the other person to monitor B2. Each of the people has one camera/recording and one monitor/transmitting the image of the partner's face/within their field of vision. A partition is installed between the two people, which separates them. The entire setup is recorded with a video camera.[14]

The other three works were also based on the phenomenon of transmission. In *Dimension 2*, the artist was sitting between two monitors which displayed the transmitted the image of her face; in the following work, a monitor displayed the transmitted image of the artist taking photographs of the studio, whereas the last work from the cycle consisted in a transmission

to the monitor of the image of the artist and, subsequently, all studio employees in her company.

Several months later, in November 1975, the works were shown at the CAYC. Marcolla was the only Polish woman artist who participated in that presentation.[15] The only existing copies of the tape were never returned to her.

Jadwiga Singer

Few materials have been preserved that document the activity of the Laboratory of Presentation Techniques (Laboratorium Technik Prezentacyjnych, LTP) – a group founded in 1975 by students of the Academy of Fine Arts (ASP) in Katowice. Film tapes and photographic documentation have probably survived until today only in the archive of one of the founding members of the collective, Grzegorz Zgraja (b. 1952). Since the 1980s, Zgraja has lived in Germany, where he lectures at the Academy of Fine Arts in Braunschweig. The artist was one of the four members of the group who formed its core. Besides him, the Laboratory of Presentation Techniques (as Zgraja recalls, the name of the group posed certain difficulties, and therefore slightly later the members began to use an abbreviated form: Laboratory TP) comprised Jadwiga Singer, Jacek Singer and Marek Kołaczkowski, who were engaged to a varied degree in pursuing activities with video. According to source materials – catalogues of the group's several exhibitions – Jadwiga Singer created a group of video works and penned the majority of texts that described the group's activity. Unfortunately, probably only one of Singer's

film works has been preserved, *Koniec, koniec* [The End, the End] (16mm, 1979), and few photographic works. As Zgraja recalls, the establishment of the group was a spontaneous gesture of several dozen students from the first year of studies at the ASP in Katowice who felt frustrated by the level of education at the Academy and the approach of the teachers to the interest in new media manifested by students.

Neither at that time, nor later, did the group write a manifesto. A gesture that inaugurated its activity came in the form of an extraordinary exhibition held on the staircase of the Academy's building. Everyone willing to take part was welcome to do so, and the make-up of the LTP crystallised from amongst the participants. The leitmotif of the show was portrait, and its premise was very open – everyone was supposed to create their own work devoted to the topic. The students created an environment of sorts, annexing for their needs the entire space of the monumental staircase of the school building.

Characterising the field of interests of the LTP, Jadwiga Singer wrote:

> The perennial human need to leave traces of their activity, the signs of their existence, is a stimulator of broadly understood transmission. The diversity and the broad spreading of the means of mass visual transmission in the recent decades of our century – these are the factors that have significantly influenced the extraordinary broadening of the iconosphere. All artistic disciplines currently borrow from that iconosphere, and thus research conducted in the fields of particular domains of artistic prac-

tice is becoming more or less the same. As a result, also graphic art, treated as one of the forms of visual transmission, shares many common features with painting, literature, photography, printing, film, television, video, science and technology.

These means of formulating artistic statements become united particularly in the field of art, in which we encounter the use of graphic art, film, tape recorders and other means of conveying information in order to investigate the nature of these means or the essence of art itself. We made observations concerning the mutual influences within different means of visual transmission (both in the sphere of aesthetics and reflection on the language of statements) during the work in the field of graphic art and they compelled us to take an interest in photography, film and video, which we treat not as a source of inspiration in graphic work, but as manners, autonomous and equal to graphic art, of formulating statements, which offer the possibility to pursue equally effective investigations into the problems that we want to share with the viewer.[16]

Published in the catalogue of the 7th International Graphic Art Biennial in Cracow, Singer's text is one of the few that outline the premises of the group's activity,[17] providing a synthetic description of the path that led the LTP members towards new media. Interestingly, it is this catalogue, devoted by principle to a different medium, that today functions as one of literally a handful of sources on the basis of which we may attempt to reconstruct Singer's works created using video technology.

There is an interesting story related to the way the group obtained access to video equipment. As opposed to the Film School in Łódź, the ASP in Katowice did not have broadcasting trucks at its disposal. Nevertheless, the artists found a possibility to work with video technology. At the beginning of the 1970s, the Silesian University of Technology founded a studio equipped with modern devices, such as video cameras with 2-inch tape. The new entity was supposed to modernise the pedagogical methods used at the university, yet it did not fulfil its task in practice – students and lecturers made little use of the available equipment. The discovery of that studio and its resources by the members of the LTP unleashed an immense potential for them. The first video works by the group were created at that very studio – as Grzegorz Zgraja recalls, prior to entering the room it was necessary to put on white antistatic uniforms in order not to disturb the recording process. Such working conditions did not seem to generate a situation marked by the characteristics that we consider as the essence of video (mobility, availability, etc.), yet it was in such a realm that the first (unpreserved) works by Jadwiga Singer came into being – some of them in collaboration with Jacek Singer. Their works, which we know merely from documentation, are rather typical examples of the interest of young artists in the phenomenon of transmission, especially concerning the transmission of the relation between time and space, as well as the relative nature of the media-transmitted image. Serving as example are two works by Jadwiga and Jacek Singer, both from 1978: *Projekt*

instalacji [Project of the Installation] and *Dwie relacje* [Two Relations].

In turn, two known works created exclusively by Jadwiga Singer also indicate a different field of her interest. They address the problem of the influence of the media on human behaviour. As the artist stated, *Rozmowa I* and *Rozmowa II* [Conversation I and II] (1978) were a series of experiments with a record of short arranged situations that accompany an ordinary conversation. 'The presence of the medium – Singer wrote – has an essential impact on the way people behave and reveals the pressure exerted by the ideology of this means of mechanical recording of reality. An analytical perspective on the means of transmission and attempts at revealing the important characteristics of its impact lead to the diminishing and neutralising of its ideological influence. It is an operation which results in a perspective on transmission in a given medium without stereotypical and thoughtless reactions – a fact that therefore liberates imagination'.[18]

Unfortunately, several years prior to her death, Jadwiga Singer discarded her archive. Towards the end of her life, the artist struggled with financial and health problems; her work did not attract interest among researchers during her lifetime. Today, an attempt at exploring her artistic practice is akin to a peculiar kind of 'archaeology', which essentially consists in analysing scarce reproductions preserved in a handful of catalogues. Yet, it does not change the fact that Singer was one of a few Polish women artists working with video in the 1970s. What is more, her theoretical texts bear testimony to her

considerable awareness of the new medium.[19]

Barbara Kozłowska

An interesting example of a video work whose potential Feminist dimension can be noticed only now, nearly four decades after its making, is a project by Barbara Kozłowska (1942–2009). Since the 1960s, Kozłowska was a member of the avant-garde art environment in Wrocław. She was a painter, performer, organiser and participant of many events of significance for the Polish art scene of the period, such as the Symposium Wroclaw 70 [Sypozjum Wrocław 70] in 1970. Between 1972 and 1981, Kozłowska also ran the independent art gallery Babel, in her studio, which functioned as a meeting spot for the Wrocław avant-garde. She created many works of ephemeral character, whose crucial component essentially consisted in the artist's sheer presence, marked solely by minute elements (sand cones on many beaches worldwide, formed by the artist and painted with basic colours within her long-lasting project *Line*, pursued since 1971).

Akin to the already discussed artists Marcolla and Singer, Barbara Kozłowska experienced a gradual marginalisation. Few of her works belong to public collections, and her archive is stored almost in its entirety by her husband, the artist and pedagogue Zbigniew Makarewicz. I was working in Kozłowska's archive in 2016, which was when I came across a probably unpublished documentation of the artist's video work. In a conversation devoted to his wife's oeuvre, Zbigniew Makarewicz under-

lines that in the 1970s and 1980s they had no access to video cameras, but if the situation had been different, they would have gladly tapped into that medium. Unfortunately, the availability of the equipment was merely incidental. Kozłowska seized such an opportunity in 1978. In May, she presented her works at the X Gallery in Wrocław, which was in possession of a video camera. It was then that her work *Punkt widzenia* [Point of View] came into being. The artist situated a large piece of fabric with a drawing of a blue circle in a room. The camera transmitted that image to another room, where Kozłowska was carrying out a performance. Lying on the floor, she was moving her arms and legs, creating an invisible circle around her, while her activity was recorded by another camera and transmitted to the room with the drawing of a circle, whose size corresponded to that 'drawn' by Kozłowska.

The work was accompanied by a commentary in Kozłowska's characteristic style, which situated the project within the grand narrative of art history. Among other references, the artist addressed the aesthetic principles of Leonardo da Vinci (study of human proportions), evoking in the exhibition leaflet the statement that the movement of our body expresses the element of life and a reference to the higher levels of the 'self' until the point of one's own expansion in a vertical and multi-faceted manner in pursuit of the absolute and its visions (sphere, cube).[20]

Kozłowska renounced Feminism,[21] yet I would venture a claim that she did so in order to protect herself from potential exclusion from the field of art, which she risked by defining

herself as a Feminist artist. In her texts, Kozłowska usually connected her works with various aspects of grand narratives in art, eagerly referring to the theory and practice of male artists as well as scientists (frequently including Isaac Newton). Therefore, the personal aspect of her works was often losing prominence. Nevertheless, her seemingly cool analytical Conceptual works lend themselves very well to interpretation through the prism of personal experience and womanhood. *Point of View*, was a work founded on a powerful gesture of 'appropriating' the space around her, defining that space by 'drawing' a circle, and brings to mind the border that the artist delineated to separate her privacy and inviolability, by tearing her autonomy out of common space. Kozłowska's gesture becomes particularly powerful exactly in the context of her mimicry, which I understand as the use of the analytical Post-Conceptual language, de rigeur in Poland at the time.

Izabella Gustowska

It seems that amongst Polish women artists who began to work with video in the 1970s it is Izabella Gustowska (b. 1948) who established the strongest relationship with the new medium also in the later period of her practice and continues to explore it to the present day.

Gustowska's dream was to study at the Film School in Łódź, yet her personal situation compelled her to stay in her hometown of Poznań and accept an assistant position at the Faculty of Graphic Art of the State Higher School of Visual Arts (PWSSP).

In order to be able to work with new media, she found employment for a year (1972–73) at a state construction company, where she made use of the company camera (16mm) to create her first film. As the artist recalls, at that time she was aware of the medium of video and had a theoretical knowledge of its potential, but such equipment remained unavailable to her for the next several years.

Although, as Gustowska emphasises, she has a 'Conceptual background' and is no stranger to constructing works also from the point of view of their form on the basis of analytical premises, the artist developed her own separate language both in terms of form and content. From the very beginning, her work has revolved around the woman's figure, both in the general and the individual sense. Her art is saturated with autobiographical motifs, interwoven with universal stories and parables, which with hindsight, form an epic narrative, where video plays a very important role as a medium that is capable of portraying the delicate matter of dreams and memories – the crucial content of Gustowska's work.

The work *Względne cechy podobieństwa* [Relative Similarities] (1979, Figs. 6a-b-c), which has a particular relevance for our reflection, is a film record, yet the choice of the motif recorded by the artist turns it into a somewhat prophetic project which anticipates the attention that Gustowska devoted in the following decades to explorations of the nature of video. The protagonists are three female twin siblings whom Gustowska recorded in different situations and in the course of the passing of time. The camera registered the changes that

gradually occurred in the young women, capturing the differences and similarities between the siblings. Let us add that the record of one of the couple of protagonists came to an end in dramatic circumstances, when one of the sisters developed cancer. In a nearly prophetic gesture, several days before the medical diagnosis, the artist filmed one of the women as absent – her silhouette was merely marked on the floor with an outline, whereas the other sister, lying on the floor next to the outline, was covered with pieces of white plaster resembling bandages.

A twin sister herself, Gustowska incessantly analysed the phenomenon of twins, choosing for that purpose the adequate medium of video. It is noteworthy that due to its specific character, video offers the possibility of simultaneous *being* and *seeing* oneself, thus building a situation of a split, which may betray a schizophrenic aspect or, from a different perspective, generate a situation in which we are encountering our twin image. *Relative Similarities* is a work that marks the starting point of the artist's long-term and profound reflection.

Later, in the 1980s and 1990s, when Gustowska already enjoyed the possibility of using video equipment, her own physicality, doubled and multiplied by means of cameras and monitors which displayed transmitted images, became – as M. Jankowska remarked – the basic aspect of the artist's works, for instance in the complex project *…99…7 dni tygodnia* [*…99…7 Days of the Week*] (1987). It comprised 99 photographic prints showing fragments of Gustowska's body, which were transmitted in a sequence to two monitors, interwoven

with the documentation of the artist's everyday life during the eponymous seven days. Gustowska was simultaneously carrying out a performance in which she used a photographic tray to develop prints that showed her face, presented to the viewers in a darkened room (with the monitors and a fluorescent tube hung above the tray as the source of light).

Apart from confronting her own image, the artist also used the medium of video to confront her memories and dreams. In her installations, she usually resigned from the ready forms of monitors and encased them in various ways, thus creating peculiar kinds of objects in which the screen remained the only trace of their original shape and function.

In the course of time, Gustowska's installations adopted monumental forms, such as the work *Life Is a Story* (2007), built of many primarily tondo-shaped screens, which filled the entire large gallery space with an intense green light. Gustowska wrote about the motifs visible on the screens:

> It is a collection of many signals resulting from many life situations, from everyday behaviour, to passions, to abstract gestures. These states are punctuated by the presence of an object, installation, intervention in space, and above all by the virtual presence of video-projection. It is them that establish the main link between different threads, both those from the past and the present situations. They are an order and an escaping energy of unexpected behaviour. As it is in life, they take a multi-threaded, but also episodic course with a varied amplitude of clashes and energies.[22]

Conclusion

In the general awareness and source literature, the history of early video art created by women artists in Poland is a forgotten and repressed phenomenon; if it is ever analysed, it happens

Figs. 6a-b-c. Izabella Gustowska, *Wzglēdne cechy podobieństwa* [Relative Similarities], 1979, 16 mm film. Courtesy of the artist.

on the occasion of researching other topics. It is a history of disappearing works and approaches, a history of broken narratives, a history of interrupted thoughts, a history of access to the camera gained with difficulty, and finally, a history of forgetting women makers of video works. It is impossible to place the blame only on technology, although technology did not prove helpful.

The current research on women's video art of the 1970s is akin to archaeology, consisting almost exclusively in reconstructing works on the basis of descriptions and drawings preserved in catalogues. It is difficult to state if the list of works gathered in this text is completely exhaustive, since we cannot definitively exclude that other projects were created. Furthermore, we are aware of missing works (Marcolla) or dramatic situations, such as Jadwiga Singer destroying her own archive due to years of lack of researchers' interest in her work.

Internationally, video art was the field where, for the first time in art history, female and male artists met on an equal basis (according to JoAnn Hanley, among others[23]), simultaneously pioneering works. In turn, in Poland it was a restricted field for women artists and a space which could be only accessed with extraordinary determination. What is more, staying in the field required adopting the 'camouflage' of the universal language of Polish analytical Conceptualism, although it is true that some of the women artists who worked with cameras in the 1970s (Natalia LL, Ewa Partum, and Izabella Gustowska) continued to pursue their practice and determined their unique language and approach during that period while tapping into the potential of video and film.

Despite these difficulties and the scarcity of sources, the entirety of works gathered appear as a slowly revealing blank spot. Further analysis of the available material and the hope for finding other works or their traces will perhaps offer the possibility to discern a connection between the generation of women pioneers of the medium of video and the subsequent generation of Polish artists, including the representatives of critical art (Katarzyna Kozyra, Monika Zielińska-Mamzeta, and Alicja Żebrowska from the 1990s). Unfortunately, their examples will likely provide yet another opportunity to analyse the mechanism of disappearance of works and artists from artistic circulation and awareness.

Endnotes

1. Chris Meigh-Andrews, *A History of Video Art: The Development of Form and Function*, (Oxford: Berg, 2006), p. 8.

2. Interviews with the members of the Workshop of the Film Form by Marika Kuźmicz, July 2014 – November 2016.

3. JoAnn Hanley, 'The First Generation: Women and Video, 1970–75', in *The First Generation. Women and Video Art 1970–75* (New York: Independent Curators Incorporated, 1993), pp. 9–10.

4. Ewa Toniak, 'Artystki a PRL', in Agata Jakubowska (ed.), *Artystki polskie* (Warsaw: PWN, 2011), p. 96.

5. Ewa Tatar, 'Feministyczna wystawa,czyli o tym co niemożliwe' (paper delivered at the *Women in Polish Transformation 1989–2009* conference, organised by the Adam Mickiewicz University and the Poznań Branch of the Polish Sociological Association on 28–29 May 2009), from: Ewa Toniak, 'Konsumpcjonizm wczesnych lat 70. a "Sztuka konsumpcyjna" ', in Jakubowska, *Artystki polskie*, p. 105.

6. *Ibidem.*

7. Jakubowska, in *Artystki polskie*, p. 330.

8. *Ibidem*, p. 331.

9. *Ibidem.*

10. Jolanda Marcolla, *Badanie aktywnoœci struktury wizualnej przekazu telewizyjnego dla potrzeb reklamy I propagandy*, 1975 (MA dissertation under the supervision of L. Kaćma, Visual Knowledge Department, Studio of Visual Activities and Structures, PWSSP, Wrocław, typescript, Archive of Jolanda Marcolla).

11. *Ibidem.*

12. *Ibidem.*

13. Meigh-Andrews, *A History of Video Art*, p. 102.

14. Jolanda Marcolla, *Scenariusz artystycznych realizacji w zapisie video (I, II)*, 2 July 1975, Warsaw (typescript, Archive of Jolanda Marcolla).

15. *Plastyka*, n. 49, 7 December 1975.

16. Jadwiga Singer, 'Przekaz – sztuka – grafika – KONSTRUKCJA OTWARTA', in 7. *Biennale Grafiki w Krakowie* (Cracow, 1978).

17. *Ibidem.*

18. Młodych Sitkowska, *Sztuka młodych 1975–1980* (Warsaw: MAW, 1986), p. 218. Translated by the author.

19. Singer, 'Przekaz – sztuka – grafika – KONSTRUKCJA OTWARTA'.

20. Barbara Kozłowska, *Punkt widzenia* (leaflet), Galeria X, Wrocław, May 1978, http://repozytorium.fundacjaarton.pl/index.php?action=view/object&objid=3662&colid=84&catid=26&lang=pl (accessed 20 February 2017).

21. As Zbigniew Makarewicz recalls, she refused to participate in a show in Sweden because the invitation concerned a Feminist art exhibition. Interview with Zbigniew Makarewicz by Marika Kuźmicz, May 2016.

22. Izabella Gustowska's website: www.gustowska.com (accessed March 2017).

23. Hanley, 'The First Generation: Women and Video, 1970–75', p. 10.

Chapter 12

Creating Crossroads: European Women's Closed-Circuit Video

Slavko Kacunko

The traditional art historical tendency to relate women primarily to women[1] has been a favourite topic of critique within the field of visual culture studies over the past few decades. As such, the topic itself has become a tradition and a point of departure for building new theoretical and historiographical canons related to deconstruction, post-structuralism, and the post-feminist approach linked to the theorists' positions being (allegedly) as complementary to those of Judith Butler and Susan Bordo. An obvious way to scrutinise both the interdependently grown art history and the visual culture traditions, with their respective views to sex and gender, is to set focus on their *ex negativo* communality – their distance to video art. The latter statement is not entirely true, but a discussion of the related theoretical positions sits far beyond the scope of this paper.[2] Therefore, in what follows, the focus will be on closed-circuit video works in Europe, conceived of and made by women, but without disputing the theories to which the named protagonists (could)

have been related. My hope is that this approach will at least avoid some theoretical and ideological pitfalls and conclusions which often emerge from the retro-analytic theorising of (video-) art history and (audio-) visual culture.

French-speaking Realm

The first manifestations of CC-video in Europe can be found in France in the field of experimental theatre (Jacques Polieri, 1964), which were followed by Martial Raysse and the neo-avant-garde-art context in 1967, and then by Fred Forest and the nexus of *art sociologique* and video in 1969.[3] In fact, the beginnings of the artistic engagement with the medium of video in France can unequivocally be thought of as being linked to their quite extensive exploration of video as a sociological phenomenon. This context was already institutionalised through the founding of *Collectif d'art Sociologique* (1974) by Forest and Hervé Fischer and described in Fischer's *Théorie de l'art Sociologique* (1977).[4] Comparable with the situation in most of the countries in Western Europe

and North America, in France in the late 60s, video collectives were mostly short-lived and had political, often feminist, agendas and objectives, and were essentially characteristic of the first phase of video work in France; a period which Jean Paul Fargier referred to as the 'major epoch of the militant video (1969–1978)'.[5] Alongside video-pioneers like Jean-Christophe Averty, Jean-Luc Godard, Pierre Schaeffer and Alain Jacquier, who worked across the lines of experimental film, television and music, a number of female activists, actors, film authors and script writers as well as performers played significant roles from the very beginning.

Carole Roussopoulos (1945–2009) was well-known for pioneering early documentaries covering the women's liberation movement in France from 1969. From 1970, she used a Sony Portapak camera and created a collective called *Video Out* together with her husband Paul. She documented both the work of homosexual authors, like her friend Jean Genet, and the first public gay rights parades in Paris in 1971 (*Front Homosexuel d'Action Révolutionnaire*); these were followed by a further 150 documentaries. In 1976, together with Delphine Seyrig, Roussopoulos directed the *SCUM Manifesto*, a documentary on women's rights written by Valerie Solana, and in 1982 she founded the Simone de Beauvoir Audiovisual Centre. Anne Papillault had also been an activist video maker since the 1960s, becoming well-known through her innovative scientific documentaries and her short-story narrative technique, realised mostly with her partner Jean-Francois Dars. They worked closely

with the pioneering filmmaker Chris Marker, taking part in the activist media collective SLON/Vidéo/ISKRA, created by Inger Servolin and Marker himself. Hélène Chatelain (playing a role in Marker's famous *La Jetée*, 1962) belonged to the wider circle of early *vidéastes*, which includes the work of the Lefebvre, Paule and Gary Belkin and Patricia Moraz. The French term *vidéastes*, coined from *vidéo* and *cinéaste*, reflects particularly well the traditionally close relationship between the two media in France.

Significant in this context is a number of male-female *couples* among the artists, a feature of the early female-made video work observed in other national contexts as well.[6] To this sub-category to which female video artists belong, among others, included couples such as Schum-Wevers, EXPORT-Weibel, Rosenbach-vom Bruch, Iveković-Martinis, Abramović-Ulay, Minkoff-Olesen, J. & O. D. Benet, Kubisch- Plessi, Beban-Horvatic, Ana Nusa & Sreco Dragan, and Woody & Steina Vasulka. It is important to remember though, that often this same relationship was more or less explicitly regarded as something of a (later theoretically heavily contested) gender 'dichotomy'.

The French artist of Italian origins Gina Pane (1939–1990) was the best known representative of another important context of female video usage of the time, the French *Art corporel*, which has found diverse parallels in video art and video activism throughout Europe.

One of the most significant cultural events of the ensuing decade in France was the opening of the Centre Georges Pompidou in Paris. The oc-

casion gave the French artist Cather-ine Ikam (b. 1942) the opportunity to make a CC-video installation, which was, in several respects unique, namely *Dispositif pour un parcours video* [Device for a Video Route] (1980), divided into three individual parts: *Identité I*, *Identité II* and *Identité III*. The third part of the work formed the centrepiece of the installation. It presented itself to the visitor as an interior room opening up from the left-hand side into the exhibition room and ending in a corridor. A series of eight surveillance cameras grouped to-gether and eleven large black and white monitors of various sizes (47 cm, 36 cm, 23 cm) awaited the visitor. In front of this arrangement, a chair was positioned at a specific spot in the room on which the visitor could sit. All of the cameras were set up in such a manner so that they could focus on one part of the visitor's face, but from different angles. Thus, the visitor could see the various sections of her face scattered around on the different monitor screens.

In the first two stations of the in-stallation, the expressly stated subject of identity in the title was presented 'physically askew' with the visitor be-ing deprived of her expected self-view, while in the last room, she was overwhelmed with details, but such details as allowed her only a fragmen-tary view of herself. The first descrip-tion of Ikam's installation comes from Nam June Paik: In the exhibition cata-logue, he praised her highly and de-scribed the third room as 'a historic breakthrough' and 'the first combina-tion of video art and the art of cryptog-raphy'.[7] Paik called the first room – the entrance – 'the room of disinforma-tion', the second 'the room of decep-tion' and the third 'the room of decom-position'. Such (de)fragmentation of the live image within a CC-video in-stallation is without doubt one of the most memorable of its kind; it also belongs to the art historical genealogy of the 'virtual', 'augmented' and 'mixed reality' *avant la lettre*. It is com-parable both to the (partly less well-known) CC-video installations by Peter Weibel, Richard Kriesche, Fried-erike Pezold, Shirley and Wendy Clarke, Susan Milano, David Cort, the so-called *Electron Movers* from the 1970s, and to those created in the early 1980s by Fabrizio Plessi, Gary Hill, Bernd Kracke, Franziska Megert, Daniel Poensgen or also Michel Jaf-frenou, to name but a few.

In Belgium, artists got the oppor-tunity to realise their first video pro-jects around 1970. Artists interested in video gathered in the Walloon city of Liège, which had a favourable geo-graphical location, with important connections to both Paris and nearby Dusseldorf, where the first world-wide video-gallery had been established by Gerry Schum in April 1969. From 10 to 14 November 1971, the first real mani-festation of 'video art' in Belgium and this part of Europe took place: Guy Jungblut, the founder of the gallery known today as *Yellow Now* in Liege, organised an international exhibition with the significant title: *Propositions d'artistes pour circuit fermé de télévi-sion* [Artists' Propositions for CCTV]. A 15-square-metre gallery space, which was to remain inaccessible to the public, served as a framework/ex-hibition set-up. A closed-circuit video camera was made available, suppos-edly to transfer footage of the respec-tive installation or performance ensemble directly to a connected tele-

vision monitor outside the gallery. The total list of over sixty participants testifies to the decidedly international character of the exhibition, with a considerable number of major European and American artists; however, female artists like Gina Pane were still the exception rather than the rule at that point.

Muriel Olesen (b. 1948) and Gérald Minkoff (1937–2009) belong to the first generation of artists experimenting with video as a medium in the French-speaking part of Switzerland and in Europe in general. They had already started collaborating artistically in 1967. From 1970 onwards, they realised CC-video installations, which seemed to be the most suitable for the disclosure of the 'tautological' nature of the medium.[8] Playing with video palindromes and anagrams remained one of their preferred formal-semiotic means, implemented by Minkoff. At the same time, certain characteristic elements emerged in the individual work of Muriel Olesen as well. One of the most prominent was the swing motif, since the Rococo period a popular motif in paintings, which was linked with eroticising subject matter. However, in Olesen's interpretation, the swing was connected to (maintaining one's) balance in a wider sense as well, so offering a parallel to the medium-specific application of the extremely 'unstable' ('female') medium of video. The motif of Kythera, the 'island of lovers', which had also become very popular in French Rococo paintings since Watteau, was also implemented by Olesen on several occasions in their CC-video arrangements. Furthermore, their works were also characterised by the 'game of cat and mouse' of the material, and 'video-reality', as demonstrated in *Du bon usage de la technologie dans les rapports de force* [On the Good Use of Technology in Power Relationships] (February 1977/1980) in a very humorous manner. The CC-video installation *Cythère* (1981) shows the simple functional-technical principle upon which the swing application mentioned above is based: A black and white wall-drawing of a swing (a female face and the outline of an ear) was recorded by a CC-video camera attached to a real swing. There was a screen on a pedestal under the camera, on which the video footage was transmitted, changing as it did according to the movement of the swing. This, together with some other works by Olesen dealing in a formal-functional manner with the balance of images and their relation to the correspondingly changing content, emphatically transported 'subjectivity' – highlighted by the repeated '*je*' in the titles – i.e. the comparatively unstable relation between the subjective and the objective in the artistic fantasy congruent with the comparatively unstable video constructions and their media correlatives.[9] Apart from the stated implications of the swing, reference to fertility rituals was also evident here as a completion of a complex network of equalisations and confrontations between the artist, her self-portraits, the medium, the changing images and the spectator.[10]

English-speaking Realm

Under the title *Sky TV*, one of the first verifiable concepts for a CC-video installation in Europe originated in 1966, although it was not simultaneously

performed, and was first published in the exhibition catalogue: *Yoko at Indica – Unfinished Paintings and Objects by Yoko Ono*, Indica Gallery in London in November 1966. The following designation can be found there: '020: *Sky TV*, 1966 (*Furniture Piece*) A closed-circuit TV set up in the gallery for looking at the sky'. This installation is part of a series of Ono's (b. 1933) works that deal with the sky; considering its form and technology, it must be clearly ascribed to the artist's conceptualism, within which the 'work's' realisation plays a secondary role.[11]

The rapidly growing video production by female artists in the following period actually generated proportionately fewer CC-video installations, but among them was the CC-video installation/event *Pray/Prayer* by Susan Hiller, which had already been realised in 1969. As she described it: 'The intention of this work was to create a situation where the use of video would modify participants' social behaviour; this was done by "rewarding" people for actively participating in the group (e.g. talking to others) or alternatively rewarding them for passive behaviour (listening to others) or by randomly distributing the attention of the camera. I assumed that a positive value would be given to being "on camera" and a negative value to being "ignored" by the camera.'[12]

Power Game was the title of a CC-video installation and performance that the New York-born Liliane Lijn designed together with Alistair Mackintosh and was shown as part of the Arts Festival for Democracy in Chile, organised by the Royal College of Art, on 24 October 1974. The entire event simulated the atmosphere of a casino including such formalities as checking guests' attire (jeans were not allowed) and the procedure of selling chips for the game. A TV monitor was positioned centrally so that the players, the audience and the organisers could all watch live footage of the two CC-video cameras recording the players of the 'Power Game' on the table. Lijn described it in the following manner: 'We used the CC-video to allow people who were not permitted into the room to view the Game, much in the same way that TV allows us to see the workings of parliament, but we cannot actually participate as players.[13] The role of the Drag Queens that acted as waitresses and croupiers was based on the idea that 'those who serve power are never who they seem.'[14]

In the UK, the participants of the 1975 *Serpentine Show,* organised on the initiative of David Hall,[15] set an important precedent, which was followed up the next year by the founding of *London Video Arts* (LVA: from 1988 to 1994; London Video Access; since 1994: London Electronic Arts, and later LUX). Video tapes, video performances and video installations formed part of the artistic practices that were specified in the first catalogue from 1978.[16] In 1977, two video tapes made by Hall were presented at *documenta 6* in Kassel, and video installations by Tamara Krikorian, Stuart Marshall and Stephen Partridge were shown in the Musée d'Art Moderne in Paris in September of the same year. The international exhibition *Video Art '78* organised by Stephen Partridge in the Herbert Art Gallery and Museum in Coventry in May 1978 marks another important date in the UK's exhibition history. This exhibition included

video installations, tapes and performances by numerous British and international artists.[17] The exhibition *About Time: Video, Performance and Installation by Women Artists*, initiated by a group of feminist artists and organised by Catherine Elwes, Rose Garrard and Sandy Nairne from October to December 1980 at the Institute for Contemporary Art in London and in the Arnolfini Gallery in Bristol, was the first event of its kind in the UK to follow up directly on its forerunners in the USA. The exhibition presented the works of Susan Hiller, Catherine Elwes, Rose Finn-Kelcey, Rose Garrard, Roberta Graham, Tina Keane, Alex Meigh, Marceline Mori and Jane Rigby. A visit to the UK by Dara Birnbaum in 1982 and the presentation of her new video tapes with the application of the 'staccato' cut technology had substantial influence on a whole generation of British video authors, representatives of the so-called 'Scratch Video'.[18] At the same time, this heralded a decline in CC-video installations, which would also be felt across the European continent during the 1980s.

In a later retrospective, both Sean Cubitt and Julia Knight noted a devaluation of the media-specific potentials of the medium of video whilst reporting an increase in the development of more narrative tendencies. This tendency ran counter to the philosophy and strategy of the first generation of British video artists. Based on the 'superficial resemblance to a number of other media',[19] it did not seem to be particularly beneficial to further research into the interactive possibilities of CC-video installations. The (somewhat delayed) recognition of multi-monitor arrangements that came about after the 1978 Coventry exhibition[20] supported this tendency, in the light of the frequent application of video quotes and 'split information'; on the other hand, it paved the way for the artistic exploration of the 'presence', often immanent in CC-video installations. In this context, A. L. Rees cites the influence of Mary Kelly and Susan Hiller, and almost certainly Lacan's 'mirror phase' too, on artists like Tamara Krikorian, Judith Goddard, Katharine Meynell, Mona Hatoum, Jeremy Welsh, Catherine Elwes or Breda Beban and Hrvoje Horvatic as well as Tina Keane.[21]

The CC-video work of the trained artist and painter Tina Keane (b. 1946) has an important role at this point and will be presented here. Keane already began to work as a multimedia artist in the late 1960s, at first with light shows and light organs in the context of and influenced by *Arts Lab* in London. In the early 1970s, she became a member of the artistic community. The *Women's Workshop* expanded the spectrum of her interests so that she became politically engaged, taking part in collective artistic projects, programmatically and chronologically parallel to the corresponding developments in the USA.[22] Keane had already begun to work with video and other electronic media by 1975, integrating her young daughter Emily into her feminist works from the very beginning. This not only formed a 'content-related component' that offered a background for the frequent engagement with childhood, identity and play;[23] but also, the (CC-video) performance became, in this context, one of the artist's preferred means of expression, not least because ' "of the moment quality", feedback properties

and the fact that performance "provided women with a significant tool for discovering the meanings of being a woman"'.[24] Keane exhibited her first CC-video installation in the Serpentine Gallery in London in 1978: *Swing/Alice through Reflection* consisted of an iron construction with three swings, a hidden CC-video camera in front of the swing in the middle and three monitors. The participant stood in the middle and could control the running live image on all monitors.[25]

The parental experience, especially the childhood memories that the artist repeatedly re-experienced as a mother, also shaped the CC-video installation and performance *Playpen* from 1979, in which Keane showed video footage of girls and women aged between 6 months and 80 years giving their own performance in a playpen; visitors got involved using mirror camera manipulations. In the early 1980s, Keane began to work for the British Council alongside her performances and other artistic projects at St. Martin's College of Art. Over the years, the artist modified her views on the range of feminism, not least due to its assimilation into the existing social structures, and continued her work with an enthusiastic exploration of 'Cyberspace', more or less parallel to the theoretical paradigm shift that Donna Haraway made with her *Cyborg Manifesto*. Keane's later MA thesis about the concept of the post-human dealt, among other things, with the French artist Orlan. The technological development as a potentially liberating force also remained at a meta-level in Tina Keane's art in the late 1980s (*Escalator* [1988]) and 1990s.[26]

German spoken realm

Austrian female artists played a pioneering role in the artistic exploration of CC-video as well. The inter-media artistic practices, including the so-called *expanded cinema*, proved to be fertile ground for later developments. On 10 and 11 April 1969, a group exhibition entitled *Multi Media 1* was held in the gallery *Junge Generation* in Blutgasse in Vienna, where Peter Weibel realised his first closed-circuit video installation and performance, as well as his first videotape, entitled *Audience as Exhibition*, or *Audience Exhibited*, which was screened over two connected gallery spaces. In the first room, the artist interviewed visitors in front of a running video camera operated by his then-partner VALIE EXPORT (b. 1940). The video footage was broadcast simultaneously to a monitor in the second space, making the visitors themselves the 'exhibits' of the exhibition. In her evaluation of the situation in the 1960s, the artist VALIE EXPORT covers the causal gamut from *expanded cinema* to 'virtual reality'.[27] She describes the CC-video installations, demonstrations and performances as decisive, 'almost paradigmatic constellation[s]' because the

> simple setup aptly demonstrated the splitting of reality through media images [...] This triangle of camera, visitor and monitor (closed-circuit) is an almost paradigmatic constellation of the early video projects, which create a media-generated perceptive space, a media space that can be seen as a wiring of spaces of perception, meaning and imagination and

which introduce a mode of representation in which the picture is not primarily the place of a representation, but rather a place where the media system (in this case, video) gets entangled with real space and real time, involving the viewer in this feedback effect.[28]

Since her public action *Tapp – und Tastkino* [Tapp and Touch Cinema] (1968, realised together with Peter Weibel), one of the outstanding examples of *expanded cinema*, VALIE EXPORT has developed a form of feminist actionism through her artistic and theoretical work. Besides her (CC-video) performances, VALIE EXPORT realised several CC-video installations between 1973 and 1978 with a mutual 'demonstration character', notwithstanding their different forms. This applies similarly to the CC-video installations *Triangel* (1974), *Inversion (Kreis-Linie)* (1976), *Negativ-PositivTransfinit (Ineinander Abbildung)* (1977, with Peter Weibel) and to the group of four CC-video installations entitled *Interrupted Movement – Zeitlücken – Raumspalten* [Gaps in Time – Cracks in Space] (1973): *Triangel* demonstrated a perspective synthesis in the 'video room' as it occurred, for example, in Peter Weibel's *Epistemische Videologie (I)* (1974) at the same time, with additional manipulation (the mirror-inverted monitor image), which had unexpected consequences for the visitors who wanted to 'have their images displayed'. The tension field between the formal rigour and the engaged, 'existential' and allegedly 'essentialist' contents was thus analysed in a versatile manner.

Vienna-born Friederike Pezold (b. 1943) made the female body her main subject, starting in the late 1960s. From 1971, she recorded her actions with the video camera, examining particularly feminine body language as a system of almost abstract signs, which allows and demands concentrated and intensive consideration of the traits and changes of the corresponding (video) forms.[29] Apart from the video installations, where she used previously recorded video tapes (from 1975), Pezold took it upon herself to change the media-political structures of television.[30]

Germany's outstanding role and significance in our context becomes increasingly evident from the mid-1970s onwards. One of the first German artists to consistently work with the medium of video was Ulrike Rosenbach (b. 1943). Although she did not realise any CC-video installations *per se*, her most famous works could neither have been planned nor realised without this technology; as such they serve as prime examples of the efficiency of its implementation. As a student in Joseph Beuys' master class at the Düsseldorf Academy, she was encouraged to start working on her own with video after seeing the exhibition *Project '71* in the Kunsthalle Düsseldorf in 1971 which included several American video works. Her first videos were created in 1972. They were usually shorter pieces dealing intensively with her own role as a woman in society and should be understood as (partly ironic-sarcastic) self-portraits.[31] During this brief but important autobiographic phrase, Rosenbach developed a critical and historic awareness, soon to be reflected in her video actions. It was above all the CC-video performances *Glauben Sie nicht, dass ich eine Amazone bin* [Don't Think That I'm an

Amazon] (1975, 15 min.) and *Reflex-ionen über die Geburt der Venus* [Re-flections on the Birth of Venus] (1976/78, 15 min.), both later re-de-signed for video tape,[32] which brought her international acclaim. In the former work, Rosenbach is seen shooting fifteen arrows at a reproduc-tion of *Madonna im Rosenhang* by Stefan Lochner. The artist's face is also recorded with a second camera and is crossfaded so that the arrows also simultaneously 'hit' her on the video tape.[33] The latter *Venus* video used a life-sized projection of Sandro Botticelli's *The Birth of Venus* as a background in front of which the artist turns around on her own axis in a black and white leotard, at times merging visually with the artwork. The formal solution of the interlocking and crossfading of one's own body with specifications and examples from art history is one of the means of film and video language that is continuously used by artists. The specific context of feminist art and the inherent work with the distribution of gender roles is also found at the same time in the works of, for example, VALIE EXPORT or the American Hermine Freed (b. 1940) (*Art Herstory*, 1974).

The self-portrait, as probably the 'most intensive image of society, in which it was produced',[34] became for Ulrike Rosenbach a radical concept of dealing critically with both history and the present. The consciously detailed and slow recording processes in her videos was also a reaction to the usual custom associated with the medium of television of rapid 'information' ex-change and the accompanying del-uge of images.

During the 1980s, Barbara Ham-mann (b. 1945) explored in her video

Fig. 1. Hanna Frenzel, *Under Pressure*, 1983, photo of the performance. Courtesy of the artist.

installations the possibilities of medi-ated fragmentation of the body and materiality. The topic of voyeurism oc-cupied the artist in several works as well, like for instance, in the CC-video installation and performance *Dirty Eyes* (1980). This consisted of a textile object with a monitor, which was ex-hibited on the first floor of the Kun-stverein Munich. On the monitor, the audience could watch the live footage of what was happening on the second floor, where there was a CC-video camera positioned in a corner of the room, with a glass plate, flour and a light as well as the inscription 'dirty eyes' on the wall. In the CC-video installation *Walking on Yourself* (1984) Hammann staged a situation in which the observer had to step on her own live video image.

Hanna Frenzel (b. 1957) realised several impressive and psychologically effective CC-video performances in Munich in the early 1980s by using semi-transparent elastic rubber membranes. The video performance *Von Innen nach Außen* [From the Inside to the Outside] was about a tangible demonstration of inner conditions and conflicts related to the immediate environment. Frenzel commented on it as follows: 'I show in my own inner space, my images of constrictions, resistances and fears and I try to overcome them. I express my sensation in this space, at this moment, literally with my hands and feet'.[35] In the CC-video performance *Under Pressure* (1983, Fig. 1), again the artist used a transparent rubber membrane, this time as a trampoline and filmed using a CC-video camera and a projector.

Christina Kubisch (b. 1948) studied music and composition before giving up a career as a flautist and interpreter in 1974 and turning to artistic work with other media. Kubisch realised a series of works in collaboration with the Venice-based artist Fabrizio Plessi. Born in 1940 in Italy, Plessi had been working almost exclusively with water since the early 1970s, achieving worldwide success with his elaborate video installations. The CC-video installation and performance entitled *Tam-Tam*, designed collaboratively by Kubisch and Plessi and performed several times, was a commission from the Folkwang Museum Essen, and can be considered a real/medially presented dialogue between the two artists. It was enacted using two CC-video cameras and monitors and an elongated building construction. Kubisch and Plessi sat on a long wooden table facing each other with a monitor in front on each side. Both artists' actions, which focused on the challenge of mediated communication means, were transmitted directly onto the monitor, so that the audience could see and compare both artists and the video partners on their 'duel table'. The audience had to keep turning their heads from side to side, like in a ping-pong game. The video installation, the performance and the concert *Tam-Tam* represented the characteristic mode of operation of the artistic duo, out of which emerges a clearly defined conception of the potential of video as a live transmission medium. Kubisch wrote:

> The video camera is an autonomous element for us and not a technical means serving only as a means of reproduction. We try to use the camera as if it were a third person acting as a filter to the audience and maintaining the tension between us. And so, the video becomes an integrated and indispensable part of our performance. It's important to say here, by the way, that you can document a live event, but never repeat it.[36]

South-East European realm

One of the most conspicuous peculiarities of the earliest inter-media and video scene in Italy was without a doubt its decentralised video production and documentation sites. The Galleria d'Arte del Cavallino in Venice was an important production site where projects were already using video equipment in the late 1960s. The release of the Sony Portapak on the Italian market in 1972 led to wide-

Figs. 2a-b. Sanja Iveković, *Monument*, 1976, stills from video. Courtesy of the artist.

spread activity that was not just restricted to Italy, but also contributed to the realisation of early and important video projects in, among other places, neighbouring Yugoslavia.

In Motovun, a historic town in Croatian Istria, an important meeting between Italian and Yugoslav artists entitled *Identitet = Identità* [Identity] took place in 1976, organised by the galleries of the City of Zagreb, the Ethnographic Museum of Istria from Pazin and the Gallery del Cavallino of Venice. The director of the Gallery del

Cavallino, Paolo Cardazzo, brought a Portapak camera, a monitor and video tapes, and these were used by local artists to create their first video works, along with those of the visiting Italian artists;[37] in all, a total of twenty video works were produced. The local critics at that time, such as Vera Horvat-Pintarić, Ješa Denegri, and Marijan Susovski, saw the significant potential of the video medium being its suitability to mediate an 'unmediated reality analysis' and to provide a 'check' of reality. This conviction was due mainly to the related technology of direct audio-visual 'Closed-Circuit' transmissions. The early video works of Sanja Iveković and Dalibor Martinis mainly involved the registering of their own actions, which were specially designed for video-recording. The lack of any editing equipment or sophisticated graphics or other special effects by no means proved to be a disadvantage – it became one of the features of the strong and widely acknowledged conceptualism in that part of Europe.

In the CC-video performance *Monument* (realised in Motovun, Figs. 2a-b) Iveković (b. 1949) reversed the traditional 'male' gazing at a woman and the woman being conceived as an 'observed object' in a symbolic and formal-technical manner by video-technically 'scanning' and recording her male partner (Martinis) from his toes to the top of his head in one slow CC-tracking shot. This live action was documented as a video tape, as were other actions of both artists.

After studying at the Academy of Visual Arts in Zagreb from 1968 to 1971 and making her first videos in the first half of the 1970s, Iveković contin-

ued her systematic exploration of the impact of modern (mass) media on the 'official' image of women and their day-to-day life. The continually created stereotypes emerging between the 'private' (the artist herself as the reference person) and public images (advertisements etc.) became for Iveković, a projection screen for the engaged artistic elaboration of 'socio-ideological implications of the mass media', on the one hand, and 'performative structures and social codes of cultural activities', on the other.[38] These became manifest in the mid-1970s in a number of photo series (e.g. *Double Life*, 1975), before the artist moved into the medium of video, making an important statement with a successful site-specific confrontation of the private and the public in her CC-video performance *Inter Nos* (1977): the overall environment consisted of two connected rooms with a CC-video camera and a monitor (without sound), and an entrance area in which the direct video transmission for the audience took place. The artist was in one (inaccessible) room for about an hour, while the second room remained open to individual visitors. The artist (inter)acted with these visitors one-by-one, by, for example, kissing or stroking her/his live image on the screen, thereby putting into effect a range of non-verbal communicative possibilities. While both participants in the interaction only saw the other person, the audience on the outside could only see the video image of the individual visitor together with his/her (re)actions.

Sanja Iveković also designed numerous CC-video, CC-installation, CC-performance and CC-tape-concepts that remained unrealised. From

a formal-technical perspective, they are sometimes reminiscent of contemporary works by Michel Jaffrenou or earlier ones by Ernst Caramelle and Jacques Lizène, demonstrating Iveković's interest in the medium-specific investigation of communicative and gender-specific, as well as social, structures.

Apart from the international exchange,[39] it was the generation of conceptual artists in Yugoslavia in the 1970s whom especially favoured the introduction of new media technologies into the art context of the time and who determinedly promoted them. Their rebuttal of the modernist 'puri(tani)sm'[40] and their corresponding openness to hitherto untested artistic means of expression of a rather 'immaterial' and 'unstable' character can be compared to similar tendencies in the UK, Poland, Italy, Spain, Austria and other European countries. The art institutions in Eastern Europe gradually started to make up both the acute and chronic lack of available video technology from the second half of the 1970s onwards. In the former Yugoslavia of the seventies, there were very few (female) 'Video Artists' with their own video equipment. Even the major institutions like Studentski Kulturni Centar in Belgrade and Studentski Centar in Zagreb did not receive their first video cameras and recorders until 1973 or later.[41] At the same time, due to the relatively open borders, on-going dialogue with artists and institutions from abroad led to a relatively early development of video concepts, including CC-video arrangements. In Serbia, the conceptual art scene of the 1970s included the internationally acclaimed Marina Abramović (b. 1946), who has lived in the Netherlands since 1976 and who, in her early career, gave a series of art-historically significant (video) performances together with Frank Uwe Laysiepen, also known as Ulay (b. 1943). Abramović became a crucial figure of the second half of the 1970s, paving the way for an ' "intermittent" history of video installations'[42] in Serbia with her CC-video performances. In a similar way to how Trbuljak used Willoughby Sharp's video equipment in Zagreb,[43] in Belgrade, Marina Abramović used the Dutch group Video Heads'[44] equipment during the group's visit there in 1975, in order to realise and present her first video installation *Freeing the Voice*, in which the artist acted in front of a CC-video camera in one room, while her live image could be followed by the audience in another room.

In Slovenia, the first genuine signs of artistic work with video may be found in the context of the conceptualist group OHO (1966–1971) and in the period after 1970 within the so-called 'transcendental conceptualism'. The Slovene video pioneers like Ana Nuša Dragan (1943–2011) and Srečo Dragan (b. 1944) realised occasional CC-video installations, mostly after 1976. Ten years after completing their first video tape (1969), they realised their first CC-video performance and installation entitled *Masculin-Feminin* for the exhibition *Trigon* in Graz. It was an installation which emerged out of an action consisting of the application of different pigments to their bodies. At the end, the pigments' materiality was converted almost seamlessly into its media equivalent. The CC-video installation *We're Going into this Time,* which the couple performed three years later,

used a similar ensemble, but consisting this time of graphics and photographs, a CC-video camera, and a monitor as well as a slogan written over the door – a 'tautologic' juxtaposition of real and media object levels demonstrating a media-critical approach.[45]

At this point, it is worth mentioning that the first artistic experiments with electronic cameras in an installation and performance context were being conducted in America in similar numbers and varieties and at around the same time as in Europe. The following digression will look at a few of the important and concrete links between women´s closed-circuit video art in Europe and the USA.

Euro-American realm

The Knokke Film Festival (Knokkele-Zoute) in Belgium provided an important node for the early development of experimental film and video art in Europe in general, and in particular, the exhibition *The experimental video 5 exhibit* (26 December 1973 – 5 May 1974). It was the first group exhibition of Canadian and American video artists in Europe and was organised by Gerald O'Grady and hosted by Jacques Ledoux, the director of the Royal Belgian film archive. Participants included Nam June Paik, Shirley and Wendy Clarke, Stan Vanderbeek, Ed Emshwiller, Peter Campus and Woody and Steina Vasulka.

At quite an early stage, Steina Vasulka (b. 1940) and Woody Vasulka (b. 1937) introduced their Northern and Eastern European contexts and competences to New York (State), to further develop both the infrastructures for the then young video art form

and the analogous electronic possibilities of image manipulation for the New York (State) video art scene, which was soon flourishing nicely. Together with Andres Mannik, Vasulkas opened *The Electronic Kitchen* in 1971 at the Broadway Central Hotel in New York, later *The Kitchen Center for Video, Music And Dance*. This initially formed part of the so-called *Mercer Art Center*, before the gallery moved to Broome Street and finally to Chelsea in West 19th Street. The Vasulkas' move to Buffalo in 1976 brought a similarly fruitful and creative period for the two artists, who, in collaboration with Don MacArthur and later with Jeffrey Schier, developed the *Digital Image Articulator*, which allowed the digital generation and manipulation of video footage in real-time. Steina's multiple CC-video installation, entitled *Machine Vision* (1976), a complex installation formation consisting of four individual installations with and without CC-video components, originates from this time. One particular installation, *Allvision,* represented the central element: with the help of a mirror ball and the two CC-video cameras aimed at each side, *Allvision* was able to maintain a permanent live video surveillance of the surrounding space. This 'machine vision' represented by the live video camera footage could be simultaneously watched by visitors via two connected monitors. Steina Vasulka explained her own vision of the piece:

> *Allvision* signifies the awareness of an intelligent, yet not human vision. The act of seeing, the image source, and the kinetic resources come from the installation itself, choreographed and programmed by the cyclical nature of its me-

chanical performance [...] I wanted to create a vision that can see the whole space all the time [...] You are not in charge of the space; it is not your choice – it is somebody else's. It was a challenge for me to create a space that would not deal with the idiosyncracies of human vision.[46]

Apart from her artistic work, Steina also participated in the inauguration of other early video-production, -distribution and -reception contexts in New York, which were relevant for her fellow women artists throughout the early 70s and for the further development of the women's video networks in the United States. At the same time, the division of Europe into the eastern and western blocks remained a decisive political and economic factor in political as well as technological and infrastructural terms. Throughout the 1970s and 1980s, European women's closed-circuit video experiments created important crossroads for the future. Retrospectively can be safely concluded that they helped to increase and enrich the understanding of video's potential for boosting an immense variety of its societal applications and open up new routes to future solutions for its sovereign and innovative usage in creative and everyday media praxis.

Endnotes

1. Gisela Breitling, *Die Spuren des Schiffs in den Wellen – eine autobiographische Suche nach den Frauen in der Kunstgesichte* (Berlin: Oberbaum, 1980).

2. In Spring 2018, an extensive anthology of the women video art theorists in the German-spoken realm was issued, edited by the author of this chapter. – Vol. 1.: Slavko Kacunko (ed.), *Theorien der Videokunst. Theoretikerinnen 1988–2003* (Berlin: Logos Verlag, 2018), with 22 contributions from Edith Decker-Phillips, Inga Lemke, Karin Bruns, Claudia Richarz, Gerda Lampalzer, Christiane Fricke, Nicoletta Torcelli, Söke Dinkla, Annette Hünnekens, Claudia Rosiny, Ursula Frohne, Verena Kuni, Katharina Gsöllpointner, Yvonne Volkart, Barbara Engelbach, Barbara Büscher, Katja Albers, Lydia Haustein, Sabine Flach, Sabine Himmelsbach, Anja Osswald and Martina Dobbe. – Vol. 2.: Slavko Kacunko (ed.), *Theorien der Videokunst. Theoretikerinnen 2004–2018* (Berlin: Logos Verlag, 2018), with 19 contributions from Irene Schubiger, Änne Söll, Inke Arns, Katharina Gsöllpointner, Yvonne Spielmann, Katharina Ammann, Christiane Fricke, Sylvia Martin, Martina Dobbe, Sigrid Adorf, Stephanie Sarah Lauke, Kathrin Becker, Sabine Maria Schmidt, Katja Kwastek, Marion Thielebein, Anke Hervol, Tabea Lurk, Franziska Stöhr and Eva Wattolik.

3. *Art sociologique. Video*, Coll. 10/18, UGE Paris 1977.

4. Full text PDF in French is available online: http://classiques.uqac.ca/contemporains/fischer_herve/theorie_art_sociologique/theorie_art_sociologique.pdf (accessed 18 February 2017).

5. Jean-Paul Fargier, 'Geschichte der Videokunst in Frankreich', in *Videofest 93* (Berlin: Medienoperative, 1993), p. 96.

6. Cf. *Kunstforum International*, v. 107, April–May 1990.

7. Nam June Paik, 'Vidéocryptography' in Pierre Restany (ed.), *Catherine Ikam* (Nimes: Chapelle des Jésuites, 1991).

8. See: Wulf Herzogenrath and Edith Decker (eds.), *Video-Skulptur retrospektiv und aktuell 1963–1989* (Cologne: DuMont, 1989), p. 207; Jacques Monnier-Raball, 'Video in Switzerland. Seeing to See', in René Payant (ed.), *Vidéo, International Video Conference* (Montreal: Artextes, 1986), p. 107.

9. The subject of embarkment on Kythera was taken on again symbolically with grouped parts of trees in *A Cythère [Pour Cythère], je l'aime, il m'en balance* (1983), while *La vidéo, je m'en balance* (1984) represents a sort of 'synthesis' and culmination of this group of works by Muriel Olesen using eight swings, two slide projectors, four CC-video cameras and four monitors.

10. Cf. Herzogenrath and Decker, *Video-Skulptur retrospektiv und aktuell 1963–1989*, p. 226.

11. It is Ono's only video installation that was – as far as is verifiable – set up in the Museet for Samtidskunst in

Roskilde in Denmark for the first time in 1992, catalogued as 'Nr. 50: SKY TV, 1966' (*Yoko Ono: Color, Fly, Sky*, Museet for Samtidskunst, Palaet Roskilde, 1992). A CC-video camera that was attached on a wall not far from a window of the gallery recorded the sky through the open window; the live image of the sky over Roskilde was transmitted on a monitor that was placed on a tripod in a corner of the exhibition room. C.f. statement by Ono: 'I would like to see the sky machine on every corner of the street instead of the coke machine. We need more skies than coke' (23 January 1966, Courtesy Archive Jon Hendricks, New York). Also included in her *Grapefruit*-art book (editions: 1964, 1970; 2013) is a *Sky Event for John Lennon* (Spring 1968), as well as other *Sky Events*; *Sky TV* is however not included. Apart from the aforementioned catalogue and Ono´s *Notes for Indica Show*, 1966 (Courtesy Archive Jon Hendricks, New York), the piece was not mentioned at the time; neither in the personal notebook of the artist for the Indica-Show nor in the newspaper-reviews then. This is why the following statement by Chrissie Iles may need revaluation: 'In 1966, Yoko Ono exhibited Sky TV at the Indica Gallery in London. A video camera was placed outside the building, relaying a continuous live image of the sky onto a television set inside the gallery. The work also existed as a written instruction, or score.' C.f. Chrissie Iles, 'Between the Still and Moving Image', in *Into the Light* (New York: Whitney Museum of American Art/Harry N. Abrams, 2001), p. 59.

12. Susan Hiller, e-mail to the author, 2002.

13. Liliane Lijn, e-mail to the author, 2002.

14. *Ibidem.*

15. Board included Roger Barnard, David Critchley, Brian Hoey, Tamara Krikorian, Pete Livingstone, Stuart Marshall, Stephen Partridge and Jonnie Turpie.

16. Julia Knight, 'In Search of an Identity: Distribution, Exhibition and the "Process" of British Video Art' in Julia Knight (ed.), Diverse Practices. A Critical Reader on British Video art (Luton: University of Luton Press, 1996), p. 219.

17. British artists included Kevin Atherton, Roger Barnard, Lindsay Bryton, David Critchley, Keith Frake, David Hall, Brian Hoey, Tamara Krikorian, Stuart Marshall, Alex Meigh, Marceline Mori and Stephen Partridge; international artists included Marina Abramovic, Nan Hoover, Friederike Pezold, Ulrike Rosenbach, Bill Viola and Peter Weibel.

18. C.f. Knight, 'In Search of an Identity', p. 361.

19. 'Indeed, video has frequently been viewed as a poor relation of film', in *Ibidem*, p. 221, footnote 13, p. 236.

20. Tamara Krikorian, 'Video Installations in Britain' in *Tamara Krikorian*, exhibition catalogue (London: London Video Arts, 1984).

21. A. L. Rees, *A History of Experimental Film and Video: From Canonical Avantgarde to Contemporary British Practice* (London: BFI Publishing, 1999), p. 109. In the Tate Gallery in London, the travelling exhibition *The Arts for Television* and *Revision* took place in 1989 at the initiative of Dorine Mignot and Kathy Rae Huffman. They concentrated, above all, on the presence of video in television and of television in video art. In 1989, *The Biennale of Video and Electronic Media Art* was organised for the first time in Liverpool.

22. C.f. Michael O'Pray, 'Tina Keane', *Performance*, March 1988.

23. Since 1976; c.f. also similar inclusions in the work of Ulrike Rosenbach, Susan Hiller, Mary Kelly.

24. C.f. O'Pray, 'Tina Keane', p. 10.

25. The installation had a clear counterpart in Susan Milano's CC-video installation of the same name, which manifested a clear parallel to the context of *Women's Interart Center* as well as to the *Women's Video Festival* organised in New York in 1974. A drawing was published in *Studio International* in 1976.

26. Lynn MacRitchie, 'On Tina Keane. Transposition', *Mute. Digital Art Critique*, Issue 4. Winter/Spring 1996.

27. 'In *Expanded Cinema*, the system of cinema was dissected, deconstructed, destructed, and then reassembled in a different order, that is, with a shift in sign meaning. *Expanded Cinema* is the forerunner of electronic cinema, of virtual reality'. VALIE EXPORT, 'Mediale Anagramme. Ein Gedanken. Und Bildervortrag. Frühe Arbeiten', in Sabine Breitwieser (ed.), *White Cube/Black Box* (Vienna 1996), pp. 99–127, p. 119. Quoted here from Reinhard Braun, 'Video. TV. Telecommunication – The Early Projects', in Sabine Breitwieser (ed.), *RE-PLAY, Anfänge internationaler Medienkunst in Österreich* (Vienna: Generali Foundation; Cologne: Verlag der Buchhandlung Walther König, 1999), pp. 401–438, 407.

28. Braun, 'Video. TV. Telecommunication – The Early Projects', p. 408.

29. Under the title *Die neue leibhaftige Zeichensprache nach den Gesetzen von Anatomie, Geometrie und Kinetik* (1973–76) originated a cycle of video tapes, in which Pezold performed herself. She painted individual body parts in b/w, took respective detailed footage and documented the changes through the positions and movements.

30. Petzold's video piece *Madame Cucumatz* from 1975 (not a CC-video installation) could be regarded as one of the early predecessors of the videographic fragmentations of the human figure, as known among others through Catherine Ikam.

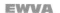

31. C.f. video tapes *Bindenmaske* (1972, 12 min.), *Der Muff und das Mädchen* (1973, 12 min.), *Zeichenhaube* (1973, 5 min.), *Mon Petit Chou* (1973, 5 min.) as well as the pieces with the artist's daughter (*Einwicklung mit Julia*, 6 min., *Brennesseltape*, 5 min., both 1972).

32. C.f. Gisela Jo Eckhardt in *Video-Forum, Künstler-Tapes und Filme* (Berlin: NBK – Neuer Berliner Kunstverein e. V., 1985), p. 114.

33. This action took place during the *Biennale des Jeunes*, 1975 in Paris.

34. Ruth Diehl in the leaflet to the exhibition *Body and Soul* in the Kunstmuseum in Bonn 1997.

35. Hanna Frenzel, e-mail to the author, 2002.

36. Kubisch in *Kubisch & Plessi*, exhibition catalogue (Aachen: Neue Galerie Sammlung; Ludwig/ Antwerpen: ICC, 1979), pp. 13–14.

37. The event included Luigi Viola, Claudio Ambrosini, Luciano Celli, Michele Sambin and Mario 'Piccolo' Sillani Djerrahain who met local artist-friends Dalibor Martinis, Sanja Iveković and Goran Trbuljak in Motovun.

38. Silvia Eiblmayr, 'Personal Cuts / Personal Cuts' in *Sanja Iveković. Personal Cuts*, exhibition catalogue (Vienna: Galerie im Taxipalais, 2001), p. 9.

39. Luciano Giaccari was a guest in Belgrade already in 1972, where he presented his early video tapes. About the same time, in 1971, Willoughby Sharp did the same in Zagreb. Jack Moore and Video Heads from Amsterdam belong, with their early visits in the former Yugoslavia, to the early supporters of the local video pioneers.

40. C.f. Dejan Sretenovi, *Video Art in Serbia*, 1999. http://www.dijafragma.com/projects/videoartins.html (accessed February 2017).

41. Ješa Denegri, 'Video in Yugoslavia', in René Payant (ed.), *Vidéo. International Video Conference* (Montreal: Artextes, 1986), p. 124.

42. Braco Dimitrijevi, 1999. http://www.dijafragma.com/projects/texts/videoart2.html (accessed 18 February 2017).

43. As early as 1972, Goran Trbuljak in Zagreb received a visit from Willoughby Sharp (the body-and video artist and editor of the legendary art magazine *Parachute*) and had the opportunity to realise his first video work *Perimetral test of the artist's visual field*. In particular, the connections to Austria and Italy provided information about video for the first generation of Croatian video artists and their audience. C.f. Marijan Susovski, 'Video u Jugoslaviji', *Spot*, 10, 1977 and Slavko Kacunko, *Closed Circuit Videoinstallationen. Ein Leitfaden zur Geschichte und Theorie der Medienkunst mit Bausteinen eines Künstlerlexikons*, (Berlin: Logos, 2004).

44. *Video Heads Theatre Troupe* (*Multi Media Arts Lab & Video Theater*) gathered since 1970, an increasingly large group of dedicated artists and technicians to act as 'a social video concentration for breaking through the anti-social home-centered effect of monolithic mass-communication'. The most prominent appearance of the group was carried out in 1972; it was the framework program of the Munich Olympics closed-circuit video installation/performance or a 'Multimedia Theatre Piece' using the Eidophor projector in the public, i.e. exactly the same technology as Jacques Polieri used in his first closed-circuit video installations in Europe.

45. Nadja Zgodnik, 'Video Conquering Space', in *Videodokument. Video Art in Slovenia 1969–1998.* (Ljubljana: SCCA, 1999), pp. 151–152.

46. Statement of the artist, facsimile. An extensive documentation of facsimiles can be found on http://vasulka.org/ (accessed 18 February 2017).

Chapter 13

Early 'Female' Video Experiments in Nordic Countries in the 1970s and 1980s

Lorella Scacco

It was Video Art that contributed to the formation of a social feminist critique in Nordic countries, where painting and sculpture were mainly carried out by male artists. In the 60s, young Swedish female artists, including Helena Lindgren and Gunvor Nelson created experimental films and video documentaries that dealt with topics such as women and women's relationships. Their work anticipated the feminist movement experiences of the 70s, such as the interdisciplinary projects of Carin Ellberg and Katarina Lindgren Cavallin whose video, *Köket* [The Kitchen] (1987, Fig. 1), is now part of the collection of the Moderna Museet in Stockholm. Two other elements contributed to the formation of a Nordic female collective imagination: on the one hand, there were the ideas of deconstruction, originality and analysis of the male point of view offered by Laurie Simmons and Barbara Kruger, and on the other, the female stereotypes recreated and photographed by Cindy Sherman. All

these American artists divulged a 'feminist postmodernism' that soon became the subject of study in art schools, including the University College of Arts, Crafts and Design of Stockholm.[1] Another artist followed with interest in the 60s and 70s in Sweden was the Austrian VALIE EXPORT, who was active in the development of feminist and activist strategies, as well as developments in conceptual photography and film.

In Denmark, Kirsten Justesen and Jytte Rex left a feminist mark on the art created between 1965–75, when expressive languages interwove with popular culture, fashion and sexual liberation. Their 1971 film, with the ironically fairytale-esque title *Sleeping Beauty* (Figs. 2–3), bluntly depicts the desires of seven women of different ages. Most of the desires have erotic undertones, while the others are forays into social and political realities. Since 1971, Justesen has continued to use video as well as other expressive languages, such as performance, body art and installation. In the 70s,

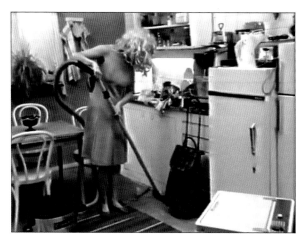

Fig. 1. Carin
Ellberg and
Katarina Lindgren
Cavallin, *Köket*
[The Kitchen],
1987, still from
video.
Courtesy of
Moderna Museet,
Stockholm.

whereby Lene walks naked, carrying with her a cross, in a place of 'business' frequented only by men. The scholar Birgitte Anderberg states that this action can be viewed as a feminist action because it shows 'an erotic, sacred, vulnerable, naked, natural – female – counterpart to the powerful, patriarchal, authoritarian, capitalist social structures as symbolised by the stockbrokers and the Stock Exchange as the holy centre of the Capital'.[2]

she contributed to several feminist-themed collective exhibitions, including *Magna Feminismus* which took place in two locations in Vienna in 1975 and *Feministische Kunst Internationaal* at the Den Haag Museum in 1979. Another duo, Bjørn Nørgaard and Lene Adler Petersen, commented on contemporary society – with its gender defined roles and purely materialistic orientations – through performances, films, actions and publications. Their video *The Expulsion from the Temple/Female Christ at the Copenhagen Stock Exchange* on 29 May 1969 recorded the action

Video Art as Commentary on Reality

In Nordic countries, documentary cinema developed in parallel to experimental cinema and created values and languages that would inspire new generations of video artists. Traces of documentary language can be found in Denmark, Finland, Norway and Sweden, whereas Iceland was influenced mostly by literary tradition and sagas, in particular.

There was a particular custom that occurred in cinemas in Denmark during the 40s, whereby a good quality, lively short, lasting about six min-

Fig. 2. Kirsten
Justesen and
Jytte Rex,
Sleeping Beauty,
1971, Super 8
blown to 16mm.
Courtesy of the
artists.

utes was screened before the begin-
ning of the film and showed solutions
to some institutional and social is-
sues, glorifying the state's heroism in
supporting its citizens. This novelty
led, until the 50s, to a wide production
of documentaries, which brought
about the so-called 'golden age' of
Danish documentary. This 'golden
age' would have a strong impact on
future generations; so much so that
Rasmus Dahl asserted that 'it was
now part of Danish people's everyday
life. Maybe it wasn't an essential ele-
ment of it, but it nonetheless repre-
sented an essential element of
people's education, knowledge and
disposition. Since then, a tradition of
cinema culture has carried forward
into Danish society that differs from
commercial production, and docu-
mentary has always been one, if not
"the", fundamental element'.[3] Since
the post-war period, documentary film
headed more and more towards an
aesthetic dimension, because the
Danish state shifted its financial sup-
port from propagandist to cultural pur-
poses – to a narrower and more
cutting-edge field, that would later be-
come that of Video Art. A Danish artist
who started experimenting with video
for documentary purposes at the end
of the Eighties was Jeanette Land
Schou, who would develop this tech-
nique further in the 90s, making sev-
eral videos. Her first work, *Liberace*,
was shot on Super 8 in 1987 with Erik
Slentø and is set to music. Another
artist, born in 1955 and active in Den-
mark in the Eighties, was Ane Mette
Ruge who used both video and digital
cameras. In Denmark, however, there
were only a few places dedicated to
video production that were active from
the end of the 60s, one of which was

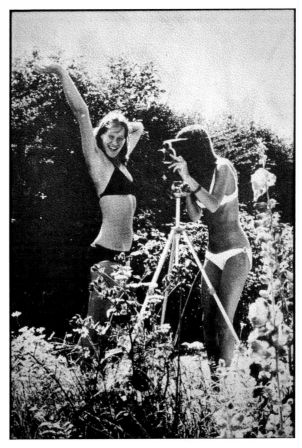

in Haderslev and the other in Haslev.
It was only in 1989 that, thanks to
Torben Christensen's initiative, the
department of Media Arts was estab-
lished at the Academy of Fine Arts in
Copenhagen.

It is difficult to define the exact line
separating short film, documentary
and art video in Nordic art during the
60s and 80s, indeed, as it is for all
other European nations. During this
time there were several directors and
artists in Sweden who worked with film
in interesting and experimental ways
and who had an important role in the
art world. Gunvor Nelson was one of
the most famous directors of interna-
tional avant-garde film and she took
part in the *First International Women's
Festival* in New York in 1972. Born in

Fig. 3. Kirsten
Justesen and
Jytte Rex while
filming *Sleeping
Beauty*, 1971.
Photo: Jan
Wibrand.
Courtesy of the
artists.

1931, she studied and trained first in Stockholm and then in the United States in 1954, where she was involved in the buoyant cultural life of San Francisco. There she became well known with *Schmeerguntz* (1966) which dealt with the topics of maternity and domestic everyday life in an amusing way. Some other important films by Gunvor Nelson include *My name is Oona* (1969), with music by Steve Reich and shot on 16mm, *Take Off* (1972), *Frame Line* (1983) and *Red Shift* (1984), where she merges influences from painting, collage and poetry in an original way.[4] Helena Lindgren was another protagonist of feminist cinema in Sweden in the 80s, and her film ... *det skall vara så här ...* [... this is the way it shall be ...], (1985) on menstruation was so successful, (unlike her films that would follow), that it helped her to continue her work within Swedish state TV. As written by Yvonne Eriksson, in this film, Lindgren 'blends both documentary footage with staged scenes and bursts of expressive and rapid cutting. Without [a] doubt the film deserves a position as a Swedish feminist classic, a position that it has never received due to the fact that it was made well before the moving image had re-entered the art scene because of the rise in interest in video art that did not take place in Sweden until the mid-1990s'.[5]

In 1979 the association Video Nu [Video Now] run by the artists Ture Sjölander and Teresa Wennberg opened in Stockholm, while the Moderna Museet started organising regular screenings of art videos within the activities of its theatre programme, under the supervision of Monica Nieckels. Yet it was only in 1985, during Bill Viola's solo exhibition, that international Video Art reached the museum's exhibition rooms and once again played an important*Implosion: A Postmodern Perspective*, curated by Lars Nittve. During the 70s, the documentary genre entered Norway thanks to youth movements, which considered the video camera to be a political, rather than artistic, instrument, which was also used to represent feminist issues, such as in the film trilogy *Hustru III* [Housewives III] of 1975, 1985 and 1996 by Anja Breien, who presented the lives of three women across three decades. In Norway, the first videos were made around 1970 by a small group of artists who mainly challenged television companies and art institutions, offering an alternative form of expression to the one prevailing.[6] In *Relating to TV* (1977, Figs. 4–5) Marianne Heske criticised the influence TV had on people, in line with Nam June Paik, whom she would meet in Paris in 1984 and whom she also quotes in her catalogue *Works & Notes* published in 1978, 'television has attacked us all our life. Now we can attack it'. In the video, a group of people are sitting watching TV with their faces covered by doll face-masks. These masks would return in another series of videos in 1977, in *All the World's a Stage Etc. Etc.*, as the symbol of the standardisation towards which TV broadcasts were leading people. Marianne Heske's first videotape called *Masque*, dates back to 1975 and showed some black and white takes of a doll's head. The artist then used the video in the performing field, for example, in *A Phrenological Self-portrait* (1979), where the artist placed herself between the video camera and the screen to create a phrenological

Fig. 4. Marianne Heske, *Relating to TV*, 1977, stills from video. Courtesy of the artist.

portrait. However, she only started using video in an installation context from the Nineties onwards. During the 80s, she would also experiment with 'video-painting', which consisted of printing video stills onto canvas or silk. Marianne Heske was also one of the first Norwegian artists to take part in international video exhibitions, including at the Aarhus Arts Museum in 1976, at the Bonnefantenmuseum in Maastricht in 1977, and the *IX e X International Open Encounter on Video* at the CAYC in Mexico in 1977 and in Tokyo in 1978.

Kristin Bergaust started experimenting with video art in 1983 in different ways, from animations to interactive installations, to the editing of works based on documentary

Fig. 5. Marianne
Heske editing,
London,
September 1976.
Courtesy of the
artist.

ticed traditional art techniques and also by the audience, as it was placed in relation to both the porn industry and to surveillance systems. Some articles by Heske for the art magazine *Billedkunst* [Visual Art] that explained how video was not a danger for painters and sculptors, but rather a new medium to widen the expressive possibilities of every artist, testify to this momentous situation.[7]

Travels and Study Abroad for Video Practice

Video art spread quite slowly in Nordic countries because of the paucity of workshops with the necessary equipment, the lack of professional training courses in academies and universities, and the absence of institutions in charge of distribution of the media format. Furthermore, there were very few places dedicated to video processing. One of the first and most important was the Film Institute Workshop, in Haderslev, Denmark.[8] It was there that courses on video practice were organised and a magazine on local video art was published from 1979 – *Dansk Video Periodical* [Danish Video Periodical], with contributions from experts and artists. The diffusion of video art also occurred thanks to a few artists who studied and worked abroad, among them: Marianne Heske, who lived in Paris, London, Prague and Maastricht during the 70s and made several videotapes – which emerged during the editing of her videography in the 70s; Swedish artists Teresa Wennberg and Antonie Frank Grahamsdaughter who studied at the Centre Pompidou in Paris in the 70s and at the Jan van Eych Academy in Maastricht in

materials. In her 1986 videos *Linjer I e II* [Lines I and II], the main subject was the body of a woman onto which colours and lights were projected or applied, where the influence of body art was obvious. Pictorial signs that draw triangles, rectangles and crosses over the human body were then displayed again in her video *Signs* (1987). Other Norwegian [female] artists who experimented with video between the 70s and the 80s also included Inger Johanne Byhring, Inghild Karlsen, Pia Myrvhold and Camilla Wærenskjold.

In Norway, the first places to host video art exhibitions were the Henje Onstad Centre in Oslo and Galleri F-15 in Moss, but they were only instituted in the 80s. Video art was, in any case, looked upon suspiciously by Norwegians, both by those who prac-

Fig. 6a. Teresa
Wennberg,
Swimmer, 1978,
still from video.
Courtesy of the
artist.

1984–86 respectively; Icelandic Ásta Ólofsdóttir, who included video among the other techniques with which she worked from the 80s onwards and who lived in Paris between 1972 and 1974 and in Maastricht from 1981 to 1984; Finnish artist Mervi Kytösalmi who took a course on video at Düsseldorf Academy in 1977, where the teachers included Joseph Beuys and Nam June Paik; and Marita Liulia, who started travelling throughout Europe, America, Asia and Africa in 1980 as a professional photographer.[9]

Teresa Wennberg, one of the pioneers of video art in Sweden, was one of the first artists to archive one of her videos at the Centre Pompidou in Paris in the 70s.[10] In 1978, together with Suzanne Nessim, she made *Swimmer*, a video with visual variations about the sensations felt by a swimmer in a pool. The video was presented at Galerie Paloma in Stock-

holm that same year. This was followed by *Nothing,* a video produced using 3D animation techniques by the Moderna Museet. The videos *Swimmer* (1978, Figs. 6a–b), *Norma or Gene* (1980), and *NO=ON* (1983) were produced by the Centre Pompidou. In 1996, she became the guest artist of the Royal Institute of Technology in Stockholm, where she subsequently developed *Brain Songs*, a work that showed a hexagon shaped as a virtual cube. Antonie Frank Grahamsdaughter was born in Toronto in 1955, but moved to Sweden in 1962 and took part in several international exhibitions. Her electronic images were often accompanied by poems. In 1986, she made the video *Transit*, where she used the technique of solarisation with herself as the performer, wrapped by a boa. The video was really successful and took part in several international festivals. Furthermore, in the late Eighties she started

Fig. 6b. Teresa Wennberg, *Swimmer*, 1978, still from video. Courtesy of the artist.

Fig. 7. Antonie Frank Grahamsdaughter, *Transit*, 1986, still from video. Courtesy of the artist.

making video-installations and she would often compose the videos' musical or poetic accompaniments. During the 90s, she promoted video art both by organising festivals at the Fylkingen in Stockholm, an artists' association committed to the production and promotion of experimental music and interdisciplinary art that was established in 1977, and by inviting other female artists to experiment with the new expressive medium.

As stated by Tiina Erkintalo, experimentation with video only started in Finland in the early 80s, when a group of artists, which included Marikki Hakola, created a video performance for a seminar.[11] This was the *Turppi Group* formed by Lea and Pekka Kantonen, Jarmo Vellonen and Martti Kukkonen, as well as Marikki Hakola, who made the first art video in Finland in 1982, *Earth Contacts* (Fig. 8), based on the relationship between mankind and nature in an increasingly technological and industrialised society. After making a second video, *Deadline* (Fig. 9), which looked at the opposition between technology and nature, the group split up in 1983. Born in 1960, Marikki Hakola studied painting at the Academy of Fine Arts in Helsinki between 1980–84 and started working with video in 1981. She then moved on to work on multimedia projects, independent productions and experimental television productions.

Fig. 8. Turpi
Group, *Earth
Contacts*, 1982,
production still.
Courtesy of
Turppi Group.

According to Perttu Rastas, the first Finnish female video artist was actually Mervi Kytösalmi, who, between 1978 and 1984, made several videos in Germany where she also won some awards for them. Her video performances arrived in Finland in 1979 thanks to an article in the cultural magazine *Taide* [Art], yet it was only in 1981 that they were presented at the Old Student House in Helsinki.[12]

In the 80s, Marikki Hakola, Minna Tarkka and Perttu Rastas founded, AV-Arkki in Finland, a video production and distribution organisation committed to gathering and archiving Finnish film production and increasing its circulation. This is still active

and is considered the most authoritative public collection of video in the Nordic region.

It was in the 80s that Marita Liulia renewed interest in multimedia forms of expression, pulling closer to video first through her work on documentaries for television programmes, such as NetTv (US), TV5 (France) and ARTE (Germany) and then turning to interactive art in the 90s, producing works in CD-ROM format. In an interview, the artist stated: 'I am a writer, a video artist, but also a researcher and a producer. In my eclectic works, I merge different art disciplines with research and technology'.[13] In the 90s, Finland would take on a prominent place within the video art world with Eija-Liisa Ahtila as a pivotal figure.

The Icelandic Phenomenon

In Iceland, by contrast, video art was already widespread among artists in the 70s, both to document performances and to investigate the medium's key elements, as asserted by Gunnar B. Kvaran.[14] This insular nation is the homeland of the Vasulkas who committed their lives almost exclusively to the experimental element of video from 1969. Born in 1940, Steina Vasulka trained in Iceland in the musical field, studying violin, to then move with her husband, Woody, to New York in 1965. There, the couple founded a workshop, *The Kitchen*, in 1971, which was committed to researching video, including research on image and sound elaboration processes and on the development of new equipment to put their creative aspirations into action. This ranged from the MIDI system to autonomous hybrids, from interactive tables to the morphing technique. Their research branched into two main directions: towards video documentary on the one hand and towards what they called

synthetic videos on the other. This led the two artists to develop new instruments together with some IT engineers, such as the Digital Video Effecter between 1972–73, and the Digital Image Articulator in 1976 with Jeffrey Scheir, as well as to modify existing instruments. Their most significant discovery was to make aesthetically clear that, in electronics, the same electromagnetic frequency, if switched in one way creates sound; and if converted to another creates an image. The same electromagnetic frequency, if adequately distorted, makes the line that our senses distinguish between sound and image visually apparent, and therefore, they established that audio-visuals were actually uniform for the very first time. They defined their videos as *environments*, because the word included the idea of immersing the audience in sound and image.[15] While the Vasulkas took part in several exhibitions, including solo ones and particularly important international shows, their first appearance in Iceland only took place in 1984 in a collective exhibition at Reykjavik Art Museum, while in 1992 they held a solo exhibition at the National Gallery in Iceland's capital city. Therefore, the impact of their vast research only reached Iceland in the mid-80s.

In the late 70s, a small group of artists, including Rúrí, founded the Living Art Museum in Reykjavik, that held the exhibition *Film-Week* in 1981 containing experimental films and video art. Born in Reykjavik in 1951, Rúrí studied in her hometown in the early 70s, where she was drawn to the ideas of Fluxus, and then in the Netherlands, where she deepened her knowledge of the Fluxus Movement,

together with that of video and film, performance and multiples. Between 1970–1980 the artist was committed to the dematerialisation of the art object and the disregard of the financial value of the same works, finding in video the optimum medium to express such an attitude. As the artist herself stated, 'for me, art is philosophy. In my research, I am the observer who documents her observations through art'.[16] The artist started using video camera in 1978 and in 1980 she made one of the first films in the series *ITEMS* (Figs. 10a–b) on 16mm – transferred on video in 1983 – that she would only finish in 2005 with various editions. In this sequence of film episodes, the artist tried to convert her ideas into visual form: the sky was the background for some words that appeared in a sequence on the background of a sky while the sound of some sea waves marked the passing of time. The sky represents the immense universe and everything that is impenetrable to our mind and our soul, while the words represent patches of our knowledge and of our existence, encouraging the audience's mind towards philosophical reflection. The words refer to the meaning of conscience, the universe and ethics. The artist wrote, 'I think that a screened film is as immaterial as an idea'.[17] An important philosophical aspect pointed out by *ITEMS* is in fact the immateriality of the projected images and ideas, already highlighted by her choice of medium, i.e. film. It reminds us of the immateriality of thoughts, emotions, and ethics, which are still of value for every individual and the foundation of our society. Her performances arose from these considerations, and became

Figs. 10a-b. Rúrí, *ITEMS*, 1980, 16 mm transferred to video (1983) and edited in 2005. Courtesy of the artist.

videos, as exemplified by *Rainbow*, based on an installation created by the artist to produce the film in 1983 with the aim of celebrating the rainbow's transitional nature. In this, the art object existed only during the performance and the screening of the video. After these moments it would just become a memory in the human mind.

From the Vote to Video: Female Visions

Finland was the first nation in the world to grant women the right to vote, in 1906, and nowadays it has the highest amount of women in political positions worldwide (62%), followed by Sweden with 43.5% of female members of parliament. If in Nordic literature there are several examples of female authors during the 20th century, such as Karen Blixen (1885–1962), Tove Jansson (1914–2011) also known as an illustrator, and Selma Lagerlöf (1858–1940) within the arts field, it is again a Finnish artist that is one of the most famous painters, Helene Schjerfbeck (1862–1946). She proved to the sceptics of the late-19th century that women too could carry out the *grande maniére*. Her determination provoked critiques of her work from her former painter contemporaries, such as Fanny Churberg, who claimed, 'even if we are for equality, we do not believe in female painters on the battle grounds'.[18] The invention of the video camera gave women a new opportunity to establish themselves in the art world, detaching themselves from traditional techniques practiced by men and defined as 'boring' by Kirsten Justesen in an interview for an exhibition at the National Museum in Copenhagen,[19] – even though she had trained as a sculptor at the Fine Arts Academy in Copenhagen. The same feeling was shared by Antonie Frank Grahamsdaughter who stated that 'video art was in some way free from the history of art and we women artists felt a great freedo7m'.[20] Therefore, for Nordic female artists of that generation, video was a medium that was still uncontaminated by the hegemony of a sexual gender, unlike painting and sculpture, practiced for centuries almost exclusively by men. With video art, history of art enriched itself with female visions, finally interrupting male dominance.

Acknowledgement: This chapter was translated from Italian into English by Simona Manca, and copy-edited and approved by the author.

Endnotes

1. Whitney Chadwick (ed.), *BENT. Gender and Sexuality in Contemporary Scandinavian Art* (San Francisco: San Francisco State University, 2006), p. 25.

2. Birgitte Anderberg, 'What's Happening? Art between experiment and feminism', in exhibition catalogue *What's Happening? Danish Avant-Garde and Feminism 1965–1975* (Copenhagen: SMK, National Gallery of Denmark, 2016), p. 47.

3. Rasmus Dahl, 'A National, Historical Perspective on Documentary in Denmark', *Screening the Past*, Issue 7, 1999.

4. Astrid Söderbergh Widding (ed.), *Konst som rörlig bild – från Diagonalsymfonin till Whiteout* (Stockholm: Sveriges Allmänna Konstförening, 2006), p. 85.

5. Yvonne Eriksson, 'The Visualized Femininity', in Yvonne Eriksson, Anette Göthlund, Bokförlaget Signum (eds.), *From Modernism to Contemporary Art, Swedish Female Artists* (Lund: Bokförlaget Signum, 2003), p. 160.

6. Janne Stang Dahl, *Norway: Networking Nodes*, in Minna Tarkka and Mirjam Martevo (eds.), *Nordic Media Culture – Actors and Practices* (Helsinki: m-cult, Edita, 2003), p. 38.

7. Interview by Lorella Scacco with Marianne Heske, November 2010.

8. Mats Stjernstedt, *La macchina interferente*, in Caroline Corbetta and John Peter Nilsson (eds.), *Interferenze* (Pistoia: Maschietto Editore, 2002), p. 169.

9. Maria Stella Bottai, *Marita Liulia* (Rome: Lithos, 2003), p. 58.

10. *Konst som rörlig bild – från Diagonalsymfonin till Whiteout* (Stockholm: Sveriges Allmänna Konstförening, 2006), p. 135.

11. Lars Movin & Torben Christensen, *Art & Video in Europe* (Copenhagen: Det Kongelige Danske Kunstakademi, 1996), p. 155.

12. Perttu Rastas, *Mervi Kytösalmi special*, in www.av-arkki.fi (accessed March 2017).

13. Marita Liulia, *Interview*, in www.artificial.dk, 2005 (accessed March 2017).

14. Gunnar B. Kvaran, *Videotransit*, in *Nuit Blånche: Scènes nørdiques: les années 90* (Paris: Musée d'art moderne de la Ville de Paris, 1998), p. 17.

15. Christian Schoen, 'Being an Icelander … an incurable disease. Interview with Steina Vasulka', *Interviewstream*, 2005 http://interviewstream.zkm.de/?p=25 (accessed March 2017).

16. Interview between the author and the artist in 2008 during the writing of the book, Lorella Scacco, *Northwave. A survey of videoart in Nordic countries* (Milan: Silvana Editoriale, 2009).

17. *Ibidem*.

18. As quoted in Markku Valkonen, *Arte in Finlandia* (Helsinki: Otava, 1992), p. 46.

19. http://www.smk.dk/udforsk-kunsten/kunsthistorier/kunstnere/vis/kirsten-justesen-foedt-1943/ (accessed March 2017).

20. See 'Interview with Antonie Frank Grahamsdaughter by Laura Leuzzi', 2016, available at, http://www.ewva.ac.uk/af-grahamsdaughter.html (accessed March 2017).

Selected Bibliography

Balsom, E., *After Uniqueness. A History of Film and Video Art in Circulation* (New York: Columbia University Press, 2017).

Barlow, M., 'Feminism 101: The New York Women's Video Festival, 1972–1980', *Camera Obscura*, v. 18, n. 3), 2003, pp. 3–38.

Béar, L. and Sharp, W., 'Video Performance', *Avalanche*, no.9, May/June (New York: Center for New Art Activities, 1974).

Boomgaard, J. and Rutten, B. (eds.), *The Magnetic Era: Video Art in the Netherlands 1970–1985* (Rotterdam: NAi Publishers, 2003).

Borčić, B., 'Video Art from Conceptualism to Postmodernism' in Miško Šuvaković and Dubravka Djurić, *Impossible Histories: Historic Avant-Gardes, Neo-Avant-Gardes, and Post Avant Gardes in Yugoslavia 1918–91* (Cambridge Mass.: MIT Press, 2003).

Cubitt, S., Partridge, S. (eds.), *Rewind: British Artists' Video in the 1970s & 1980s* (New Barnet, Herts: John Libbey, 2012).

Curtis, D. (ed.), *A Directory of British Film and Video Artists* (Luton: Arts Council/Luton Press, 1996).

Deepwell, K., 'Felicity Sparrow: forming Circles', *n. paradoxa*, v. 34, 2014, pp. 86–95.

Duguet, A.-M., *Video la mémoire au poing* (Paris: Hachette, 1981).

Elwes, C., *Video Art: A Guided Tour* (London: I. B. Tauris, 2005).

Jeanjean, S., 'Disobedient Video in France in the 70s: Video Production by Women Collectives', *Afterall A Journal of Art, Context, Enquiry*, n. 27, Summer 2011, pp. 5–16.

Fagone, V. (ed.), *Camere incantate, espansione dell'immagine*, exhibition catalogue Milan, Palazzo reale, 15 May – 15 June 1980 (Milan: Comune, Ripartizione cultura e spettacolo, 1980).

Gazzano, M., *Kinema. Il cinema sulle tracce del cinema dal film alle arti elettroniche, andata e ritorno* (Rome: Exorma, 2012).

Gogan, J. 'Derry Film and Video Collective', *Film Base News*, n. 3, September/October 1987.

Guy, L. 'Hiding in plain sight: Recognition and resistance in recent queer artists' moving image', *MIRAJ*, v. 5 n. 1/2, 2016.

Kacunko, S., *Closed Circuit Videoinstallationen. Ein Leitfaden zur Geschichte und Theorie der Medienkunst mit Bausteinen eines* (Künstlerlexikons Berlin: Logos, 2004).

Knight, J. (ed.), *Diverse Practices: A Critical Reader on British Video Art* (New Barnet: Arts Council of England and John Libbey, 1996).

Krauss, R., 'Video: The Aesthetics of Narcissism', *October*, v. 1., Spring, 1976, pp. 50–64.

Gunnar B. Kvaran, *Videotransit*, in *Nuit Blånche: Scènes nørdiques: les années 90* (Paris: Musée d'art moderne de la Ville de Paris, 1998).

Halle, R., Steingröver, R. (eds.), *After the Avant-garde: Contemporary German and Austrian Experimental Film* (Camden House, 2008).

Hanley, J-A., 'The First Generation: Women and Video, 197–75', in *The First Generation. Women and Video Art 1970-75* (New York: Independent Curators Incorporated, 1993).

Hooykaas, M., van Putten, C. (eds.), *Revealing the Invisible - The Art of Stansfield/Hooykaas from Different Perspectives* (Amsterdam: de Buitenkant Publishers, 2010).

Huet, L., Neetens, W. (eds.), *An unexpected journey, Vrouw en kunst/Women and Art* (Antwerpen: Gynauka, 1996).

Leuzzi, L., Partridge, S. (eds.), *REWIND*Italia: *Early video art in Italy/I primi anni della videoarte in Italia* (New Barnet, Herts: John Libbey Publishing, 2015).

Leuzzi, L., Shemilt, E. and Partridge, S., 'Body, Sign and Double: A Parallel Analysis of Elaine Shemilt's *Doppelgänger*, Federica Marangoni's *The Box of Life* and Sanja Iveković's *Instructions N° 1* and *Make up – Make down*', in Catricalá, V. (ed.), *Media Art: Towards a new definition of arts* (Pistoia: Gli Ori, 2015, pp. 97–103).

Magri, L. (ed.), *Centro Video Arte: 1974–1994* (Ferrara: Gabriele Corbo, 1995).

Marangon, D., *Videotapes del Cavallino* (Venice: Edizioni del Cavallino, 2004).

Meigh-Andrews, C., *A History of Video Art: The Development of Form and Function* (Oxford: Berg, 2006).

Movin, L. & Christensen, T., *Art & Video in Europe* (Copenhagen: Det Kongelige Danske Kunstakademi, 1996).

Mulvey, L., *Visual and Other Pleasures*, London: Macmillan, 1989.

Mulvey, L. 'Visual Pleasure and Narrative Cinema', in Leo Braudy and Marshall Cohen (eds.), *Film Theory and Criticism: Introductory Readings* (New York: Oxford UP, 1999), pp. 833–844.

Murray, P. (ed.), *0044 – Irish Artists in Britain* (Cork: Crawford Municipal Gallery, 1999).

Nigg, H, and Wade, G., *Community Media – Community Communication in the UK: Video, Local TV, Film and Photography* (Zurich: Regenbogen Verlag, 1980).

Nochlin, L., 'Why Have There Been No Great Women Artists?' (1971), in: *Women, Art, and Power and Other Essays* (New York: Harper and Row, 1988).

Payant, R. (ed.), *Vidéo. International Video Conference* (Montreal: Artextes, 1986).

Saba, C. G., Parolo, L., Vorrasi, C. (eds.), *Videoarte a Palazzo dei Diamanti. 1973–1979 Reenactment* (Ferrara: Fondazione Ferrara Arte, 2015).

Scacco, L., *Northwave. A survey of videoart in Nordic countries* (Milan: Silvana Editoriale, 2009).

The First Generation. Women and Video Art 1970–75 (New York: Independent Curators Incorporated, 1993).

Videodokument. Video Art in Slovenia 1969–1998 (Ljubljana: SCCA, 1999).

Video Positive '89, exhibition catalogue (Liverpool: Tate Gallery, Merseyside Moviola, 1989).

Video Positive '91, exhibition catalogue (Moviola, Liverpool 1991).

Westgeest, H., *Video Art Theory: A Comparative Approach* (Malden, MA: Wiley Blackwell, 2016).

Biographies of the Authors

Jon Blackwood is a Reader in Contemporary Art and Research Lead at Gray's School of Art, Robert Gordon University, Aberdeen. He is also a freelance curator and writer. He studied at the University of St. Andrews and the Courtauld Institute of Art, London. Formerly Head of History & Theory of Art at DJCAD, University of Dundee, from 2011–14 he was based between Sarajevo, Bosnia and Skopje, Macedonia, where he researched modern and contemporary art in former Yugoslavia. This, along with contemporary art in Scotland, remains the main focus of his work, with particular interests in performance, sound and video. In recent times, he has authored books on Contemporary Art in Bosnia-Herzegovina (duplex 100m2, Sarajevo, 2015) and on Macedonia (mala galerija, Skopje, 2016) as well as curating exhibitions in Summerhall, Edinburgh, the WorM, Aberdeen, and the Institute of Contemporary Art in Zagreb. He is currently engaged in a number of research and exhibition projects in Scotland, and in Macedonia. He divides his time between Aberdeen and Skopje.

Maeve Connolly co-directs the MA in Art & Research Collaboration (ARC) at Dun Laoghaire Institute of Art, Design & Technology in Dublin. She is the author of *TV Museum: Contemporary Art and the Age of Television* (Intellect, 2014), on television as cultural form, object of critique and site of artistic intervention, and *The Place of Artists' Cinema: Space, Site and Screen* (Intellect, 2009), on the cinematic turn in contemporary art. Her recent publications include contributions to the anthologies *Workshop of the Film Form* (Fundacja Arton and Sternberg Press, 2017), *Exhibiting the Moving Image: History Revisited* (JRP Ringier, 2015) and *The International Handbooks of Museum Studies: Volume 3, Museum Media* (Wiley-Blackwell, 2015). Connolly has contributed to journals and magazines such as *Afterall, Artforum, Art Monthly, Frieze, Millennium Film Journal, MIRAJ, Mousse, Screen, Third Text* and *The Velvet Light Trap,* and authored catalogue essays on the work of numerous artists, including Anita Di Bianco, Vivienne Dick, Laura Horelli, Jesse Jones, Mairead O'hEocha, Alex Martinis Roe, Bea McMahon, Niamh O'Malley, Susan Philipsz and Sarah Pierce. She has also programmed screenings in relation to her own research, at Bluecoat, FACT, the Irish Film Institute, LUX, Mother's Tankstation Gallery, Project Arts Centre, and Tate Modern.

Cinzia Cremona is an artist and academic living between Sydney, Beijing and London. She completed her practice-based Ph.D *Intimations: Videoperformance and Relationality* at the University of Westminster in London in 2014. She graduated at Central Saint Martins College of Art and Design, University of the Arts, London, in 2003. Her artworks have been exhibited in Europe, USA, Russia, China and Japan. Her key concerns are gendered mediated relationality and performativity in the context of contemporary art and emerging technologies. She has published chapters in books about video art and digital performance. She is co-editor of the Critical Practice publication *Non-commercial Practices of Market #Trans-Acting Value*, published by Intellect. Since 2013 she has been an Honorary Research Fellow at Duncan of Jordanstone College of Art and Design (University of Dundee). She is part of the research cluster Critical Practice (Chelsea College of Art and Design, UAL), and was co-curator of the moving image and performance events *Visions* (London) between 2007 and 2016. She is Associate Lecturer at Wimbledon College of Art in London (UAL).

Sean Cubitt is Professor of Film and Television at Goldsmiths, University of London, Professor Grade II at the University of Oslo and Honorary Professorial Fellow of the University of Melbourne. His publications include *Timeshift: On Video Culture* (Routledge, 1991), *Videography: Video Media as Art and Culture* (Palgrave, 1993), *Digital Aesthetics* (Sage, 1998), *Simulation and Social Theory* (SAGE, 2001), *The Cinema Effect* (MIT Press, 2004), *EcoMedia* (Rodopi, 2005), *The Practice of Light: A Genealogy of Visual Technology from Prints to Pixels* (MIT Press, 2014) and *Finite Media: Environmental Implications of Digital Technologies* (Duke University Press, 2017). Series editor for Leonardo Books at MIT Press, his research focuses on the history and philosophy of media, political aesthetics, media art history and ecocriticism.

Malcolm Dickson is a curator, writer and organiser. Dickson is Director of Street Level Photoworks, an arts organisation and production centre, which supports artists and the public to make and engage with photography. He curates a year-round programme embracing different genres of new photography by emerging and established artists, as well as bringing to public awareness neglected bodies of work from previous decades. This has wider audience reach through a network of local and regional partners, which takes photography to outlying towns and remote locations. Recent international collaborations include VU Photography Centre in Quebec City, Centre Photographique Marseille, Lithuanian Photographers Association, aff Galerie (Berlin) and Ostkreuz Agency (Berlin). He is currently developing a project connecting Scotland to Northern European countries. He regularly participates in international portfolio reviews. A former Senior Research Fellow at University of Dundee, he writes regularly for artists publications and contributed a chapter to the *REWIND* book in 2012. Through Street Level, he initiated the web platform Photo-Networks (https://photo-networks.scot/) to raise awareness of and to grow audi-

ences for photo-based art in Scotland whilst providing a resource for those outside the country.
http://www.streetlevelphotoworks.org/

After a long career in teaching and research, **Catherine Elwes** retired as Professor of Moving Image Art at Chelsea College of Arts in November 2017. Elwes is also known as a video artist and curator, and was active in the feminist art movement in the late 1970s. She co-curated the exhibitions *Women's Images of Men* and *About Time* at the ICA in 1980 and was the director of the biennial *UK/Canadian Film & Video Exchange (*1998–2006) and co-curator of *Figuring Landscapes (2008–2010),* an international screening exhibition on themes of landscape. Elwes has written extensively about feminist art, performance, installation, landscape and the moving image and is author of *Video Loupe* (K.T. Press, 2000), *Video Art, a guided tour* (I.B. Tauris, 2005), *Installation and the Moving Image* (Wallflower/Columbia University Press, 2015) and is currently writing *Landscape and the Moving Image* (Wallflower/CUP). Elwes is Founding Editor of the *Moving Image Review & Art Journal (MIRAJ,* Intellect) and has published in numerous books, journals, exhibition catalogues and periodicals including *Art Monthly, Third Text, MIRAJ,* the *Millennium Film Journal, Time Out, Independent Media, Performance Magazine, Variant, Filmwaves* (of which she was an editor), *Vertigo* and *Contemporary Magazine.* Elwes' video practice is archived at LUX online and REWIND.

Slavko Kacunko (Ph.D. Dr. phil. habil.) was born in Osijek (Croatia)

where he studied art history and philosophy. He received a Ph.D. and a post-doctoral qualification in Art History from the University of Düsseldorf (1999) and Osnabrück (2006). Since 2011 Kacunko is Professor of Art History and Visual Culture at the University of Copenhagen. Since 2014 he is an elected member of Academia Europaea. Key foci of Kacunko's research profile are Video, Performance, Installation, Visual studies and Aesthetics. For his interdisciplinary approach in Art History and Media Studies he has received international recognition. His *Closed Circuit Videoinstallationen* (2004) was referred to as a 'milestone in the history of media art' and 'the pivotal source book for the decades to come'. His *Marcel Odenbach. Konzept, Performance, Video, Installation* (1999) is described as an 'Art history pioneer achievement in the field of video art' and awarded with the DRUPA-prize 2000. Kacunko has furthermore authored monographs *Sabine Kacunko: Bacteria, Art and other Bagatelles* (2016), *Culture as Capital* (2015), *Wiederholung, Differenz und infinitesimale Ästhetik. Matthias Neuenhofer* (2012), *Las Meninas Transmedial* (2001), and *Dieter Kiessling* (2001), as well as *Spiegel. Medium. Kunst* (2010). Recently, he has edited a comprehensive two-volume anthology *Theorien der Videokunst* (2018).

Marika Kuźmicz (Ph.D.) is a graduate of art history at the University of Warsaw in the Institute of Art, Polish Academy Institute of Sciences, Warsaw. She conducts research on Polish art of 70s. Head of the Arton Foundation (Warsaw), a non-profit organisa-

tion, she concentrates on researching and exhibiting Polish art of the 70s. Author and editor of books dedicated to the art of that time, such as *Workshop of The Film Form* (2016, co-edited with Łukasz Ronduda), among others. Currently, she is working on a book dedicated to the history of performance art in Poland (1930–1982). Curator of many exhibitions, she is the originator and main coordinator of *Forgotten Heritage – European Avant-Garde Art Online*, an international project supported by the Creative Europe Program. She is lecturer at the Academy of Fine Arts, Warsaw University, Warsaw and Collegium Civitas.

Laura Leuzzi is an art historian and curator. Currently, she is Research Fellow and Co-Investigator on the Arts and Humanities Research Council funded research project Richard Demarco, the Italian Connection (Duncan of Jordanstone College of Art and Design, University of Dundee). She was Post Doctoral Research Assistant on the AHRC funded research project EWVA | European Women's Video Art in the 70s and 80s (DJCAD, University of Dundee). From 2011 to 2014 she was Post Doctoral Research Assistant on the AHRC funded research project REWIND*Italia* Artists' Video in Italy in 70s and 80s (DJCAD, University of Dundee). She completed her Ph.D at Sapienza University of Rome in 2011 and sits on the curatorial Committee of the Media Art Festival in Rome. Author of articles and essays in books and exhibition catalogues, her research and curatorial practice focus on video art, new media, art and feminism, time and the relationship between word and image in visual art. She has curated exhibitions, screen-

ings and events in Italy, United Kingdom and Switzerland. She is co-editor with Stephen Partridge of *REWIND Italia. Early Video Art in Italy* (2015).

Adam Lockhart is the Media Archivist and Researcher at Duncan of Jordanstone College of Art and Design (University of Dundee, Scotland, UK). He is a leading specialist in the conservation, preservation and restoration of artists' video. Lockhart has worked on a number of AHRC research projects including REWIND | Artists' Video in the 70s & 80s, Narrative Exploration in Expanded Cinema with Central St Martins College of Art & Design, REWIND*Italia*, European Women's Video Art & Richard Demarco: The Italian Connection. He has acted as curator, co-curator and consultant for a number of screenings and exhibitions at organisations such as Tate Modern, Tate Britain, BFI Southbank, Dundee Contemporary Arts, Scottish National Galleries of Modern Art, Ambika P3, Street Level Photoworks Glasgow, DOCVA in Milan and Shanghai Minsheng Art Museum.

Laura Mulvey is Professor of Film and Media Studies at Birkbeck College, University of London. She is the author of *Visual and Other Pleasures* (1989), *Citizen Kane* (1992), *Fetishism and Curiosity* (1996), *Death Twenty-four Times a Second: Stillness and the Moving Image* (2006) and is renowned for her essay *Visual Pleasure in Narrative Cinema* (1975) – which had a major impact on the course of film scholarship. Between 1974 and 1982 Mulvey co-wrote and co-directed six films with Peter Wollen: theoretical films, dealing in the discourse of femi-

nist theory, semiotics, psychoanalysis and leftist politics; and two films - more recently - with artist/filmmaker Mark Lewis. Mulvey's interests are broad, ranging from contemporary art to the introduction of sound in cinema, from Douglas Sirk to Abbas Kiarostami.

Stephen Partridge is an artist and academic researcher. He is the Principal Investigator on research projects REWIND and REWIND*Italia* which have been awarded successive grants in 2004, 2008 and 2011 from the Arts & Humanities Research Council, and in 2012 the Royal Society of Edinburgh. Currently is Co-Investigator on the AHRC-funded research project, EWVA | European Women's Video Art in the 70s and 80s led by his colleague Professor Elaine Shemilt. He was in the 'landmark' video shows of the 1970s including the *Video Show* at the Serpentine in 1975, the *Installation Show* at the Tate gallery in 1976, the Paris Biennale in 1977 and the The Kitchen in New York in 1979. His internationally renowned artwork *Monitor* (1974) was acquired by TATE Britain in December 2014 and is in the current re-hang of the collection in *A Walk through 500 years of British Art*. He has also curated a number of influential video shows: *Video Art 78* in Coventry; UK TV New York; *National Review of Live Art*, 1988–90; *19:4:90 Television Interventions*; and the touring tape packages *Made in Scotland I, II, Semblances, Passages*. He has lectured since 1975 in a number of art colleges and established the School of Television & Imaging at Duncan of Jordanstone College of Art & Design (University of Dundee). He is presently Professor of Media Art. He has been peer reviewer for the Arts Council, Channel 4, the Scottish Arts Council, Scottish Screen, SACLottery, Ludwig Boltzmann Gesellschaf, European Research Area, Creative Scotland Awards, REF2014, REF2021, Portuguese Foundation for Science and Technology, and the AHRC.

A graduate in History of Art and Aesthetics, **Lorella Scacco** teaches Phenomenology of contemporary arts in Italian Academies of Fine Arts. Key foci of Scacco's research profile are Videoart, Media art, Interactivity, Visual Studies and Phenomenology. She has curated exhibitions and edited catalogues for contemporary art exhibitions in public and private spaces in Italy and abroad, such as the Venice International University on the occasion of 52nd International Art Exhibition of the Venice Biennale, La Triennale in Milan and Stenersen Museum in Oslo. Since 1999, she has collaborated with Nordic institutions and artists. As a journalist, she contributes to specialised art magazines. She has authored a number of books including *Media Aesthetic. From Jean Baudrillard to Derrick de Kerckhove* (Guerini 2004), *Northwave. A Survey of Video Art in Nordic Countries* (Silvana Editoriale 2009), and *Alberto Giacometti and Maurice Merleau-Ponty. A dialogue on perception* (Gangemi 2017). She is currently a Ph.D candidate at the University of Turku, Finland.

Professor Elaine Shemilt, BA, MA (Royal College of Art), FRSA, FRGS is an artist, academic and researcher. She holds the Chair of Fine Art Printmaking at DJCAD, University of Dundee. Her artistic practice involves

sculpture, installation, printmaking video and digital media. Shemilt was a pioneer of early feminist photography, video and multi-media installation work. The video works *Doppelgänger* (1979/1981) and *Women Soldiers* (1984), were recovered and migrated to digital by the AHRC funded research project REWIND in 2011. She experiments with a combination of materials and media and has an international reputation for innovation in the use of printmaking across art forms and also collaborative work with scientists. Her early work was exhibited at The Hayward Annual 1979, The Bradford International Print Biennale 1978, and the Video Show 1975 in the Serpentine Gallery, London. More recently her work has been shown at the Imperial War Museum, London and in Warsaw, Berlin, Rome, Singapore, Melbourne and Shanghai. Shemilt is a Fellow of the Royal Society of Arts, the Royal Geographical Society. She is a Shackleton Scholar and a Professional member of Society of Scottish Artists. She is the Director of the Centre for Remote Environments and is also the Vice Chair of the South Georgia Heritage Trust. These organisations are principally involved in environmental management and protection and Shemilt was a founder member of both.

Emile Josef Shemilt is an artist and academic researcher, with a specialisation in experimental film and moving image art. Shemilt's research interests include contemporary art practice and theory, specifically lens-based and print media, as well as

histories and theories of media art, video art and avant-garde film. Shemilt studied at the Ruskin School of Drawing and Fine Art, University of Oxford, and holds a Doctorate in Moving Image Art from Duncan of Jordanstone College of Art and Design, University of Dundee. He was recipient of an Early Career Leverhulme Fellowship (contemporary moving image, theory & practice), and a Royal Society of Edinburgh/Caledonian European Research Fellowship. From 2015 to 2018, Shemilt has been a Visiting Researcher within the School of Film, Philosophy and Spectacle, at the University of Roma Tre, Italy.

Siegfried Zielinski was Chair of media theory/archaeology & variantology of media at Berlin University of the Arts, and director of the Vilém Flusser Archive until 2016. He is also Michel Foucault Professor of Media Archaeology and Techno-Culture at the European Graduate School in Saas-Fee, honorary doctor and professor of the University of Arts Budapest, and founding rector (1994–2000) of the Academy of Media Arts Cologne. Zielinski has published numerous books and essays mainly focusing on the archaeology of media and co-authored, edited, or co-edited a number of anthologies. He is also a curator of large format exhibitions at the ZKM Karlsruhe, such as *Allah's Automata* (2015), *Ramon Llull & the Ars Combinatoria*, and *Art in Movement – 100 Master Pieces of Art with and through Media* (curated with Peter Weibel in 2018).

Index